MVFOL

ALSO BY PETER WATSON

From Manet to Manhattan
The Caravaggio Conspiracy
Wisdom and Strength:
The Biography of a Renaissance Masterpiece

SOTHEBY'S

The Inside Story

SOTHEBY'S

The Inside Story

PETER WATSON

RANDOM HOUSE

NEW YORK

Library of Congress Cataloging-in-Publication
Data is available.

ISBN 0-679-41403-7

www.randomhouse.com
Printed in the United States of America on acid-free paper
2 4 6 8 9 7 5 3
First U.S. Edition

Contents

BOOK THREE

THE ARREST

SOTHEBY'S

The Inside Story

—◠◠—

The Lady from Naples

The Hotel Vesuvio in Naples must offer one of the best views in the world. The building looks out on the round, crenellated tower of the Castel dell'Ovo, which guards the Bay of Naples, and across the waters to the volcano itself, with its smooth, gently sloping shoulders rising to a summit that is sometimes lost in clouds. But on the morning of Tuesday, February 27, 1996, as I shaved in my room on the fourth floor of the hotel, the spectacular view was the last thing on my mind. I was nervous.

Today was an important installment in a complicated and delicate undercover operation that might finally confirm my research: one of the world's most prestigious art auction houses was flouting the law in the most striking way.

The operation was the climax of years of investigation, which had begun with two men and a tip-off. Bit by bit, I had managed to corroborate many of the details disclosed in the tip. This Italian operation, if successful, would be a most impressive demonstration that what I had been told was true.

I finished shaving and got dressed. Today I was to be Peter Carpenter, supposedly a British connoisseur. I was wearing the most expensive clothes I possessed and carrying false business cards that gave telephone and fax numbers in both London and New York.

Downstairs, in the lobby, I met two colleagues. Cecilia Todeschini, a Rome-based researcher and interpreter, was on hand to translate. Tall, statuesque even, Cecilia had grown up in South Africa, an experience that had given her a keen eye for wrongdoing. She was already on her third cigarette of the day. Sam Bagnall, a television producer, would be posing today as my assistant. With his close-cropped hair, stubble beard, and chunky boots, Sam from a distance resembled one of Britain's notorious soccer hooligans, and he was indeed a fanatical team Arsenal supporter. But appearances can be deceptive. Now thirty, and a brand-new father, Sam was wise beyond his years; he had impeccable judgment and a determined ability to see the funny side of any situation, however bad. As a colleague, his only drawback was that like Cecilia he was a heavy smoker.

We checked our watches. Five to ten. It was still too early to call on art dealers, so we took a walk along the edge of the bay, to finalize our cover story. Outside, it was sunny but fresh. At sea the waves glittered, more silver than gold. According to the story we had worked out, in collaboration with Britain's Channel 4 TV network, which had to approve all our undercover operations, I was a slightly shady art-world type, more a collector than a dealer, though we would leave my precise standing uncertain. I was in Italy scouting for paintings and planned to drop a few good names, to prove I was credible. We were looking for a particular kind of picture.

The three of us had already collaborated on a British television program about Sotheby's that aired in November 1995. It had shown that the company dealt in illegally excavated antiquities smuggled out of Italy. But that program, which had been produced for Channel 4 by Clark Television, owned by Bernard Clark, had explored a relatively narrow range of wrongdoing. We had had far

more information than we could use in the first program, when we had been testing the waters to confirm that documents I had been shown by an ex-employee had some validity. Now, four months later, Sotheby's had not demonstrated that the documents were false, nor that we had drawn the wrong conclusions. It was time to tell the larger story. That was why we were in Naples.

Eventually, we turned back from our walk. Sam and I were assured by Cecilia that the city's traffic pattern had recently been reorganized and was now much better than it had been. We found it hard to believe. The cars and trucks still made a terrible din and raced along the embankment as fast as ever.

We reached the hotel and climbed into a taxi. "Via Domenico Morelli," Cecilia instructed the driver.

The Via Domenico Morelli is shorter than London's Bond Street and a great deal less imposing than Manhattan's Madison Avenue, but like those thoroughfares it is the major artery of the city's art trade. It is a gently sloping street, and its features include a pretty square at the top end, a statue of four lions, a famous chocolate shop, and all the art dealers of significance in Naples. The taxi dropped us at the foot of the street shortly after 10:30. Our first stop was number 6 *bis*, the Galleria Antimo d'Amodio. This, I had been told by dealer friends in London, was the most important gallery in the city. Cecilia had telephoned a few days before, on my behalf, to ensure that Signor d'Amodio would be on hand.

The three of us swept in. After years of covering the art market for *The Observer* in London, I had learned that the art trade liked a bit of panache and that the best way to impress dealers was to behave as though you were extremely rich and used to being surrounded by servants or sycophants. Signor d'Amodio was there: a small, chubby, friendly man with black hair and an open face. He did not speak English. There were three other people in the small gallery, including a woman who spoke some French and enough English to understand us, so we dealt mainly with her.

Our goal was fairly specific. We were looking for an Italian old master painting, produced at any time from the fifteenth to the eighteenth century, priced somewhere below £10,000, or about $15,700. There were a number of other requirements, but those were not details we cared to divulge. Also, we did not want to say anything to the dealers that would have prevented them from being able to sell us such a picture legitimately.

D'Amodio had a number of wonderful paintings, including a pair of crystal-clear architectural fancies by Michelangelo Cerquozzi, a splendid view of Vesuvius, and a small but exquisite panorama of Naples harbor by Oratio Grevenbroeck. Each of these, however, posed major problems for us. The pair by Cerquozzi, though fabulous, carried a price that reflected their quality: £50,000—way beyond our budget. More important, d'Amodio had bought them at Sotheby's in New York in the late 1980s. They were of no use to us.

The view of Vesuvius was not a topflight picture, and its price was not quite within our budget—£12,000—though I knew enough about the market to be sure that d'Amodio would come down to our level. The major problem was that the subject was too Italian. This was a picture that was worth far more in Italy, and in Naples in particular, than anywhere else. It would be no help.

The third picture, the Grevenbroeck, was better in almost every respect. The asking price was £18,000, but again, d'Amodio would almost certainly accept an offer well below that. The subject was agreeable: the boats in the harbor were superbly painted, you could identify their nationality from the flags flying at their sterns, the sea was calm (collectors hate rough seas), there were plenty of human figures in action, and the colors were strong. The only problem here was that Grevenbroeck was not an Italian; he was Dutch. Strictly speaking, the painter's nationality did not matter for our purposes, but for clarity's sake we wanted to buy a painting by an Italian artist. Still, I whispered to Cecilia to ask d'Amodio if he would object if we took a photograph of the harbor scene. He did not, and so Sam fished out his Polaroid and aimed it at the Grevenbroeck. When he

had the photo, we made our farewells. I gave d'Amodio my card and promised to be in touch.

The next gallery along the street was Falanja, a much larger place, which sold furniture as well as paintings. Here we came across a beautiful work, *Christ Being Lowered from the Cross*, said to be by Francesco Zuccarelli, though I doubted it. The asking price was 95 million lire—about £43,000, or $67,500. There was also a massive picture, about five feet by four, showing a seaside town, the bay in front of it, and wooded hills behind. It was not in good condition and the asking price was 35 million lire, over £15,000. Sam took photographs of both and we left.

Farther down the street, the third gallery, Bello Goia, had in the window the most stunning *Portrait of a Woman*. The picture was obviously an early work—fifteenth or sixteenth century—and showed a lovely girl with her blond hair in braids piled up on her head. Painted on panel rather than canvas, this picture also had an elaborate carved frame. Unfortunately, the gallery owner was not there and the assistant, a young man of about twenty, seemed to know next to nothing about art and to have little idea what the price of the painting was. He was also very reluctant when we asked if we could photograph it. It was frustrating.

We decided to break for coffee. At the foot of the Via Domenico Morelli, the road curved around to gardens that edged on to the sea; a café overlooked the gardens. We were getting nowhere, and we were subdued. Cecilia and Sam gulped at their cigarettes. All the paintings we had seen were either too costly for our budget or too poor for our plan to work. We had come to Naples for a specific reason, but the trip had been expensive, and now it was beginning to look like a dismal failure.

After coffee, we walked back up the other side of the Via Domenico Morelli. First we came to a couple of small galleries—boutiques almost—where it was immediately obvious that there were no paintings to interest us. Then, at number 33, we arrived at Artemisia. This was perhaps the second most impressive gallery in

the street, after d'Amodio. It was long, narrow, and high, with a spiral staircase at the far end. There were paintings and sculptures, and scattered about the gallery on wooden pedestals were huge bunches of flowers. A bearded man sat behind a desk, and a blond woman was arranging the flowers. They smiled at us as we came in, and they began to turn on some lights: although it was already 11:30, we were surely the first customers of the day.

There were some fine things on the walls. A large, vivid archway in the manner, I guessed, of the Carracci, a family of Bolognese painters, was 110 million lire, about £50,000. A drawing in red chalk of a woman's head, in the manner of Rubens, was 50 million lire, or £23,000. And in the back was a huge oil of a dead swan. That was 77 million lire—£35,000. Anything I liked, and that I thought might work, always turned out to be well above our budget.

Just then a young man came clattering down the spiral staircase. As he went past, he said something in Italian. Cecilia turned to me and said, "It sounds as though there's another gallery upstairs. He says the lighting has been fixed." The staircase was rather rickety and the steps were narrow, but up we went. At the top were two rooms, each filled with paintings. In the first, there were some large works—landscapes, battle scenes, more architectural fantasies— but they all looked rather weak to my eye. The second room contained smaller works, much more intimate pictures. There were still lifes of lemons, bread and oysters, flower pictures, and interiors: all fairly dull.

Then, suddenly, I saw what we were looking for. In the middle of the far wall was a portrait of an old woman holding a cup. In some ways, this was a curious picture. It was not exactly beautiful, for the woman's eyebrows were gray, the veins on her cheeks stood out, and her neck was scrawny. And yet there was something about the portrait. The detail had been painted meticulously throughout, and the handling of the paint on her white collar showed the artist to have been extremely accomplished. Most notably, the fingers were very

lifelike; hands are notoriously difficult to paint, and many artists avoid them.

None of the staff from downstairs had accompanied us to the upper galleries, so I asked Sam to photograph the old woman with the cup. When we returned to the main gallery, a surprise and a shock awaited us. The surprise was a tray of strong, freshly brewed coffee. That was welcome and seemed to confirm that we had been accepted for what we were pretending to be: international characters in the art trade. The shock came when I showed my business card. The person in charge at Artemisia was the blond woman, who introduced herself as Concha Barrios. As she took my card and read it, she smiled, nodded, and said calmly that she had seen me before.

Sam looked at me sharply: was this about to get sticky?

It was soon apparent, however, that although she recognized me, it was not in my role as a journalist, but merely as a man who hung around the auction salerooms.

We relaxed and finished our coffee.

Concha Barrios informed us that *Old Woman with a Cup* was by Giuseppe Nogari, an eighteenth-century painter from the north of Italy, and that the asking price was 45 million lire—just over £20,000, twice our budget. I told her we had photographed it when we were upstairs and would like to think it over for a few days. She didn't appear to mind about the photograph and then said that she was willing to come down a bit on the price, to 35 million lire, or about £16,000. But no further.

I made a show of writing down in my pocket notebook what she had said. I asked her if it would make any difference to the price of the painting if I paid wholly in cash. She said she would like to think about that. I finished my coffee, and then strolled around the gallery again, inspecting the more valuable paintings on the lower floor.

After a few moments, we made as if to leave. Concha Barrios came across the gallery, carrying a catalogue she had produced some

weeks earlier. I didn't take it, but motioned to Sam, as if to suggest
that my assistant dealt with all menial matters.

Concha Barrios asked if I was going to Maastricht. This was a big
European old masters art fair, held in the Dutch town every March.
In mentioning it she had given me the opening I was looking for. No,
I said, I wasn't going to Maastricht, because the following week I was
going to America. In fact, I added, if I decided to buy the Nogari I
would have to carry out the negotiations by fax, from the United
States, where I would be traveling around. I pulled out another busi-
ness card and pointed to the New York fax number, which in fact be-
longed to my literary agent, who had been briefed on what to expect.

All of this appeared to satisfy, and even impress, Madame Barrios,
and we parted amicably, promising to keep in touch.

And that was that. The Via Domenico Morelli might be the Bond
Street of Naples, but Naples is not London, and we had by now vis-
ited every gallery. It was time to go.

We went to take the train back to Rome. When we reached the
Naples railway station and boarded the 12:25 express, it was to find
that the train had been delayed indefinitely because a political
demonstration was blocking the line. There was nothing we could
do but wait. We had a compartment to ourselves and passed the
time discussing the morning. We decided that the only paintings we
had seen that remotely suited our purposes were the Grevenbroeck
at d'Amodio and the Nogari at Artemisia. And of the two, the latter
would be preferable, because Nogari was Italian.

I was, in fact, traveling to America that weekend. We decided I
would open negotiations from there. That would be about the right
amount of delay, although we could not afford to delay too long, as
we had an inflexible deadline. If we reached agreement, Sam would
come back to Naples by himself with the cash and pick up the
painting.

At 1:50 a man in uniform appeared at the door to the compart-
ment. "He's from the dining car," said Cecilia. "He wants to know if
you want tickets for lunch."

"But what about the demonstration?" Sam and I asked together. There had been no sign of movement.

There now followed a prolonged exchange in Italian between Cecilia and the man. And then she laughed.

"What is it?"

"He says this is Italy. The demonstrators will want their lunch too. The demo is bound to end at any moment."

So we took tickets.

Sure enough, five minutes later a huge crowd of people came down the platform and trooped past the train, carrying banners and bullhorns and chanting slogans. They were accompanied by a police escort and seemed good-natured. As we made our way to the restaurant car, and the train at last inched forward, an hour and a half late, one of the demonstrators shouted out, *"Buon appetito!"*

Ah, Italy.

Back in London, and before any negotiation, I needed to check out the value of the paintings. If we were to make an offer to Concha Barrios or d'Amodio, it would have to be realistic—the sort of offer a genuine dealer or connoisseur would make. This was one reason why I had had Sam take the photographs. I sent them to a friend who was a dealer in old masters. But first I needed a story to tell him, as I didn't want to involve him in our plan, or even alert anyone to the fact that we had a plan. I told my dealer friend that, in the course of research for a thriller I was writing—a thriller set in the art world—I had come across a selection of paintings for sale in Ticino, the Italian part of Switzerland. I hinted that the pictures were in fact in Locarno, on the shores of Lake Maggiore. A Swiss provenance for this "collection" was important, because while it is illegal to export old master paintings from Italy without a license, no such restrictions apply in Switzerland. My dealer friend was accommodating. He sent back the photographs by return of post, with values scribbled on them. Against the Grevenbroeck he had penciled "£10,000–14,000" and against the Nogari "£8,000–12,000."

That weekend I flew to America. Two days after I arrived, I sent a fax to Concha Barrios and, with the appropriate details changed, to d'Amodio.

> Dear Ms. Concha Barrios,
> It was very nice to meet you the other day, when I was in Naples with my assistant. Thank you for showing me your paintings. I have now had a chance to make my inquiries and am pleased to make you the following offer. In your upstairs room you had a portrait of an old woman, eighteenth-century, Venetian, oil on canvas. For this painting I can offer you 18,500,000 lire [about £8,000].
>
> I realize that this is not what you were asking, but we both know how the market is now, and I can certainly offer you a quick sale. In fact, I say that if you agree to this price, one of my assistants will be in Naples in the next three weeks and can pay you the entire sum in cash.

I gave details of my whereabouts in America, and sat back to wait.

D'Amodio replied first, two days later. I had offered him 18.5 million lire also. He came down to 26.5 million lire—more than £12,000—but wouldn't budge any further. The next day Concha Barrios replied. Her fax said that she had paid 20 million lire for the Nogari and that I had to offer her more than that if I wanted the picture. Twenty million lire was, at the time, £9,090, within the budget. But I had to offer more. On the day the transaction was made, there were almost exactly 2,200 lire to the pound sterling, which meant that 21 million lire was equivalent to £9,545, a few hundred pounds under our limit. This was for the picture we wanted.

I let twenty-four hours go by, then offered 21 million. Next day Concha Barrios sent a further fax, giving me the details of her bank, for payment. I was slightly flummoxed by how quickly she had come down, from 45 million lire, to 35 million, and then to 21 million, in three huge jumps. We had paid less than half the asking price. We had no time to dwell on that. The deal had been done and we were

within budget. The first step in our plan was on the road. We needed to move forward quickly. Sam went back to Naples with the cash. He picked up the painting in the last week of March. The delay of two weeks was brought about by our need to have all the other aspects of our plan in place.

When I had originally been approached by a former employee of Sotheby's, the documents he had appeared to show that the company, among other things, dealt in old master paintings smuggled out of Italy to England, where they were sold at auction. Certain documents pointed to the Milan office, Sotheby's headquarters in Italy, as a center of this traffic—there were scores of documents on Milan office letterhead, discussing Italian clients who had contacted Sotheby's personnel and, usually, asked what such-and-such a painting would fetch "in Italy or in London." Several documents identified paintings by name and artist, and over the months Sam and I had tracked down a number of works from Milan that had subsequently been sold at auction in London.

We needed to put to the test this pattern of clandestine trade. Also, the documents referred to the 1980s. We wanted to see if the trade was still going on. It was therefore our intention to take an Italian old master to Sotheby's Milan office and then see what Sotheby's did. Why Naples? The city was a long way from Milan. Sotheby's had no office there. The art trade world is small, and we did not want to risk choosing a picture that had been sold at auction only a few months before. That would have scuppered our plan completely. Naples' galleries were as remote from the major auction rooms as we could get in Italy.

Now that we had a painting, we needed a plausible history for it. We had been working out that "history" in the intervening days, before Sam went back to Naples. Since I was somewhat known in the art world—better known than Sam, anyway—for this next stage I would be in London, out of sight, although in constant touch by telephone.

Our plan was to have someone go into Sotheby's in Milan with the painting and say that it was part of a recently inherited collection. The problem was that because we were making a television program for Britain, the transaction had to be in English. Therefore, we needed a good reason why the person taking the painting spoke English and not Italian. Having been to Australia not long before, I knew that Sydney has a sizable Italian community. We therefore decided to look for a "front man" who had links to Australia and, for credibility's sake, an address and telephone number there. This plan had the added advantage that Australia is a long way from London. The chance that anyone inside Sotheby's would suspect what we were involved in was much more remote, or so we judged.

Sam and I considered friends who might fulfill this role. We alighted first on someone I shall call Gloria. She was a researcher in television, a trim, professional-looking woman who was in all respects perfect for our needs. To me she looked exactly like the kind of woman who might inherit a collection of paintings. Gloria was in fact of Lebanese extraction, but her father could easily have married an Italian woman in Australia. Unfortunately, after at first agreeing to take part, Gloria had a change of heart. She was perfectly entitled to do so, but we had lost a week. We were hoping to have the painting smuggled in time for inclusion in the summer sale of July 3, and for that we needed to get it into Sotheby's as soon as possible.

Then we had a stroke of luck. Also working at Clark Television, on another program, was an Australian camerawoman named Victoria Parnall. Even better, she was of Italian extraction—her mother's maiden name had been Costello, and her cousin Peter Costello still lived in Sydney. So Victoria came from the right background and had an address we could use in Sydney, plus a telephone and fax. Her final strength was that as a camerawoman, she was perfectly trained for the rest of our plan.

We spent days briefing her. She had never been to an auction, knew little about the art world, and had no idea what was expected of her. Gently I explained that that was no problem; in fact, it was an

asset. For she would be playing the part of a woman who had no knowledge of the art world, who had spent most of her life in Australia but had suddenly inherited a collection of paintings from her grandmother in Italy. Victoria was instructed to say that her grandmother had lived in a small village outside Bergamo, but to be no more specific than that. We chose Bergamo because Nogari was a northern Italian painter. It was entirely credible that his work should be in a collection in that area.

In the first contact, Victoria was to be vague about exactly what she had inherited and to say only that a local dealer had made an offer for the collection. We did not want Sotheby's to feel it had the field to itself; the impression we wanted to get across was that Victoria was bringing the Nogari into Sotheby's to have it valued, so that she could make a direct comparison with the dealer's offer. We also gave Victoria a sister. This sister had children, and so could not leave Sydney, but she knew more about art and the art world than Victoria did. This might be useful at some future stage if Victoria had to negotiate and maybe show more understanding of the art world: she could then be operating on instructions from her sister. This could also buy us time if we needed it.

After Sam left Naples, he traveled north with the painting to rendezvous with Victoria at the Milan airport; they then drove to the Hotel Excelsior San Marco in Bergamo. Here another little Italian drama was enacted. According to the plan, Sam and Victoria were to check into the hotel separately. Security demanded that they should not know each other—otherwise, because they had arrived together, calls from Sotheby's for Victoria might be put through to Sam's room if she could not be found, and since his name had been on the first television program it might be recognized. However, when Sam and Victoria arrived at the hotel, the receptionist saw them getting out of the car together in the hotel's parking lot. Sam was forced to improvise: he took the manager to one side and explained that Victoria and he were having an affair, and that her husband might be calling. On that account, no calls for Victoria were to be

put through to his room. The hotel manager nodded and said that he quite understood.

Italy came through again.

The staff member at Sotheby's Milan office whom the documents mentioned most often was Nancy Neilson, an American. However, she no longer worked there, and our inquiries showed that her place had been taken by one Roeland Kollewijn, who was Dutch. It was he whom Victoria called late on the morning of Wednesday, March 27. Planning had gone into this telephone call. It was made at lunchtime, because, for verisimilitude, we wanted to call Kollewijn when he was out and leave a message. If he himself called Victoria back at the hotel, he would have no doubt that he was speaking to someone in Italy, and in Bergamo. Our story would hang together.

On this first occasion, Victoria was told that Kollewijn was away all day and would not be back until Thursday. There was nothing for it but to wait. Bergamo is a hill town and not unattractive: there are worse places to kill time. Next day, early, Kollewijn called back and Victoria told him that she had recently inherited some paintings. She also explained that she would be in Italy for only a few days. She asked if she could see Kollewijn quickly. He suggested she come to Milan right away. Sam and Victoria got there at about 11:30 A.M.

It was a dull, overcast day, the sort of weather that in winter sometimes closes Milan's Linate Airport. Sotheby's offices, in the Via Broggi, are discreet, located in a quiet, fashionable area between the public gardens and the central station. Sam had prepared Victoria electronically. In her bag she carried a state-of-the-art tape recorder. No less important, hidden inside a crystal brooch on her lapel was a tiny fish-eye camera, whose wire ran under her jacket to the Hi-8 tape machine, about the size of a cigarette pack, pinned safely inside her pocket. The camera angle had been tested so that Victoria knew exactly where to sit in order to capture Kollewijn's face on tape. Before entering the offices, she and Sam walked

around the block to ensure that the whole apparatus was working—and to settle Victoria's nerves.

At 11:45, alone now, she stepped into Sotheby's. She carried the Nogari in a plain paper bag, double-wrapped in bubble plastic and brown paper and sealed with masking tape. When Victoria asked for Roeland Kollewijn, she was led up some stairs to the mezzanine floor. This was a large room where auctions were normally held and had a skylight. Both the audiotape and the videotape would last for two hours, so she was in no hurry.

After a few moments, Kollewijn arrived. He was a short, slight, blond, good-looking man with rimless spectacles. He wished Victoria good morning in clear English with a clipped Dutch accent. She explained all over again that she had inherited a number of paintings and had made a special journey from Australia. Implicitly, she made it plain that she was a newcomer to the art world.

She let him unwrap the painting. Kollewijn was enthusiastic—and yet held back. He said that it was a good picture, in that it was an authentic Nogari, when normally people who came in out of the blue did not have the real thing. The painting was, he added, worth about 15 to 20 million lire (in other words, a few hundred pounds less than we had paid for it). It was "very beautifully painted, but . . . it's not very commercial. . . . It's a nice picture, but she's so sad." Then he cheered up again, and made some comments about the woman's hair being indistinguishable from the background and added, "This is nicely painted. Well done."

He then proposed that if Victoria agreed, Sotheby's could sell the painting in May, in Italy, with an estimate of 15 to 20 million lire. He made the point that the frame was only twentieth-century imitation, but, he said, that did not matter. He ended by saying that if she wanted to sell the painting in the May sale, he needed to know immediately. The catalogue was to go to the printer the very next day.

Victoria began to sweat, and stalled. This was not what we wanted—not at all. She hid behind her "sister," saying that she would have to check with her; she knew much more about art. Since

she was in Australia and they were nine hours ahead, it was already 9:00 P.M. in Sydney. But not too late for an important matter. Kollewijn offered her the use of Sotheby's phones, but again Victoria played for time. She did, however, agree to leave the painting with him, and had the presence of mind to ask for a receipt. He agreed. There was then some small talk about the commission that Sotheby's would take if Victoria agreed to sell the painting in Milan, and the cost of value-added tax (paid on the saleroom's commission) and insurance.

Since Kollewijn had not introduced the possibility of selling the Nogari in London, Victoria now reiterated that the painting was only one of several she had inherited, and that she and her sister wanted to "maximize our profit." They wished to judge, she said, between what a local dealer might offer and what the paintings might achieve in the salerooms. She then asked whether the Nogari would fetch the same price in London.

Yes, Kollewijn said. The Nogari would sell just as well in Milan as in London. It was an Italian painting and, by the standards of the Sotheby's market, not very expensive. Thus far, this was a disappointing answer, but still interesting in its way. It suggested that although our Nogari was not, after all, a suitable subject for the traffic we hoped to see demonstrated, a more expensive picture, of a different subject, might be. Tantalizing.

Later on in the conversation, Kollewijn said as much. Referring to Victoria's comment that she and her sister wanted the maximum profit on the collection, he said, "Yes. Well, with this kind of stuff . . . the difference between the international market and local Italian market is when you've got the high-level stuff. . . . This is a minor good painter who has a local market here, so it's better to put it in with the others here rather than to let it come to New York. . . . If you have something for the international market, a beautiful Guido Reno or a Raphael, something good or a gold background or a major painting in very good condition, then you have the differ-

ence, then someone on Fifth Avenue, of course, everyone in New York, may say, 'Oh well, I love this picture, let's go for it . . .' "

Victoria: "Yes."

Kollewijn: ". . . and then you go well over the Italian price. This is not an international market picture. But if you have international quality, you really should send it away, it's very important. You know, if you have a Canaletto or a Guardi, you know—out—never here. So that's—when you go to London . . ."

Victoria: "Yes."

Kollewijn: ". . . then they will say, well, it's worth six or nine thousand pounds—same thing. But if you bring a Guardi here and say, well, you know, we might make one hundred million [lire] for it [about £45,500] and London might say we'll give a hundred thousand pounds for it and then it's worthwhile, because you have to think—when you put something on the international market, why do you do it? So, this is not a picture that's going to enter Houston, Dallas, New York, but if you have a Guardi or something very chic . . ."

Victoria: "Yes."

Kollewijn: ". . . then it is a rather drastic difference and then it's absolutely worthwhile and then we try to organize export for you. From Italy it's better to send them to London rather than New York, because [of] your VAT on the declared price, because you're going outside the . . . Community. So I wouldn't do New York, I would do London. . . . It's a perfectly good picture. This is nice, it's a bit loose here, but it makes it nice. It's an allegory on old age, how you are loo— . . . that's how you are intended."

Victoria: "A portrait of Dorian Gray."

Kollewijn: "Yes, they were made in pairs. . . . You have the same in still lifes. You have fish still lifes and game still lifes . . . which are the meager years and the fat years . . . or you have this one paired with a young lady who is for youth. And this one is for the elder."

Victoria: "Oh, I see."

Kollewijn: "So if you can choose, then you take the young one. You know, it's a more gayful subject, this is one that means . . . you don't leave any material with you, that's the moral behind it."

Victoria: "How interesting."

Kollewijn: "If you have the young girl then . . . then it would still be a picture for here."

Victoria: "Okay."

Kollewijn raised a possibility: "Then it would already start to be a London picture. It might."

Soon after, the conversation came to an end. Exact transcripts of conversations are often confusing, as anyone who has served on a jury will know. But Kollewijn's message was plain enough. He was saying that our picture was not valuable enough to send to London, that the market for it was as good in Milan as in London, but that if we had had something more important, more beautiful, more valuable, then that would have been a different matter. He could have "organized" the painting's export. Toward the end of the interview, he was saying that if we had had the companion work to our picture, then maybe the pair would have been worth exporting.

Victoria wound up the encounter as quickly as she could, saying that she would think over what he had told her, telephone her sister in Sydney, and call back tomorrow. She said she was planning to leave for Australia the next evening—an important detail, as it turned out. She left the painting with Kollewijn, gave him the address, telephone number, and fax number in Australia, then left.

When Sam and Victoria called me at home later that afternoon, they were low. Over the phone I could hear Sam pulling anxiously on his cigarette. We were so near, yet so far away. Kollewijn had hinted that smuggling went on, but only with more valuable paintings than we possessed. Sam and I spoke for some time, chewing over our thoughts, but going nowhere. He was impressed by Kollewijn's eventual openness, but having heard the tape, he said the

Sotheby's man seemed adamant that our picture was unsuitable. We decided to sleep on it.

That evening I went to the opera at Covent Garden. Letting the music wash over me, I kept turning over our problem in my mind. The more I did so, the more two things stood out. The documents we had been given by the former employee of Sotheby's indicated that the smuggling of old master paintings from the company's Milan office to London went on at many levels, and not only with more expensive pictures—even allowing for the fact that the dossier related to the 1980s, when values were different. Not all the paintings that had been smuggled out were six-figure master-pieces.

When I got home, I inspected the documents again. Yes, I was right: a lot of the paintings that had been sent to London from Italy were minor works. Why then was Kollewijn balking? It was only when faced with the wording and facts in the documents that I felt I understood. Many of the people mentioned were people who were on first-name terms with Sotheby's staff. They were dealers or collectors who consigned shipments of pictures regu-larly. In other words, they dealt often and in bulk and so were re-garded as good security risks: Sotheby's would be inclined to do things for them that they wouldn't do for a relative stranger, like Victoria.

There was something else I noticed that night that had never struck me before. The chief person mentioned in the Milan docu-ments during the 1980s was an American, while the person in charge now was a Dutchman. Was that a coincidence? Did non-Italians find it easier to take part in the export of old masters, where native Italians might have experienced qualms of conscience when disposing of their national heritage? On the face of things, it was unusual for an Italian not to be in charge of the old masters depart-ment in Milan. Italians were surely the most knowledgeable people about their own art, weren't they?

I became convinced that Kollewijn was the right person to deal with. But I also realized that we had to raise the stakes—persuade him that we were worth his while.

By 8:00 A.M. London time, Friday morning, I was on the telephone to Sam and Victoria. I explained my thinking and told them that it had two consequences. In the first place, I wanted Victoria to go into Sotheby's in Milan that day, but unannounced. If she simply turned up, we might wrong-foot Kollewijn. More important, her sudden arrival would emphasize her keenness to deal with him, to make the sale happen; it would show how eager she was to try the auction route rather than simply sell to the local dealer in the Bergamo area. This, I thought, might relax and reassure Kollewijn; and if he was more at ease, he might be more cooperative. It was, I added, quite plausible for Victoria to drop in. She had explained the previous day that she was flying back to Australia that night and was in a rush to have everything settled.

My second point was that this time Victoria was to explain that she had talked to her sister, in Sydney, and that the sister had instructed her to tell Kollewijn about the other paintings in their "collection." Describing the collection in greater detail would allow Kollewijn to value it more closely, which would whet his appetite. His remark the previous day about trading up a young girl by Nogari into "a London picture" showed that what we had was close to being smuggling material. With a *collection* in the background, who knew what Kollewijn might do?

The composition of the collection was all-important. Kollewijn, we now knew, was impressed by the Nogari. The artist was scarcely a well-known painter, but the picture was genuine and well executed, and that was what mattered. Many people who turn up at auction houses bring with them pictures supposedly by, say, Titian or Caravaggio or Tiepolo. In practice, these big names turn out to be "school" paintings, pictures by followers of the artist in question, and usually dismal examples at that. A "School of Titian" painting is worth considerably less than a genuine Nogari. More to the point,

if someone brings into an auction house a "Titian" that turns out to be a school painting, then it is pretty clear (a) that that person does not know much about art, and (b) that any collection to which he or she has access is likely to consist of second-rate works that have been miscatalogued in the past by other people who also knew little about art. Conversely, because our Nogari was genuine, and well painted, it was reasonable to think that the collection Victoria and her sister had inherited might be made up of similar works.

It followed that when we made up our list of pictures in this so-called collection, we should not fill it with Tintorettos or Titians or Tiepolos but with works similar in standing to Nogari's and similar to those which, we had reason to believe, had been smuggled in the past. That would amount to a tidy enough sum to whet Kollewijn's appetite, I thought. All manner of painters who are unknown to the general public still fetch prices at auction somewhere between £40,000 and £400,000. It would not be too hard to assemble a ficti-tious "collection" of ten or a dozen paintings that were worth, in theory, a total between, say, £500,000 and £5 million. The commis-sion to Sotheby's would be anywhere between £100,000 and £1 mil-lion. Well worth having.

The names we chose were these. First, we selected Nicolò Frangipane, a Venetian painter active in and around Venice at the end of the sixteenth century, whose pictures sell for £5,000–15,000. Then we went for Benvenuto Tisi, called il Garofalo, who lived and worked in Ferrara from 1481 to 1559 and was an early painter of ex-quisite Madonnas that sell for about £20,000. We also put the words "gold ground" against his name, meaning that the picture was painted on a gold background. A pair of paintings by Mario Nuzzi came next. He specialized in flowers, and although his works fetch only £10,000–15,000, if genuine, a collection such as ours would al-ways have some examples. Andrea di Bartolo came next on the list. He too painted gold-ground Madonnas in Siena in the period 1389–1428, which sell for around £20,000. We deliberately mis-spelled his name "Bartola" to reinforce the idea that Victoria knew

nothing about art. Then came Michele Rocca, who lived and worked in Parma and Venice between 1670 and 1751, and whose works sell for £10,000–20,000. All of these were northern Italian painters on a par with, or slightly better than, Nogari.

Rather better were the names Pompeo Batoni, an eighteenth-century Roman painter who portrayed several popes and scores of princes, and whose work might be expected to fetch £75,000–100,000, and Bernardo Strozzi, a Genoese painter who followed Rubens and whose richly colored works were easily worth £40,000–50,000. Finally, we threw in some relative "stars." If all the other paintings were genuine, which Kollewijn was invited to believe, because the Nogari was genuine, these more important pictures would improve the profile of the collection by a factor of ten.

We listed one work by Luca Carlevaris, a precursor of Canaletto, who lived and worked in Udine and Venice between 1663 and 1730, and whose paintings can reach £150,000. Another painting we had was by "Crivelli." This was left deliberately vague, for in fact there were two Crivellis, Angelo Maria Crivelli, who was active in Milan in the early eighteenth century and whose pictures sell for £5,000, and Carlo Crivelli, who worked in Venice at the end of the fifteenth century and was influenced by Mantegna and whose paintings may reach £500,000. On top of that, we threw in works by Orazio Gentileschi, Marco Ricci, Sassoferrato, and Luca Giordano. I thought that after all the other names, Kollewijn would not be able to resist the idea that these four might just be authentic. The Gentileschi and the Giordano, if on the right subject, might be £1 million paintings, and the Sassoferrato and the Ricci might just reach £250,000 each.

By my calculation, this meant that the collection Victoria had inherited contained well over 50 percent northern Italian paintings, worth roughly £4.4 million—about $5.3 million. This would produce a commission of more than £800,000 for Sotheby's. I dictated

the names to Sam but deliberately did not tell Victoria anything about the paintings. If she pleaded total ignorance, she couldn't make any mistakes. Then I wished them luck and hung up.

What I did not know was that Sam had elaborated on my scheme. He had faxed my list to the office in London, telling them to rewrite it and fax it back. Then he tore off the top strip, which identified where it had come from. His idea was that Victoria would show Kollewijn a fax and pretend it was from her sister in Sydney. It was a good idea.

I was in the middle of lunch when the telephone rang at about 1:30, or 2:30 in Milan. It was Victoria, and she was excited.

"Peter," she said, breathlessly, "he admitted everything. *Everything.*"

Let Kollewijn speak for himself. The following pages contain the relevant extracts from the transcript of the encounter with Victoria. Once again, the exchange took place on the mezzanine floor. Again the exact transcript reads in a disjointed way. Nonetheless, its thrust is clear. After pleasantries were exchanged, Kollewijn explained that he was checking out our picture. That is to say, he was looking through reference works and art history books to see if any photograph of the painting had been published before. He said there was a problem in exporting a work of art over fifty years old, and clearly if a picture had been published, it was harder to do, or to claim ignorance later. When the Italian authorities saw Sotheby's catalogue, they would be able to point to the publication in Italy as proof that any particular painting had been inside the country not too long ago, and *if no export permit was attached*, it must have been smuggled out.

Victoria then gave Kollewijn the list of other paintings that were in the collection she had supposedly inherited.

Kollewijn: "Good stuff. . . . If it *is* what it is. . . . It's a lot of money. . . ."

Victoria: "Now you can see why we . . . used one that maybe wasn't so expensive . . . so maybe we could test the market . . ."

Kollewijn: ". . . You know, this is good stuff. . . . It's stuff that can't be exported. You know, with Italy within the European Community it's a very difficult country because they are rather upset about losing works of art from the country. It's more or less the only natural resource they have . . . they don't have oil or whatever . . . so they're very strict. . . . If you have a really good Luca Giordano they will block it. A Garofalo, if it is really good, they block it. A Gentileschi, if it's good they will block it. . . . Crivelli, no. Batoni, they might, Carlevaris they might block, Strozzi they might block, Marieschi they might block. . . . Very much off the record, I have strict instructions from London. . . . Because there is a sort of ideological thing, no government—either going to the left wing or the right wing—will let pictures go out easily because we know it doesn't matter but they say we don't want to be accused—oh, we are giving away our cultural heritage. They are very nervous about their cultural heritage because that's the only thing they're still good at, you understand me? . . ."

Victoria then asked how much difference it would make to sell her pictures in London. "I mean, what for . . . can you give me . . . an example of one that the price here and the price in London, maybe on the list . . ."

Kollewijn: "Well, er . . ."

Victoria: "Just suppose . . ."

Kollewijn: "Just suppose . . ."

Victoria: "I mean . . ."

Kollewijn: "If you have a real Gerini which is a gold ground . . . if it's as big as this [he gestured, holding his arms about three feet apart], for example, which normally they are, then they make here about fifty million lire and they might make in London two hundred million lire."

Victoria: "Mmmm."

Kollewijn: "I don't want to put wrong ideas in your mind. . . ."

He then pointed out that selling pictures openly in Italy posed one problem. ". . . I never have Class A, five-star pictures because

they're notified. . . . In Italy it might get notified and then get un-sold because people won't buy notified pictures."

Notification means that the government keeps a record of a painting. It means that the importance of a picture has been offi-cially recognized, but that its export will almost certainly never be allowed, and that an official record of its whereabouts exists. A noti-fied painting has a stamp burned into its reverse side, so that every-one may see its official status.

Victoria: "So, um, I mean, from what you're saying, though, is there some way we can get it out of the country?"

Kollewijn: "Yes. Well, I'm not telling you this as Sotheby's . . ."

Victoria: "Just Roeland to Victoria."

Kollewijn: "Yes. . . . You need an address in London. Doesn't matter who."

Victoria: "Yes."

Kollewijn: "Who knows about it. He says he's [unintelligible] a private person obviously."

Victoria: "Yes."

Kollewijn: "Then we can smuggle it out."

He explained that he was having the Nogari photographed and ex-ploring Victoria's legal position, because he had never come across this situation—an Australian citizen and resident owning pictures in Italy. He said that the problem Victoria and her sister faced in selling the collection in Italy was that it would come to the notice of the state and that if the paintings were good there was a chance that some of them would be notified and they would render themselves liable to tax. "And say this is a whole group of pictures which probably in Italy will get notified, and we wouldn't suggest that you put it in a sale here . . ."

Victoria: "Right. Okay."

". . . then you have two options. Either sell this privately off to the dealer who takes the risk and probably takes it out of Italy himself, and you don't have a risk but you take less money. . . . Or you're doing it in an illegal way. An illegal way, you need an address in Lon-

don, somebody who doesn't want to know anything about it. The
expert in London will go to this address to look at the pictures and
they will think, not to think—'Oh, we found it there.' Um, the ex-
port will cost you . . . it's going to be done by someone which we can
organize—no problem. I know how to do it and they don't want me
to do it, but they want me to do it [rolls his hands]. . . . It's going
to cost you for each picture about a million lire [about £450 or
$700]."

Victoria: "Right."

Kollewijn: ". . . The good thing is that you don't have any export
problems, you don't have any legal problems. You will find the pic-
ture in London. Everything is fine."

Victoria: "Yes."

Kollewijn: "You have to pay the money in advance to the truck
driver."

Victoria: "Yes."

Kollewijn: "Then the best thing about this story is that it cannot
be insured because it does not exist so you cannot insure it so it gets
to a total [smacks his hands] to a *camion* [truck]."

Victoria: "An accident."

Kollewijn: "An accident and the whole thing burns, we don't
know, I didn't know you, I didn't see anything, I will deny every-
thing."

Victoria: "Yes."

Kollewijn: "Sorry about the pictures. Were there any pictures? I
don't know you lost them. . . . If the illegal transport goes wrong . . ."

Victoria: "Yes."

Kollewijn: ". . . they will confiscate the pictures. We don't know
the owner and you lost them. . . ."

Victoria: "How often does this happen?"

Kollewijn: "It never goes wrong, but it will at some point. . . . Be-
cause I always feel when I do this . . . statistically it never goes
wrong, which means that every time it didn't go wrong—"

Victoria: "There's always the chance."

Kollewijn: "There's always the problem that it will go wrong. At some point it will go wrong. It's not easy because nowadays . . . free traffic . . . it shouldn't, but if it does, I'm out, I'm sorry."

Victoria: "Okay."

Kollewijn: "I would say if you're going to send it out I'm going to need for this group at least ten million lire, or fifteen million. I'm not taking a penny, but they want cash."

Victoria: "No, no, I understand what they are saying."

Kollewijn: "And then it goes to an address in London and then Sotheby's expert goes there and says, 'Oh, how nice, what a surprise!'—he knows, but he doesn't [unintelligible]. If anything goes wrong, he says, 'I saw those pictures in London. I didn't know that the owner exported them illegally.' "

Victoria: "Okay."

Kollewijn: "It's not a nice story."

Victoria: "No."

Kollewijn: "It's not good. We want to avoid it. I hate it."

Victoria: "Yes."

Kollewijn: "Sotheby's hates it very much. I've got strict instructions not to do it."

Victoria: "Yes."

Kollewijn: "But sometimes it's a waste and I do it."

For a while they returned to a discussion of the paintings that Victoria had inherited. Kollewijn admired the Nogari all over again, and then said that if the Carlevaris was as good an example of his work as the old woman was of Nogari's it could be worth £250,000. He also returned to the risk of being caught sending paintings out of Italy.

"It's like a card box house, the whole thing will collapse, so it's not the sort of risk you want to take but you might have to take it if it's really top-rate quality, then I would take it. . . . It depends how tough you are."

There was more talk about the Italian authorities. Victoria asked, "Do you think those—this business we're not talking about. Do they know that it goes on?"

Kollewijn: "Sure."

Victoria: "Okay, maybe that's why—"

Kollewijn: "That's why I wouldn't call you here . . . we don't like to phone."

Now Victoria took the bull by the horns: "What would you do if you were me?"

Kollewijn: "I would smuggle it."

Victoria: "Would you?"

Kollewijn: "I would definitely, but I'm from a different point of view because I see smuggling all the time. . . . You know, I'm in it. I know the risk. I would take it but you might not because you are a stranger in this thing. . . . If those names are all right [meaning the artists in the list], then you want to have it out because there's just pots of money in it, so I would do it. But that's my point of view because I know what I'm talking about. . . . The list is wonderful. . . . But it may be anything. . . . So you're definitely not going to make any decision until you know what this stuff's worth in London. What you want to know, really, your next step's just to get it there. [unintelligible] then Sotheby's or Christie's or whoever you want goes there and you get London quotes on this stuff. Then you know what it's worth."

Victoria: "Right, so you've got to get it out first?"

Kollewijn: "Yeah, somebody has to go there. Either I have to go there or it has to come to me somewhere. . . . I will give you an idea if you will have any troubles exporting it legally. . . . I think the Nogari shouldn't be blocked. It might be blocked, it shouldn't be, it depends on who's sitting there. And as they're changing we can't bribe them. They won't let you, that's more or less the problem. . . ."

Then Kollewijn made a different proposal, one that Victoria, being inexperienced, did not take on board. ". . . if you have a transport problem then you want to figure out if you are either going to go ahead with your dealer and he buys it off you, or we make a private sale and we go ahead with a similar deal as your dealer. . . ."

In other words, Kollewijn was saying that perhaps Victoria and her sister could sell their entire collection to Sotheby's, instead of to the dealer in Bergamo. If they decided to do so, though, they would receive only about 60 percent of the likely auction price. And presumably Sotheby's would then sell the paintings at auction, in Milan or London, on its own account. He was proposing a deal not as agents but as principals.

Victoria: ". . . how do I contact you if we decide to go ahead with the illegal thing? . . . I was thinking of the Nogari. . . ."

Kollewijn: "Oh, I would say to keep the Nogari now until . . . you would rather put it in one trip."

Victoria: "Oh, I see . . . yes. We were thinking of selling them one by one so as to not draw attention, maybe."

Kollewijn: "Yes, well, you can send them away all together and then sell them one by one. It's again a kind of statistical thing. If the truck gets lost, they lose everything at one time, but if you send twenty pictures in twenty trips you might get twenty times for it to go wrong . . . the more times you take the risk anytime the truck might get stopped. And they might find out who you are. . . . The Nogari, if you want to go ahead with it, let me know. I'll organize it. I need for the Nogari, as it's a small picture . . . about . . . he will probably ask for about eight hundred thousand lire or something."

Victoria: "Okay."

Kollewijn: "I will put it on a truck for you and then it will go to an address which you have to give me."

Victoria: "Yes."

Kollewijn: "I need this money in advance or I am not going to give it to you. . . . Then I put it on a truck. Then it goes to an address in London. . . . So you're feeling bad for three days because that's what it takes the driver. Then I will phone you—it's there, and you're happy. . . ."

Kollewijn repeated these instructions several times, making it plain that the up-front money was not for him but for the truck

driver. Then he added, "I will also make a receipt that this picture has been taken away with you. We don't have . . . you can't say that we have it. I want you to sign something: 'I took it away.' . . . I'm not going to smuggle it until I have it out of this office legally. . . . It's not that I don't trust you, it's just that this is such a filthy business. . . . If it's only the Nogari, you know, on a good day you get five million lire more in London than you get here."

Victoria then said that she and her sister wanted to use the London route with the Nogari, just to try it out, even if the price achieved was not greater than in Italy. She asked how she should behave over the telephone if she spoke to Kollewijn from Sydney.

Kollewijn: "Well, don't be too explicit."

Victoria: "No, okay."

Kollewijn: "Because they can bug us and they do. . . . We hope they aren't doing it but they are allowed to."

Victoria: "Really?"

Kollewijn: "Yes, they um—"

Victoria: "How can you tell?"

Kollewijn: "Well, um, I'm not good at spy stories. . . . It's that the legal background with this, that the judge here has investigative powers. He can decide . . . you can only bug someone if it's important, but the one who decides if it is important is the one who is doing it . . . so important would be if they thought Sotheby's is going to do illegal exports of art—that's important."

Victoria: "Yes."

Kollewijn: "So that's important enough."

Victoria: "Yes."

Kollewijn: "So you might." And then he added: "If I were a judge I would bug Sotheby's."

Victoria: "Yes? Because it's happening all the time?"

Kollewijn: "Well, they know it's happening all the time, and why are we here?"

Victoria: "Yes."

Kollewijn: "So of course it's all lies buried here, so of course we should be bugged immediately. If I were in power I would arrest the whole lot here."*

Victoria was sweating. She had never expected Kollewijn, a man she had met only the day before, to incriminate himself, and the staff in Milan, in this way. But Kollewijn was now eager to do business. "So, if you want to say go ahead, I will send you to Australia by DHL [an express delivery service] a thing that you sign that you took [the Nogari] away with you. . . . I get it back, I want to have about eight hundred thousand lire, whatever it is. I might make a deal with the courier that he gets paid in London. . . . I'd rather not have it. So it would be better that I give and that your London person pays it so I'm out."

There followed an exchange in which Kollewijn said that he understood why Victoria wanted to try the system with the Nogari and that maybe it was not such a bad idea, because if there was an accident she would have risked a relatively unimportant part of her inheritance. He made clear that he had told her the problems, about accidents and so forth. "Normally," he said, "it's fine."

They agreed on how much they would say on the telephone.

Kollewijn: "I only phone someone and say I've got something for you and that's it."

Victoria: "Cash on delivery now?"

Kollewijn: "Cash on delivery."

Victoria: "Yes."

Kollewijn: ". . . Yes, we want to go ahead. I say okay, I just send you the mail, I'll get my mail back. Having my mail back I understand that you have understood what you're going to do."

Victoria: "Yes, absolutely."

He also said that he needed photographs of all the pictures so that

* Kollewijn was later to claim that he was referring to the entire art world of Milan (and perhaps Italy), not just to Sotheby's. The reader can decide.

he could check that they had not been published, even a long time ago, as, say, "Private Collection, Bergamo." That would prevent any of their plan going forward. Victoria agreed to provide him with photographs as soon as she could. Meanwhile, he would continue to check the Nogari, in books and in the private archives of such well-known scholars as Roberto Longhi, in the Kunsthistorisches Institute in Florence.

He took care to end with a reassuring remark. "But don't be too upset about this story. In the end it's easy."

And the meeting ended. What a meeting it had been.

Kollewijn had not only agreed to smuggle our painting but had also given us details of the way the operation worked, admitted on several occasions that smuggling went on all the time, that his company should be bugged by investigating magistrates, and that the whole of the office in Milan should be arrested. His most arresting phrase had been "Why are we here?" In other words, what the documents suggested had been amply corroborated, and the smuggling still went on, despite the earlier, if limited, TV and newspaper exposure of illegal dealings in antiquities.

For the time being, the pressure was off us. Victoria had done well, very well. She had prompted Kollewijn superbly, without putting words in his mouth, and kept quiet when she should have kept quiet. He was now going off on vacation for a week, so nothing would happen soon. We had to find an address in London to which the painting could be delivered, and Victoria's relatives in Australia had to be alerted about the DHL package they would soon receive.

At least, that was how it was supposed to proceed in theory.

That weekend I was researching an article for an American magazine. As part of this work I had to visit Sotheby's London office early the following week to consult a certain file regarding items that had been discovered in recent months and sold at auction. One of the

most exciting events in the art world occurs when collectors or deal-
ers, or even ordinary people who know nothing about art, stumble
across something they think is worthless, or next to worthless, and
then discover that it is in fact a long-lost masterpiece. I had been as-
sembling about twenty such cases, half a dozen of which involved
objects sold at Sotheby's. There was a Hindu sculpture found in a
hedge (sold for £15,000), a Russian manuscript unearthed in a
Helsinki garbage dump (£14,000), and a Dürer etching that turned
up in a barn (£588,000).

On Tuesday I went to the St. George Street back entrance of
Sotheby's in London. There I met the company's chief press officer,
Christopher Proudlove. A small, friendly man from the northeast of
England, fast-speaking and efficient, he had with him the firm's
"Discoveries" file. He took me into a small interview room and left
me with the file for half an hour. I sat quietly going through the
material, making notes and taking out of the folder color trans-
parencies of the objects I was interested in. When I had finished, I
called Christopher, who came down to collect the file.

However, instead of taking the file and seeing me out, he carefully
closed the door again. "Peter," he said, "I need to ask you a question."

I was immediately tense. Until this point, our exchange had been
friendly and casual. Now, Christopher had grown serious.

"Tell me," he said, "are you making another program about
Sotheby's?"

I looked straight at him, trying to remain calm. What was he get-
ting at? How much did he know? I did not want to give anything
away; but I also did not want to lie. Christopher and I would have to
work together later, and I didn't want him to hold anything against
me, other than things that were inevitable given the kind of investi-
gation we were conducting. Mindful of the fact that all we had from
Clark Television at the moment was a development budget, I said,
truthfully, "Christopher, no decision has been taken as yet, one way
or the other. Why do you ask?"

"It has come to my notice," he said, "that the same company which made the first program is making another one." And then he added, "I also hear that what they are doing is very underhand."

I repeated what I had already said, and escaped as quickly as I could. But as I walked back to my car I felt shattered. I disliked the use of the word "underhand." All undercover and investigative work involves some form of secrecy; it goes with the territory. What we were doing was undercover, but not underhanded (and it was in the public interest). Kollewijn, an employee of Sotheby's, was a person who was regularly flouting the law; we weren't. However, much worse than Christopher's use of that word was the fact that he knew what we were up to.

We were faced with a major security leak at the point when we seemed to be on the verge of proving our case.

Over the weekend, Sam, Bernard, and I met at my house in Chelsea. We had agreed not to use the Clark Television offices for the time being, until we had some idea of where the leak might be. Bernard was adamant that the leak had not come from within Clark. Yes, there were people working on other television programs in the office, but no one with access to our material. One or two secretaries did know what we were doing, but he swore they were trustworthy. There was Gloria, who knew what we planned and was not part of the team; but she did not know the details, the painting, or the fact that Victoria was involved. Nonetheless, if anyone inside Sotheby's had been alerted to the fact that people from Clark Television had been in Italy the week before, it would not have been impossible for them to put two and two together. We had used Victoria's real name.

We considered the possibility that the leak came from inside Channel 4, the network, only to discount it immediately. The staff there knew only the broad outlines of what we planned and had no knowledge of the painting, the dates, or the personnel involved. They produced investigative programs every week, without leaks. It was baffling. It was also frustrating because Kollewijn had gone on

vacation. If Sotheby's was on to us, it was unlikely it would take any overt action; it would simply return the painting to Victoria, with or without an explanation, and cease all cooperation. But we would not know this until Kollewijn was back from vacation and Victoria had her next telephone conversation with him.

Meanwhile, we still had to put in place the two other aspects of the cover story: our Australian cover and our London address. Thinking that the project was dead, we set about these tasks without any real enthusiasm.

Victoria had already telephoned her cousin Peter Costello in Sydney and explained to him, his wife, and his two sons that a man named Roeland Kollewijn, of Sotheby's, might call or fax from Milan. They had been instructed to say that although Victoria lived at that address, she was at that moment traveling on business somewhere in Australia—exact whereabouts unknown, although she called in frequently. Then, as soon as they had hung up, they were to call Victoria in London, no matter what time of day or night, so that she could call back Kollewijn as soon as possible. If he sent a fax, Victoria's relatives were under strict instructions to fax it to Victoria in London, then send the hard copy by DHL or Federal Express the next day.

Our problem with an address in London was that it had to be absolutely convincing: that is to say, it had to be a genuine address, with a genuine name. Preferably, both the name and the address should be in the telephone book. Then, if Sotheby's staff in London made inquiries, no suspicions would be aroused. This meant we had to find someone who did not mind his or her name and premises being used. The risk was that we clearly could not expect anyone to lend us an identity and address without our explaining why. But if we did and the person then decided against cooperating, there would be yet more people like Gloria who knew about our project and yet were not part of it. With the leak so fresh in our minds, we were worried about approaching the wrong person.

The first name that came to mind was an old friend of mine, an actress, Swedish, living in Sussex, who spoke excellent English with a slight Scandinavian lilt. No one could link her to us. Unfortunately, and to my great dismay, she was unable to help because of urgent domestic commitments. So here was yet another person who was privy to our plans and not part of the team. I began to sweat all over again. Fortunately, another friend came through. I had not seen her for perhaps ten years, but we had once been good friends and colleagues on a magazine. Heather Cotham, as I will call her, had lived at the same address, on Princess Road in Primrose Hill, north London, for twenty years, and her telephone number had not changed. Moreover, she had seen the first program and been outraged at Sotheby's behavior. After thinking it over for a day, she agreed to lend us her identity and flat. She did not want to play any further role in our project, but that was fair enough. Sam had someone in mind who could play her.

And so our waiting resumed. Sam had gone off on vacation himself, to Greece, but had left his number. He was as anxious as anyone to know what had gone wrong. Kollewijn returned on Monday, April 15. We resisted the temptation to call him that day, reasoning that we might appear too keen to get the whole thing on the move again. Next day Victoria came to my house, connected the tape recorder to the telephone, and dialed Sotheby's number in Milan. It was 10:30 A.M. in London, 11:30 in Italy. To say that we were anxious is to put it mildly. While the videotape and audiotape we had of Kollewijn admitting smuggling was pretty powerful stuff, it would be still more convincing if our—and his—whole scheme went through.

Victoria was connected with the Via Broggi. She was told that Roeland Kollewijn was in London. Now what did that mean? Had he been recalled to London to discuss our undercover operation, and how Sotheby's should play it? But if so, it appeared they had let him finish his vacation before recalling him. Surely if they were on to us they would have acted sooner. But why else would Kollewijn

be in London? We were still baffled. We were told that Kollewijn
would be back in Milan on Thursday, the 18th.

Victoria returned to my house two days later, and we went
through the same routine with the tape recorder and telephone. I
had called Sam in Greece and told him what was happening. Victo-
ria got through to the old masters department in Milan without dif-
ficulty. However, Kollewijn's assistant said he was with a client.
Victoria said she was calling from Australia and asked if he could be
interrupted. The assistant said he could not, but added that Roeland
would call Victoria back as soon as he could.

We had anticipated such an eventuality: Victoria said it was 7:30
P.M. in Sydney, and that she was calling from a restaurant, whose
number she did not know. She asked when Kollewijn would be free,
so that she could call back.

"Just a moment," said the assistant, "I'll check."

We hung on. I was listening to the exchange through headphones
linked to the recorder.

The assistant came back on the line. "Just a moment," she said
again. "Roeland will be free any minute. I'll put you through."

I looked at Victoria. What did that mean? Had the assistant been
expecting our call? Had Kollewijn given instructions to put Victoria
through whenever she called? Were they about to denounce us over
the phone?

"Hello?" It was Kollewijn.

"It's Victoria Parnall, in Sydney."

"Hello there." He didn't *sound* suspicious or belligerent.

"I called you the other day, Roeland. You were in London."

"Yes, I took the photograph of your painting. It's been allotted a
space in the catalogue."

What was this? Again, he did not seem suspicious at all. So what
had Christopher Proudlove been talking about? Could the project
go forward after all? My heart lifted.

"Roeland, I have the address you wanted."

"In London?"

"Yes, in London."

Kollewijn obviously did not want Victoria to tell him over the telephone. He said he would be sending the release note to Australia, and told her to write the name, address, and telephone number of her London "contact" on a piece of paper and include it when she sent back the signed release note. He was very friendly, mentioned his vacation, but made no reference to any undercover or "underhand" project. Victoria, not wanting to make any mistakes, and as relieved as I, wound up the conversation as quickly as possible.

Now began another anxious period of waiting, for Roeland to send the release note. Victoria again called her relatives in Sydney and told them to send on anything from Sotheby's to London by Federal Express.

Meanwhile, Sam returned from Greece, and he, Bernard, and I met in my house to go over the Christopher Proudlove incident again. For the previous two weeks, I had kept out of the Clark Television offices, and Bernard had put it about that Channel 4 had pulled out from backing our Sotheby's program—all as an effort to persuade any leaker that the company was doing nothing more on the story. It was a pretty lame attempt at closing the stable door, but there was little else we could do.

Now, however, Bernard and I concluded that the leak was not from inside Clark Television but via Scotland Yard. After the first program, on antiquities, we had been in touch with the Yard's art and antiques squad, just as we had been in touch with the Italian carabinieri, since both wanted to see the documents we had. Charles Hill, head of the Yard's art and antiques squad, had admired the first program and said he wished he had the budget to carry out that sort of investigation. He had then added—quite freely—that the Yard was pursuing its own inquiries concerning Sotheby's, but, tantalizingly, would say no more.

Bernard and I had discussed this, and shortly before Christmas we had invited Hill out for a drink. We had arranged to meet him in a wine bar called the Nelson, just off Trafalgar Square. There, it

turned out, three members of the art squad were drinking with several insurance loss adjusters and lawyers who specialized in art protection. During the evening, Bernard and I drew Hill to one side and asked him if he would be willing to pool information so that we could make a program that would include his inquiries as well as our own. Hill said he would think it over. In fact, he never mentioned it again, but on a later visit to Scotland Yard, to discuss an entirely different art theft case with him, I learned that one of the lawyers in the wine bar that night worked for Sotheby's. Bernard and I could never be sure, but we concluded that the Sotheby's man had recognized me from the first program and had overheard our conversation with Hill. It was possible, from Sotheby's point of view, that our trying to join forces with Scotland Yard could be seen as "underhand." If so, it seemed ironic to us that Sotheby's should regard the involvement of one of the world's most famous police forces as somehow improper.*

Time was passing. We were now in the fourth week of April and there was no sign that the release note had been received in Australia. Sam and I went to check out Heather Cotham's flat. For filming, the location was perfect. The door opened directly onto the street, but the flat itself was on the floor above. The sitting room was small and stacked with books, perfect for hiding two miniature cameras, which between them could cover the entire room.

We also gave some thought as to whether—and if so how—we should attempt to follow the person who delivered the painting. We had no idea who this would be, and we had no idea if Heather was his only delivery point or if he would be visiting many addresses that day. It would add to the story if the courier went around London dropping off old master paintings at a variety of locations. We decided there were three ways that a vehicle could leave Princess Road

* Mr. Hill disputes this account. He has left Scotland Yard and now works for Nordstern Art Insurance.

and that to be sure of following it, we would need at least two vehicles, one of them a motorcycle to allow greater maneuverability in traffic. We thus explored the possibility of hiding a camera in a crash helmet, since the motorcyclist would need both hands to steer.

The release note arrived in Sydney at last on Tuesday, April 30. Unfortunately, we did not hear about it until the next day, when Victoria received a fax of the contents, and a note to say that the release note itself had already been sent on to us *by express airmail.* Despite our instructions, Victoria's relatives had used the mails.

This was more important than it might seem, for the old master sale was set for July 3. The catalogue would appear a month before—say June 3, a Monday. Allow a week for printing (most catalogues are in full color) and that meant our picture had to be in London by May 27 at the latest. We knew that Sotheby's had allowed space in the catalogue, but we could not be sure that it would include the picture without being certain it was safely in London. If Sotheby's included the picture and then had to withdraw it, the firm could look foolish.

There was nothing we could do. The packet was already in the postal system. What was worse, the next Monday, May 6, when we should have received the release note in London, was a legal holiday: another day lost.

The first post of Tuesday, May 7, arrived at Victoria's house in west London just before 9:00 A.M. There was nothing from Australia. Sam and I were beside ourselves. Victoria was not. "I expect it will be in the second post," she said blithely. "That usually arrives about twelve."

It was. Relief all around. We made color photocopies, and Victoria signed the relevant part to return. In the meantime, however, Sam and I had been thinking hard. Australia was halfway across the world. Considering time zones and turnaround times and so on, the signed release might not arrive in Milan until the following Tuesday, May 14. That left less than two weeks for Kollewijn to export

the painting to London in time for inclusion in the catalogue. Time had become very tight.

The attraction of sending the papers to Sydney and then having them FedExed to Milan was obvious: Kollewijn would not suspect a thing. He had sent the release note to Australia; it should come back from there. But the more Sam and I thought about it, the more the likely delay was unacceptable. Alternatives?

There was in practice only one. It was to hand-deliver the release note and the London address to Sotheby's offices in the Via Broggi as if from a friend of Victoria's who was coming to Milan on Qantas or Alitalia. The more we thought about it, the more attractive this plan seemed. It would save us days and give Kollewijn more time to meet his deadline. The only problem was that a hand-delivered package did not have quite the smack of verisimilitude that a FedEx package from Sydney would have.

We played with various possibilities. I was a FedEx client in Britain and had a number of unused FedEx envelopes. Could we put the release note in one of those and have it hand-delivered? No—it would not have the accompanying paperwork. Could we get some Qantas letterhead from the company's offices in London and have the supposed courier write a covering note on it, as if he had done so on the plane coming over? We discarded that as too elaborate. Could Sam take the package to Milan, stay in a local hotel, and write a covering note on hotel notepaper, as if the courier had written it from his hotel, after his arrival? Could we get a clipping from a recent Australian newspaper, mentioning the art market perhaps, and include that with the package, as a sort of extra communication from Victoria, in Australia, a casual act of friendship? Amazingly, we could find no recent Australian newspapers in London, at least not on the day we allowed ourselves to search for them. But that did give Sam an idea. He looked up the wire services on the Internet. Just in time, he came across a Reuters report, datelined Melbourne, that described a recent

boom in the Australian art market. He checked with Reuters as to whether the various codes at the top of the report would show where it had been taken from, and was assured that the codes were the same all across the world.

So Sam printed out this report and tore it off the sheet in a casual way and then we had Victoria write across it: "Roeland, Hope this augurs well for our sale. Victoria." That, we hoped, would keep him thinking he was dealing with Australia. It was included in the package along with Heather Cotham's address and home telephone number.

Delivery was easier to arrange. Cecilia Todeschini had a brother living in Milan. We FedExed the package to him with instructions to hand-deliver it, either early in the morning or last thing at night, when Kollewijn would not be in the office. (The last thing we wanted was for Kollewijn to meet the courier.) In practice, the courier did even better: he delivered the package on Saturday morning, when the offices were open but most of the senior staff, including Kollewijn, was away for the weekend.

Now we had to wait a couple of days to check that Kollewijn had received the package, that his suspicions had not been aroused by its being hand-delivered, and that he was acting on it. We called him on Tuesday. Ostensibly, Victoria telephoned to give him Heather's work number, which we had deliberately left out of the package for this reason, and to tell him that Heather needed at least twenty-four hours' notice for delivery, since she had to negotiate time off from work.

Kollewijn was relaxed. He had received the package, he said, and all was well. He had been in touch with the couriers and he had just missed one truck, but now there would not be much delay. Astonishingly, he added further explicit details: the couriers were a London firm called Europe Express, and they would call Heather direct, once the picture had arrived in London. It would be cash on delivery, and he would let us know the exact amount

too. Kollewijn was clearly not at all suspicious about our hand-delivered package.

Everyone was now on standby: the Australians, Victoria, Heather, Sam, I myself, and a firm of specialist camerapeople. We still had to find someone to play Heather.

Then, on Friday, May 17, at about 3:00 P.M., Heather called. She had just been talking on the telephone to Kollewijn. The delivery would be on Wednesday or Thursday of the following week, and the fee would be £200 (about $300), strictly cash. She was to call George Gordon, second in command in Sotheby's old master department in London, after it arrived. She would receive a phone call from a Tony Morgan of Europe Express.

So that meant the picture would arrive in London on Wednesday or Thursday, May 22 or 23, only two working days before the old master catalogue deadline. We were cutting it very fine.

We planned two cameras in the sitting room of the flat and one outside, hidden in a van with windows made of one-way glass. We had abandoned the idea of following the courier, for two reasons. First, we now knew the courier was Europe Express. (Sam paid Europe Express a short visit: it was a moving company based in Camberwell. He noted the numbers of the vans parked there and carried out a company search. One of the directors was a Mr. A. Morgan.) Second, we thought it too risky. Following people without being spotted is much more difficult than it is made to appear in the movies, and since we now knew the identity of the courier, we didn't want to jeopardize the entire project for a bit more color. In any case, we had no reason to believe that Europe Express knew that carrying the merchandise involved any wrongdoing.

We had also found someone to play Heather. This was a woman named Fiona who worked at Clark. Her strength was that she was more or less Heather's age and was an actress. So, to some extent, she would try to emulate Heather's voice, and she spent a while talking with Heather for that purpose. Kollewijn wasn't the risk here,

but the Europe Express man, Tony Morgan, was. He would be calling Heather to give her the exact time of delivery, but would then meet Fiona. We didn't want him spotting the difference, not at this late stage.

If Fiona's advantage was that she was an actress, her drawback was that she had been on television. Business television, it was true, and at some ungodly hour in the morning. Nevertheless, there was a risk the Europe Express man might have seen her. I was worried, but Sam eventually persuaded me that the risk was so small it didn't matter.

As on what seemed countless occasions before, the only thing now was to wait. Early the following week, a new problem arose: Heather couldn't let us use the flat on Thursday. She had some un- specified personal problem, which wouldn't take all day, but would preclude our setting up the cameras in her flat on that day. Since we owed her so much, there was nothing we could do except pray.

Wednesday came. No word.

Thursday. We were next to our respective phones at all times. Fiona would be alone in the flat, Sam in the van with the camera- man.

The call came after 11:00. The man from Europe Express wanted to deliver the picture immediately, but Heather, playing her part su- perbly, stalled him and said she couldn't meet him before the next day, Friday. He grumbled, but eventually agreed to make "the drop," as he called it, at 10:30 A.M. He reminded Heather to have the cash on hand. The main problem, from our point of view, was that this conversation with Heather had been quite long. We had asked her to keep things as short as possible, but it wasn't her fault. We just had to hope that he wouldn't spot the difference between her voice and Fiona's.

Sam was at Heather's flat the next morning by 8:15. It took about an hour to install the cameras and make sure the view was clear and that the natural light was enough to film by. A certain amount of briefing was needed for Fiona. The courier might ask to use the

bathroom, so she needed to know where that was and how the lock worked. He might ask to use a pen and some paper to write on, so she needed to know where that was. In case he asked, she needed to memorize the phone number at the flat, and the postal code. She needed to know what Heather's job was. We wanted to unplug the phone, because it might ring during the encounter and Fiona would have to answer it. But he might ask to use the phone, so we had to provide her with a mobile, which she could legitimately ask him to use. Probably none of these details would matter, but we had to be prepared.

By 10:00, the flat was ready, and Sam retreated to the van outside. Having arrived early, the cameraman had found a good parking space, where the door to Heather's flat could be clearly seen through the one-way windows. As Sam and the cameraman made themselves comfortable, they found themselves being watched from a picture framer's shop across the street. Sam cursed. That was the last thing we needed: nosy neighbors.

In the flat the cameras were switched on. The film and tape would last for two hours.

That day in London the rain poured, but it wasn't cold. At 10:30 there was no sign of the courier. There was still no sign at 10:45, and Sam, for one, began to get jittery. There was no way now that he could get out of the van until the courier had come and gone. The project, not for the first time, was in the lap of the gods. On the other hand, the framer had lost interest and retreated inside his shop.

At 10:50 a large white truck pulled into Princess Road. "That's him," Sam whispered to the cameraman. He recognized the license plate from his earlier reconnaissance in Camberwell. Inside the van the camera started rolling, and sure enough, the truck pulled up outside Heather's flat.

There were two men in the cab. The one in the passenger seat reached behind him and took out a painting, wrapped in see-through bubble wrap. The driver got out and was handed the can-

vas. It was the Nogari. Quickly, to avoid the rain, he skipped across the pavement and rang Heather's bell. Using the intercom, Fiona let him in.

We had given some thought to what should happen if the courier bumped into any of Heather's neighbors on the stairs. She had told us they would be very inquisitive of strangers, and so we had suggested that she tell them in advance that a friend from Australia would be staying with her to attend a number of art fairs that were on at the time, and that the friend might be expecting antiques delivered.

But there was no one on the stairs as the courier arrived, and Fiona ushered him into the sitting room, and the full view of the cameras. He was a dark-haired man, in a blue shirt that emphasized his beer belly. Fiona had laid the £200 in an envelope on the sofa so he could see it as soon as he arrived. He unwrapped the bubble wrap, took the painting to the window so Fiona could inspect its condition, and then propped it on the sofa in full view of the cameras. He grumbled about the traffic to explain his lateness, said he was taking a £1 million painting to Belgium the next week, inspected the notes in the envelope in a cursory way, and left. Fiona had tried to say as little as possible throughout the encounter. Outside, he stopped briefly in the rain to check the contents of the envelope, and then he was off.

At about 12:30 that afternoon, the real Heather took a call in her office. It was Roeland Kollewijn, in Milan, telephoning to check that the painting had arrived. Fortunately, there had been just enough time, in theory, for Heather to have taken delivery of the picture and to have returned to her office. Yes, she said, the picture had arrived safely. Now what?

Kollewijn sounded relieved. Clearly, he had been worried, as we had, that it wouldn't arrive in London in time to be included in the catalogue. He asked Heather to call George Gordon in Sotheby's old masters department and to take the picture in.

When we tried to do so, however, later in the afternoon, Gordon was at first on the phone and Fiona, posing as Heather, was told to call back in ten minutes. When she did, she was told Gordon had already left for the weekend. This was annoying and frustrating. The following Monday was another legal holiday, and Fiona was told Gordon would be out of the office all day Tuesday, making a valuation. Kollewijn had made it plain that we should deal with Gordon, which meant the painting couldn't be delivered until Wednesday, May 29, at the earliest. There was still a chance that we might miss the deadline for the catalogue.

Five more days of waiting. More fingernails chewed. We decided that Victoria should call Kollewijn to celebrate the painting's safe arrival and to enlist his help to ensure that it was put into the catalogue. She called him on Monday, May 27, a legal holiday in Britain but not in Italy or Australia. Kollewijn, relaxed, said there was obviously no problem about missing the catalogue because, after all, the London office had had the photograph for some time. So that was fine. One other part of the exchange that day is worth recording in detail.

Victoria had explained that she was having a problem contacting George Gordon, but there was never any suggestion that she could deal with anyone else. She said he was out of the office and Kollewijn commented that there was no hurry, but in any case, "he's always flying back to London every week, so he will be somewhere."

Victoria: "Oh, you think? Okay."

Kollewijn: "So he will be coming back. And he is, he is the one to contact . . ."

Victoria: "He'd know?"

Kollewijn: ". . . yes, because, well not know, because he is the expert on it, that picture, but he's a friend of mine and . . ."

Victoria: "Right. So he knows the story?"

Kollewijn: ". . . so I do speak with him, yes. He knows the story, although he will deny it, he doesn't know anything."

Victoria: "Yes."

Kollewijn: "But he does."

Victoria: "Right. Okay."

Kollewijn: "So he's the one I usually contact first to get the picture in the catalogue."

Naturally, this made us somewhat more interested in Mr. Gordon. We decided that when Fiona took the painting into Sotheby's, she too would carry a hidden camera.

Eventually, Wednesday arrived, and Fiona spoke to Gordon. He was businesslike and noncommittal over the telephone, but seemed relieved when "Heather" offered to take the painting in to him rather than have him come to Princess Road. (We didn't want that, either.) Fiona/Heather arrived at about 3:00 that afternoon and used the back entrance in St. George Street. She was fitted with the same tiny camera, hidden in the same brooch at her lapel, that Victoria had used in Milan. She gave George Gordon's name to the receptionist, and he soon appeared. He looked inside the paper bag that Fiona was carrying and took the painting from her. Then he asked about payment. Was she to be paid in pounds, in London?

This was not something we had considered, and for a moment Fiona panicked. "I don't know," she said. "I don't want to make any mistakes. I'd better ask Heather."

The film of the encounter at this point shows George Gordon rolling his eyes—as well he might, for of course Fiona was supposed to be Heather. She realized she had made a major error, but there was nothing she could do about it. She wound up the conversation and left as quickly as she could before anything else went wrong.

Sam and the technical staff at Clark Television spent all the next morning trying to sync the film and the tape. When Sam and I watched the finished product that afternoon, there was no question in our minds that at the moment when Fiona said "Heather," Gordon rolled his eyes and his expression changed. But was it suspicion,

surprise, or merely confusion? Had he really taken in that the woman he was dealing with was called Heather? Or did he think she was Victoria?

Whichever way we looked at it, though, Sam and I thought deep inside that Fiona had blown it. Even if Gordon had not put two and two together, any untoward development with our picture could well lead him to withdraw it from the sale. Sotheby's old masters sale was a big affair, with paintings from the British Rail Pension Fund Collection and a £3 million work by Pieter de Hooch as the stars. Our picture was small beer and hardly worth the risk. Over the weekend, Sam and I talked in circles about what we could do. Would Gordon call Kollewijn, who would call Victoria? We alerted her relatives, the Costellos in Sydney, all over again. Should Victoria call Kollewijn and casually mention that her sister's name was Heather, as if she were the Heather Fiona had been referring to? We decided that that would do more harm than good. The more we talked, the more we decided that there was nothing we could do except, as many times before, wait.

The catalogue, we learned, when one of the Clark Television secretaries called to inquire, was due out on June 5, a Wednesday: five days away. Before then, a meeting was called at Channel 4, which was interested to know what progress we had made. Glumly, we explained the situation: that we were 80 percent of the way, but that the whole project might just have blown up in our faces.

On June 5, we were told that the old masters catalogue was not now due until the 10th, the following Monday. This further delay was all but unbearable. We wondered why it had occurred. What had gone wrong? Had our picture been withdrawn, forcing Sotheby's to redesign certain pages? Sam and I called each other twice a day, our conversations going nowhere. On the 10th we were told that there was yet another delay. Now the catalogue would not be out until Wednesday, the 12th. Sam and I were convinced now that the whole game was up. To make matters worse, in the meantime the Christie's catalogue had appeared. Christie's old masters

sale was on the evening of July 3 and on July 5—in other words, *after* Sotheby's sale. Yet its catalogue was already out. On the 12th, we were told that the Sotheby's catalog would not now be published until Friday, June 14. Three delays. Obviously, Sotheby's had a major problem, and that problem was us. Sam and I were beside ourselves with frustration. We were so near, yet we could still fall at this last fence.

Since we had been told the catalogue would not be published until Friday, I thought nothing of the green packet that arrived at my home on Thursday. I received scores of auction catalogues from the salerooms each week. But when I tore at the plastic covering, I suddenly realized what I was holding. There on the cover was the Pieter de Hooch, *A Maid with a Broom and a Pail in a Sunlit Courtyard*. The Sotheby's old masters catalogue.

My pulse raced. It was only 6:30 in the morning, but my hands were already sweaty. It was a thick catalogue of 250 pages, and rather than flip through it for our painting, I turned to the index in back. It ran over two pages—five columns of names, 250 names in all. I moved my finger to those beginning with "N." "Neapolitan school," I read. "Neefs." Never heard of him. "Neer." Never heard of him either. "Netscher." "Nogari."

But was it ours? Lot 140, said the index.

I found lot 140 on page 160. "Guiseppe Nogari," read the entry. "Venice 1699–1763, Portrait of an elderly woman, oil on canvas, 56 by 40 cm; 22 by 15¾ in. £7,000–10,000." On the opposite page was a color illustration. It showed an old woman with gray eyebrows, veins in her cheeks, a white collar. Her fingers, which held a bowl, were meticulously rendered.

It was not the loveliest painting in the catalogue, not by a long way. But it had something. It was ours.

BOOK ONE

BEGINNINGS

1979–1989

—⊸∭⊷—

1989: The Man
in the Oratory

This story started in three different places, at different times, leading to a remarkable coincidence that resulted in this book. One beginning took place in October 1989.

As he waited for the lights to change, so that he could cross the Cromwell Road, James Hodges fiddled nervously with the key in his raincoat pocket. Cromwell Road, in London, is a racetrack at the best of times. Traffic rushes down from Harrods, the fashionable department store, toward the Victoria and Albert Museum, where the thoroughfare broadens to such an extent that crossing from one side to the other on foot is all but impossible. Hodges, who had driven three miles from his home in west London, had parked his car opposite the museum and walked the last few hundred yards, to cross at the lights, at Brompton Oratory.

It was a Sunday morning and it was cold, windy, and gray. The bitter winds had lasted for days and seemed to make a mockery of the idea of global warming, then so much in the news. A tall, brown-

haired, bareheaded man of thirty-two, Hodges was wearing a green raincoat over brown corduroys and a woolen sweater. The lights changed. He pulled the belt of his raincoat more tightly about him and stepped off the curb. Ahead, the facade of the Oratory was washed by autumn light, its Baroque pillars and statues and triangular lintels casting pale shadows to the left. Hodges climbed the steps to the church. The Oratory is London's second-largest Catholic church and by far its most beautiful one. Although he was not a regular visitor, Hodges knew the place and loved it, not least for its magnificent choir. But though today was a Sunday and he had arrived in time for mass, his chief concern was not worship. He had something quite different in mind.

Hodges paused inside the doors to the nave. The Oratory is a little piece of Rome in central London. By Protestant standards, its nave is uncommonly ornate, lined in gray, pink, and chocolate-colored Carrara marble. The pulpit, halfway down on the left side, is built of mahogany and juts out a long way from the wall, dominating, almost threatening, the congregation. All around the church are twelve enormous statues of the apostles. These, carved by Giuseppe Mazzuoli, a pupil of Bernini, graced the Cathedral of Siena for two hundred years before, in a fit of Gothic puritanism, they were ejected by the cathedral authorities. The Oratory authorities found them in a Genoa warehouse in the nineteenth century and picked them up for a song. They are magnificent.

The service had already started, and Hodges was immediately struck by the sharp smell of incense inside the building. He dipped his fingers in the holy water stoup and, crossing himself, knelt. This was a deliberate pause, not devotion, not today. He wanted time to survey the church. He was a prudent man, and had learned even more prudence in recent years. He was also a chess fanatic and knew well the value of preparation. Surreptitiously, he slipped a peppermint into his mouth; he had a problem with his ears, and sucking mints helped keep them unblocked. He stood up and, as best he

could without drawing attention to himself, looked around. Hodges
wanted to see if there was anyone present he knew. For what he in-
tended, he needed absolute anonymity. But no, so far as he could
tell, there was no one yet assembled who was familiar. He loosened
his raincoat and turned to where a small stack of brown envelopes,
for contributions to the church's upkeep, stood on a table. He took
one, plucked a pen from his trouser pocket, and scribbled a few
words on the outside. Then he put the key he was holding into the
envelope.

He stepped down the aisle to the left of the nave and found a seat
about three rows in. Ahead of him was the transept, a pool of bright-
ness on this October morning, thanks to the three roundels in the
great cupolas above. He undid the zipper of his coat but didn't take
it off. He looked around. Hodges worked in the art world, had spent
more than a decade at Sotheby's, so he was naturally drawn to the
decorations of the church. From here, in this seat, he could see
clearly the painting of St. Philip Neri, above the altar in the chapel
devoted to him. Here, on Tuesdays, the Oratory's relic of the body
of the saint, who founded the Oratory order, is exposed. From
where he sat, Hodges could hear the sound of the organ, off to the
right. Given his less-than-perfect hearing, he always preferred to be
as close to the organ as possible. Hodges was meticulous in his at-
tention to such details. He had found that others often underesti-
mated this quality, to his benefit.

He was alone. Not even his wife knew where he was this morning,
why he had come, or what he planned.

Although the service had started, the nave was still filling on all
sides. A black woman with a small child took a seat directly in front
of him. Suddenly, the organ sound swelled even louder as it reached
the crescendo of a Palestrina magnificat. Hodges turned as the
sound blared forth, only to glimpse the statue of St. Peter on the far
side of the nave. This almost life-size figure, underneath the organ
gallery, was cast in bronze and was an exact facsimile of the original

in St. Peter's, Rome. The saint was seated on a white marble throne, under a gilt halo. As Hodges looked, he was disconcerted. St. Peter held in his hand his traditional symbol: a key.

Hodges was too nervous to enjoy the service. And this was no ordinary mass. Brompton Oratory has had one of the most distinguished choirs in Europe since the nineteenth century. Indeed, the quality of the music there, which must be one of the best-kept secrets in London, makes the Oratory services a cut above those anywhere else in the British capital.

Hodges was by no means certain that he ought to go through with what he had planned. His action would be far from dramatic in the theatrical sense. On the contrary, it would be secretive. But it would be dramatic in its consequences, because it would be irreversible, and that was the important thing. By one simple clandestine act, his own life might change forever.

The service wore on. The Kyrie was over, and the Gloria was beginning. The acoustics were superb. The combination of marble walls, a parquet herringbone floor, and three magnificent cupolas had produced an interior in which when the organ rang out it was impossible to tell where the sound was coming from; the most beautiful music simply filled the church. When the choir finished singing, the last notes took seconds to die away. It never failed to be moving.

The time arrived for the sermon. Sitting where he was, at the back, Hodges found it difficult to hear, and the crying of the baby in front of him didn't help. So far as he could make out, the priest's theme was sin, how it is an inevitable part of life yet can be conquered.

If Hodges was going to act, it would be right after the sermon.

The child in front of Hodges continued to fidget and then complain loudly. After a few more outbursts, the priest got the hint and quickly wound up. As he went back to his place in the sanctuary, the congregation relaxed, people shifting on their chairs, talking qui-

etly, coughing. Hodges stared ahead, noticing nothing. Then the organ started for the Offertory.

Along with everyone else, Hodges stood up. He pretended to sing. In his left hand he held high the hymn book, but his right fist was clenched firmly inside his raincoat pocket.

The vergers began to spread around the nave. Their large metal offertory plates were lined with blue velvet or felt. One of the vergers, a big, bearded, balding man, started a few rows in front of Hodges. The plate was passed along the row of seats, slowly, from left to right. This was a fairly rich church and not many coins were being laid on the plate, only notes and those discreet brown envelopes. When the plate reached the end of a row, the last person turned around and handed it to the person behind, who then started it off in a reverse direction. Back and forth the plate went, like a slow spindle in a weaving mill. Hodges kept his head straight forward but with his eyes followed the weft and warp of the plate's movements.

It was now at the row immediately in front of him. He could see it clearly, covered in £5 notes, brown envelopes, and a few—very few—coins. There must have been hundreds of pounds on that one plate alone.

Now the plate had arrived at his row, at the far end. It began the journey toward him. At that moment, out of the corner of his eye, he caught sight of someone he knew—a West End art dealer, a small, busy man with hooded eyelids. Hodges went hot and cold at the same time but at least had the presence of mind to sway back on his feet, so that other members of the congregation hid him from the dealer. He didn't think he'd been seen.

The plate was two persons away. Hodges's fist in his pocket was clenched more tightly than ever. An attractive woman with closely cropped hair, who looked foreign, laid an oddly colored note on the plate. With a start Hodges recognized it as a French 100-franc note. About £10.

And then the plate was being passed to him. With his left hand he put the hymnal down on his seat and took hold of the plate. Swiftly, he brought his right fist out of his pocket and laid his envelope in among the others, making sure the writing was facedown. Then he turned and passed the plate to his left.

The rest of the service passed slowly. He had thought that once he had acted, once he had made his move, the uncomfortable feeling he had had in the pit of his stomach for days would go away. But it didn't. If anything, it got worse. Had he done the right thing?

But the service ended eventually, and Hodges made his way out to Cromwell Road, making sure he was surrounded at all times by other worshipers and thus hidden from the art dealer. Outside, it was still gusty, and he refastened his raincoat. As he went down the steps at the front of the church, he came face-to-face with the signboard advertising the Oratory Appeal, the familiar campaign board showing, in the form of a giant thermometer, how much was needed to save the roof and how much had already been raised. That made Hodges think yet again of the offertory, and he hurried away, west toward the Victoria and Albert Museum and his parked car. The priest might already have found what Hodges had put into the offertory plate and might come looking.

Everyone else that morning had put money in the plate. James Hodges had put in a key and a note, which read: "Father, please give this to Detective Sergeant Quinn at West End Central Police Station."

—⁓—

1985: The Man from the British Museum

The second start of this story had taken place four years earlier across London at the British Museum. In 1985, Brian Cook was keeper—that is, curator—in the museum's Department of Greek and Roman Antiquities. He and I would meet from time to time to discuss professional matters, museum business, or recent developments in archaeology that might make articles for the London *Observer*, for which I wrote a regular column covering the art world. On this occasion, however, Cook had let it be known beforehand that he had something "pretty hot" to tell me.

It was an overcast November day. We met in his office, lined with file boxes and maps of the ancient world; archaeological fragments littered Cook's desk. The windows overlooked the main gate of the museum. Cook is a thin, tidy man, with precise, deliberate movements, someone who chooses his words carefully and never rushes into anything.

As I sat down, I noticed there was a Sotheby's catalogue on his desk. On the cover was a photograph of an Egyptian sarcophagus in

green-and-yellow-painted wood. Cook is a world authority on this
type of antiquity.

 We chatted about the state of the museum in general, and the way
the Thatcher government's cuts were beginning to affect British
scholarship. I had just returned from a visit to Harvard, where I had
heard several American scholars bemoaning the sad state of British
academic life under Thatcher, and Cook was eager for news. This
went on for some time, coffee was brought by a secretary, and I was
beginning to wonder whether this was Cook's idea of a story when
he reached across, picked up the Sotheby's catalogue, and placed it
on my side of the desk. "There," he said quietly. "That's your story.
Sotheby's is selling a whole batch of smuggled antiquities."

—ↀↀ—

1979: The Man
from Florence

There was yet another starting point for this narrative—even earlier than the other two. For the first person who was to lead me, indirectly, to James Hodges was a small, bald whisky connoisseur named Rodolfo Siviero. He had influenced me even more than Brian Cook had. I first met Siviero in 1979, when I was planning a book on international art theft. Stealing art is almost as ancient as the oldest profession, and in recent years, as the price of art has skyrocketed, the theft of masterpieces has kept pace, to the point where paintings, drawings, sculpture, and furniture worth billions of dollars have gone missing.

Siviero was the world's first "art detective," charged by the Italian government after World War II with recovering the country's treasures that had been looted by the Nazis. After considerable success, Siviero had been given a high-ranking civil service post to carry on the good work of looking for all the art that had been stolen since the war.

Unlike most policemen, Siviero was a rich man and well educated, and he came from a noble Venetian family (his father had been a judge). Unmarried, he lived with his sister in a small but ex-

quisite palazzo overlooking the Ponte Vecchio and the River Arno in Florence. One cold evening in February 1979 I entertained him at dinner in a restaurant just across the river, and we discussed what my book might contain. Afterward we strolled back across the bridge toward his palazzo, where he offered me a nightcap.

The *piano nobile*, the grand living room of the palazzo, was on the second floor. It had pink marble columns, medieval painted wooden sculptures, huge windows that gave onto the river, and an ornately carved stone fireplace. Although it was late, Siviero pressed a bell by the mantelpiece and a manservant appeared and put another log on the fire. Siviero opened a large wooden chest to display scores of bottles containing every imaginable brand of single-malt whisky. We made ourselves comfortable. A bowl of sugared almonds stood on the low table between us. Shadows from the fire flickered across the walls. It was long past midnight.

"May I make a suggestion," said Siviero softly. "You should write a different kind of book." He said that he thought a series of accounts of the most sensational art thefts was fine, so far as it went, but the idea left him unmoved. He then said that he thought it would be far more gripping and more revealing—and more useful— if I tried to *recover* something beautiful that had been stolen. If I was successful, he said, then stolen objects would be returned to their rightful owners, and any account I wrote would have the smack of truth about it, far more than any general account could.

I was surprised at first, and skeptical. But over the second whisky, he added that he was willing to show me certain of his secret files on stolen art. These files contained confidential police reports on some of the more shady art dealers in Europe and North America. His reason for doing so, he said, was that the Italian police had no jurisdiction outside Italy and international cooperation between police forces was little more than a joke. I didn't make up my mind there and then, but next morning we traveled to Rome together, by train, and visited his offices in the Via d'Astalli.

Siviero was as good as his word. He showed me several files, and one especially stood out. It related to a painting of the Nativity by Michelangelo Merisi da Caravaggio, the turbulent seventeenth-century artist whose brilliant, vivid realism deservedly made him one of the painters most admired by scholars and the general public alike. The painting had been stolen in 1969 from the Oratory Church in Palermo, Sicily. It was a large picture, showing poor Italian peasants overcome by the miracle they were witnessing. The peasants had dirty feet, torn clothing, and unruly hair, and they were painted with a loving attention to detail that truly brought home the scene. This was without question the most famous and valuable missing masterpiece at the time.

There was a special reason why Siviero took me into his confidence about that particular picture. Over the years he had set up his own network of dealers around the world, people who kept their eyes and ears open and told him things. The file showed that a London dealer who often sailed close to the wind had been offered the Caravaggio by an Italian. The dealer had not bought the picture, but he had not told the police either. Siviero thought that if I could somehow earn the confidence of this dealer I might find out the identity of the Italian who had offered the painting to him and that, together, we could go on from there.

Thus was born an elaborate plan and my first effort at working undercover in the world of art. Using a number of art dealer friends and the professional advice of a former member of Scotland Yard's art squad, and with the participation of the major auction houses, I set myself up as a slightly shady but very well-heeled international *amateur*.

I became A. John Blake. I had adopted this identity using the method outlined by Frederick Forsyth in *The Day of the Jackal*: I found someone who had died very young and applied for a passport in his name. I changed my hairstyle, always wore a bow tie, and walked with a limp and the aid of a cane, all in an attempt not so

much to disguise my appearance as to draw attention to myself, since I needed to make my mark very quickly.

My wealth was established in the following way. In those days all auction houses maintained the fiction that every artwork that came on the block was sold. Nowadays, if a painting or other object is "bought in"—that is to say, if it fails to reach its reserve, the minimum price the seller will accept—the auctioneer calls out, "Pass." In those days, however, the salerooms used what were called "buying-in names." Instead of saying "Pass," the auctioneer would pretend that the picture had sold and call out a fictitious name. By persuading Christie's and Sotheby's to use the name of the character I had created, A. John Blake, we made it appear Mr. Blake was a very active player in the art world. That season he "bought" around twenty-eight Italian old masters worth hundreds of thousands of pounds.

We made Blake appear shady by the simple expedient of having the former Scotland Yard man, who was now a private security consultant in the art insurance field, visit several galleries in London and New York, asking searching questions about Blake: Who was he? Had the dealers had any dealings with him? Had he reneged on any deals? Did they have an address for him? And so on.

Siviero was apprised of my progress, which went on for some weeks until the culmination of the first phase of the plan. This occurred at the old masters auction at Sotheby's in July 1979. These sales are all-ticket affairs, a fact that on this occasion worked to our advantage. The London dealer whom Siviero wished me to meet was a man named Julius Weitzner. He had booked his seat for the sale, and Sotheby's agreed to seat A. John Blake next to him.

That is what happened, but then luck intervened. One of the main attractions in that sale was a Madonna and Child by Dieric Bouts. Sotheby's told me that Norton Simon, the American collector, had left a commission bid for the picture, though he himself would not be at the sale. It was agreed that on this lot, the auction-

eer would act as though Blake were bidding and knock the picture down to me if Simon's bid was successful.

When this painting came on the block, it quickly became apparent that there were just two main bidders in the room, and they were seated side by side: Weitzner and "Blake." Being much richer than Weitzner, Simon was bound to get the picture if he wanted it, which he did. At the end of the tussle, Weitzner turned to Blake, introduced himself, and congratulated the other man on his victory. The contact Siviero wanted had been made.

In fact, Weitzner did more than introduce himself; he invited Blake to a cocktail party at his London home that evening. Blake went, and on a later occasion, Weitzner asked if he might buy the Bouts from Blake. It wasn't Blake's to sell, of course, but he told the other man that he could have the painting—for the same price that Blake had paid—if he provided some information. Blake then raised the matter of the Caravaggio. Weitzner was surprised, but not fazed. He had been offered the painting, he said, by a Naples-based dealer named Vittorio Baratti.

Blake now melted away. Unable to keep his end of the bargain with Weitzner, he ceased to exist as a presence in the London art world, disappearing as quickly as he had arrived. He turned his attention to Naples.

Baratti operated from a magnificent house on a cliff overlooking the Bay of Naples, in the Posillipo quarter of the city. Blake telephoned ahead from London and mentioned Weitzner's name and those of a few other dealers who, he had found, knew the Neapolitan. On their first meeting, a sunny morning some time later, Baratti, a small, cheerful man, offered Blake Italian champagne on a terrace festooned with bougainvillea and then showed him his paintings.

This was a crucial encounter, and to ingratiate himself with the Neapolitan, Blake paid $8,000 for a seventeenth-century portrait of St. John. Baratti offered to export the picture to a contact of his in

New York, named Renzullo, who had a company called Italcraft. Blake traveled to New York, met Renzullo, and collected the painting, saying he would be in touch again at a later date. With these credentials, he revisited Baratti quite a few months later, in 1980, and said that he understood Baratti had offered Caravaggio's *Nativity* to Weitzner, and that Weitzner had turned the offer down. Blake said he was interested in buying the painting.

Baratti didn't take the bait immediately. However, a few weeks later, Blake was called in London and a rendezvous was arranged with a man who called himself Manzu. There, after some to-ing and fro-ing, a deal was struck, for $130,000. More than that, however, the former Scotland Yard detective who had been advising Blake followed Manzu to his hotel and managed to check him out. He was staying under the name of Giovanni Pulcinelli. We knew from Siviero's file that Pulcinelli was one of the gang who had stolen the Caravaggio.

The scene now shifted back to Naples, where a second rendezvous had been arranged for Blake to look at the picture. Blake was picked up from his hotel by two men and driven south from Naples to the village of Laviano. There, at the back of a bar named Nicastri's, he was shown a photograph. This photograph showed the *Nativity* together with a copy of a local Naples newspaper dated three days before. This was Manzu/Pulcinelli's way of showing that he had the painting and that it hadn't been destroyed.

However, the photograph showed that the Caravaggio was in a bad condition, bad enough to affect the price Blake had agreed on. He insisted on another meeting when he could inspect the actual picture. A new rendezvous was set for two days later.

Unfortunately, at 7:36 on the evening of Sunday, November 23, the day before the second rendezvous, just as Blake was walking along the seafront at Naples, an earthquake of about 6.5 on the Richter scale struck southern Italy. The damage was horrendous. Three thousand people were killed and between 200,000 and 300,000 were made homeless. The hotel where Blake was staying

lost its electricity, and residents were told that they slept in their rooms that night at their own risk. The only food offered that night was boiled spaghetti. The car Blake had rented was unharmed by the earthquake, and so the next day he set out to revisit the village where he had been shown the photograph three days before.

South of Naples, the damage got worse, not better. Whole villages had been destroyed, including Laviano. Nicastri's had ceased to exist. Indeed, the entire neighborhood was unrecognizable. Blake returned to Naples chastened by the damage and destruction he had seen and only too well aware that his plan to recover the missing Caravaggio was over.

Several months went by. The only way to pick up the trail again was via Baratti, but since Blake had not kept his end of the bargain with Weitzner, even that was risky.

However, around Christmastime Blake was contacted in London. One day he received a call from Renzullo, Baratti's New York friend, who at the time was in Italy. There was no mention of the Caravaggio, but instead Blake was asked if he was going to Italy in the near future, because Renzullo had a painting by Bronzino that was very beautiful. Blake made it understood that he could travel to Italy if something like the Caravaggio—that is, a stolen artwork, selling for less than its market value—were to be available. A rendezvous was fixed in Milan for early 1981, but Blake was then driven to Cremona, a much smaller northern Italian city about two hours' drive away. Here he was introduced to a certain Signor Giordano Garuti. Garuti, it turned out, was a picture restorer specializing in old masters, and he was based in Cremona. There Blake was introduced to a most interesting scam.

Garuti, a small, round-faced, balding man, would tour the small villages of Italy, paying particular attention to the churches. He would seek out those places of worship where there were paintings located high up on the walls, badly displayed and badly lit. Then he would offer to restore these works. The local priests would guess

what was happening. Garuti would take the paintings away, paying the local priests for the privilege. He would clean the paintings—but he would also copy them. Then, of course, he would return the copies. They would be hung where the originals had been, high up, where no one could really examine them closely.

Garuti had a small but well-appointed apartment on the second floor of an apartment block overlooking a small square in Cremona, which was the location of a superb pasta restaurant. Over dinner there, he told me I could tour a whole range of northern Italian churches, select pictures I wanted, and then, after a delay, have them delivered—in London, Paris, New York, or wherever. He also had a mass of paintings he had done himself. They were all hideous, though one, it was pointed out to me, was actually a disguise. It was a painting by Andrea del Sarto, a sixteenth-century Italian old master who had worked a lot in France. Garuti's handiwork covered the old master underneath, a true cover story. I asked to look at this, but was told it was too late.

Promising. On a later occasion—criminals are almost always careful—I was shown the picture. Very carefully, Garuti's own canvas was unstapled from the wooden supports—to reveal a much more delicate old master underneath. This was del Sarto's *Portrait of St. John the Baptist*. The painting had been stolen, I was told, from a collection near Piacenza. The asking price was 80 million lire—$80,000 at the time—and I was told there was a newspaper cutting available that would prove that the painting had been stolen.

I was effusive in my praise of the picture, but nevertheless spent some time examining the canvas and its stretchers. Garuti next offered to put the painting under an ultraviolet light. It was an encouraging sign; the picture showed few signs of having been restored.

There was quite a discussion about the price. I offered 20 million lire to begin with, which upset Garuti. I countered by saying that if the picture had been stolen the price I was offering was more than generous. They, of course, did not see it that way. I was a rich man

and quibbling. Garuti actually lost his temper and said at one point that if I didn't improve my offer I wouldn't be shown "the Bronzino." This was the "very beautiful" portrait that had been mentioned to me, but about which little had been said over the previous weeks.

Eventually we agreed on a price for the del Sarto of 28 million lire. The Italians complained, but they were smiling as they complained, so I judged that they were pleased.

Then Garuti went to a stack of his own paintings leaning in a row against a wall. He extracted the one at the end of the row, nearest the wall. He put the painting on the easel. I blinked hard. It was without question a Bronzino—bright and brilliant. It was on a board about two feet high and eighteen inches wide. The subject was a woman, bust length, wearing a red-brown brocade dress. Her face was stern—cold, even—but lovely in an austere way. Her dress had a deep V neck and she wore a pearl necklace with pear-shaped drop earrings. Her hair was chestnut brown and piled high. She wore an elaborate stand-up lace collar.

"How did you come by this?" I asked, taking out my notepad.

"It was also taken near Piacenza. We can tell you no more, because the man who stole it was killed in a car crash."

How very convenient.

"Who is she supposed to be?" I asked.

Garuti beckoned me closer and pointed to some faintly visible lettering at the top of the picture, above the woman's head. There, in capital letters made from gold leaf, but on a scarlet ground, I could just make out the words GLORIA FARNESE. The Farnese had ruled the duchies of Parma and Piacenza from 1545 to 1731.

There was a large crack running down the painting, which did not really affect its beauty but would affect its price at auction, and so A. John Blake drove a hard bargain. They asked for 40 million lire, Blake offered 20. We settled at 30 million.

A day or so later, back in London, I made a crucial discovery. I had been told that the man who had stolen the Bronzino had been killed

in a car crash the previous year, which meant that perhaps the painting had been stolen in 1979, 1980, or 1981. I therefore checked, first, the Italian carabinieri's records. There was nothing, but the records I had ended in 1978. Next, I tried the *Stolen Art Alert*, a monthly newsletter produced by the International Foundation for Art Research in New York. It was more up-to-date than the carabinieri's record, and there were two pictures reported as stolen from Piacenza in 1979. They were portraits of ladies, but there were no illustrations of them and they were labeled "Venetian." Bronzino came from Florence.

I turned to my third and final set of records, the least complete and, usually, the least up-to-date: Interpol's file on stolen art. File number 2492/121/80 recorded a theft from a private home in Piacenza in August 1979 of a portrait of a lady, attributed to Bronzino. More important, there was a photograph, showing a woman with an icy beauty, a deep V neck to her dress, a row of pearls around her throat, pear-shaped drop earrings, and an elaborate stand-up lace collar. There was also a deep crack down the picture. It was the one I had been shown in Cremona.

Garuti, of course, was part of the loose agglomeration of shady characters that extended to Baratti in Naples, Weitzner in London, and Achilles Renzullo and Vincent del Peschio, who ran Italcraft, a furniture shop and warehouse located on the sixteenth floor of a building at 200 Lexington Avenue in New York. By the time of our adventure in Cremona I had visited Italcraft several times, and so A. John Blake chose to take delivery of the Bronzino and the del Sarto via Italcraft in New York.

When that was broached, however, Renzullo asked for a special meeting to discuss the transport of the paintings. This time we met in a bar on 34th Street, Brew's. Before that meeting Renzullo had shown me a cutting from an Italian newspaper, *Il Gazzetino*, a Vicenza publication, dated April 15, 1981. This carried an account of an art theft at the villa of a Marquis Dr. Giuseppe Roi at Monte-

galda, which had included a painting by del Sarto. So Renzullo had obligingly told Blake that the second painting had been stolen also.

At the bar, Blake was to be introduced to the courier. Shortly before this man appeared, Renzullo said, "Don't be put off by the man's appearance, eh?" He wore a slight smile as he said this, which was mystifying.

It soon became apparent what he meant. When the courier appeared he was introduced as Lorenzo Zorza, an Italian of Yugoslav extraction. My jaw almost dropped open. Underneath the black astrakhan hat and brown raincoat the man wore the small black-and-white collar of a Roman Catholic priest.

During the discussions that followed, it emerged that Father Zorza was on the staff of the Vatican's Mission to the United Nations and attached to the Consolata order. He was about five foot ten or eleven and of medium build, and had brown eyes—and a small brown mustache. In a distant way he reminded me of the actor Karl Malden, since he had a slightly bulbous nose and very mobile lips.

Our discussion that night rambled. I didn't want to seem too eager to do a deal, and he obviously enjoyed conversation—about newspapers, politics, and, of course, religion. But eventually we got down to specifics. Zorza wanted $10,000 to smuggle the two paintings, the Bronzino and the del Sarto. We haggled. I offered $5,000 and we settled at $8,000.

We also arranged a code and a date. Renzullo had a phone number for me and said that he would call me on a certain Sunday to say whether the "books" would arrive.

Now I called in the U.S. Customs Service. I had a contact there, one Charles Koczka, with whom I had had many discussions about stolen art, and we had formed a good relationship. He agreed that if the deal went ahead, Customs would come in on it with me.

Sure enough, on the Sunday in question Renzullo called and said the books would be arriving—"both of them"—and so the fee would

be the full $8,000. The date for the transaction was the following Thursday.

That Thursday I went with Charlie and several of his fellow agents to the international arrivals building at Kennedy Airport. Via the one-way glass that Customs uses in the baggage hall, we watched Zorza enter America carrying two smuggled paintings in a roll. Zorza was followed from the airport to the address he used at the Vatican Mission. But we didn't make our move yet. By then, Renzullo had told me that Garuti was arriving from Italy two days later and would mastermind the transaction. This suited Charles Koczka. Garuti was clearly the big fish, and his presence would seal the whole thing. So we waited.

In fact, on the Saturday of Garuti's arrival, I—or rather A. John Blake—went with Renzullo to the airport to meet Garuti. Strictly speaking, this was unnecessary, but from that meeting on I was wired by Charles, and we hoped to obtain as many incriminating tape recordings as possible. Renzullo and Blake met Garuti and rode into the city together. Garuti was staying at the Sheraton Centre Hotel, on Seventh Avenue in the Fifties, and he announced that that was where the transaction would take place. They dropped Blake at 66th and Park, near where he was supposed to live, and arranged to meet the following evening, at the hotel, for Blake to inspect the pictures.

That meeting took place as arranged, with Blake, Renzullo, Garuti, and del Peschio all present, though Zorza was nowhere to be seen. The price agreed was $58,000, plus $8,000 for Zorza, plus a surprise $6,000 for Renzullo on the side, which he claimed as he and Blake descended in the elevator. Since it was all academic, Blake agreed.

The following day was organized by Charles Koczka. He had arranged the money, $72,000 in used bills. It was money that had been seized in drug raids, but even so, for safety's sake and for evidentiary reasons, each note had to be photocopied before it could be

used. This took up quite a lot of the morning. The deal was supposed to go down at 1:30 P.M.

I was again wired, and at 1:20 P.M. I was dropped by Charles a few blocks from the Sheraton Centre. A. John Blake then limped the rest of the way, a briefcase under his arm stuffed with bills. Lest Blake be robbed by some unknowing mugger on the way to the Sheraton Centre, he was tailed by Koczka and two other armed Customs officers.

But there were no mishaps. Exactly on time, Blake met Renzullo in the lobby of the hotel. In as public a way as possible, Blake handed Renzullo his $6,000 commission. Customs had commandeered the hotel security cameras, and the whole transaction was being videotaped.

Renzullo took the envelope.

"Aren't you going to count it?" Blake said.

"No, Mr. Blake, I trust you."

"Then you are a fool."

Renzullo pried the envelope open to reveal the money. Caught nicely on camera.

They took the elevator to the sixth floor. Renzullo had no idea that the other two people in the lift were Customs agents. We all got out together, but the Customs people turned left and we turned right.

Inside the room, Blake was invited to inspect the paintings again, while del Peschio counted the money.

Everything was in order, the money was all there, and the paintings were rewrapped in an imitation-leather portfolio. Blake made his exit. Renzullo went with him as far as the elevator, where they shook hands and parted. As Blake reached the lobby he was met by Koczka, who checked the paintings and then spoke into his mobile phone.

Moments later, no fewer than eight Customs agents broke into room 619 at the Sheraton Centre, six from the corridor and two

from an adjoining room. The three men were dividing up the money when the raid took place. Zorza was picked up later.

All of them were charged with conspiring to smuggle stolen paintings into the United States, conspiring to sell stolen paintings, and receiving and handling stolen goods. Renzullo and Zorza were also charged with making a false declaration on importation documents. If found guilty on all charges, the defendants faced a maximum of ten years in jail and/or a $10,000 fine. The arrests made front-page news in America and were reported as far afield as Britain, Italy, and Australia.

In fact, all the defendants in time did a deal. This suited the Customs Service, saving effort and money. It also helped maintain my anonymity until I published my book on the affair, *The Caravaggio Conspiracy*, some time later. Only Renzullo actually went to jail. The most interesting sequel concerned the priest, Lorenzo Zorza.

On the day that he was arrested, Renzullo—like the others—was searched. A notebook-diary was found in one of his pockets, and in the notebook were two names, a Miss Turkham and a Mr. Bove. Charles Koczka recognized the first name—Miss Turkham worked on the staff of Sotheby's in Manhattan. When contacted she confirmed that although she didn't know Renzullo, she did know a Mr. Bove. It appeared that some months earlier Mr. Bove had taken into Sotheby's a number of beautiful pieces of ancient pottery, apparently Sicilian and with some wonderful paintings on them. The Sotheby's staff had been enchanted by the pottery and eager to have it auctioned. Just to be on the safe side, however, they had sent the pieces across to the Metropolitan Museum to be authenticated.

Just as well. Miss Turkham was told by the staff at the museum that however beautiful the pottery might be, certain of the warriors depicted were holding their spears "in the wrong way" and that some of the trees in the background did not grow in Sicily. Mr. Bove's pottery was fake.

The antiquities were returned to him. But that was not the end of the story. About six months later, Miss Turkham was offered the same pottery again—and she described an Italian who wore a small mustache and the collar of a Roman Catholic priest: Zorza.

In court, Zorza wept and was given a suspended sentence. However, his name was left in the Customs Service computer, and over the months, although he was never stopped, his movements were watched. What emerged was that his itinerary strongly suggested that he was smuggling money for drug peddlers. He repeatedly traveled from Europe to South or Central America, on to Canada, and across the land frontier into the United States. Eventually he was arrested, one of a large number of suspects apprehended in a Drug Enforcement Administration dawn raid. He was found guilty and this time went to prison for several years in a blaze of tabloid headlines that dubbed him "Father Sin."

Thus, my first foray undercover in the art world had been far more successful than I had a right to expect. However, that is not why I retell it here. I mention it because at the very time I met Brian Cook in the British Museum, when he told me that Sotheby's was selling smuggled and illegally excavated antiquities, James Hodges—the man in the Brompton Oratory—was reading my book *The Caravaggio Conspiracy*. It was to prove a fateful coincidence leading, in the long run, to the book you are now reading.

BOOK TWO

THE
INVESTIGATION
1991–1996

—ꟷ—

1991: Three Suitcases

Early on the evening of Sunday, March 3, 1991, there was a knock on the door of my house in Chelsea, west London. It was James Hodges. Outside in the road was a Morris Oxford, a 1960 model with gleaming chrome and old-fashioned tail fins. Sitting in the backseat were two friends of Hodges, whom I came to know as George Campbell and Charles Flint.

Hodges drove, and we headed off west along the King's Road. It was surprisingly warm for early March, and still light. I had known him less than a week. Our first meeting had taken place the Friday before, at his house. One of the things I remember about this encounter was the enormous amounts of coffee that we drank. Hodges must have made three if not four pots of fresh coffee in our first hour and a half together. It was, I suppose, the only sign of nerves that he betrayed.

A pleasant-looking, blue-eyed man in his early thirties, he wore baggy corduroy trousers and a woolen sweater. His home, though not in a fashionable neighborhood, was clean and sparkling inside, filled but not overfilled with works of art—paintings, sculpture, and

good furniture. However, the photographs of Hodges and his wife and young daughter that were displayed about the house showed a different man. In the photographs he was not much younger than in the flesh but much, much thinner. The Hodges who was making me coffee was a good thirty pounds heavier than the figure playing with his daughter in the photographs, and I came to realize that the compulsive eating that had brought this about was the second sign of nerves.

The more I listened to his story, the more I realized how much he had reason to be nervous. What he told me initially was that he had worked for Sotheby's auction house for more than a decade and that for a lot of the time he had been involved in unethical and illegal practices. Also, he had in his possession enormous amounts of documentation from Sotheby's which, he claimed, showed that wrongdoing extended to many departments—antiquities, old masters, furniture, Southeast Asian works of art.

He also said that Sotheby's had a good inkling of what he had squirreled away and that although he had left the company in 1989 in honorable circumstances, with eight months' pay, Sotheby's had later caused him to be charged on two counts of theft (of art objects) from its premises—partly, he alleged, as a way of shutting him up and partly as a means of getting the police to search his house, looking for stolen and incriminating documents rather than the art objects themselves. The police had taken some documents, he said, but nothing else. None of the incriminating papers had been found, but he had returned two allegedly stolen antiquities. He had been arrested about a year before and had spent the weekend in a cell at West End Central Police Station in Savile Row.

I was not sure at first what to make of this story. Writers and journalists are not unused to disgruntled or disaffected employees, or ex-employees, who make allegations against their former companies. As often as not the allegations are a waste of time. About six months earlier, I had been approached by an ex-director of a large central London department store. He had a story to tell, he said, of

malpractice inside the company—but he had no evidence to prove it. And although I sometimes thought Sotheby's to be high-handed and self-satisfied, this was no more true of that company than of its fierce rival, Christie's. I had several friends in both houses and never for a moment imagined them to be systematically dishonest or corrupt. Hodges, though, claimed to have a small mountain of documents that supported his allegations.

At that first meeting, I was also taken aback by the fact that there was another man in the house, George Campbell, who was quite clearly a bodyguard or "minder." It was not that I thought Campbell's presence melodramatic. I was more concerned about the cost. Bodyguards, even if they are unemployed friends, do not come cheap. Hodges had left Sotheby's more than a year before and had not found new employment in the meantime. Where was the money coming from?

For the time being, though, I sat on these misgivings. I would not get very far if I started with my objections so soon. (In fact, I learned later that Campbell was staying in Hodges's house for free, and was paid only intermittently.) Instead, I asked why Hodges was so certain he needed a bodyguard.

He told me that one night not long before, he had come home to find two Italian antiquities dealers sitting in his living room. They had heard he had left Sotheby's and wanted to make sure he would not reveal anything about their dealings with the company. They were civil enough on that occasion, said Hodges, though at that point he would not give me their names. But there was no doubt in his mind that their visit was a form of threat. When they left, they made it plain they hoped they could "rely" on him. Immediately afterward, he had sent his wife and daughter to live with relatives in the United States and Campbell had moved in.

Nor was this all. Hodges added that he and Campbell had on occasion posed as trashmen and rummaged through the dustbins of several Sotheby's directors to see if they could find anything incriminating that could help with his defense.

What was to be made of this? Either it was a damned good story or Hodges and Campbell were a pair of unhinged Walter Mitty creatures who were best avoided. Much would depend on the quality of the documents that Hodges had, and by the end of that first meeting, he said he was prepared to show some of them to me. And so a second meeting was arranged.

The Morris Oxford followed the King's Road as it curled around, past the antique shops near the Chelsea football stadium, and then alongside the common at Parson's Green. At the far end of the common was a pub, the White Horse. Hodges parked the car, and we all got out. Next to the bar was a separate entrance, with some stairs to the floor above. They led up to an empty room containing two tables, some chairs, and a dartboard. It was apparent that Hodges and his friends knew the landlord of the White Horse and that this room had been reserved for us. It was also made clear that I was expected to pay for the drinks, so I gave a £10 note to George Campbell, and he went back downstairs. The other friend, Charles Flint, also disappeared.

Hodges and I made desultory conversation until Campbell reappeared with the beer, and then he went back down again. Shortly after that, however, Charles and he could be heard on the stairs once more, this time huffing and puffing. Between them they were carrying a huge, bulging suitcase. Hodges said that he had three suitcases filled with papers, but that night I was shown the contents of only one of them. A number of bright red ring folders were tipped onto the table. They contained hundreds of documents. I began to go through them.

A lot of organization had gone into these papers—they were not simply a bunch of things taken in a hurry and at random. They ranged in date from 1975 to 1989 and in location from Japan to Milan, from New York to Bangkok, from London to Jaipur. Nearly all the papers were neatly kept, organized by subject matter; and,

ironically, there was even one Sotheby's memorandum recording the fact that "a bright red ring binder has been taken . . ."

The documents were almost certainly genuine. We would have to confirm that—authenticity is always a problem in matters like this—but I was fairly well convinced that the papers had not been faked. To begin with, there were many different types—originals, photocopies, handwritten notes. Some were on Sotheby's letterhead, others on blue internal memo forms or yellow property cards. Some were franked with Sotheby's internal franking machine, which recorded the date of receipt. Some were telexes, and still others were signed or initialed by people I knew and whose signature I recognized. A number referred to events I was familiar with. Some were not even Sotheby's documents, but had originated with third parties. And many related to mundane matters—internal affairs that described nothing illegal whatsoever. What forger would bother to do that? Amid all the dull documents, there were plenty that were quite the opposite. There appeared to be prima facie evidence that certain key individuals in specialist departments were involved in illegal or unethical activities. And, with two honorable exceptions, there was never any soul-searching about the legality of such conduct.

Hodges had three reasons for coming to me. He wanted the story told in the first place because, he said, he thought it should be. He wanted it told, secondly and ideally, before his trial was held, in the hope that any resultant publicity or scandal would either cause the trial to be abandoned or influence the verdict in his favor. Finally, he wanted a share of the proceeds of anything I might write and have published. (We did not discuss money until later.)

The first reason, of course, I had to take with a pinch of salt. He had sat on these documents for years, and only now, when it suited him, was he coming forward. He clearly had an ax to grind. I could see that publishing his story before the trial might make sense from his point of view, but it could land me in contempt of court if any-

thing I published was prejudicial. At that stage, it all looked academic anyway; it would be very difficult to corroborate the story before court proceedings got under way. His trial, which he told me had already been postponed twice, was set for July, only four months off. Even if we'd had a finished manuscript at that stage, which we obviously did not, publication would still have been difficult. Theoretically, we could have published the story in America, avoiding contempt-of-court problems, but I did not like doing that. It would still have contravened the spirit of the law. But I had no problem with the fact that Hodges wanted money for his story. He was not proved to be a criminal yet, and could be acquitted. Also, from the little I had seen, it already looked as if the collective malpractice inside Sotheby's might far outweigh anything that Hodges might have done.

On the basis of the Sunday meeting, I told him that I could be, in principle, interested in writing a book and that, on the understanding that the rest of the papers were as powerful as the ones here, I would approach a publisher for an expression of interest. Such interest was readily obtained on both sides of the Atlantic, and on Monday, March 20, I sat down in Hodges's kitchen ready to go through the documents in detail.

It took two weeks. Each day we would begin at 9:00 A.M., and I would be plied with coffee all day long by Hodges. We would sometimes break for lunch at a nearby Indian restaurant. To get there, we had to walk past the local police station near his Tunis Road house and the corner of Uxbridge Road, where Hodges had been incarcerated for a short while. We never finished before 6:00 P.M.

As the days went by, I became more and more convinced that whatever Hodges's role, more senior figures at Sotheby's had indeed been involved in some of what he said they had. Among the three or four thousand pages, there were many that gave revealing glimpses of the way salerooms—or at least Sotheby's—operated: the internal rivalries, the salaries of senior executives, the perks, the routine glosses that they put on the true situation when writing

press releases. But such was hardly red meat: the real story lay else-where, in the evidence that senior Sotheby's personnel acquiesced or actively engaged in flouting the laws of several countries, se-cretly rigged various aspects of the auction process, and misled the press and the public about that process, all while they were profess-ing to all and sundry their high social and moral character. The salerooms love the conceit that they are gentlemen (and gentle-women) and scholars.

The picture revealed was that at Sotheby's, dishonesty and mis-representation were widespread. Most dramatic of all, Hodges had a series of documents describing in great detail a number of individ-ual cases in which the wrongdoing was breathtaking.

Over the days, I narrowed down Hodges's documents to 592 core papers, consisting of 878 pages.

Beyond the documents, however, there was also Hodges's own story. He had worked at Sotheby's from 1978 to 1989. The department in which he had spent the most time was antiquities. The whole busi-ness was so dishonest, he claimed, and contained so many illegally excavated and smuggled goods that he had been prompted by two of Sotheby's largest customers in antiquities to set up two bank ac-counts, in false names, in which money was kept to pay off couriers who brought the smuggled goods to London and needed to be paid in cash.

If much of what Hodges said was true, it was a story crying out to be told—the biggest scandal the art world had seen for many years. But there was at least one big problem before that could happen, one dilemma that had to be sorted out. It was pretty fundamental. All the documents had been stolen.

Handling stolen property is always a difficult experience for a writer or journalist. On the one hand, you are technically a party to an offense. Many of the documents that Hodges had were marked "Highly Confidential." On the other hand, I—like many other col-

leagues on *The Sunday Times* and *The Observer* over the years—had been in exactly this situation several times before. Invariably, one is "leaked" documents because someone inside a company or institution believes that illegal or unjust activities are proved by those papers. Almost as often, the person doing the leaking is an employee or ex-employee with a grudge against the company. The source is rarely pure.

British law does not offer protection to journalists in the way that U.S. law does, but I was pretty sure that if the Sotheby's documents *did* show that innocent members of the public, or the trade, or official government authorities had been duped or defrauded, then our handling of the documents would be seen for what it was, a necessary involvement to get at the truth. There was also the fact that Sotheby's was a public company, indeed an American-owned company, listed on both the London and New York stock exchanges. Those bodies have rules on how companies should behave, so as to maintain trust in the way corporate affairs are conducted.

One alternative, of course, would have been to turn the documents over to the police. There were three reasons not to do that. First, Hodges would not allow it. He could have been indicted on another charge of theft, and if so the possibility of a book, with its disclosures, would have disappeared. For me, a more powerful reason was that London's Metropolitan Police have never taken the theft and smuggling of art and antiques as seriously as I believe they should. An art and antiques squad has been set up twice and disbanded twice in the last fifteen years. Hodges's documents required specialist knowledge, which I did not think the police could provide. Hodges also claimed that the police he had been in touch with had had no interest in what he had to say.

There was another worry, in practice far more powerful. A sense of justice and fair play, not to mention the rules of journalism, required me to face Sotheby's with the allegations before we published anything. And here, paradoxically, the very fact that we had *so many* documents was a drawback. The picture as revealed by the docu-

ments that Hodges had given me was that corruption was common, not that there was the odd misdemeanor here or small dishonesty there. If I went to Sotheby's with the range of documents, its officials could not fail to see how damaging they were. And since the papers had all been stolen, Sotheby's would seek an injunction for breach of confidence, hoping to persuade the court to take a dim view of employees stealing documents (or anything else) from their employers.

But if we could not face Sotheby's with the documents, neither could we go ahead and publish. It was one thing for me to be convinced, quite another to convince a publisher's lawyer, or indeed a publisher, who would be equally culpable in law for any mistakes.

Here then was our dilemma. We had to corroborate the story as revealed in the documents *without* going to Sotheby's and, for the same reason, *without* drawing attention to the fact that we had them at all. How on earth would we do that?

Blue Blood, Blue Chip

Sotheby's is a formidable institution. Now, in 1997, it is 253 years old and likes to think of itself as one of the most substantial, respectable, and upmarket companies anywhere in the world. Among its board of directors and its advisory board are eleven people with royal and other aristocratic titles. It wasn't always like that.

Begun in 1744, Sotheby's was for many years primarily a book auction house, founded by Samuel Baker, a well-known bookseller in eighteenth-century London. The first Sotheby entered the picture in 1778. After that, three generations of Bakers ran the firm until the line died out in 1861. In the late twentieth century, Sotheby's and Christie's are rivals, but until comparatively recently they coexisted easily enough, side by side. In years gone by, when a great estate came up for sale, Christie's would be given the pictures and furniture to sell and Sotheby's would get the library. The company did not sell its first old master until 1913, when Lord Glenusk, an eminent book collector, sent in a Frans Hals along with a number of rare volumes.

Despite the aura of the two main salerooms and despite the original James Christie's great friendship with the celebrated actor

David Garrick, the artist Thomas Gainsborough (who painted his portrait), and the writer Dr. Samuel Johnson, auctioneering was for centuries regarded as a rather raffish—even dishonorable—activity. (In the United States this had a lot to do with the fact that auctioneers often sold pictures and slaves at the same time. When Gus Kirby, the son of the man who owned the American Art Association, America's premier auction house, got married at the turn of the century, the marriage contract stipulated that he never become an auctioneer.) It is really only since Montague Barlow bought Sotheby's in 1908 that the social profile of the auctioneer has been raised. Barlow was the brilliant son of the Dean of Peterborough, but the main love of his life was politics. When he bought Sotheby's he had two aims: auctioneering was to provide him with the financial wherewithal to enter politics; and, as his widow told Frank Herrmann, the official historian of Sotheby's, "He was determined to make the art auctioneering business in London a gentleman's business for gentlemen, you know. He had the vision of putting it on to an entirely different social status because I remember one of his friends in Society saying, 'Oh, *he's* an auctioneer.' He was resolved to remove the slur of the auctioneer business and to bring it on to a higher level." How far Barlow succeeded may be judged from the fact that in 1924 he was, as *Sir* Montague, minister for labor in Ramsay MacDonald's government.

By the eve of World War II, Sotheby's had so completely shed its raffish past that the young Peter Cecil Wilson entertained no doubts about working for the company. There was no question that Wilson was out of the top drawer, for at his birth he had familial links to both Buckingham Palace and 10 Downing Street, the official address of Britain's prime minister. His mother, the Hon. Barbara Lister, was the daughter of the last Lord Ribblesdale, Master of the Buckhounds and an important personage in Queen Victoria's household. And Wilson's maternal grandmother was the eldest of the extraordinary Tennant sisters, one of whom, Margot, Wilson's great-aunt, was wife to H. H. Asquith, prime minister at the time

Peter Cecil was born.* Naturally, with such a pedigree, Wilson went to school at Eton, Britain's premier "public" school, and then on to Oxford University.

Wilson became chairman of Sotheby's in 1957. The Suez Crisis, a year before, had closed the canal and put money into the pockets of Greek shipowners. So when three great sales took place in New York and London in 1957, the first postwar art boom began. Wilson ruled at Sotheby's for the next quarter century with flair and imagination. Under him, Sotheby's sold the great Goldschmidt collection of impressionists. Under him, black-tie auctions were introduced to London. Under him, celebrities like Somerset Maugham and Dame Margot Fonteyn were invited to sales to add luster. Under him, Sotheby's finally overtook Christie's, its traditional rival, both in terms of turnover and in its public profile. No less important, under him, Sotheby's bought Parke Bernet, the New York saleroom, in the early 1960s, to become the single most important presence in the art market. One or two American shareholders resisted the takeover move fiercely, but were eventually outmaneuvered by the British. The dominant London–New York axis in the auction world was firmly established as a result of this move by Peter Wilson.

There has long been an old chestnut in the art trade to the effect that whereas "Christie's are gentlemen trying to be auctioneers, Sotheby's are auctioneers trying to be gentlemen." As Barlow and Wilson show, this difference never really existed, and as the postwar world developed and the art market prospered as never before, Wilson and Sotheby's did everything they could to heighten their social as well as commercial standing. Under Wilson, art collecting—on both sides of the Atlantic—became more and more the mark of someone who was both a scholar *and* a gentleman. Far from being staffed by déclassé types, Wilson would have you believe, Sotheby's

* Margot Asquith's most celebrated remark came at a dinner where one of the other guests was the actress Jean Harlow. During the evening, Harlow kept referring to her hostess as *Margott*, with a hard *t* at the end. "No, no," said the exasperated hostess, "the *t* is silent—as in Harlow."

was home to scholars of unimpeachable pedigree. It was as nice a piece of snobbery as you could find anywhere.

At the same time, there was an intriguing enigmatic side to Wilson. In 1940, in the dark days of World War II, he was admitted to MI5, the British equivalent of the FBI. He was posted to Washington, where he had "the most exciting period of my life" and for a time served alongside Donald Maclean and Kim Philby, who were both later exposed as Soviet spies. Wilson remained in military intelligence for nearly two years after the war ended but returned to Sotheby's in 1947. A year later he left his wife to pursue fairly open homosexual relations and formed a friendship with an art dealer who was also part of the circle that included Maclean, Philby, and Guy Burgess, another spy and homosexual. It was a link that did not go unnoticed.

Throughout the 1950s, 1960s, and 1970s Wilson preached loudly and effectively the gospel that "the price of art will always go up." He himself dabbled in antiquities and bought a house in the south of France that had a mosaic by Picasso in the hall floor.

An air of intrigue never left him. In fact, in 1979, it deepened when he appeared to resign in a hurry. He always claimed that he did so in order to live in France and avoid paying double death duties (both British and French). On November 15 of that year, Prime Minister Margaret Thatcher announced to a packed House of Commons that Sir Anthony Blunt, formerly surveyor of the Royal Collection and a director of the Courtauld Institute of Art History, had been the fourth man in Britain's infamous troop of homosexual spies. It did not go unnoticed either that four days later, Peter Wilson gathered the staff together at Sotheby's and announced precipitately that he was resigning immediately.

So *was* Wilson implicated in the Blunt/Burgess/Philby ring? There are certainly some who believe that Wilson was a spy, or had been. Did he strike a deal with the British government, to leave Britain in return for immunity?

Wilson's apotheosis was the von Hirsch sale in 1977. Robert von

Hirsch was a German leather manufacturer who had bought art since the early part of the century. Within twenty-four hours of Hitler's coming to power, von Hirsch had asked Göring, then gauleiter of Prussia, if he might emigrate. Göring had agreed on condition that von Hirsch donate to the German people a picture by Cranach, *The Judgment of Paris.* Von Hirsch left for Switzerland, where over the decades he built an unrivaled collection of medieval and Renaissance works of art. Some of his objects came from the Hermitage in St. Petersburg and from the Guelph treasure in Brunswick, Germany. There were enamels, reliquaries, fantastic ivories, unrivaled Venetian glass, watercolors by Dürer, drawings by Rembrandt and van Gogh, paintings by Guardi and Cézanne. Almost every museum in the Western world was represented at the sale, where several records were established, including the £1.1 million paid for a bracelet that had belonged to Frederick Barbarossa, Holy Roman emperor in the twelfth century, who led the Third Crusade.

But when Wilson retired, he left behind half a dozen strong personalities jockeying for position. More important, he left a company that was weaker than it looked. In his last years, Wilson believed instinctively that increased sales would bring increased profitability, and so he had not worried unduly about costs. But the plain fact was that by the early 1980s, costs were out of control at Sotheby's, and partly as a consequence of this, profits began to fall. In 1978–79 the company had netted £8.2 million from worldwide sales of £186.4 million; two years later it was making just £7 million from sales of £321 million. The situation was made worse by the recession of 1980–82 and came to a head at the end of 1981, when figures were released for the first half of the season. Christie's, which had been making headway in the United States, had sales there of £70.84 million, up by half a million pounds. Sotheby's, however, refused to release its figures, claiming there had been no sales in late 1981 to compare with what it had done in 1980. Few swallowed this.

The company tried to restructure its management team. It also moved offices in New York, from Madison Avenue to the corner of York Avenue and 72nd Street, a supposed improvement. But it didn't work, and the low point was reached in February 1983, when the 1982 figures were released. Business had not followed the move, and sales in New York had declined from $90 million to $56.6 million. Indeed, Christie's was now outselling Sotheby's in America, the first time this had happened since the 1950s, when Peter Wilson had taken proper command. Sotheby's was still a glamorous name, but it was not the creature it had been under Wilson. Its shares fell by 48 percent, from £5 to £2.60, and there were fundamental divisions within the company about the way to go. The proportion of the shares held by directors had shrunk from over 50 percent to just 14 percent. Sotheby's was on its knees and had, in fact, become the perfect target for a takeover.

Sure enough, during late November and early December 1982 two American self-made millionaires, Marshall Cogan and Stephen Swid, paid $12.8 million for 14.9 percent of the shares of Sotheby's. Their banker then contacted Sotheby's chairman, Gordon Brunton, for a preliminary discussion about a takeover.

It is fair to say that over the next few months, Sotheby's fought off Cogan and Swid by using some of the most unpleasant tactics ever seen in a corporate battle in Britain. Snobbery certainly played a part, and anti-Semitism was suspected. Cogan and Swid were two New York investment bankers who in the 1970s had bought General Felt Industries and, later, Knoll International, the leading maker of modern furniture. They were highly successful commercially, and Mr. Cogan was a graduate of Harvard College and Harvard Business School. But for the barons of Bond Street it wasn't enough.

Brunton was the first to give the Americans a taste of what the British were capable of. At their first meeting, according to Cogan

and Swid, he was "red-faced with rage." "You have made a mistake," he bellowed. "You manufacture carpet underlay. We auction works of fine art."

This cut no ice with the Americans, who concentrated on the performance of Sotheby's and reminded Brunton that the company he was chairman of was underperforming. Their arguments appeared justified, for Sotheby's had reported a pretax loss, for the previous year, ended August 31, 1982, of £3.06 million.

That only made the Sotheby's top brass all the more determined to see off the "felt manufacturers" from Manhattan. Fearing a direct bid, Brunton issued a directive to all members of staff not to speak to the Americans, though he later denied it. In-house they were referred to, demeaningly, as "Toboggan and Skid." And when a second meeting took place, in April 1983, by which time the Americans owned 29 percent, the attitude of the Sotheby's board was even more hostile. As Cogan put it, "We were treated like pariahs and they did everything possible to try to intimidate and frighten us." This meeting was held at Sotheby's Bond Street offices on a Sunday, and Cogan and Swid were shown in by the back door. That really hurt.

Among the board members who met the Americans, apart from Gordon Brunton, were Lord Jellicoe, the Earl of Westmorland, the Hon. Sir Angus Ogilvy, Julian Thompson, and Graham Llewellyn. Brunton had not softened his style over the intervening months. He would not even shake hands with Cogan and Swid and began by repeating that they had "made a mistake." "You are in *manufacturing*," he insisted. "*We* are a prestigious auction house." And he didn't stop there. He said that the recent American presence in the wings, so to speak, had already damaged the company by threatening to cost it certain consignments. "Lord Astor," he said, "has personally called me to express his deep misgivings about you." Should Cogan and Swid succeed in their bid, Astor had said, reportedly, "I shall have no choice but to remove my armor suits [which he intended to sell] from Sotheby's and sell them through Christie's."

Julian Thompson was no less hostile. That day he was still visibly in pain, having not fully recovered from injuries sustained in a car crash the previous autumn. Nevertheless, he claimed that certain of his clients were "repelled" by Cogan and Swid, who, he thought, would "exploit" the good name of Sotheby's for their own "personal profit." Then came the most telling jibe of all. "You are simply not our kind . . . of Americans."

Llewellyn, the chief executive officer, saved his comments for afterward, but they were no less unpleasant. "They brought their whole crew," he said. "Their whole crew of sharpies arrived in a caravan of long black hired automobiles." For the record, these "sharpies" included Roger Seelig, of the investment bank Morgan Grenfell, and no one else.

It is fair to say that Cogan and Swid were deeply distressed by this onslaught. They were businessmen, there to discuss business. Instead they were subjected to a vicious personal attack, a deeply unpleasant amalgam of snobbery and, so far as Cogan could see, anti-Semitism.

But the two Americans had not become the self-made millionaires they were without having some resilience. Next day they instructed Morgan Grenfell to make a £60.6 million bid for the company, offering $7 (approximately £5.20) each for the remaining shares. This valued the shares at roughly twice the £2.60 they had been worth when the takeover battle had started.

Sotheby's board, under Brunton, decided to fight the bid. And now came the most unsavory episode. Sotheby's had always been such a high-profile company that the tussle was bound to be fought out in the glare of media attention. Graham Llewellyn, as next down in the pecking order after Brunton, was appointed to deal with the press. After the Cogan and Swid bid was made public, he described it as "wholly unacceptable." Asked to explain why, all he would say was that the two Americans were "wholly unacceptable. . . . They're just the wrong kind of people." These were ambiguous words at

best, but when a journalist called to ask him what he would do if
Cogan and Swid actually succeeded in their bid, Llewellyn thought
for a moment, giggled, and then said, "I'll tell you what I'll do, I'll
blow my brains out—that's what I'll do." His comments got worse.
He told another journalist that "there is no price at which we would
recommend a bid from them." This sounded suspiciously like rank
anti-Semitic talk, and indeed, John Hignett, head of Britain's
takeover panel, publicly censured Llewellyn for his "emotional" ap-
proach to the situation and ordered him to curb his language.

But the damage had been done. The following weekend, *The Mail
on Sunday* printed a long article headlined "Snobbery Under the
Hammer," suggesting that Sotheby's had an inflated opinion of itself
and was stuffed with snobs who looked down on Cogan and Swid
because they were "mere" manufacturers of felt, and Jewish. One
merchant banker who watched Sotheby's in its dilemma was quoted
in the article as saying, "Not since the whole affair started has
Sotheby's presented any kind of rational argument for their dislike
of Cogan and Swid. Just looking at the figures shows that they can-
not afford to be too proud. The company boosted its turnover from
£5 million to over £300 million in about twenty years. But in recent
years the gilt has gone. In 1981, even though it had a turnover of
£321 million it only made £7 million. It should have been at least
double that. And last year it made a loss. It is sheer arrogance to be
satisfied with figures like that. Snobbery is no substitute for perfor-
mance, which is presumably what Cogan and Swid believe they
could bring."

Despite his censure by Hignett, despite *The Mail on Sunday*,
Llewellyn could not bring himself to shut up. "It's their lack of asso-
ciation with the sort of material we handle—they've nothing to offer
us," he now said. "I'm sure carpet felt is profitable and worthwhile.
We all need it. As for the furniture, we understand it's of quite ex-
cellent design. But it's not my sort of thing."

Such massive condescension was not confined to him. One hun-
dred and thirty of the company's experts wrote to Cogan and Swid

threatening to resign if the company fell into their hands. The experts at Knoll had made much the same move years before, when Cogan and Swid were buying that company, but the two men had talked to the staff and, as a result, hardly any of them left. But the Americans were never allowed to address the Sotheby's experts.

In the event, Sotheby's did rid themselves of Cogan and Swid. They succeeded in having the unwelcome bid referred to Britain's Monopolies and Mergers Commission by the secretary of state for trade, Lord Cockfield. He did so on the grounds that it was "in the national interest" to keep London as the center of the international art market. Sotheby's also acquired a "white knight" in the form of Alfred Taubman, who was American and, it is important to note, Jewish. Known chiefly as a property developer, the man who invented the concept of the gas station as a general store as well, Taubman had also made a fortune from building shopping malls. He was himself a collector and had trained as an architect, but it was never made clear why Cogan and Swid's manufacturing experience was unsuitable to Sotheby's and Taubman's shopping malls and gas-station stores weren't.

But now the British Establishment was shown up for the disgraceful club that it can be. Taubman had told the Monopolies and Mergers Commission that for tax reasons he would turn Sotheby's into a privately owned company based in the United States. So much for Cockfield's pious worries about the Cogan and Swid bid being "against the national interest" and the need for London to be the center of the art world.

But Sotheby's had fought off the felt and furniture manufacturers. By hook and by crook the company had managed to retain its high opinion of itself, and that was the main thing. And this, of course, was what Taubman was buying, a company that dated back to 1744 (though it had been selling pictures only since 1913), that stood for—or thought it stood for—all that was best about Britain, a business that combined a noble and elevated concern for the arts with a practical down-to-earth commercialism. Sotheby's saw itself as both

blue-chip and blue-blooded. Never had this been revealed so nakedly as during the takeover battle.

In the years ahead, Taubman would to an extent Americanize Sotheby's. His socialite wife loved the glitz and glamour that surround art auctions. She once told a friend, "We are the new Hapsburgs." Taubman packed the board with fellow socialites, aristocrats, and minor royalty. From Spain came Her Royal Highness the Infanta Pilar de Borbón, Duchess of Badajoz; British royalty was represented by Sir Angus Ogilvy, husband of Princess Alexandra; from Germany came Baron Hans Heinrich Thyssen-Bornemisza de Kaszon; from Italy came Giovanni Agnelli, head of Fiat; from Japan came Seiji Tsutsumi, head of the Seibu department store chain. Taubman also added aggressive marketing techniques, and in a celebrated interview he once told *The Wall Street Journal*, "Selling art has much in common with selling root beer. People don't need root beer and they don't need to buy a painting, either. We provide them with a sense that it will give them a happier experience." Third, he introduced elaborate financial services, by which potential buyers or sellers of art could borrow money from Sotheby's to make the transactions much easier. All of which helped to create an art boom of unprecedented proportions in the late 1980s, culminating in the sale of Vincent van Gogh's *Portrait of Dr. Gachet* and Renoir's *Au Moulin de la Galette*, acquired by the same person, within forty-eight hours of each other, in May 1990, for a combined total of $160.6 million. The numbers were breathtaking. No wonder that Michael Thomas, the *New York Observer* columnist, rechristened Sotheby's new owner "Lord Taubman of Treasure."

Taubman had finally dotted the *i*'s and crossed the *t*'s on the Sotheby's deal in the second week of July 1983. After that, his first act was to gather the company's staff together in the book department in Bloomfield Place, a small alleyway through an arch off Bond Street, diagonally across from the main building. There, in a room lined with empty bookshelves, the staff faced the board, which

stood in a group by the door. Taubman looked very different from the pasty British directors. His tan glowed in the watery London light, and his chubby features and shiny hair underscored his prosperity. At that meeting Taubman showed that he too was well aware of the attitudes rampant in Bond Street. "I told [the staff] that I wanted them to know that I had been mistreated for years at Sotheby's and Christie's," he said later. "I said that if I was going to buy the company, I wanted them to pledge that their manners would improve, that they would say 'please' and 'thank you' to customers, that they would offer good service and show that they cared about what customers thought. Their expertise and scholarship were beyond question, but they were in a service business and if they couldn't behave properly, they didn't belong."

Among the people standing in the room listening to Taubman, and who liked what he heard, was a middle-ranking clerk from the antiquities department. His name was James Hodges.

—ɯɯ—

The Chess Player

Hodges had joined the firm five years before, in 1978. It was a natural move for him. His parents are High Church Anglicans, thoroughly English, and experts in English silver, English furniture, and English porcelain. A distant descendant of Guy Fawkes, the man who tried to blow up the Houses of Parliament, Hodges's father, Cecil, was in the RAF during the war and still drives an old MG sports car from the time when the MG marque still meant something.

Hodges was born in 1957 in St. Albans, Hertfordshire, north of London, and raised there. St. Alban was the first English martyr, and the city named in his honor was rather more distinguished in the past than it is now. The Roman town of Verulamium was destroyed by Queen Boadicea, and all that remains is an ancient theater. To that have been added an eleventh-century Benedictine abbey, a Norman cathedral, and what is supposed to be the oldest pub in England, the Fighting Cocks Inn. In 1960, Hodges's parents bought an antique shop in George Street in the center of St. Albans, and by the time he transferred to the senior part of his public school

in 1970 the teenager had developed a good eye for furniture—
Victorian pieces especially—and works of the Arts and Crafts
movement. He was also knowledgeable about seventeenth- and
eighteenth-century English silver. He liked military history and
therefore also developed an interest in medals and decorations.

From age seven until he was eighteen, Hodges attended St.
Columbus College, a Catholic boys' school overlooking the abbey
and run by monks of the Sacred Heart order. At school he shone at
math and chess. Chess has formed an important and constant back-
ground to Hodges's life and is intimately bound up with his charac-
ter and what happened to him at Sotheby's. His mother had taught
him the game when he was a boy. He took to it straightaway and at
school was on the chess team. Though he was not the best player, he
understood the psychology of the game instinctively. He studied
Bobby Fischer's games, as reported in the newspapers, and was con-
vinced that chess was won or lost in the first ten moves. It was, he
felt, rather like meeting someone, when first impressions count for
most.

In one school contest he was being comprehensively trounced by
the captain of the rival team. Nevertheless, Hodges refused to re-
sign, which exasperated his opponent to such an extent that in the
last game of their match, Hodges actually beat the other boy. It was
a lesson he never forgot.

He graduated from school with a reasonable record—not outstand-
ing but not a disgrace either. He joined a coin dealer near the British
Museum but then in 1978 moved to Sotheby's Belgravia branch. This
was the poor relation of Bond Street. Originally, it had been created
to deal with the vast untapped area of Victorian art, which Sotheby's
believed, quite rightly, was an area of business capable of enormous
expansion. The actual building was the Pantechnicon, a sort of Victo-
rian warehouse-cum-stables where the nineteenth-century inhabi-
tants of Belgravia—diplomats or soldiers in the age of empire—could
leave their belongings (and their horses) when they served abroad. No
less a person than John Betjeman, poet laureate and man-about-the-

suburbs, had written the history of the building, for Sotheby's. Unlike Bond Street, which was run by men with an elite public school education, Belgravia was more the province of ordinary "grammar school" graduates—very bright but not necessarily well connected. Lunches were taken not in gentlemen's clubs but in nearby pubs. The atmosphere at Belgravia was more down-to-earth, less stuffy or staid than Bond Street, and everyone was conscious that new fields were being opened up.

The relative youth of the staff also meant that there was a lighter side. Practical jokes and exotic characters were part of the fabric. For reasons best known to himself, one of the auctioneers at Belgravia liked to greet clients wearing a curly ginger wig. Hodges formed a friendship with one young expert who roamed the streets of Earl's Court in west London dressed in an elaborate cowboy outfit, armed with a (toy) gun. This man loved to poke fun at collectors who he thought took themselves too seriously. To make his point he formed two collections of his own. One was of photographs clients sent in showing the objects they wished to sell. Often these were family snaps that also showed the owners, sometimes in unusual poses, and Hodges's friend displayed these for all to see: a woman with an enormous bosom, pictured on a couch with a tureen and diaphanous nightdress; identical twins pictured with a pair of (identical) ginger jars; an antique bed with the owner tucked up *in* it. The friend's second collection consisted of used cigarette butts that had once, allegedly, "belonged" to famous clients. Meryl Streep's butt had pride of place.

However, not all the eccentricities Hodges encountered at Belgravia were harmless. Within months of joining he had come across minor improprieties, but thought little of it. In one case, he said, he noticed that one of Sotheby's French clients, a pudgy man, clearly lived in France but had an address in London. Hodges asked his superior which address was to be used for payment, whereupon the superior told him that the British address was there to keep the company's records "clean," so that no one could tell, from the pa-

perwork, that the French client's goods were smuggled. On this occasion the superior agreed with Hodges that it would be safer if there was just one address associated with this client, and the French address was expunged from the records. On his next trip to London, the French client thanked Hodges and tipped him.

Although this was a minor matter, it had an important effect on Hodges's position. He was now a trusted member of the team and the experts took him into their confidence much more. On a separate occasion, an Italian dealer whom Hodges knew under one name came into Belgravia. When Hodges greeted him using the name he knew, the Italian grew agitated and whispered, "No, no," then used another name beginning with the same two letters. This man had two addresses in Westbourne Grove, west London, to be used in all official paperwork. At this level, Hodges found that the dishonesty could sometimes be amusing.

After those first incidents, it became fairly apparent to Hodges that the passage of smuggled goods through the Belgravia saleroom was, if not exactly routine, far from uncommon. So too was the preparation of misleading paperwork. Until then, however, they had all been individual incidents. But there now occurred Hodges's first encounter with someone who, much later, would loom large in his life. He was introduced to a French-speaking Swiss dealer named Christian Boursaud.

It would actually be more accurate to say that Boursaud introduced himself to Hodges. He telephoned the furniture department one day in the autumn of 1978. It was late in the afternoon, and Hodges was preparing to leave for home. Instead, Boursaud suggested they meet for a drink in the Turk's Head pub on the corner of Halkin Street and Kinnerton Street. This was a fashionable spot that advertised itself as the only pub in London still lit by its original gas lighting. Its windows were made of fine glass, etched into military scenes.

When Hodges arrived, Boursaud was already there, drinking vermouth. Slim, tanned, good-looking, he wore expensive suits and

spoke excellent English. He said that the pudgy French dealer had suggested he contact Hodges. After he had bought Hodges a gin and tonic, Boursaud came straight to the point. First, he said he wanted to sell a collection of nineteenth-century French furniture at Belgravia and wanted to negotiate a lower commission than the normal 10 percent. Second, as an extra refinement, he wanted Hodges to set up a bank account, either in Hodges's own name or a fictitious name, into which the proceeds of the sale would be paid. In this way Boursaud could be paid later on, he said, in several smaller amounts, so that the money could be repatriated to France without attracting attention from the tax authorities. Over the second round of drinks, Boursaud made it clear that Hodges would be handsomely rewarded for his part in the scheme.

Nothing further happened. No collection materialized and no bank account was opened. For a time, in fact, Boursaud disappeared.

Hodges's star at Sotheby's was in the ascendant. In 1980 he was transferred to Bond Street, where for a time he had a roving brief, moving from department to department. While he was temporarily in the antiquities department, he was again approached by Boursaud. The Swiss dealer appeared pleased that Hodges was working in antiquities and said something to the effect that "Felicity Nicholson [director of the antiquities department] is an interesting character to work for." The two men then spent about twenty minutes walking through Sotheby's galleries and discussing the state of the art market. While they were in one of the back galleries, Boursaud suddenly dropped his voice and again mentioned his need for an account in a British bank. His reasons were the same as before, he said. There were charges he had to meet here in London, it was helpful to have an address in Britain from which to consign objects to Sotheby's—concealing the fact that these objects had been brought to London from abroad—and it would help him to repatriate the money, to France or Italy, in small amounts. He preferred not to open the bank account himself, he said, because his accent was so strong the bank clerk would surely notice it, and it would look odd

if he tried to open an account in a British name. If he used a French-sounding name he didn't know when, or if, the British tax authorities would inform their French counterparts, which could defeat the purpose of the exercise and land him in trouble on top of everything else. Boursaud again made it clear that he would compensate Hodges for his cooperation, not only in cash but by introducing other dealers to him, who would then use him as their Sotheby's contact.

On this occasion, Hodges said, he agreed immediately to cooperate. He liked Boursaud and could use the extra cash, but his main reason for complying was Boursaud's promise that he would introduce other dealers. Hodges's path upward inside Sotheby's led first to his becoming a cataloguer, then an expert, and finally a director of a specialist department. In order to do that he had to not simply acquire knowledge and expertise (he already had some of that) but, as he soon realized, *bring in business*. At Sotheby's this mattered above everything else.

The bank he chose was a branch of the National Westminster on the corner of Pont Street and Sloane Street, not too far from Harrods. It was a good way from Sotheby's in Bond Street, so it was extremely unlikely he would be seen using it by anyone he knew from the company. The name used was Yarrow, which was suggested by Boursaud. Hodges chose Albert as a first name after someone he had had dinner with the evening before.

Over the next year, Hodges saw little of Boursaud, although the other man did keep his end of the bargain and introduced two other dealers. One was named Serge Vilbert; the other I shall call Georges Quimper. They dealt mainly in antiquities but also in furniture.

After his roving brief, Hodges settled down in the furniture department. It was a field he knew something about, and he found the work especially enjoyable. He was also becoming known around the company, not least for the fact that he lived with his parents on a farm just outside London and each day would bring in fresh eggs, which he sold.

So far so good. Hodges had enjoyed his time at Sotheby's. The deception he sometimes saw did not especially bother him, and he looked forward to further promotion. After he had been in furniture for a while, however, things began to go rather less well. By the summer of 1983, the time when Taubman bought the company, Hodges had been in furniture for a year. Furniture was his first love, but he was not entirely happy with the fact that he had now been at Sotheby's for five years and had not been promoted. He had more money and more responsibility, but he was still an administrator.

Worse, he saw people with less ability than he, and less knowledge, being promoted over his head. For him, there was one reason for that, and one reason alone: class. As Hodges saw it, class pervaded almost everything that took place at Sotheby's. If people came from the right background they would start as porters, to introduce them to the objects, or maybe, if they were women, they would be put at reception, where they were felt to be more presentable. But this was only for a short time, after which they would be promoted on a fast track directly to the specialist departments, as cataloguers, prior to becoming junior experts.

The "right background," in this context, meant first and foremost being born into an aristocratic family. This, it was felt, gave people the right sort of preparation for dealing with the owners of great works of art, who, as often as not, were members of those same families. It also helped to have attended one of about a dozen public schools (Eton, Stowe, Radley, Harrow, Winchester, etc.) where a good education was supplemented by the opportunity to form fast friendships with the offspring of other wealthy, art-owning families. Finally, a degree from a good university was preferable, though not strictly necessary.

Hodges was not aristocratic—he was not even upper-class—and the public school he had attended was not one of this magic elite, far from it. Therefore, his career path inside Sotheby's was very different. He became an administrator straightaway, and thereafter his entire life was spent trying to escape from this position. Administra-

tor was an accepted role in the department, but it was a second-rate job, nevertheless.

Hodges had not been aware of this divide when he joined Sotheby's, but he found out about it soon enough. By the time of the takeover battle, he was thoroughly disillusioned. He found it unbelievable that Sotheby's directors should be so appalled at Cogan and Swid, and yet they had been the ones who had allowed the company to slide into its ignominious position, where it was ripe for takeover. When Taubman bought the company and spoke at that first meeting about manners improving, Hodges had hoped that Sotheby's would change.

So far as he was concerned, it did not, and the final straw came toward the end of 1984. By then he had actually been allowed to work on certain weekends as a temporary cataloguer and thought that this might be a stepping-stone to his becoming a cataloguer full-time. A cataloguer assesses the age and authenticity of objects sent for sale and puts a value on them. In the furniture department he or she is aided by reference books and wood samples. The most important tasks are getting the age of an object right and spotting whether the piece was made by anyone noted—Sheraton, say, or Hepplewhite. This was the kind of "game" Hodges had played with his father for as long as he could remember, and he was good at it.

In November a position as cataloguer in the furniture department became available, and Hodges applied. One afternoon he was in the room belonging to the head of the department and took the opportunity to raise the issue. The superior was sitting at his desk in his shirtsleeves. He looked at Hodges, clasped his fingers together, and said, "You are not in contention. You are not cataloguer material."

Hodges was devastated. He knew his worth, but the superior's remarks seemed to sum up the barriers at Sotheby's. Whatever he did, he was "not cataloguer material." In code, he suspected that he was, in fact, the wrong class. The prospect of doing the same job for years ahead did not appeal, and he began to look around for something else.

. . .

During the lull in activities that always occurred in the Christmas season, Hodges contacted the personnel department and asked if there were any cataloguing jobs available elsewhere in the company. He was told there was nothing just then, but three days later, the woman called back to say that there *was* an administrator's job coming up in antiquities and that two of the experts there, Felicity Nicholson and Brendan Lynch, had specifically mentioned him. They had remembered him from his temporary stint a year before. This was not the cataloguing job he was looking for, but it was flattering that both Nicholson and Lynch had mentioned him. It promised a different attitude in antiquities, and he said yes.

Officially he made the move from furniture to antiquities in March 1985. His transition went smoothly enough, except for one odd incident. He had had lunch with the outgoing administrator, and on their way back to the office this man had mentioned that smuggling in antiquities was "rife," then said, "Some people can do all right out of it," and added, "Watch your back." When Hodges asked him what he meant, he said there was a lot of false paperwork to conceal the widespread trade in smuggled objects and that the administrator handled most of that paperwork. He told Hodges to be very careful.

There were three elements in Hodges's reaction to these comments. Part of him was worried. He knew perfectly well from his own experience that some smuggling went on and that an administrator doing the paperwork could be in a very exposed position. A second part of him was intrigued. He had, as did many people, an undeniable fascination with the art underworld. And a third part of him—the biggest part—simply wanted to get out of furniture. So he didn't let the other man's comments deter him.

The antiquities department was at the back of Sotheby's, on the first floor, overlooking St. George Street. From the windows of his new office he could see the columns of the neoclassical portico of St. George's Church. But the department itself, physically speaking,

was a shambles. It occupied four large rooms with a number of additional cupboards, a kitchen, and a darkroom for developing photographs of objects taken for the catalogue. As in the furniture department, the walls were painted a dingy white, but again, little of them could be seen because of the plywood shelving in every room, loaded with either catalogues or the objects themselves. Each object had a piece of pink paper folded around its handle or taped to its rim. This was the property receipt that identified the object and contained other information to be used in cataloguing. The display looked like a miniature parade, with the figures waving tiny pink flags.

The main room, the largest, was occupied by Felicity Nicholson, the director of the department. Besides her desk and her secretary's desk, this room boasted two large windows, a fireplace, and a magnificent bookshelf containing an impressive array of reference works. Nicholson's desk was invariably piled high with papers, as often as not held in place by valuable antiquities—an Egyptian wine jug perhaps, or an Etruscan bronze figurine. Various old electric radiators were placed around the room.

Hodges's first weeks in antiquities were far from easy. Each of the experts had different interests—tribal art, Indian objects, Italian vases—and expected Hodges to work primarily for him or her. But the main reason was Nicholson herself. Known throughout the company as either Flick Nick or the Witch, because of her preference for black dresses, her chief characteristic was her voice—plummy and loud. Her hair, once jet-black, was now graying and was pulled straight back and often tied in a bun. She was a heavy smoker of Gitanes, and in winter she had the disconcerting habit of lifting her dress to warm her buttocks on the radiators dotted about her office. She had started in the company as a secretary and then become the coordinator of advertising before turning to antiquities. She ran the department very firmly, but when she was away, visiting clients, which happened quite a lot, the regime slackened considerably.

After the first few awkward weeks, Hodges settled in well and began to enjoy himself. Over the summer of 1985, however, he made two discoveries that were to prove important. The first was that his old friend Christian Boursaud was one of the antiquities department's biggest customers. Because he had access to the paperwork and to the marked catalogues of Sotheby's sales, which recorded who sold what, who bought what, and for how much, Hodges could see that Boursaud was consigning up to £500,000 worth of objects at a time, an enormous sum by antiquities' standards. As many as seventy objects—bronzes, vases, wine jugs, figurines—would be sent in one load.

Second, it also came home to Hodges that Boursaud was in fact a front man. He was merely the visible tip of a small but highly organized network of continental antiquities dealers. And he realized with a shock that the others included the men Boursaud had introduced him to—Serge Vilbert and Georges Quimper. He also learned that Vilbert was a nom de guerre. His real name was Giacomo Medici, sometimes referred to as Guido. Like Boursaud, Vilbert/Medici was very pleased when he heard that Hodges was moving back to antiquities, and he proposed a drink. When they eventually met, Vilbert/Medici said that, like Boursaud, he needed an English bank account to help with "certain transactions." Most particularly, he said he needed to pay couriers who were bringing goods to London. He would, of course, pay Hodges for his trouble. Again, Hodges obliged, opening an account with the Abbey National Building Society the next time he went to Covent Garden looking for medals. This account was opened in the name H. C. Banks—his father's initials and his grandmother's maiden name. From then on, he says, he put monies into these accounts to help pay off couriers, storage costs, and other incidental charges. He did so by marking on the departmental records that "introductory commissions" were payable on certain items. An introductory commission is a small percentage that an auction house pays to people who bring in business. Hodges says he took 10 percent of each transaction as his own share.

One other event from his first year in antiquities needs to be recorded. It was a Wednesday right at the end of November, and Hodges had just returned from lunch. As he was taking off his coat, the telephone rang. When Hodges answered, the caller identified himself and asked to speak to Felicity Nicholson. Hodges wasn't sure if she was back from lunch yet but tried her line. She picked up immediately. He didn't listen in, though he could have. But his interest was piqued by the call because the person he had put through to Felicity Nicholson was a journalist from the London *Observer*. It was the author of this book.

The reason for my call to Nicholson that day is fully explained in Chapter 10, "The Apulian Vases." But the encounter that day was important because six years later, after Hodges had left Sotheby's and was looking for a writer/journalist to take up his case, he remembered that phone call, and that he had been reading *The Caravaggio Conspiracy*, my earlier book, and decided to contact me.

The reason he needed help from anyone at all has to do partly with the nature of Sotheby's antiquities business and partly with Hodges's own character—particularly the amalgam of stubbornness and cleverness that he had shown in his chess games. For the blunt fact was that, as the 1980s wore on, Hodges came to fully appreciate the scale of smuggling inside the antiquities department. More than that, he also realized that he himself had a central role in that business. Here the old issue of class reasserted itself. Everyone in the department—no matter where he or she went to school, or what type of family he or she came from—was aware of the smuggling and its extent, but it was Hodges's name, as administrator, that was most often on the paperwork. The documents were filled out in his handwriting. He was more vulnerable than anyone.

Realizing this, and that someday it might backfire on him, he began to steal documents. Over the next four years, Hodges amassed the three suitcases of documents, and not only from the antiquities department. While investigating a query from an Iranian

woman, he says he visited the company's "Central Archive" at the top of its Bond Street offices, where he stumbled across a whole dossier on the company's business in Iran. This led him to search the rest of the archive, and what he found there led to the later chapters of this book.

One may ask why he did all this. But we need now to flash forward to 1989, to the time that Hodges left Sotheby's.

It is important to make clear that when he left Sotheby's in that year he was not in disgrace. He was made redundant because many of his duties had been computerized and was given the equivalent of eight months' salary.

It is fair to say, however, that although Hodges did not leave the company under a cloud, by that time he was regarded as "difficult" and was not popular. Over the previous months, he had gradually fallen out with Felicity Nicholson, one reason being, according to Hodges, that he was suffering badly from Ménière's syndrome, an affliction of the middle ear that is not only painful but causes the sufferer to lose his or her balance. As a result, he had been forced to take time off work, often at busy periods. Relations with his boss had deteriorated to the point where Hodges had requested a meeting with Lord Gowrie, then chairman of the company, to discuss his future. He did not tell Nicholson.

It was at this meeting that Hodges was told that his colleagues had labeled him difficult. He saw red, and says he told Gowrie that, on the contrary, he had been very cooperative—too cooperative, in fact. And then, Hodges says, he gave Gowrie some papers testifying to how import documentation in the antiquities market had been falsified. Hodges says Gowrie became very distant at this point, and the interview was quickly terminated. Later, he was told that he was being made redundant.

That was in June. In July he attended the antiquities sale as a private individual. Nicholson was more friendly now, saying he could watch the proceedings from *behind* the rostrum if he wished. He de-

clined, he says, because he was bidding on someone else's behalf. In August he visited Washington with his wife. He says that after he returned, toward the end of the month, he received a telephone call from Felicity Nicholson inquiring about some missing documents; he said he didn't have them, though in fact he did. He did admit to having some papers about India that Nicholson was not inquiring about, and volunteered to return them, which he did a few days later.

It was then, he says, that he received a visit from the two Italian antiquities dealers. Following that encounter, he says, he had two others, one with a foreign antiquities dealer, the other from two antiquities transporters. They threatened him, he says, and all wanted to know if he had taken any records from Sotheby's. He says he denied having any paperwork but, after the third visit, put the documents he had amassed into three suitcases. One he left with his parents, and the others with friends in London.

In the last week of September, nearly three months after he had left his job, he received a visit from Detective Sergeant Martin Quinn, of West End Central Police Station, in Savile Row, a block or so from Sotheby's. Hodges says he expected Quinn to have come about the missing documents, but in fact the policeman wanted to know if he had at home an ancient bowl and a helmet. Hodges denied any knowledge of them, both at that meeting and one held a week later, at the police station. Besides the bowl and helmet, Quinn was also investigating the loss of an Egyptian figurine and some paintings—goods worth £500,000 in all.

Hodges did not have the figurine or the paintings, but he did have the bowl and helmet. In fact, Quinn's approach seems to have worked. Presumably, he had invited Hodges into the police station to impress on him the seriousness of the situation. At the station, Hodges attempted to convince Quinn that the issue at the root of Sotheby's actions was a fear of exposure regarding smuggling, but, he says, Quinn never took him seriously. In any event, following this encounter Hodges decided to return the bowl and helmet. He did so

in a bizarre manner, wrapping them in copies of the *Racing Post*, leaving them in a luggage locker at Marylebone Station, and then sending Quinn a note via the offertory plate at Brompton Oratory, as described in Chapter 1. Quinn visited Hodges the following Tuesday and took him to the local police station in Shepherd's Bush. Here he was arrested, placed in a cell, and interrogated, and then released on police bail. Quinn said he wanted to see Hodges again in three months' time, in December.

That autumn, ironically, when Hodges was plunged into despair, was the high point of the art boom. In November, in New York and London, no fewer than 160 paintings sold for $1 million or more. Hodges was in the United States for those sales. He had an American wife, after all, but he was also mulling over in his mind the fact that Sotheby's was now an American company, run from New York. He wondered whether the top brass there knew what went on in their name in London. Hodges had always regarded Al Taubman, the chairman of Sotheby's, as a decent man, ever since Taubman's first speech to the staff, during which he confessed that before he bought the company, when he was just a client, he had been ill-treated himself by arrogant employees. It occurred to Hodges that if Sotheby's senior American personnel did not know what went on in London, and if they understood what documentation he had and that it might come out in any trial, they might want to do a deal. In essence he would trade the documents for an agreement to drop the charges.

And so, while he was in Washington, he contacted an attorney recommended by his father-in-law. This was Michael Conlon, of Conlon, Frantz, Phelan, and Knapp, who then brought in Paul Knight, from a larger company, who had worked in the U.S. Attorney's Office, and who, although a mild-mannered man, was an extremely tough negotiator. They examined the documents Hodges showed them and agreed that there was more to the case than met the eye. They agreed, too, that Hodges should meet senior Sotheby's staff to discuss the wrongdoing inside the company and his part in it.

A first meeting took place in New York early in December. Present for Sotheby's were Marjorie Stone, the company's in-house attorney, and Richard Davis, of Weil, Gotshal, and Manges, one of the city's biggest law firms, which was retained by Sotheby's, and in whose offices, at 60th Street and Lexington Avenue, the meeting was held. Present with Hodges were Paul Knight and Michael Conlon.

At that first meeting, Richard Davis seemed most interested in Hodges's claim that others in the company, besides himself, took home unknown-owner property. (Hodges's argument was that he had been given the bowl and helmet to take away, with the full knowledge and agreement of his superiors. According to Hodges, when property was left at Sotheby's for a long period of time without being collected, and the owners repeatedly failed to pick up what was theirs, and the records no longer showed who the owner was, that property was sometimes given to Sotheby's staff.) Hodges refused to give other names at that stage but did hand over some documents. He says he did not mention Boursaud or Vilbert because he was mindful of the threats that had been made. He did not care to reveal his entire hand, but wanted to show Davis and Stone that he had more documents than he says he had given Lord Gowrie.

The other matter discussed at that first meeting was Hodges's bail hearing, in London, set for December 17. When it became clear that a second meeting was likely to be called, Hodges said he had to be back in London to see Sergeant Quinn. Exactly what happened next is disputed, but, according to a letter Paul Knight wrote to Richard Davis, "you made statements to me expressing reasonable certainty that James' meeting [with Quinn in London] had been postponed. On December 5, 1989, Marjorie Stone unequivocally stated to me that at her direction, Sotheby's had spoken to Sgt. Quinn and that he had agreed to postpone the matter [i.e., the meeting] indefinitely. . . ."

After Stone and Davis discussed what had happened at the first meeting with their superiors, a second meeting took place, in the

same offices, about ten days later, shortly before Christmas. This one, according to Hodges, was much more confrontational. Richard Davis stated formally that unless Hodges gave them the names of Sotheby's directors who had taken home unknown-owner property, they could or would do nothing to help him. If he did give them names, they would carry out an investigation. There was some discussion of the documents that Hodges had provided at the first meeting, but Davis was mainly interested in people who had taken unknown-owner property. Shortly before a break in the meeting, Hodges provided some names, but not at director level, and only on condition that no disciplinary action be taken against these relatively junior employees.

During the break, a disagreement emerged between attorneys Conlon and Knight. Paul Knight, the experienced negotiator, felt that now was the time to show the Sotheby's attorneys more documentation, but both Conlon and Hodges himself were concerned that Sotheby's attorneys, although perfectly pleasant on a personal basis, had not given away one single item of information from their side. Hodges therefore decided he would make no more documentation available. As a result, the rest of the meeting was much more formal, and soon ended.

What followed is confirmed by Paul Knight. About two weeks into the new year, he spoke with Richard Davis, who said he was now "ninety-eight percent certain there would be no prosecution." In the light of this information, Hodges decided to return to Britain, and he flew home toward the end of January. However, a week later Knight called from Washington; what he now said was less reassuring. Recently, he said, he had had problems contacting Davis, who was not returning his calls. A day or so later, Knight called again. Now his message was even bleaker. "Davis says that Sotheby's claim they have come across evidence that you have embezzled money by the misuse of introductory commissions."

Hodges says that at first he was not as worried by this as he perhaps should have been. He explained to Knight about the Banks and

Yarrow bank accounts and what they were used for. Then, about two weeks later, on a Saturday morning, Quinn appeared at Hodges's home. He wanted to know why Hodges had missed the bail meeting in December. Hodges was astounded—he had assumed that Quinn had been told about the New York meetings. He had returned to Britain voluntarily and was living at home; by no stretch of the imagination could he be said to be hiding or dodging anything.

It did no good. Quinn arrested Hodges and took him to West End Central Police Station. Because it was by now Saturday afternoon, no magistrate could be found, which meant that Hodges was kept in the police cells until the following Monday morning. No doubt Quinn was theoretically well within his rights to imprison Hodges in the way that he did. But in the circumstances, this was unbelievably humiliating for Hodges. He was no threat, was not about to abscond, and had never been in trouble before.

The imprisonment, and the further humiliation of being taken to court next Monday in the "sweat box," the police van that ferries prisoners between the courts, police stations, and prisons, produced a marked effect on Hodges. In retrospect, Sotheby's may feel that Quinn's move backfired; indeed, it made the stubborn Hodges a much more determined opponent. For it was as a result of his treatment that weekend that Hodges decided he had to go public with what he had. He put out feelers that, eventually, reached me.

—ന്ന—

The Release Notes

The documents Hodges made available to me were powerful, but not enough. They had to be corroborated by independent investigation, and that had to be done, as mentioned, without alerting Sotheby's, which might seek an injunction.

I used three methods of corroboration. In the first, I repeatedly cross-examined Hodges, taking him through his story time and time again. I was trying to catch him out, and he knew it. I cross-examined him in London, I cross-examined him at his parents' home in Suffolk, and I cross-examined him in Washington when he was visiting his wife and daughter. At all times, I found his story unvarying; his grasp of detail and of chronology was immaculate. He knew the documents backward and would refer me to specific pages to substantiate a point he wished to make. Not once, at that stage, did I catch him in any inconsistency or changed fact. It was impressive.

When he had presented me with the remainder of the documents, in his house, they had been divided into two. One group was neatly filed in the red ring binders; these were the ones he thought were important. The others were loose—he hadn't had time to go

through those. I did go through them, however, and found four sets
that showed evident wrongdoing in areas quite different from those
that concerned Hodges. On the face of it, the presence of docu-
ments whose importance Hodges had not recognized was added
proof that they were genuine.

Or was he being very clever, and had he deliberately left me to
find those extra documents, in an attempt to convince me that what
he had was genuine?

The second method of corroborating the documents was to check
the handwriting of the people who either had written them in the
first place or had signed them. This created two problems, for a
good many of the documents were photocopies, and the handwrit-
ing expert whom I consulted said that it was difficult to be certain of
handwriting samples known only through photocopies. Still, there
were about a dozen examples of original documents written by
hand: those of the deputy chairman, the head of old masters in
Milan, the head of sculpture in Rome, the head of the Geneva of-
fice, the head of the book department, and employees in the antiq-
uities and furniture departments in London.

We had Hodges's bodyguard, or "minder," George Campbell,
pose as a collector, and he wrote to three of the names, pretending to
offer works of art for sale, and received signed replies. Using the ex-
cuse that I was researching a thriller set in an auction house, I wrote
to three others, asking their advice on technical auction-house mat-
ters. All three replied, sending letters written entirely by hand. By
complete coincidence, and a nice irony, one of the other names wrote
to me out of the blue, complimenting me on an article I had written.
That letter too was handwritten. Finally, because I had been cover-
ing the art market for several years for *The Observer*, I already had at
home, in my files, letters from two Sotheby's people in whom we
were interested, so I had examples of their handwriting, too.

As a result, we soon had writing samples from nine of the twelve
names on our list. In early May 1991, I gave these samples to a
forensic handwriting expert, and within a week, she came back with

her answer. In all nine cases she was at least 90 percent certain that the handwriting was the same. Hodges had had no say in the choice of documents used, nor had he been involved in any way in the decision to bring in a handwriting expert. So the results looked good—yet more evidence that the documents were genuine.

Our third method was to try to replicate the procedure as revealed in at least some of the documents. Again, Hodges played no part, either in the choice of what we did or in its execution. What seemed clear from what he had given us was that so far as old masters were concerned, the traffic was organized from the Milan office by one Nancy Neilson. My problem at that stage was that I had no access to old master paintings. I approached two dealers in London and one in Sussex, asking to borrow a painting worth anything between £10,000 and £30,000. I refused to explain why I needed the picture but said it would be "out of action" for up to six months. I was, no doubt, being naive, and understandably all three declined. I then approached two dealers in New York, who also declined.

Growing a bit desperate, I consulted two other dealers in London whom I knew well, but who did not deal in old masters. One sold Far Eastern art, the other silver. Amazingly, the dealer in Far Eastern art agreed to lend me a small ninth-century wooden sculpture of a Chinese figure, valued at £30,000. And the silver dealer said yes, too, lending me a seventeenth-century tray valued at £14,000. In both cases they did not want to know why I needed the objects; all they wanted was for them to be insured, which I was happy to arrange. I traveled to Italy with them, in the company of an old friend, the dealer Andrew Purches. Andrew had extensive Italian contacts, and we needed a genuine Italian collector to take the objects into Sotheby's Milan office and see if he could arrange for the sculpture and tray to be sent to London.

Our first stop was in Villafalletto, in the hills south of Turin. There I was introduced to Andrew's collector, a colorful man who had an English wife and whose companies supplied parts to Fiat. He listened to our story—we had to tell him the whole truth, of

course—and then said he would think it over. Meanwhile, he would offer us dinner. Over a sumptuous feast of pasta and veal, we all drank more than was good for us, and our host fell asleep. Andrew looked at me and whispered, "I think that means no."

The next day saw us at Campione on Lake Lugano, on the Italian-Swiss border. Here lived some dealer friends of Andrew's, in a splendid house-cum-gallery on the lakeshore. It was a Sunday, and we arrived in time for lunch at a nearby restaurant with a wonderful terrace. To my astonishment, this couple agreed to help out, and we left the sculpture and tray with them. They promised to take the objects to Milan later in the week. Andrew and I returned to London.

Back home, a shock. In fact, it was a double blow. We were now in the third week of May, and, since Hodges's trial was set for July 8, he was heavily embroiled in preparing his defense. That week, however, he heard that the trial had been postponed—for the third time. The reason given was that Sotheby's London managing director Tim Llewellyn (Graham's son) and Roberto Fainello, another Sotheby's executive, would not be available to give evidence. Hodges was incensed by this. His funds were drying up, and he also felt that Sotheby's was using delaying tactics, so that the documents he had and wished to introduce at the trial would become dated. He was also worried that any statute of limitations relating to offenses disclosed in the documents would have run out. I did not agree. The age of the documents would not affect their potency, or their effect on a jury.

However, a bigger setback than the third postponement of the trial took place when Hodges and Anthony Burton, his solicitor, visited Detective Sergeant Quinn at West End Central Police Station on the 20th of the month. Quinn, the man who had originally arrested Hodges, now said that he was increasing the number of charges against him. It was part of Hodges's case that he had set up two false bank accounts, in the names H. C. Banks and A[lbert] Yarrow. Money had been paid into these bank accounts from Sotheby's, ostensibly, Hodges said, as "introductory commissions." In certain circumstances, if someone introduces a seller to an auction house, a commis-

sion is paid for bringing in the business—normally 4 percent of the sale price. When the sale results in antiquities were printed out, Hodges would sometimes scribble on the top copy something like "£400 to Yarrow," or "£650 to Banks." His case was that these bank accounts were built up so that he could pay off, in cash, certain "couriers" who brought smuggled goods to London as well as restorers, warehouse charges, and so on. Quinn's response was that Sotheby's itself, with the help of Freshfields, its solicitors, had looked into the Banks and Yarrow accounts and took the view that Hodges's version of events was nonsense, that he had operated them on his own, for his own benefit. In effect, he had embezzled money.

There were no fewer than eighteen charges of false accounting. But that was not all. Quinn also said that Hodges was to be charged with forgery.

This was bleak news indeed. If Hodges was a forger, we clearly could not trust the documents we had (underlining how right it had been not to try to publish ahead of the trial). But it turned out to be more complicated. In fact, the charges of forgery against Hodges did not relate to any of the documents we had. There were two charges. One concerned a release note he had, signed by Felicity Nicholson, the head of the antiquities department, giving him permission to open the two bank accounts. The other allegedly forged document was signed by Brendan Lynch, number two in the department, who specialized in Oriental antiquities; it gave Hodges permission to have at his home the two antique objects—a bowl and a helmet—he was in fact accused of stealing. In both cases, there was no question but that the notepaper on which the document was written was genuine Sotheby's paper, and so were both signatures. And so, if these *were* forgeries, which Hodges denied to me, they had been achieved by typing in the text Hodges wanted on blank Sotheby's notepaper that carried only Nicholson's or Lynch's signature, the sort of sheet a director might sign and leave behind before going on vacation.

While this was extremely reprehensible, if true, it did not make Hodges capable of widespread forgery of the kind needed to falsify the mountain of documents we had.

All the same, it did give us pause. If Hodges had been determined enough to forge the release notes, then he just might be determined enough to have someone else—a professional—forge the rest of the documentation. I did not believe this for an instant, but one could not ignore the fact that the forgery charges had altered the whole scenario.

No sooner had this news struck than more followed. Andrew Purches's Italian friends, the dealers with the gallery at Campione, called to say that they had changed their minds. They would not now do as they had promised and take the objects I had borrowed into Sotheby's Milan office.

The whole investigation appeared to be collapsing. Then lawyers for the American publishers came up with an idea—that, in the circumstances, Hodges should be asked to undergo a lie detector test. When I suggested this he agreed immediately. However, we thought that for his own protection, the test ought to be left until after the trial. If he took it before the trial, and for some reason failed, and if, by chance, the prosecution got to hear of it, that could be damaging for him.

I had promised myself at the beginning of my association with Hodges that although I would be sympathetic, I did not need to take his side against Sotheby's. My chief interest lay in the fabric of wrongdoing inside the company, irrespective of Hodges's role and culpability. I would have to go on dealing with Sotheby's after whatever I wrote, and I needed to play fair by the firm. And I wanted to play fair. After all, not everyone in that organization was tainted, twisted, or, as we say in Britain, "bent."

It was, however, hard not to take Hodges's point of view at times, simply because I spent so much time with him, and because of the evolving tactics. When the trial was postponed, for instance, he was

certain in his own mind that it was part of a Sotheby's ploy to "get him." Had he gone to trial in the autumn of 1990 or the spring of 1991, as had originally been intended, he would have faced one charge—of theft. As it was, he had been told that the trial was being postponed because certain Sotheby's witnesses were not available. All the while, however, as he saw it, fresh charges were being prepared. Was that fair?

Still, I was not sure that I entirely believed his version of events. I am not a conspiracy theorist. But then I was not facing trial. As the summer passed, though, Hodges did begin to convince me that there was more to Sotheby's behavior in connection with the prosecution than met the eye. He said that the people whom the Banks and Yarrow accounts benefited most were four regular importers of unprovenanced antiquities—Christian Boursaud, Serge Vilbert, Georges Quimper (as I am calling the man), and a Mr. Ghiya of Jaipur. However, none of these names was featured in the indictment. As a result of excluding these names, Sotheby's was accusing Hodges of misappropriating only £11,000 when he knew, because he was a stickler for detail, that the true amount of money that had passed through these accounts was closer to £30,000. Moreover, he pointed out that none of the Sotheby's customers alleged to have lost money by his "false accounting" had actually complained.

I listened to Hodges and blew hot and cold over his views. Sometimes I accepted them, sometimes I did not. When I didn't, it was because of something else that had by now come to my attention. When Hodges was first accused of having the antique objects at home, he had said he had taken them because he had been given them. Later, he said he had a release note, signed by Brendan Lynch, giving him permission to take home unknown-owner property. Much later, he changed his story and said that the bowl and helmet really belonged to Serge Vilbert, one of the Swiss dealers who regularly consigned smuggled goods, and that Vilbert had asked Hodges to look after his things.

This was bad enough, but two other points affected my attitude. In the first place, it took awhile after he had been accused of stealing the helmet and bowl for him to come up with the two release notes. In both cases it had taken him weeks to find these very relevant—vital—pieces of paper. He told me it was because a lot of his documentation was disorganized. But I had seen Hodges in operation with the other documents, and I knew what a master of detail he was, how well organized many of the documents were. That he should be unable to find these all-important release notes for such a long time was so out of character that I privately thought he might have forged them.

The second point was the bizarre way he had returned the missing objects. He said he was frightened of certain people in the art world, but even so what he did was strange. Coming so soon after Quinn's interrogation of Hodges, it did not take the policeman long to put two and two together. What was to be made of such behavior?

All this did not necessarily change my general belief in the documents that Hodges had given me, or of the picture outlined. But it meant that I kept my distance. It also meant that we would or could do little to advance our investigation, such as it then was, ahead of the trial.

On the plus side, because the prosecution had introduced more charges, concerning false accounting, Hodges would now have a freer hand to widen his defense, including a chance to introduce some of the documents. This was not entirely good news from my standpoint—after all, anything mentioned in court could be reported in the newspapers. But it would certainly be a good test of the veracity of the paperwork. If Hodges was on trial for forgery, then any forged documents that he introduced in court would be seized upon by the prosecution.

For Hodges, summer was grim. He had sold his car to provide funds. He had forgone a vacation in Washington with his wife and

daughter because as part of his bail arrangement he was required to sleep at home in London. He risked one night away with his parents in Suffolk. While there—it was a Thursday in August—he went into the local village, Cratfield, to do some shopping. Unusually for him he bought *The Independent*. Normally he preferred *The Guardian*, but that day it had sold out. He drove home, made coffee, spread the paper out on the kitchen table, and settled down to read. And there, on page 4, was an article describing how Roberto Fainello, an art dealer and former employee of Sotheby's, had committed suicide by throwing himself off the cliffs at Swanage, on the south coast of England. The article said that a note had been left, but its contents were not disclosed. It was hinted that Fainello, like a number of art dealers at the time, had financial problems.

Hodges did not know what to make of this. So far as he knew, Fainello was a devout Catholic. He did have a cocaine habit, which made him unstable. More to the point, however, Hodges had been hoping that Fainello would give evidence in his behalf, to show that unknown-owner property was indeed given away at Sotheby's. More worrisome still was the question of whether Fainello's death had anything to do with the impending trial. It was most likely not a major reason, Hodges concluded. But the episode was disconcerting all the same.

The trial had been scheduled to start on Monday, November 4. It was now put back a fourth time—but only for a week—because of pressure of legal business. Being a prudent man, Hodges suggested that he and I have a "last supper," just in case, a week beforehand. He knew that once the proceedings started, he would not have much free time: in the evenings between appearances in the dock, he would be going through court documents and reevaluating his strategy.

We went to a Greek restaurant in south London, well off the beaten track. We did not want to be spotted either by anyone else in the art world or by other journalists. By now, it was clear that our

aims for the trial differed somewhat. Obviously, Hodges's first priority was his liberty, and to that end he needed to widen the trial as much as possible—to introduce as many of the documents as his barrister said he could, and as were consistent with the charges against him. I, of course, wanted as few of the documents used as possible, so as to keep what we had fresh for disclosure later, although at the same time I wanted *some* to be introduced.

Over the hummus, taramosalata, and retsina, it became clear from Hodges's conversation that he was ambivalent about the trial. He was in a strange way looking forward to it. He wanted to see how his former colleagues—former friends—would perform in the witness box. How many lies were they going to tell, to save their jobs, their skins, and the company? At the same time, he tapped the table, played with the knives and forks, and repeated the same jokes time after time. He was, understandably, shaken. He wanted his day in court, yet he was also dreading it.

—w—

Black Christmas

In 1991, Knightsbridge Crown Court, second in line to the Old Bailey in terms of importance, was quite possibly the most cruelly situated judicial building in Britain. It has since moved but was then housed in a redbrick building with a mock-Dutch facade down the street from Harrods. No one could have been in more marked contrast to the well-heeled shoppers who thronged to the "top people's store" than the raft of sad and desperate souls who peopled the court next door.

Tuesday, November 12, was wet, an icy wind driving the pellets of rain almost horizontally. Court Six, where *Regina* [the Crown] *v. James Edwin Hodges* was billed to start, was at the end of a crooked corridor with no windows. The corridor was furnished with a solitary coffee machine.

The court was large and square, with the jury occupying most of one side. At right angles to them was a raised platform with three high-backed red leather chairs, for the judge or judges. On the far side, opposite the jury, was the public gallery, seating about fifteen, including the press. In the center of the court were four rows of ta-

bles and chairs. Prosecuting and defense counsel sat in the front row, with defense nearer the jury. Behind them sat the leading solicitors, and behind them sat their clerks, junior solicitors, and police.

The entire fourth wall of the court, on the side opposite the judge and at right angles to the jury, was taken up by the dock, with a barrier and a raised platform. There was a single door set into the wall where defendants who had not been allowed bail were brought to court from jail. Hodges was shown into the dock by the usher. He sat down, blushing.

Hodges had been in court, briefly, the previous day. Both sides had certain pretrial motions before the proceedings proper began. The prosecution had petitioned the judge to the effect that some of the documents to be used in the case contained commercial information that ought to remain confidential. Counsel proposed that the court allow certain names to be blacked out in the documents used in the case, and that certain individuals be referred to only as Mr. A, Mrs. B, Dr. C, and so on. "After all," counsel said to the judge, "it's not as if Sotheby's is like Marks and Spencer." (Marks & Spencer, the department store, sells clothes and food. In the United States it owns Brooks Brothers.) In replying, the judge remarked that he could not see the difference between Sotheby's and Marks & Spencer. Nonetheless, he allowed the motion.

For the defense, Michael Grieve complained that Freshfields, and through it Sotheby's, had not allowed Hodges sufficient access to the documents in the case that related to the false accounting—the Banks and Yarrow accounts. Grieve proposed that Hodges be given access to Freshfields' files *in* the Freshfields offices. The judge agreed to this, too, and for the rest of that first day Hodges had sifted through a huge stack of papers at the legal firm's offices in Fleet Street, looking for yet more material that would show what the false accounts had really been used for.

It was 10:30. The trial was scheduled to start. Grieve had arranged his papers in front of him and now stood talking to Anthony Burton, Hodges's solicitor. Paul Clark, the prosecuting coun-

sel, was a shorter man than Grieve, slightly older, and redder in the face. He too had arranged his papers and now stood talking to someone whom Hodges didn't recognize—a solicitor for Freshfields, presumably. Occasionally Paul Clark looked over in Hodges's direction, trying to size up his man. Hodges's mother, Barbara, was in the public gallery. He tried not to look at her.

It was 10:35 A.M. For a wild moment, Hodges thought the judge was not going to show, that the trial had been delayed yet again. But then the usher shouted, "All rise!" and Judge Lloyd swept into the room. He was a slight man, wearing a short wig and gray robes dominated by a purple sash. When he spoke he had a clear, very British voice, down-to-earth, as Hodges heard it, a voice that reminded him of that of a gardener.

As the charges were read out, Hodges studied the jury. He found them difficult to fathom, these strangers who were to have such a profound importance in his life. Some of them were young, his age. Some, to judge from their gray hair, were probably in their sixties. Some were white, some were black. No one looked expensively dressed. One by one they returned his gaze. They were as interested in him as he was in them.

Stripped of legal jargon, the charges against Hodges were (1) that he had stolen the helmet and bowl, valued at £50,000; (2) that he had forged two release notes, purportedly signed by Brendan Lynch and Felicity Nicholson; and (3) that he had falsified twelve documents so as to obtain twelve checks payable to either H. C. Banks, A. Yarrow, or Mrs. S. A. Halls (Hodges's sister), which were rightly due to Sotheby's. These checks ranged in value from £478 to £1,920 and totaled £11,882.08p.

I was not in court when the charges were read. In fact, I was not in court for the first few days, although my researcher made full notes. Hodges and I had discussed this at length. Our problem was that we did not know how much interest the press would take in his trial. This was important, because the amount of interest would be a reflection of how much other journalists knew.

At one level, *Regina v. Hodges* was merely the trial of a relatively junior employee of Sotheby's, someone who had been caught with his hand in the till, a rotten apple in an otherwise pristine barrel, according to the way Sotheby's conducted its defense. As he outlined the Crown's argument on that first day, Clark adopted the Sotheby's line completely, alleging that Hodges had stolen the bowl and helmet of his own accord and on his own initiative, and that therefore he alone had forged the release notes. Furthermore, he had so abused his position of trust within the company as to squirrel away money into special accounts that he had deliberately set up for the purpose. This would obviously be news, if only because, for the previous decade, the auction houses in general and Sotheby's in particular had maintained such a high profile, making the most of the 1984–90 art boom. Also, anything that promised to reveal the inner, secret workings of the auction houses would be snapped up.

But that was a long way from knowing about the whole background of the trial, and all the documentation in Hodges's possession. Therefore, since we simply could not tell how much the other journalists knew, or had worked out in conversations with their contacts inside Sotheby's or the police, we decided that it would be better for me not to appear at the trial to begin with. My presence there would only alert Sotheby's and conceivably other newspaper people to the fact that at least one journalist thought there might be more to this trial than a single "rotten apple."

In fact, in that first week *The Times* reported baldly that Hodges had denied the twenty-two charges against him, but *The Independent*, which covered the trial more thoroughly and consistently throughout, ran a headline that read, "Sotheby's man 'said he paid off art smugglers.' " David Connett's piece began, "A Sotheby's employee told police he had used fake bank accounts to pay cash to people who smuggled art and antiques, and that senior directors at the auction house had authorised the scheme. . . . But the jury at Knightsbridge Crown Court in London was told that James Hodges's story was nonsense and an attempt to cover up his dishonesty."

This was both good and bad news. It was good in that I could now attend the court openly. Hodges and I had agreed that we would not acknowledge each other in public. I was in court, therefore, merely as a journalist interested in the art market who had read about the case. It was bad news in the sense that all the serious daily newspapers were paying attention now and could not fail to pick up on any allegations, or documentation, that Hodges might introduce. This was confirmed when I attended the court in the second week and found the public benches mainly occupied by my colleagues/ rivals—correspondents from *The Times*, *The Independent*, *The Daily Telegraph*, and the *Evening Standard*, and someone from a television company.

Regina v. James Edwin Hodges was not a case in which the facts were in dispute. Hodges admitted that he had had the helmet and bowl at home. He admitted that the bank accounts had existed and that he had paid monies into them and withdrawn monies out of them. The central issue in the case was therefore the interpretation of those facts, and that, in turn, meant that a great deal depended on the credibility and character of those giving evidence. Bluntly, it boiled down to this: would the jury believe the raft of Sotheby's employees giving evidence against Hodges, or would they believe Hodges himself?

Evidence was sought by the Crown from twenty-three individuals. These included the police but were otherwise all employees of Sotheby's. The most important witnesses fell into two groups. There were those relatively senior personnel who, Hodges was to claim in court, were involved in antiquities, and in antiquities smuggling; and there were those *very* senior people who, as Hodges also alleged, were aware of the various forms of dishonesty inside the company. Five witnesses fell into the former category and three into the latter. Their testimony, Hodges felt, was likely to be the crux of the case.

In Hodges's defense, his chief problem was tactical. He had to an-
swer the specific charges against him, but the essence of his argu-
ment was that these incidents were part of a much larger picture.
Therefore, throughout the trial his defense was always seeking to
widen the discussion, to bring in additional details that would show
the jury that the dishonesty at Sotheby's was widespread and even
routine. It was a kind of guerrilla action, reinforced by the fact that
every evening, after that day's court proceedings were over, Hodges
made directly for the Freshfields offices, where he sat for two or
three hours sifting through yet more documents. It was exhausting,
but he was determined.

Would the judge allow this campaign? If Judge Lloyd would not
allow Michael Grieve to range beyond the narrow confines of the
charges, Hodges's case would be much harder to make. There was
also the problem of the documents that Hodges had. Without them,
his allegations would have been much weaker. Sotheby's probably
had no idea exactly what he did have (though it had been told by
Paul Knight that the documents Hodges had amassed were "as high
as your shoulder"), but that wasn't really the point. The point was,
would the judge allow the documents to be used *at all*?

Michael Grieve, Anthony Burton, and Hodges had discussed this
in detail before the trial. They had concluded that since it was
Hodges's case that the false accounting charges related to smuggled
goods, and since the helmet and bowl belonged to Vilbert, a re-
puted antiques smuggler, they would seek to introduce as many
documents as possible that related to antiquities smuggling but go
no further. Hodges was not happy with this, but Grieve impressed
on him that should they lose the sympathy of the judge it would be
very difficult to win the case. This was because Hodges's chosen
line of defense was already risky, since it involved admitting that he
had changed his story after his arrest. When he was first tackled by
Quinn he had said he had been given "unknown-owner property,"
which he explained. At a later date Hodges had come up with let-

ters authorizing his possession of this property, thus substantiating his earlier explanation. Now, however, after being charged with the forgery of those release notes, he was saying that the property really belonged to Vilbert, who had asked Hodges to store it on his behalf.

If one had access to *all* the documentation, this story might be believable. If one did not, it was a difficult case to make. Nonetheless, this was the defense that Hodges wished to use, and on that basis, Grieve thought they ought to be allowed use of the smuggling documents. But that was all. There would be no mention of the other documentation that Hodges had, which went much further than antiquities smuggling. For Hodges it was like throwing away half his argument. But he had to accept the advice.

After the charges were read, Hodges was allowed out of the dock and sat in the main body of the court immediately behind Michael Grieve. Burton and Grieve regarded this as a good move. Not only did it enable Hodges to give constant advice, and therefore do something rather than simply sit in the dock like a prisoner, but it also meant that the jury saw Hodges in action—locating documents, whispering points in Grieve's ear, sending clerks on errands.

Paul Clark, for the prosecution, began by seeking to show that Hodges had falsified documentation, both the company's internal records and the release notes that purportedly gave him permission to have the antique bowl and helmet. Testimony was produced from bank personnel and a printing company to the effect that the stationery on which the release note was typed was not in use at the time the note was dated. Clark also pointed out that where checks drawn on the Yarrow and Banks accounts could be traced, they had been used for Hodges's personal needs rather than paid to couriers as he claimed.

The first real encounter, from Hodges's point of view, occurred on day six of the trial, when Isabelle Hamon, from Sotheby's Paris

office, took the stand. She had consigned goods to London on be-
half of certain clients. These goods, the Crown alleged, should not
have been subject to introductory commissions, yet Hodges had fal-
sified the record to make it appear that commission should be paid,
to Yarrow or Banks as the case might be.

Ms. Hamon's performance in the witness box was curious. An in-
terpreter was provided by the court, because her English was said to
be less than perfect. Hodges thought this odd, because he had had
many dealings with her and knew her English to be excellent—it
had to be, because she was dealing with London all the time. And in
fact, as time went by, she dispensed with the interpreter, answering
questions directly before he had a chance to translate. Hodges won-
dered whether the services of the interpreter had been requested so
that she could have time to think through her answers to the ques-
tions she was being asked. He could not help but be cynical by now.

The crux of the exchange came when, during cross-examination,
Michael Grieve produced a memo to Isabelle Hamon from Roberto
Fainello in the antiquities department, dated November 1985, in
which Fainello said, "All my big French clients don't deal from the
Paris office for the obvious reasons." When asked what Mr. Fainello
meant, Ms. Hamon said she didn't know.

Grieve persisted. "The obvious reasons are they did it to avoid
tax, didn't they?"

"I don't know," Ms. Hamon replied.

Grieve explained his understanding of French export law in more
detail. Under that law, he said, the French authorities had the op-
tion of buying any art object an individual wished to export, at the
owner's valuation. He suggested that certain people deliberately un-
dervalued their objects so that the export authorities would think
those objects less important than they really were—and for tax pur-
poses. Again Ms. Hamon said she did not know this.

Grieve next turned to a telex sent by Hamon to Felicity Nichol-
son on April 25, 1985, dealing with export arrangements. Being a
telex, this message had somewhat abbreviated syntax, but it con-

cluded: "Thanks to destroy this telex after reading." The telex read, "Definite exports with payment in France to be made by the client himself to a foreigner client. A list with individual lots should be made with French prices. The client should decide himself which prices he wants to fix for customs." Grieve then said that this telex again outlined the system whereby a French client was evading French export law.

Ms. Hamon replied, "It could be, it may be."

Grieve went on, suggesting in more detail how the scheme worked. "The French client exports his items to someone abroad [the "foreigner client"] and makes a declaration of the value of the items for customs' purposes. But in order to reduce the impact of the 6 percent [export] tax, he states a price which is well below what he knows to be the true value." The reason someone might do this, Grieve suggested, was to avoid attracting the attention of the French museums. "The recipient of the goods can then enter the goods for sale abroad, in London, at their true value." When asked why she might want Felicity Nicholson to destroy the telex, Ms. Hamon replied, "I no longer remember."

But it was the arrival in the witness box, on November 21, of Felicity Nicholson, head of antiquities at Sotheby's, that provoked the first of the main courtroom tussles. The trial was in its ninth day. Here was Hodges's erstwhile colleague, boss, and friend testifying against him. Wearing a gray cardigan over a black shirt, her graying hair swept back in a bun, she was in the witness box for two days. Every so often when the judge suggested a recess she would escape to the corridor outside the court and light up a Gitane. She spoke to no one and evidently found the proceedings almost as harrowing as Hodges did.

In early cross-examination she had admitted that there was an illegal trade in antiquities out of Italy and that Sotheby's was a signatory to a British Antique Dealers' Association convention that forbade knowingly trading in such objects. She also confirmed that

a Serge Vilbert and a Christian Boursaud had consigned an object
that had been withdrawn from the July 1985 sale, after she had re-
ceived a letter of warning from Dietrich von Bothmer, at the Met-
ropolitan Museum in New York, who told her that the object had
been illegally excavated and smuggled out of Italy. Then the follow-
ing exchange took place:

Grieve: "Was the result that you began to be somewhat suspicious
of property in the name of Vilbert or Boursaud?"

Nicholson: "Well, as I say, I mean I saw . . . when I go to wher-
ever it is, shall we say Switzerland or in Germany or in France, and
I am offered property, I believe the people to have good title to it,
and I do not really question it."

Grieve: "I understand that, but in this case and with this person,
an item of property had been called into question—withdrawn from
your sale—so the suspicion about it had been drawn to your atten-
tion, hadn't it? I just wondered if it caused you to be suspicious gen-
erally in relation to property coming from this source?"

Nicholson: "I find that very difficult to answer. I just don't . . . I
mean suspicion is one thing, but I really don't . . . I can't . . . Suspi-
cion is one thing, but knowing is another."

Grieve: "I accept that, but if you only suspected that an item
might have been smuggled, but you didn't know, or have strong
grounds to believe it, would you be prepared to sell it through
Sotheby's sales?"

Nicholson: "I think as long as I don't actually . . . As long as . . .
Yes, I think we would, yes."

Grieve then asked her if she agreed with the proposition that she
"turned a blind eye to the whole problem." She replied, "Yes, I think
I would. Well, no maybe . . . yes, yes. I did not, as I say when I went
to see them I did not . . ."

Grieve pressed these points repeatedly, putting it to Nicholson
that when she dealt with Boursaud, for example, she had reason to
suspect that he dealt in smuggled goods. At one point she replied,

"As I have already said several times, when I went to see these pieces, whether I had suspicions or not was really not the point. The point is: Did I know or did I not know? I am afraid I just . . . I don't suppose I thought about it very much, but I mean, I don't know how to explain really . . . I mean our sales are widely publicized for everyone to see, and presumably governments concerned would get in touch with us. I mean, it is not as if we are selling them privately. . . ."

Grieve next turned to the relationship between Nicholson and Hodges. "So far as Mr. Hodges is concerned, I suggest to you that it was understood between you, that is to say, it was plain between you, that some of these antiquities, and some of the people that were dealing in antiquities, were suspect in the way that I have been putting to you; that they were of doubtful origin. They may have been dug up; they may have been smuggled. This was something which, without being spoken about in any great length, was something that was understood between you."

Nicholson: "Again as I say, this antiquities market is a very controversial one, and I suppose that . . . Sorry, could you just repeat that again?"

Grieve: "That it was understood between you and James Hodges in your working relationship that some of the articles you dealt with, some of the people you dealt with, were suspect in the sense I put to you; that is to say, they were suspected of being either smugglers or smuggled goods?"

Nicholson: "Perhaps, yes."

Grieve: "And you particularly handed over to James Hodges the responsibility for all the arrangements that had to be made in connection with the import of such goods, where necessary?"

Nicholson: "I didn't particularly hand them over to James Hodges. I handed them over to our administrator."

Grieve: "I meant in his capacity as administrator?"

Nicholson: "Right."

Grieve: "But you wanted him to look after all the details necessary to bring about the importation of these?"

Nicholson: "Of course."

Grieve: "And whether or not, even where there was a suspicion they may well have been smuggled. Do you follow me?"

Nicholson: "I do, absolutely. Yes."

Doggedly, Grieve now switched back to France. "Was it ever part of your experience that, taking as an example, France . . . that exporters of goods from France, who desired to have them consigned to your sales, might be anxious that the goods should appear to be coming from somewhere other than France?"

Nicholson: "Yes, I think that might well be the case."

Grieve: "Why did you understand they wanted their goods to appear to be coming from somewhere other than France?"

Nicholson: "That is their business really. That is nothing to do with me—I don't think."

Grieve: "Wouldn't Sotheby's, in order that something should appear to be coming from somewhere other than France, in such a case, wouldn't the documents presented to Sotheby's misleadingly indicate goods were coming from somewhere else?"

Nicholson: "I don't think it is up to Sotheby's to examine their clients' business methods really. We are acting for them, selling their goods. I really don't think I can, or Sotheby's can be expected to ask them questions of that sort."

Grieve next addressed himself to a bronze statue of Venus, consigned by one Pierre Mettral in Switzerland but in fact owned by a woman in Paris. At first Felicity Nicholson refused to speculate as to why or how the piece had got from Paris to Switzerland, although she did admit she had seen the object in the French capital. Later, however, she said: "I suspect I realized that there was a reason for her sending it to Switzerland, and that probably there was some reason for that, such as you are mentioning [i.e., that the statue had been smuggled to avoid customs duty]. But as I say again, it is

really . . . I mean that is her business really." She also conceded that Vilbert or Boursaud "may" have been specialists in this type of transportation.

The cross-examination had started well, from Hodges's standpoint. Grieve had succeeded in getting Felicity Nicholson to admit that the picture of business as reflected in the paperwork confirmed the illicit trade, which is what Hodges had claimed all along.

As the first day of her testimony came to an end, however, things began to go less well. Nicholson was adamant that Hodges would under no circumstances have been allowed to manage clients' accounts or would have paid couriers in cash. Yes, she said, she let Hodges handle all sorts of administrative details that she wanted nothing to do with, but payments to couriers wasn't one of them, for it hardly ever took place, and never in cash.

On the second day of Felicity Nicholson's testimony, Grieve began by asking about an Egyptian basalt sculpture that Nicholson had first seen in London, in Chelsea, in 1985. In this case, at Sotheby's insistence, all the names were referred to by initials. A Mr. Fantechi was thus Mr. F and a Mr. Jatta was Mr. J. When she first saw the statue, Nicholson said, she had not known where it had come from. She then did admit, however, that it had been reexported from Britain to Switzerland and reimported from there, in a "nominee's name."

Ms. Nicholson finished giving evidence about halfway through the afternoon of the second day. The balance of it was difficult to gauge. She had admitted that smuggling was widespread in antiquities traffic, and that she had turned a blind eye to it. She had said she did not regard it as Sotheby's problem to look after its clients' morals or business practices. How would that go down with the jury? At the same time, the jury had seen only a few of the documents, and there was no time for them to study the full details of the statue's journey and to compare them with Nicholson's sworn testimony. To that extent her testimony was unsatisfactory to Hodges's

case, despite her admissions. Then there was her adamant insistence that Hodges had no authority to pay couriers in cash or to operate the Banks and Yarrow accounts. Did the fact that she had admitted some wrongdoing (in the case of the statue) make her whole testimony suspect, or did it make her denial of any knowledge of the two accounts more credible? It was difficult to know.

Nicholson was followed by Oliver Forge, her deputy in the antiquities department. Grieve began by presenting him with a series of property receipts for objects whose sellers, Forge admitted, were Italian or French—and yet in each case the receipt had been incompletely filled out, or an English or English-sounding name had been used. In every case Forge blamed his own inefficiency and denied any more sinister intent. However, then came these two exchanges.

The first concerned an ancient glass bowl that had arrived broken from France. Forge admitted that he had seen it in France and that he had suggested it be broken. He accepted, when Michael Grieve put it to him, that the name on the property receipt had been changed from a French one to "an English-sounding" one, and that the space for an address had been left blank, as had the boxes indicating whether or not the piece needed import documents. In this case, however, Grieve argued that the reason the bowl had been broken was to make it easier for it to be smuggled through French customs. Forge replied that that was "a ludicrous suggestion," that he had merely suggested to the man I'm calling Georges Quimper, who owned the bowl, which had been broken before, that it needed to be broken again and then repaired in a better way to improve its value. However, he did say that the breaking of such an object was a job for a skilled person, and that the most desirable way to go about it would have been to have it done in London. When asked by Grieve why, therefore, it had been done in Paris, Forge said he didn't know, "but how do we know it was not broken by a skilled person in Paris?" At the same time he admitted that the owner of the glass bowl had asked him to remove his name as the seller and

replace it with another. When asked whether he looked upon such a move as "pretty peculiar," Forge said: "No, I did not."

Forge could not explain why the requisite forms had not been filled out properly, nor did he know why the bowl had been broken in Paris when London "would have been a better" venue, but Grieve let it go. Instead, he turned to the case of E. Cardone, who had consigned an inlaid buckle in two parts. In the first instance, there was one document provided to the court by Hodges that showed that it had been received on Sotheby's behalf by "KW," who, Forge confirmed, was a person working on the front counter. This document gave the address of E. Cardone as in Rome. A second document, however, purported to show that the inlaid buckle, with the same property number, had been received by Oliver Forge and that Mr. Cardone's address was now "66 Kensington Gardens Square," in London.

Grieve: "Would the normal procedure not be to put the details on the original property receipt?"

Forge: "It would have been, yes."

Grieve: "Do you know why you came to fill out a second one?"

Forge: "I do not."

Grieve: "Can I put to you the circumstances in which I am suggesting it came about, to see what you say? I suggest that James Hodges brought your attention to this top sheet, the one with the address in Italy and no rings in the import dockets and post entry sections. [That is to say, if the object had come from Italy, Forge would have been required to attach the Italian export license to the docket, and the British import documentation.] He said that you could not handle this, because it had come from Italy. You had said there would be no difficulty, you could simply fill out the form we see on the second sheet, which gives an address in Kensington Gardens Square, number 66, and indicates there are no import documents and no post entry. These two things together would normally indicate the article had not been imported, would they not?"

Forge: "Yes."

Grieve: "So it gets a U.K. address. It is indicated that there are no documents. You have put: 'No report required.' Originally there had been a report required, I think?"

Forge: "Yes, there had been."

Grieve: "This is a day or two later, is it not?"

Forge: "Yes."

Grieve: "I suggest this shows a deliberate falsification by you of this property receipt in such a way as to indicate the goods have not been imported and that the consigner has a U.K. address, and that this came about after Mr. Hodges brought the top sheet to your attention and said that you could not deal with this property."

Forge: "It might have come about as a result of that."

Grieve: "Are you accepting that you might have deliberately filled in the second sheet, the address in Kensington Gardens Square, and put rings round the boxes regarding import dockets and post entry dockets for the purpose I have put to you, namely to give a false picture of—"

Forge: "I do not think I went about it in quite such . . . I mean I do not think I . . . I mean I obviously did do all that, fill it out, but I do not think it was for those reasons."

Grieve: "What reasons did you think it was for? Are you clear what I am putting to you as the reason you did it?"

Forge: "Yes, I think I am clear."

Judge Lloyd: "You must be clear, Mr. Forge, because it is alleged that you deliberately falsified the second document."

Forge: "Yes."

Grieve: "Not that it might have been drawn to your attention by Mr. Hodges. The question is whether or not you deliberately falsified it. That is what is being put to you."

Forge: "Well, I suppose I did, then."

Grieve: "It is no good saying you suppose you did. Did you or did you not? That is the point. Have you deliberately falsified something so as to mislead somebody?"

Forge: "Well, yes, I did, it would appear."

Grieve let a very long silence elapse at this point, so that the full impact of Forge's admission would sink in with the jury.

It was an important exchange, of course, and not merely because of Forge's admission. There was also the way it had to be dragged out of him, giving the impression that Forge had something to hide. There was also the fact that Hodges had drawn his attention to the top copy of the property receipt, with the Italian address. All this appeared to confirm what Hodges claimed, that he—Hodges—was part of a close-knit team who together falsified documentation, and that Hodges was not working alone or without the knowledge of someone higher up.

Despite this, however, Forge adamantly stuck to the same line as Felicity Nicholson when it came to the Banks and Yarrow accounts. He said he knew nothing about them, had never heard those names, and had certainly never authorized Hodges to use any such accounts or to pay couriers out of them.

When Forge left the witness box on the afternoon of the second day, it was again difficult to know what conclusions the jury would draw. It was similar to the effect created by Felicity Nicholson's responses to Grieve's questions. Given that Forge had admitted wrongdoing on his own part, the jury might treat all he had to say with suspicion. Or they might take the view that he had admitted wrong, had behaved honestly in that regard, and should therefore be believed when he denied that Hodges had authorization of the Banks and Yarrow accounts.

Now came Brendan Lynch, head of Oriental antiquities. Michael Grieve's performance with Lynch, in the defense's view, was perhaps his finest moment, a living embodiment, almost, of Rumpole of the Bailey, the television character. (Grieve had, in fact, helped advise on the TV series.) Lynch fell headfirst into two traps set by Grieve. The barrister first asked him if he knew that Mr. Ghiya, an Indian dealer, had stored objects with Hodges at his west London home. Lynch said that he was aware of this. Next, Grieve asked him why he had gone to visit India in 1986. Lynch replied that it was for re-

search and to give valuations. Grieve then handed him, and the jury, a memo showing that Lynch had in fact gone to India on that date to look for objects that would be sent to London to be sold, objects that would have to be smuggled out of India.

Next, he was asked about the objects he had seen on that trip. Again, he insisted that he had "valued" objects in the amount of approximately £120,000. This was to underestimate Grieve a second time: the lawyer now produced documentation confirming that £120,000 was the value of the *reserves* on the objects Lynch had seen. A reserve is the minimum figure an object will be sold for at auction, and is agreed on between the seller and the auction house ahead of the sale. This document, with its discussion of reserves, thus confirmed that £120,000 was the value of the objects that had been *consigned* for sale. Lynch had not merely "valued" objects that would stay in India but, in setting reserves, had agreed which objects were to be sent out. Faced with this document, Brendan Lynch now admitted that £120,000 worth of Indian objects were all intended for sale in London. A second fairy tale.

Now Grieve twisted the knife. Using Hodges's information, he asked Lynch whether he had ever hidden in a cupboard in a Mr. Ghiya's house to avoid being seen by Indian police who had visited the place while he was there. Hodges knew Lynch had once joked about it on his return from India. After the other traps, which had turned out to be backed up by incriminating documentation, Lynch was clearly running a risk if he denied something, only to have Grieve produce yet another document. As it happened, Grieve had nothing—but Lynch did not know that. He eventually denied hiding in a cupboard but said he had moved to another room so as not to be seen by the police. This was a double-edged answer, of course, because although he had denied hiding in a cupboard, Lynch had conceded that Mr. Ghiya had been visited by the police while he was there. Why? Grieve did not explore this, but left the jury members to draw their own conclusions.

. . .

At this stage, Hodges, Burton, and Grieve were all feeling fairly buoyed up. Each of the "heavy" witnesses—Nicholson, Forge, and Lynch—had admitted to some form of misdemeanor, while others such as Isabelle Hamon had put up poor performances, on occasions seeming haughty and evasive—exactly the qualities that Hodges was seeking to prove pervaded the entire company.

One of the jurors now asked to be excused because of an important commitment. In allowing this, the judge took the opportunity to note that the trial, originally scheduled for ten days to two weeks, had now lasted two and a half weeks and that this "was far too long." The next morning the jury presented the judge with a note, which was not read in open court but was shown to the two counsel. Michael Grieve recalls that it read something to this effect: "The defendant's future is at stake; no length of time is too long if it does justice to him." Grieve felt encouraged.

Now it was the turn of the really big guns: Joe Och, formerly Sotheby's legal officer; Peter Dangerfield, from Client Services; and lastly, Tim Llewellyn, Sotheby's managing director. Hodges and Grieve felt that if these three performed as poorly as the others, Hodges's team stood a good chance of convincing the jury of their argument.

Och went first. His signature was on a number of the checks that had been paid into the false accounts, and it was Hodges's contention that Joe Och was aware of what was going on. Och's argument was that he signed a lot of checks as a routine formality because of his position within the company and that he often did not know exactly what a specific document was for, but relied on others to ensure that his signature was not abused.

The Och situation was made still more complex by the fact that Grieve found him almost impossible to cross-examine. Och had a guttural, clipped voice and spoke extremely quickly in long, complicated sentences. Asked a relatively simple question, he would rush off in all directions. On occasions even the court stenographer had to ask him to slow down. Often in response to questions he said he

simply could not remember. As a result, and for reasons Hodges never quite grasped, Grieve got nowhere with this witness. It was a setback.

Peter Dangerfield was different again. With a round, fresh face and dark hair, he was running to fat. He had an obsequious manner and a somewhat plummy voice that did not sound entirely natural. Dangerfield was in charge of some of Sotheby's services. For instance, one of the documents that Hodges had collected concerned the Advisory Services Department and had been prepared by Dangerfield. This department essentially comprised Sotheby's reference library of pictures in Britain and continental Europe and regularly provided, among other things, press clippings, obituaries, wills, records of houses coming on the market, a list of sitters in famous portraits, and advice on titles, modes of dress, and how to start and finish letters.

In court, Dangerfield was asked about an exchange of memorandums between himself and Tim Llewellyn, concerning taxation. Dangerfield had written:

> The penetration of our records by foreign tax and customs authorities usually occurs when they ask for information from the British authorities under the increasing number of European Community reciprocal arrangements. They also make direct enquiries to us and in these circumstances, where there are Sotheby's offices in their country we endeavor to reply in a straightforward but not very revealing way. There is already a great deal of information within Sotheby's and organizing it systematically can be a means of tying up loose ends and getting tracks covered comprehensively rather than revealing more information. It is things like import documents rather than our records which are usually the weakest links in the chain.
>
> We may consider using codewords or names for some clients so that Signor X appears to have nothing while "strawberry" does have records.

Michael Grieve asked him if this document did not imply that he, Peter Dangerfield, and Sotheby's were helping clients to evade pay-

ing duty. In response, Dangerfield blustered, arguing that "covering our tracks" was a term from computer technology. He then asked Grieve if he was at all familiar with the jargon of computer technology, terms such as "software." This was, as Grieve later put it, "conspicuous nonsense," and the jury burst out laughing.

So what had been lost with Och was regained with Dangerfield. That left Llewellyn, who was in the witness box for only fifteen minutes. He never looked at Michael Grieve, but spoke into the middle distance. Yet he did look straight at Hodges, as if to say, "So this is the person who's caused all this trouble." When questioned about the same memorandum, he argued that it was simply about the privacy of clients, who were worried that if their personal details were kept on computer at Sotheby's all manner of undesirables might get access. He was also worried, he said, that the company would forsake the "personal touch."

Hodges had a whole file on Llewellyn and his dealings with Italy when he was running the old master paintings department in the early 1980s. But Michael Grieve felt that by now, with the trial well into its fourth week and the judge getting itchy about cost, not to mention the proximity of Christmas, it was tactically unwise to extend his cross-examination beyond the exchange of memorandums with Peter Dangerfield. Thus, rather than finish the cross-examination on a strong note, which the jury might have remembered, Hodges's arguments against the main prosecution witnesses rather fizzled out.

Now the case switched to the defense presentation. Anthony Burton had considered calling a number of expert witnesses on Hodges's behalf, to show that his version of the illicit art trade was borne out elsewhere. But because Felicity Nicholson, Oliver Forge, and Brendan Lynch had admitted so much, Burton thought that an expert was not necessary. And so Hodges's entire case depended on one piece of testimony: his own.

In the course of his evidence, which lasted five days, Michael Grieve produced no surprises but instead gave Hodges time to tell

his own side of what was now a familiar story. Hodges gave his ver-
sion of how the Banks and Yarrow accounts operated, how paper-
work was falsified, how an Egyptian statue had been smuggled out
of Italy (see Chapter 13), how the Vilbert and Boursaud operations
worked. As far as he could, and within the constraints imposed by
the charges against Hodges, Grieve sought to show that his client
was, as had been maintained all along, not a bad apple but a small
cog in a much bigger machine. The only drama came when the
threats to Hodges by certain antiquities dealers were mentioned,
and he reddened and seemed close to tears. As Grieve said later,
"This was not an act."

Paul Clark, for the prosecution, focused, not unnaturally, on the
fact that Hodges had changed his story. He cast doubt on the new
story—on the fact, for instance, that the instructions for the Yarrow
and Banks accounts were only ever written, in hand, on one copy of
the company records, the copy that Felicity Nicholson and Oliver
Forge said they never saw. Clark went through the charges one by
one, to emphasize just how many counts there were against Hodges,
a theme to which he returned in his closing address to the jury.
Clark's message, essentially, was "There's no smoke without fire."
He argued that several checks, drawn on the Banks and Yarrow ac-
counts, were for Hodges's personal use and not paid to third parties.

Grieve was not overlong in his own address. He felt that the trial
had gone on long enough and he did not wish to risk alienating ei-
ther jury or judge. He simply emphasized the wrongdoing that had
been admitted in court by three of Hodges's colleagues in the antiq-
uities department and pointed out how convenient it was for the
prosecution's argument that the bottom copy of the antiquities de-
partment's accounts, which contained receipts for "courier charges,"
etc., stapled to them, and which according to Hodges were counter-
signed by Nicholson and Forge, could not be found. In doing so, he
tried to turn Clark's argument in on itself. So far as the wider picture
inside Sotheby's was concerned, Grieve said, the prosecuting coun-
sel was entirely right: there was no smoke without fire.

. . .

Judge Lloyd began his summing up on the morning of Friday, December 13, and did not end until the morning of Tuesday the 17th, exactly five weeks after the trial had started. He was absolutely evenhanded in his treatment of the evidence, giving both sides equal weight, in terms of both time spent on their arguments and emphasis placed on them. He did, however, state that Felicity Nicholson was "perhaps not the best witness in the world" so far as the prosecution was concerned.

There were two episodes worth dwelling on. The first occurred on Friday afternoon when the judge gave an extempore disquisition on the art market, his theme being that enormous sums were now paid for material that had been considered "junk" in the past. People, he said, would pay £20,000–30,000 for objects that twenty years before had been considered "pots and pans." On Monday morning he received another note from the jury. Again this was not read aloud but was shown to counsel. Michael Grieve recalls that it read more or less as follows: "The members of the jury come from a wide range of cultural heritage, of which they are proud. They would remind the court that there were cultures that were great when England was just an island in the sea. They resent the reference to 'pots and pans.' " In fairness to the judge, he took the reprimand in good part and apologized to the jury.

The second noteworthy aspect of the summing up occurred later that day, when Judge Lloyd was considering Hodges's position within Sotheby's. A second great risk Hodges's defense had run was that the judge could have said at any point in the trial, "What Hodges alleges about the wider picture inside Sotheby's may well be true, but he has admitted wrongdoing on his own part and he is the only one on trial in this court." That would have been an invitation to convict.

But the judge did not say that. In fact, what he said was that if the jury decided Hodges was part of a wider picture—that what he was doing was being done by others in the company and was known to

The author, on location in Italy, reconstructs the action in the Prologue, where he buys a Nogari painting and prepares to put his suspicions of smuggling to the test. *(Courtesy of Channel Four Television)*

Roeland Kollewijn, then Sotheby's old masters man in Milan, who said he would arrange for the shipment of the Nogari out of Italy. *(Courtesy of Channel Four Television)*

The Nogari, a painting central
to the investigation.

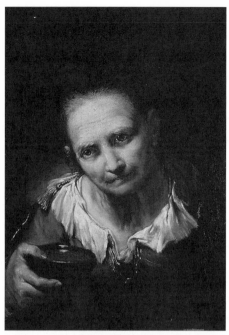

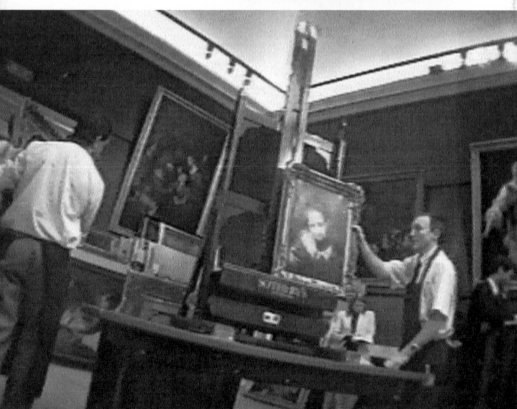

he painting, secretly filmed for British television, goes on the block to be sold at Sotheby's,
ondon. *(Courtesy of Channel Four Television)*

SOUTH ITALIAN GREEK POTTERY VESSELS,
all 4th Century B.C.

365a _BOURSAUD_

**A South Italian Greek Pottery Hydria, 4th Century
B.C.**, decorated with a bearded male figure and a
female figure standing to either side of an elaborate
funerary stele, a woman's head under each of the side
handles, palmette and split palmette under the carrying
handle, scroll ground line, palmettes on neck, stripes
around the rim, the decoration enriched with white
and yellow paint, *33cm. (13in.).*

£800–1,000

366 _FRITZ BURKI_

**A South Italian Greek Pottery Lekanis and Cover,
4th Century B.C.**, the lid decorated with a horseman
and winged griffin between palmettes, *20.3cm. (8in.)
diameter*; a South Italian Greek Pottery 'Owl' Skyphos,
4th Century B.C.; 15.3cm. (6in.) diameter; and a Number
of other Ancient pottery Vessels (a lot)

£600–800

367

367 _BOURSAUD_

A Paestan Pottery Amphora, 4th Century B.C.,
Side A: Nude young man, standing with his right fo
on rocks, in conversation with the you
woman facing him,
Side B: Nude young man running towards the left,
casket in his outstretched left hand
Scroll ground line, palmettes under the handles, laur
wreath on shoulder, zigzags around the base of nec
woman's head to either side of neck, *45.5cm. (17⅞in.).*

£800–1,2(

368 _BOURSAUD_

**A South Italian Greek Pottery Hydria, 4th–3
Century B.C.**, black-glazed and undecorated, *28.5cr
(11¼in.)*; a South Italian Greek Pottery Bowl, *4th–3
Century B.C.*, black-glazed, with stamped decoration
the centre, *17.7cm. (6⅞in.) diameter*; a Small Sou
Italian Greek Pottery Dish, *4th–3rd Century B.C.*, wi
stamped decoration in floral and circular motifs
the horizontal rim, *8.8cm. (3½in.)*; a South Italia
Greek Pottery Guttus, *4th Century B.C.*, with the figu
of a putti in relief in the centre, *8.8cm. (3½in.);*
'Gnathia-ware' Pottery Plate, *4th–3rd Century B.C.*, o
stemmed foot, with stamped decoration and bunches
grapes in white slip, *11.5cm. (4½in.) diameter*; an
Three Other South Italian Greek Pottery Vessel
4th–3rd Century B.C., 9.5/7.5cm.; (3¾/2⅞in.). (

£1,000–1,5(

369 _BOURSAUD_

**Six South Italian Greek Pottery Beakers, 4th–3
Century B.C.**, black-glazed, all with double-ribbe
handles and vertical ribbing on the body, *9/7.8cr
(3½/3in.)*; two South Italian Greek Pottery Beaker
4th–3rd Century B.C., black-glazed, undecorated
8.2cm. (3¼in.); Another, *4th–3rd Century B.C.*, black
glazed, the lower part of the body with vertical ribbin
10.8cm. (4⅛in.). (

£600–8(

370 _HYDRA_

**Three Apulian Pottery Trefoil Oinochoai, all 4(
Century B.C.**, one decorated with a figure of Ero
33cm. (13in.), Another with a Female Head , folia
tendrils to either side, *34.3cm. (13½in.)*; and Anothe
with a Nude Seated Male Figure, *33.7cm. (13¼in.).*
(

£800–1,00

Sotheby's catalogue entries for Apulian vases, without provenance or explicit origins.

305 306 307

306 E.S. 3000 N.B€€

An Apulian Pottery Volute Krater, circa 330-320 B.C., with Gorgon masks instead of volutes on the handles, those on Side A painted white with scrolling foliate motifs below, those on the reverse reserved, four ducks' heads in relief, two with white-painted beaks, to either side of the handles, stripes between them, tongues below,

Side A: Figure of Herakles wearing the lionskin and holding his club, helmet and shield in the field, he is standing within a naiskos supported by Ionic columns, outside the naiskos to left and right a female figure, on the neck a figure of Eros surrounded by a profusion of scrolling tendrils and flowers, two rows of meander above,

Side B: Funerary stele surmounted by a phiale, and flanked by two female figures, one holding a garland and thyrsus, the other a bunch of grapes and a thyrsus, palmettes on neck, foliate wreath above,

Elaborate palmettes under the handles, scrolls around upper outside rim, tongues around outside edge, the decoration enriched with white and yellow paint, *81.3cm (32in)*

£3,000-4,000

307 E.S. 2500 2500 TREE

An Apulian Pottery Volute Krater, from the Group of Copenhagen 4223, circa 330-320 B.C., with Gorgon masks on the handles instead of volutes, painted white on Side A and reserved on the reverse, ducks' heads in relief on the shoulder to either side of the handles,

Side A: A warrior holding a spear and a sword and facing a youth carrying a helmet and shield, in a naiskos supported by Ionic columns, the naiskos flanked on the right by a nude youth holding a flowering branch and on the left with a female figure holding a flowering stem and a mirror beside a column, casket below, on the neck a female head arising from a profusion of flowering stems, rosettes above,

Side B: A funerary stele flanked by a female figure holding a casket and flowering garland on the right, a nude youth holding a thyrsus and sash on the left, tongues on the shoulder, palmettes on the neck, laurel wreath above, elaborate palmettes under the handles, meander ground line, scrolls around top of neck, tongues around outside edge, the decoration enriched with white and yellow paint, *73.7cm. (29in)*

£2,000-3,000

ore catalogued Apulian vases.

The Temple Singer was exported from Italy via Switzerland and scheduled for public sale but had to be sold privately to a buyer from California.

The handsome statue of the Lion Goddess, exported from Italy, when placed under bright lights for photography in New York, turned out to be less than met the eye.

A Gallery of Sotheby's People, Past and Present

Tim Llewellyn, once head of the old masters department and managing director of Sotheby's in London, is now director of the Henry Moore Foundation.

Brendan Lynch, promoted to head the Indian and South-East Asian department, left Sotheby's after the British edition of this book was published. *(Courtesy of Clark TV)*

Marcus Linell, a Sotheby's director, became involved with the Lion Goddess.

Julian Thompson, director and board member of Sotheby's holding company.

James Hodges, an ex-employee at Sotheby's, once an administrator in the antiquities department, gave the author documents that helped inspire the investigation. He is now living in the United States.

Felicity Nicholson, Hodges's former boss, whose personal review indicated that she was "not beyond taking a gamble . . ." and who found "the occasionally 'shady side'" of the market "not uncongenial." She is now retired. *(Courtesy of Jakob Purches)*

Giacomo Medici, a key trafficker in antiquities, whose role excited the interest of the author and, ultimately, of the Italian and Swiss police.

A few of the tens of thousands of treasures found in one of four warehouses in Geneva used by Medici; the building was sealed after the revelations in this book.

The shrine in India where the author encountered a sadhu, or holy man, praying—to a jumble of stones, all that remains of the twenty goddesses that once filled the shrine.

The author inspects one statue that had been brought inside to prevent its theft. Lokhari village, Uttar Pradesh, India.

...ssa Sham (left) and Zohar Sham (center), secretly filmed in Bombay. They were major con-...gnors of smuggled Indian antiquities, as Sotheby's documents show. *(Courtesy of Channel Four ...levision)*

112 113 114
 115

112†
A Sunga Terracotta Votive Plaque
Probably Chandraketugarh, West Bengal, 2nd/1st century B.C.
depicting a *yakshi* wearing a diaphanous robe and an elaborate headdress bedecked with auspicious implements, a heavy jewelled belt, a necklace, bracelets and anklets, surrounded by a narrow border of floral motifs
27cm, 10⅝in

A related example is in the Ashmolean Museum (Harle & Topsfield, pp. 6 & 7, no.7). Two closely related plaques were sold in these rooms, 27th April 1995, lots 372-373.

TECHNICAL ANALYSIS
This lot is sold with a thermoluminescence analysis report, no.581x45, from the Research Laboratory for Archaeology, Oxford, affirming its antiquity.
£2,000-3,000

113†
A Sunga Terracotta Votive Plaque
Probably Chandraketugarh, West Bengal, 2nd/1st century B.C.
depicting a standing *yaksha* wearing a diaphanous robe, ornate earrings, lop-sided headdress and a heavy belt with a pendant jewelled element, a series of bracelets on one arm, with a narrow floral border
26cm, 10¼in

The depiction of a male subject is unusual on the terracotta plaques of this period; for a fragmentary example with similar headdress, see Pal, *Indian*, p.142, no.S22.

TECHNICAL ANALYSIS
This lot is sold with a thermoluminescence analysis report, no.581x44, from the Research Laboratory for Archaeology, Oxford, affirming its antiquity.
£1,500-2,000

114†
A Sunga Ivory Handle Terminal
West Bengal, 2nd/1st Century B.C.
carved in the form of a snarling, winged lion's head and foreparts, the front paws extended forwards, with stylised wings terminating in a ridged cylindrical band
7cm, 2¾in £4,000-6,000

115†
A Sunga Terracotta Votive Plaque
Probably Chandraketugarh, West Bengal, 2nd/1st century B.C.
depicting a female figure and attendant, the former wearing a diaphanous robe and attending to her elaborate headdress whilst gazing into a mirror held in her right hand, the latter, a youthful maid, resting a tray of cosmetics on her head
4.8cm, 5¹³⁄₁₆in

TECHNICAL ANALYSIS
This lot is sold with a thermoluminescence analysis report, no.581x46, from the Research Laboratory for Archaeology, Oxford, affirming its antiquity.
£1,000-1,200

Sotheby's catalogue entries for terra-cotta religious plaques from West Bengal, India, consigned by the Shams and auctioned in October 1996.

Mottled-pink sandstone column, somehow transported to England and consigned by Essa Sham to Sotheby's.

92 **A Large Central Indian Buff Sandstone Stele Depicting a Goat-Headed Goddess. Post Gupta, 8th/9th Century.**

seated in *laitasana* on the back of a couchant goat, her right hand raised holding a rosary, a water-pot in her left hand, wearing a scarf and *dhoti* with swagged belt and incised horizontal bands, the slender face with long ears and jewelled crown, also wearing a thick jewelled collar, anklets and armlets, plain arched aureole behind. *1m. 32cm (52in.)*

£10,000-15,000

The goat-headed goddess, stolen from Lokhari and smuggled out for sale, as it appears in Sotheby's catalogue.

his superiors—then he had not acted dishonestly. The judge's words came in the context of whether Felicity Nicholson and Joe Och were aware of the Banks and Yarrow accounts, knew their purpose, and had given Hodges permission to operate them. "Of course, if they did know and he was operating these accounts with their approval . . . you have then to ask yourself if the accused was operating these, even if he was making money on the side, as he says, that he would have been doing it with the permission of his superiors and therefore obviously not acting dishonestly; he could not possibly be. That is the vital matter you [the jury] have to decide." This was exactly the kind of sentiment that Hodges had hoped the judge would express.

On the other hand, toward the end, the judge dwelled on the Banks and Yarrow accounts, taking them one by one, in detail, and drawing the attention of the jury to the fact that in every case where a check could be traced, the money had been for Hodges's personal use. In other words, where there was concrete evidence of payment, such payment was not made to couriers. This was potentially very damaging, although Hodges claimed, for instance, that when he had used the money to have an alarm installed in his house, it was because he needed extra protection when he was storing goods for foreign dealers like Mr. Ghiya.

The judge did not finish until about 11:00 A.M. on the 17th. Then he sent the jurors out to consider their verdict.

The jury stayed out all that day and were taken to a hotel for the night. Hodges was in court at 10:00 the next morning when they were brought from their hotel and led straight into the jury room. One or two glanced in his direction, but it was impossible to read their faces.

Lunchtime came and went . . . 4:30 . . . and it began to seem the jury would go out for a second night. But then, at 4:50, the loudspeaker boomed around the building. "All parties concerned in the case of James Edwin Hodges report immediately to Court Six."

Hodges, his mother, and Michael Grieve hurried along the corridor and into the court. For the judge's summing up, Hodges had resumed his position in the dock, and he went there now. He put a small bag on the floor beside his chair. It contained books, his Walkman radio, toothpaste, and two packs of cigarettes. He had never smoked in his life, but Anthony Burton had told him that if he was sent to prison, he would find cigarettes useful "currency" with which to buy small favors. It sounded sordid, but Hodges was a realist and faced the grim prospect that the cigarettes might be needed.

For the first time, there was someone else in the dock with him. A policeman sat on his left.

"All rise!"

The judge came in, soon followed by the jury. Judge Lloyd asked the foreman of the jury if they had reached a verdict. The foreman said that they had.

The judge looked at Hodges and raised his head. "The defendant will stand."

Hodges stood up. The clerk read the charges, all twenty-two of them, one by one. Count one was a charge of theft, stealing the helmet. The clerk looked at the foreman. "Have you reached a verdict on which you are all agreed? Please answer 'Yes' or 'No.' "

"Yes."

"What is your verdict? Please answer 'Guilty' or 'Not guilty.' "

The foreman hesitated. He was a gentle-looking man with an oval face. Hodges thought he looked Polish. Perhaps the foreman was unsure how to pitch his voice. After a moment's delay he spoke up. "Guilty."

Hodges reddened.

Count two was the second theft charge, that of stealing the vase. "How say you?"

"Guilty."

Hodges gripped the rail in front of him, eyes downcast. His worst fears were coming true. Their strategy of broadening the case, to

show that dishonesty at Sotheby's was widespread and routine, had failed.

Count three was forgery—that Hodges had faked the Brendan Lynch release note, enabling him to have the bowl and helmet at home. "How say you?"

"Guilty."

Hodges could feel the eyes of the press on him.

Count four was the second forgery charge—that he had faked the Felicity Nicholson release note, so as to operate the bank accounts. "How say you?"

"Not guilty."

What? How could the jury bring in different verdicts on the two almost identical forgery charges? It made no sense. Hodges looked at Michael Grieve. The barrister was seated with his back to the dock, but he had half-turned in his seat, so Hodges could see his face in profile. Grieve raised his eyebrows: he too was surprised.

Count five was the first of the false accounting charges. "How say you?"

"Not guilty."

The court was absolutely silent now, as it began to dawn on everyone why the jury had taken so long. They had carefully considered each charge on its merits and had absolutely no intention of lazily or carelessly finding Hodges guilty on everything, or of acquitting him of everything, just because a bunch of charges had been put together and included in the indictment.

Count six was the second false accounting charge—that he had falsely "awarded" an introductory commission to be paid to H. C. Banks. "How say you?"

"Not guilty."

Count seven concerned a check for £540 that Hodges was alleged to have paid into the H. C. Banks account, therefore benefiting himself. "How say you?"

"Not guilty."

Count eight was the first of the charges to concern A. Yarrow. This time Hodges was alleged to have falsified a document authorizing an introductory commission. "How say you?"

"Not guilty."

Count nine concerned a check for £478, made out to A. Yarrow, that Hodges was alleged to have obtained by deception from Sotheby's. "How do you find?"

"Not guilty."

By now there was a steady buzz in the courtroom. What had begun as a disaster for Hodges was turning into something quite different—if the row of "not guilty" verdicts in connection with the false accounting charges continued.

It did. Hodges was acquitted on eighteen of the twenty-two charges. He was convicted of two charges of theft, one of forgery, and one—just one—of false accounting. However, that single charge of false accounting on which he was convicted was most interesting. It referred to a check, for £920, that Sotheby's and the Crown claimed that Hodges intended to obtain dishonestly but that, *in fact*, was never picked up. That is to say, Hodges never received the money and Sotheby's therefore suffered no loss.

On the face of it, this appeared to be a thoroughly perverse set of verdicts. The forgery charges were nearly identical. If Hodges had been found guilty on one, he seemed sure to have been found guilty on both, and vice versa. Again, if he was not guilty on one false accounting charge, he was surely not guilty on all—and vice versa.

But if the logic of the verdict escaped Hodges, at least to begin with, it did not escape a professional of the criminal courts like Michael Grieve. The two objects Hodges had been convicted of stealing had been returned to Sotheby's. The sole false accounting charge on which he was convicted was the one in which the check had not been picked up. In other words, Hodges had been convicted only on charges relating to his personal conduct as opposed to the acts that were allegedly performed on behalf of Sotheby's. Also, he was found guilty only of those charges that had involved no loss to

Sotheby's (and in this context the forgery charge was, in effect, ir-relevant). To Grieve, the jury was saying that Hodges had, in a sense, won. They were saying that he had behaved dishonestly but that they believed this dishonesty had been carried out within the context of a corrupt system. They had found him guilty on some-thing, as they felt bound to do, since he had definitely had the bowl and helmet at home and did not dispute that. But the fact that no loss was involved meant that they believed a custodial (jail) sentence should *not* be imposed.

The above reasoning is conjecture, of course. In Britain it is ille-gal to question jurors about how they reached their verdict even after a trial. But the conjecture is borne out by something that Michael Grieve overheard during sentencing, which followed.

After the foreman of the jury had finished announcing the ver-dicts, all eyes turned to Judge Lloyd. Michael Grieve rose to make his plea of mitigation. He reminded the court that this was a first of-fense, that there had been no loss to Sotheby's, and that Hodges was of a previous good character. He sat down.

Throughout the trial the judge, as noted, had been evenhanded in his treatment of the prosecution and defense, allowing Grieve use of all the documents he chose to introduce. He had been evenhanded in his summing up, even going so far as to make the all-important statement that if Hodges's superiors had been aware of what he was doing, then what he was doing was not dishonest. The jury seemed to have taken this to heart in their verdict on the false accounting charges; they had apparently at least entertained the possibility that Hodges's superiors did know what he was doing, and therefore he was not guilty of all but one of those charges—the one that involved no loss to the company.

Hodges himself had not worked all this out by the time Judge Lloyd delivered his sentence, but Grieve had, and felt therefore that whatever sentence was imposed would be suspended. All those "not guilty" verdicts surely meant that Hodges would not have to go to jail. So when Judge Lloyd said that he was sentencing Hodges to

nine months' imprisonment, Michael Grieve shared the view of one
of the jurors, who completed the judge's sentence with a whispered
"Suspended," as in "Nine months, suspended."

But, to Grieve's surprise, and to the juror's, the sentence was not
suspended. The judge now turned tough and chose to take the view
that in stealing the helmet and vase and being convicted on one
charge of false accounting, despite there being no loss to Sotheby's,
Hodges had breached the trust that had been placed in him by the
company and should therefore be made to pay for his lapse.

So, having been plunged into despair by the early verdicts and
lifted up by the great majority of "not guilty" results, Hodges was
now thrust back down again. The jury were looking at him with pity
and maybe even regret. The press had its headline for tomorrow.
His mother . . . he could not look at his mother. He had come so
near, as he saw it, to exposing what went on inside Sotheby's, but in
the end he had failed. Sotheby's had succeeded in damaging him be-
fore he could damage it. At 5:14 P.M. he picked up his bag and al-
lowed himself to be led away.

—ɯ—

Black Friday

The day Hodges woke up in prison for the first time was the day of Sotheby's Christmas party. In the Bond Street saleroom, the rostrum was pulled to the edge of the room and a platform was erected for a band. As he was "banged up" for the night, a prisoner in Brixton, Hodges's former colleagues drank wine, danced, and gossiped about the verdict.

Earlier that day, having no idea of my link to Hodges, Sotheby's invited me to visit the company's offices, where I was greeted by managing director Tim Llewellyn; John Watson, a Belfast man who had replaced Joe Och as legal officer; and Fiona Ford, Sotheby's efficient and fair-minded press officer. I liked and admired Fiona and wondered how much of the background she was aware of. Tim Llewellyn's message was simple and clear, and he had obviously spoken to other journalists in the same tone. "Sotheby's was not on trial here," he told me. "Hodges was a solitary rotten apple in the barrel. He made all sorts of allegations against the company, which we repudiate entirely, and for which there is no evidence." He said that he recognized there was a lot of "funny stuff" knocking about in antiqui-

ties, but that it was difficult to prove objects had been smuggled, "especially if owners deny doing it" (though who would actually admit to such a thing?). Llewellyn added that Sotheby's was breaking no laws in selling smuggled material. It consulted the published records of stolen antiquities but acknowledged that these "are very inadequate."

He said that he thought that a blanket embargo on the trade would drive things underground, and then added: "We are here to make money. You can't ask me to take a high moral tone. We can't be responsible to police the market, though it is reasonable to ask: if we were to withdraw from the market, would it solve the problem? It would not."

Llewellyn agreed that the verdict was "odd" and admitted that he was surprised by the amount of documentation Hodges had. "But ask yourself why he had it." He also admitted that he had been embarrassed by the "occasional questions" raised in the trial but said he didn't think the company would lose business as a result of it. "We are known to be reputable. People who know the market know the issues. Our clients rarely have more than ten pieces."

But Llewellyn's main point, to which he returned several times, was that Sotheby's was not a police force. "We have a right to protect the anonymity of our clients. We avoid breaking the laws in the countries where we operate. Our clients seek anonymity for a variety of reasons, but it is not our job to police our clients." There was more, but the thrust was pretty much the same. I noted Llewellyn's use of the phrase "rotten apple."

One matter on my mind throughout the preceding months had been the question of whether Sotheby's, and Sotheby's alone, should be the focus of our inquiry. There are hundreds of auction houses across the world, and obviously I couldn't hope to visit them all. On the other hand, the international art market is chiefly made up of what is probably the most famous duopoly in the world—the much-publicized rivalry between Sotheby's and Christie's. Should I also look at Christie's?

I spent some considerable time discussing this, mainly with Bernard Clark. In the end we decided not to extend the investigation. I cannot be certain, even now, that that was the right decision. The most important reason, of course, was the documents. The papers we had concerned only Sotheby's. Only in that one company did we know which departments to concentrate on, which individuals, which sales and which lot numbers in those sales. The documents also suggested which customers of Sotheby's we might look at. We had no information at all about Christie's. Another reason was the personal element. Hodges, who was in jail, had worked for Sotheby's. Whether he merited a prison sentence, his time at Sotheby's and his actions were part of the story, the personal human drama that had led to the investigation in the first place. Christie's was not part of that story.

A third reason was moral/legal/journalistic. It was in our view not a particularly attractive stance to go looking for wrongdoing at another auction house just because we had prima facie evidence of malpractice at Sotheby's. For our inquiry to have force, there had to be a reason for it in the first place, and we simply had no hard evidence, or documentation, about any firm other than Sotheby's. We were also aware that in order to demonstrate wrongdoing, we might at some point have to mount a special operation. In this regard we were mindful of the laws of entrapment both in the United Kingdom and in the United States. That law says that entrapment occurs when a law enforcement agency, or a journalist, or someone else, causes someone to do something wrong that he or she wouldn't otherwise do. It is not entrapment if the policeman, or journalist, merely taps into an ongoing system of malpractice in order to obtain evidence that it is still taking place. On this reading of the law, it would not be entrapment if we looked at Sotheby's—where we had documentation—but it might very well be if we investigated Christie's, for which we had no comparable evidence.

For all of these reasons, therefore, we decided that we ought not to extend the inquiry beyond Sotheby's. It was a hard decision and

one that, we realized, might leave us open to the charge that we "picked on Sotheby's." In the end we really had no choice.

I judged it proper not to visit Hodges straightaway. He would want to see his family first, Christmas would no doubt be an emotional time, and he would certainly want a chance to adjust to his new surroundings. I kept in touch via his parents and in that way learned that after a grim few days in Brixton, he had been transferred to Ford Open Prison, a minimum-security jail near Arundel in Sussex.

Meanwhile, I was doing some thinking. It may sound cold, but the plain fact was that in many ways the trial had been useful. Because of Sotheby's insistence on having many names blocked out, or identified only by their initials, it had proved difficult for the press to follow what was going on. Because the trial had gone on so long, few of my fellow reporters lasted the course, and, as had happened on the day Oliver Forge had made his damaging admission of falsifying a document, at times no other members of the press were in attendance. All this meant that Hodges's story had only been picked at in the newspapers. It was apparent that no one else in Fleet Street had the foggiest idea of what lay behind the story, and now, with the trial over, all had gone quiet.

Something else was even more important. The trial had lasted five weeks. During that time, Hodges had faced two charges of forgery and been convicted on one of them. Over the five weeks, scores of documents relating to the smuggling of objects, tax evasion, and many other matters had been produced in court. Very senior members of the company had been called as witnesses. There had never been the slightest hint that any of these documents had been forged. Surely, in the bracing exchanges between Michael Grieve and Felicity Nicholson, or Oliver Forge, or Brendan Lynch, if the documents used against them had been falsified, or altered in any way, they would have said so. They never did. So, as 1992 began, I pondered the case. I was now more certain than ever that the documents we had were genuine. Also, I was convinced—from what

had gone on in court—that the collage those papers formed was the
true picture. And for the first time, I began to see a way in which we
might tell this story in public.

Before I could make any move, I needed to see Hodges. One Tues-
day near the end of January I drove south out of London, through
the beech woods of Surrey and across the Sussex Downs. A crisp
winter sun warmed the landscape with a false feeling of spring,
though the puddles in the shade were still frozen.

As prisons go, Ford is about as good as they get in Britain. Most
nonviolent white-collar criminals go there sooner rather than later,
and it is also the place where men serving long sentences spend their
last few years inside before they are released. The liberal regime—
the prison has a fence rather than a wall, mail is not censored, and the
inmates are allowed out into nearby towns for a few hours at a time—
is designed to reintroduce inmates gradually to the outside world.

Nonetheless, Ford is still a prison. As Hodges and I shook hands
it was a shock (though I tried not to show it) to see him in prison-
blue shirt and trousers. His associates now included men who, how-
ever long ago, had killed or severely maimed their victims. He had
picked up prison argot, words like "jam" (-roll = parole) and "nee-
dle-and-thread" (= bed). He had learned the importance of Sun-
day—the only day on which he received fresh fruit. He had been
introduced to the tobacco economy and corruption endemic in jails.
In his first weeks in Ford, a fellow inmate who had sunk into serious
debt had settled what he owed in a way unthinkable to Hodges: the
man's wife had been smuggled inside to fellate all the other inmates
to whom he owed tobacco. On a separate occasion, Hodges had
been approached by another inmate and offered a Rembrandt and a
Monet stolen from a Bond Street gallery four years before. Some of
the corruption had its funny side. Forbidden goods were constantly
being thrown over the fence at Ford, by relatives of the inmates. On
one occasion a guard had been patrolling the fence when a package
sailed over just in front of him. He managed to catch it before the

package hit the ground—only to have a Chinese chicken dinner ex-
plode in his face.

That January afternoon, Hodges and I sat in the communal visi-
tors' room at Ford, drinking tea and nibbling chocolate. The sun
threw long shadows across the room. Forgers, embezzlers, financial
con men of all sorts sat cheek by jowl with armed robbers and mur-
derers. Young children stared sullenly at the guards, as if they had
inherited their father's hostility. Brassy blondes embraced their men
openly. Only later did I learn that this was a common way for
cannabis to be smuggled inside: the girlfriend or wife would enter
the visitors' room with a quantity of the drug hidden in her mouth
in a small plastic bag and transfer it during the kiss.

I had been apprehensive as to whether prison might change
Hodges and his attitude toward the book. Would the rough, humil-
iating company of so many cynical, sad, coarse criminals infect him
and make him want to forget the whole damaging experience?
Strictly speaking, his fate was not bound up with mine. I was by no
means certain that he hadn't got what he deserved. We had all the
documents and could proceed. All the same, I would rather continue
with his blessing than without, and we would need his cooperation
in all sorts of ways.

I needn't have worried; he was as determined as ever. There was
no question of abandoning the book. On the contrary. "The court
case was just round one," he said. "You've got to tell this story. The
whole story."

The fact was, however, that now that Hodges had been convicted,
the project had gone backward in some ways rather than forward.
Had he been acquitted in court, he would have been a much more
sympathetic source.

On top of that, during our talks while Hodges was in prison, he
told me three things that I could see might have had an effect on the
jury, had they known. I told him they would have to go in any book
I wrote.

The first was that Hodges twice, in dealings with a fairly junior employee of Sotheby's, whose name he told me, agreed to enter items owned by friends of that employee into one of the company's sales, but as if they had been introduced by a small private dealership that Hodges owned. This dealership received an introductory commission that was passed on to the other employee after Hodges had taken a small cut. Hodges claims he was entitled to do this, but, strictly speaking, Sotheby's employees were not eligible for introductory commissions. In my view this shows that Hodges *did* abuse the introductory commission system—which he always denied doing. This would have been damaging to his case in court had the jury known.

Second, Hodges told me that he and Serge Vilbert had concocted a plan to have the ancient helmet that he was accused of stealing copied by a master forger in London—the idea being that they could pass the copy off as genuine and double their proceeds. This admission had two immediate consequences. On the one hand it suggests that Hodges was prepared to consider illegal acts on his own behalf and without his employers' knowledge. On the other hand, it purports to confirm that he was indeed given the helmet by Vilbert, as he maintained in court. However, Hodges told me that one copy of the helmet had been made, which he had hidden by dumping it in the large pond at his parents' house in Suffolk. On several occasions I asked him to locate it for me, but he never did. I therefore came to the conclusion that this story was untrue.

Because of this, and coming on top of the fact that he had changed his defense, claiming first that the helmet and bowl were unknown-owner property that he had permission to have at home, and then that he had stored them for Vilbert, I formed the view that the jury had been absolutely right in that part of their verdict. Hodges was aware of my views but stuck to his story.

The third admission made by Hodges during our discussions on his day outings from Ford was that a friend of his, the friend who acted as a bodyguard, had been expelled from his school for the mis-

use of a checkbook. This friend had come across someone else's checkbook and falsified the signature on several checks, until he was caught. The signatures on the release notes were genuine. The "forgery," at least in the Brendan Lynch instance, for which Hodges was convicted, had, I believed, been achieved by typing a false message on a sheet of blank Sotheby's paper that already carried a signature—the sort of sheet a director might leave when going on vacation. But did that matter? Hodges's friend had shown the will to forge something—had proved he had the nerve to go through with it. Both this friend and Hodges continued to deny that either of the release notes had been forged, and there was some evidence at Hodges's trial that the typewriter face resembled those used in the antiquities department at Sotheby's; even so, who can tell what effect this piece of information, together with the two others, above, would have had on the jury, had they known? All of this added to my doubts about Hodges.

There were other things, too, that Hodges told me that were not exactly incriminating but still made me uneasy. One was a tape recording he made secretly in the company's legal offices on one occasion when, he claimed, antiquities smuggling had been discussed. This tape had been made by hiding a cassette recorder in his jacket pocket. Hodges had had the tape cleaned up by an electronics expert, but even so its quality was extremely poor, and I thought the transcript he had made was somewhat ambitious. He thought that Felicity Nicholson had made various comments about Boursaud under her breath, and that you could just hear these on the tape if you listened carefully.

That may or may not have been true. I was more concerned, as Michael Grieve had been, by *why* Hodges had felt it necessary to make this tape in 1985, four years before he was ever charged with anything. I also knew by then that it was not the only tape that Hodges had made: there were at least four that I knew about. He claimed that he had the tape recorder to make notes with at

Sotheby's warehouse in west London, that he was already engaged in regular wrongdoing on the company's behalf, and that he was merely protecting his back, in case he was ever made a scapegoat. That was one way of looking at the chain of events. I could think of others.

Then there were the raids that George Campbell and he had made on the garbage bins outside the homes of Sotheby's directors. These had been carried out very early in the morning, often in the dark, with Hodges and Campbell dressed for the part in gloves, hats, and coveralls. They had not trespassed but had taken the garbage bags from the sidewalks outside Sotheby's directors' homes after they had been left there by "advance" garbagemen and before they could be picked up by the main cart. (In Britain, where most people live in houses, the advance men collect the bags of garbage from the bins, normally kept in people's yards, and leave them on the sidewalk. The main cart comes by about half an hour later.) There was no question but that these "visits" had taken place, for I was shown the results—packets of papers with the distinctive smell of garbage, plus tea stains, cigarette ash, stale milk odor, and so on.

These jaunts had turned up nothing of consequence, but what light did they throw on Hodges? On the one hand you could say that he was just a desperate man, facing trial against an opponent whom he considered underhanded and who was scapegoating him, and he was using every method he could think of to support his case. On the other, his behavior advertised a devious streak, plus a stubborn willfulness that, allied with his secret tape-recording of colleagues' conversations, showed him to be capable of committing the crimes he had been accused of.

Finally, there was Hodges's claim that one night he had returned home to find two men seated in his living room. He mentioned this many times, from our earliest meetings, and forbade me to publish the real name of Georges Quimper, because he was the greatest threat. According to Hodges, the men had let themselves in with a

key he had left under the doormat. They were both business associ-
ates of Quimper's. One of the men, who worked with Vilbert, he
knew just as Stefano; the other was a stranger. Hodges's case was
that these two men were worried about what might be revealed in
court during his trial, and that they threatened him and forced him
to destroy a special ledger that he kept at home. This was his per-
sonal record of the false A. Yarrow and H. C. Banks bank accounts,
showing a list of checks he had paid to antiquities smugglers over
the years.

I simply did not know what to make of this story. I could not
imagine Hodges leaving a key to his house lying under a mat. He
was far too house-proud and private. And the story about the de-
struction of the ledger and the list of checks was convenient, to say
the least. Hodges had certainly sent his wife and daughter to Amer-
ica after that, but was that out of fear? His wife was American, and
she was living with her parents. That could have been mere conve-
nience, too—an obvious way to begin a fresh life, as indeed hap-
pened. It would have protected his daughter from the inevitable
unpleasantness of a trial in London.

On the other hand, as was mentioned above, during the trial he
had been questioned by Michael Grieve about the visit of Stefano
and the other man. During this exchange the proceedings had to be
temporarily halted, as Hodges became visibly upset, and, as Grieve
was moved to remark to the jury in his closing address, this was
no act.

All this did not necessarily affect my attitude toward the docu-
ments' revelations, but it did reinforce my continuing skepticism
and would, without question, affect a reader's attitude toward
Hodges. A change of strategy was called for in the search for the
truth.

The idea that I'd had over Christmas had two main elements. On
the one hand, I still planned to produce a book inspired by

Hodges's documentation. Such a book could now include details of the trial, and Hodges's experience in prison added an important personal dimension. But a book would still have to explore *all* the documents—and, of course, only a selection had been tested in court. They convinced me, but would that be enough to satisfy the publishers' lawyers in London and New York? And, as the publishers in New York pointed out, a book is not like a TV program or a newspaper article. It was not enough to produce an indictment; a book needed to go further, examine the allegations—however well documented—in detail, to arrive at a balanced conclusion.

The second line of reasoning I followed arose precisely from the fact that several of the cases referred to in the documents had been mentioned in court, at Hodges's trial. What if I concentrated on just *those* cases and tried to test the story, not all at once, but bit by bit? Furthermore, could I in some way intimate to Sotheby's that the information I had was derived not from documents but from the trial? If Sotheby's thought that was all I had—what I had picked up in open court—the company would have no grounds to keep me from pursuing the story. If, however, Sotheby's knew I had far more documents than had been discussed at Hodges's trial, it could still go to court and obtain an injunction, preventing publication, on the grounds that the papers belonged to Sotheby's. We had a defense in law, that the documents showed wrongdoing and that therefore it was in the public interest that they should be published. But it was by no means certain we would win such an action.

The publishers and I knew that much more corroboration was needed.

I had for years been friendly with Bernard Clark, who as a television journalist had sometimes written for the section of *The Sunday Times* that I once edited, and I had appeared on programs produced or directed by him. A sizable man, with unruly hair and a bushy mustache, Bernard is close to being a Coca-Cola addict and has a deceptively casual manner. Nothing escapes him.

He had known about the Sotheby's project from the beginning, and over the course of several discussions we conceived the notion of a television program based in part on the Hodges trial. This would examine the incidents discussed in court, allude to the documents, and explore one or two other episodes we knew about from the papers Hodges had made available. Such a collaboration with television journalism would inject fresh resources into the project, help test the veracity of more of the documents, and enable us to approach Sotheby's with some of the material, to assess its reaction. (Under the statutes and codes governing British broadcasting, program makers are obliged to give the subject of their allegations the opportunity to respond to those allegations before broadcast.) All this made good sense to both the publishers and me.

If, however, there was a risk of injunction, as there definitely was in this case, it would not go down well with the television company, be it the BBC or Independent TV, if money was spent on research, filming, and so on, only to have the whole thing scrapped a couple of days before airtime, when Sotheby's slapped a writ on us. Bernard therefore felt that for any approach to a broadcasting channel to have credibility we first needed to test the water ourselves. This was also something that had been discussed with the publishers, and so we were all agreed.

We planned this as a two-stage process. In the first place, I would try to interview Felicity Nicholson, the head of the antiquities department, and bring the conversation around to the trial. In that way I could see how she would respond and at the same time, in mentioning the trial, seek to convey the impression that my information had come from the court.

This encounter turned out to be extraordinary. I made an appointment, ostensibly to discuss the general traffic in antiquities around the world, including illegal traffic—a legitimate interest, so I was not being wholly misleading. When I arrived, it was to find Ms. Nicholson accompanied by an in-house lawyer. The reason given was that the international traffic in antiquities involved legal

issues, which the lawyer might be able to help with. I was not sure that was the real reason.

With Felicity Nicholson's agreement, I tape-recorded the meeting. I started with a few general questions about the size of the international antiquities market, the number and value of objects available for sale, whether it was growing or contracting, whether the fashion was for Greek and Roman art, or pre-Columbian, or Far Eastern, and so on. Soon I launched into the main reason for my visit. Felicity Nicholson had said, obligingly, that since 1984 Sotheby's had been a signatory of the British Antique Dealers' Association code of practice, whereby it had agreed not to trade in goods that it had good reason to believe had been illegally excavated, stolen, or smuggled from their country of origin. If that was so, I said, I wished to discuss with her two cases that had occurred in 1985 and where, on the face of things, it appeared that Sotheby's *had* dealt in smuggled antiquities. They concerned a black basalt statue of the Temple Singer Penhutbit, and a sculpture of the Lion Goddess, or Sekhmet (see Chapters 12 and 13).

To begin with, Nicholson blustered. Her denials were unconvincing. She soon refused to continue the discussion, citing client confidentiality. I noticed a sudden exchange of looks between her and the lawyer. The lawyer said, "Er, don't you have another appointment, downstairs?"

"Yes," said Nicholson quickly. "Yes, I do. In the main gallery."

This was surprising—and also dubious. So far as Nicholson was concerned, I was there as a representative of a national newspaper, to discuss a serious issue about the international movement of antiquities, prior to writing an article. It was ridiculous to suggest that it could be done in twenty minutes. Still, there was no point in pressing. We all traveled down to the ground floor in the elevator together. Since I was so obviously being put off, I did not go home but walked down Bond Street to the Westbury Hotel, in Conduit Street, a distance of no more than a hundred yards, which took two minutes. In the Westbury I found a pay phone and dialed Sotheby's.

I asked to be put through to Felicity Nicholson's office. On the second ring she answered.

Bernard Clark was highly amused by this rigmarole, and he put the tape in his safe. We now decided to let a couple of weeks elapse before doing anything else. In retrospect, it all seems slow, but we were still concerned that if Sotheby's thought I was close to Hodges and had a wide selection of documents, it might sue, citing Hodges's breach of confidence, and I would have to return the documents.

Another factor in our decision was that with time off for good behavior, Hodges's nine-month sentence would be reduced to five and he would be out sometime in May. We felt sure that Sotheby's would keep track of Hodges's movements and whereabouts, and we wanted to see what it would do when he came out. Would it let sleeping dogs lie, or would it sue him for return of the documents? Also, if we contacted Sotheby's again *after* Hodges was released from jail, that would make it appear that I had been in touch with him only recently. If we waited, there was more chance for Sotheby's to think that my relationship with Hodges was new, post-trial, rather than the longer association it had been. So we planned to approach Sotheby's again in the autumn.

But it did not work out like that, for by then I had completed and delivered a new version of the manuscript. In New York, Random House had appointed Martin Garbus, a high-profile libel lawyer with impeccable liberal credentials, to review what I had written. He and his staff went through the draft during two bruising weeks in late summer in Manhattan. The report he wrote for Random House said that he believed the documents to be genuine, and that the story was important and should be told; he also pointed out a number of legal dangers that he thought still existed.

And then we shot ourselves in the foot. Hodges had been released from Ford in early May, spent a couple of weeks with his parents in

Suffolk, and then gone to join his wife and daughter just outside Washington, D.C., where he planned to make a fresh start. Since he was not too far away, and since the trial had confirmed the authenticity of only some of the documents, Random House and Garbus made their decision to invite Hodges to New York to take a lie detector test.

Lie detectors, or polygraphs, are controversial instruments. Many American security companies swear by them. But the tests are actually much cruder than one might think and are often subject to much "contamination" that renders the results useless. In practice, questions must be framed in a way that means they can be answered with one word. And only four questions can be asked in one day. After each question the subject is allowed to relax, to enable his body to resume its equilibrium; this can take an hour or more.

The tests took a considerable time to arrange. Martin Garbus, his assistant Kyran Cassidy, and I had to frame the correct questions, and for that we needed to have the whole procedure explained. Then the lie detector people had to rephrase the questions in such a way that they could judge the veracity of Hodges's replies. Then we had to okay their new wording. Finally a time convenient for all of us had to be worked out, a time when Garbus, Hodges (who was just starting a new job in America), the lie detector people, and I were all free to attend the sessions in Manhattan. That took us into the spring of 1993.

We finally made it one weekend late in March. We all gathered at the company's offices on West 57th Street. This was a curious building, home to six lie detector entities, among them the *Journal of Polygraph Science*, the Academy of Certified Polygraphists, and the New York State Polygraphists, Inc., and also the headquarters of Count Basie Enterprises, Inc. The questions we had selected were these:

"Did you give Peter [Watson] even one forged document?" (Desired answer: "No.")

"Is that a forged release note for those two Roman objects?" ("No.")

"Is that a forged bank account release note?" ("No.")

"As far as you know, did [the minder who acted as bodyguard] forge even one Sotheby's document?" ("No.")

"Did Felicity Nicholson really know that you had opened those two fraudulent bank accounts?" ("Yes.")

"Did you keep a ledger of those two fraudulent bank accounts?" ("Yes.")

"In 1989, did you really destroy the ledger of those two fraudulent bank accounts?" ("Yes.")

"Is there anything of importance to the book that you have not told Peter about?" ("No.")

Late on Sunday, we got the bad news. Hodges had failed. According to the testers, *every* answer he had given had been a lie.

Martin Garbus and Random House were understandably made uncomfortable by this news. Had Hodges passed, then in any subsequent trial we could have used the lie detector results as evidence for responsible publishing. As it was, if we went ahead now and it later emerged that we had disregarded Hodges's failures in the lie detector test, we would have paid, expensively in both time and money, for the ammunition with which to maim ourselves.

I was not as bothered by all this as they were. In fact, I partly blamed myself for the result, because on looking back through the questions I realized that one of them was bound to produce a lie, and once Hodges had lied, his answers to other questions would be contaminated. That question was: "Did you ever give Peter even one forged document?" And of course those documents included the release notes signed by Felicity Nicholson and Brendan Lynch. Nothing that had happened had changed my mind about the release notes. I still believed, in my heart of hearts, that Hodges had forged them, even though he had been acquitted on one forgery charge, and even though he strenuously denied doing so.

But if I was right, it would partly explain what had happened with the lie detector. If I was right, his answer to the very first question had been a lie, and who knew how that had affected his other answers? Lie detector experts say that contamination shouldn't occur if the necessary precautions are taken, but I had had training in psychological sciences, and therefore was very skeptical of their claims.

But in any case, we had already decided on a change of strategy. We had to do far more to corroborate the events and procedures reported in the documents, and to that extent Hodges's performance in the lie detector test would become peripheral, if not entirely irrelevant: either the documents would check out, or they would not.

Martin Garbus and the people at Random House listened to my arguments and sympathized. But they too emphasized that I had to do far more work before they would sanction publication.

It is fair to say, I think, that the British publisher, Bloomsbury, was not as fazed by the lie detector results as Random House was. Like me, Bloomsbury took these things with a pinch of salt. Lie detectors have never caught on in Britain. Instead, Bloomsbury proposed another solution to our difficulties.

During the intervening months, I had spent as much time with Bloomsbury's libel lawyer, David Hooper, of Biddle & Co., as with Garbus in New York, and we reckoned that the draft manuscript was as "bulletproof" as we could make it. Nigel Newton, managing director of the publishing house, decided on one extra maneuver. He commissioned George Carman, QC (Queen's Counsel), one of Britain's top two libel barristers, to read the draft manuscript. This was an impressive tactic, for Carman is a formidable court performer. The only problem was that Carman was phenomenally busy. We needed a week of his time—four days for him and a junior counsel to read the manuscript and a day face-to-face. He could not fit us in for *six months*, not until November. It was tedious, but we all could see the sense of Newton's idea. I passed the intervening time refining the manuscript but could do little else. Hodges got on with

his new career in an employment agency in the Washington, D.C., suburbs. We kept in touch, but only intermittently.

On Friday, November 26, 1993, Bloomsbury's editors and I met George Carman in his chambers in the Middle Temple, one of the old areas of London, near Fleet Street, where leading lawyers have their chambers. He is a small, dapper man, good-looking, with a deep attractive voice. It was a surprise to find him a virtual chain-smoker. That day his performance can only be described as a tour de force. He questioned me throughout the morning, after which we adjourned for a short sandwich lunch and reassembled at 2:00. He then spoke, extempore, until 4:45, pausing only to light cigarettes. He never hesitated or repeated himself. He said he thought the story was true, that the documents appeared to be genuine, that the story was important and ought to be told. But he said there was one problem, one overriding problem, that posed great dangers for us. He said that in his view the main issue was not whether the documents were genuine but whether they were complete. We could not be certain of what we had because we did not know whether we had *all* the relevant documentation. Quoting from his extensive experience, he gave us several examples of documentation that appeared to have a sinister explanation but, once other, hitherto missing, papers were inserted into the sequence, were shown in a different light.

We had known this all along, of course, and that was part of the point of waiting for the trial. Just as Sotheby's would surely have pointed it out if any of Hodges's documents were forged, so it would also have introduced other documents, if it had them, that would have put the ones that Hodges had into a different light. In that sense, therefore, Carman was telling us nothing new. But that Friday afternoon, he spoke so well, with such conviction and authority, that despite his opinion that the story *ought* to be told, he did—I think it is fair to say—concentrate the minds of the Bloomsbury people as they had never been concentrated before. In that sense, it was a Black Friday. By Christmas they had cooled as much as the Random House people had. For different reasons, but the result was the same.

In the same Christmas season, I had a drink with Bernard to bring him up to date. I told him that book publication was on temporary hold (at least). It was time to try the television probe again. We were no further forward than we had been in summer 1992. Except that we had lost eighteen months.

Bernard still thought that we had to have an idea of Sotheby's reaction, once it knew we had access to more documents than had been introduced at Hodges's trial. But here the delay operated in our favor. It had been months since I had been in touch with Sotheby's. From Sotheby's point of view, I was hardly devoting much energy to it. We therefore thought that January 1994, the dead month between auction seasons, would be an excellent time to approach the company with the first batch of documents.

And so, toward the end of the month, Bernard and I made our move. Because Sotheby's was by then run from New York, I sent photocopies of documents showing apparent wrongdoing in three areas to Diana Phillips, chief press officer in Manhattan. The documents I sent included some referring to the illegal excavation of Apulian vases, which Brian Cook had first alerted me to (see Chapters 10 and 11), the falsification of the provenance of a black basalt statue (see Chapter 12), and the smuggling of an Egyptian statue of Sekhmet from Genoa to London to New York (see Chapter 13). But it was not just documents that I sent. I also sent my interpretation of the "system" the documents revealed.

I wanted to give Sotheby's every opportunity to explain its position. I said in my covering note that if the documents were incomplete in any way, so that a false picture was conveyed, or if the documents had been tampered with, altered, or forged, I would not publish the story, provided Sotheby's could show me how any forgeries or alterations or additional documentation changed the picture.

Then we waited for Sotheby's reaction. I had hidden the original documents in a safe-deposit box, and photocopies had been sent abroad. But this was really only protection against random burglary,

or fire. If Sotheby's sued, and succeeded, I would have to return the documents, and all copies, to the court.

Diana Phillips called back after a few days. She said she wanted to set up a conference call, with me, herself, Diana D. "Dede" Brooks, now the chief executive of Sotheby's worldwide, and Marjorie Stone, the company's in-house attorney. That conversation took place in mid-February. Many things were said then and subsequently, but since they were all off the record, I cannot report them. On the record, all Sotheby's would say was "No comment."

At one level this was frustrating; at another, revealing. I had given the company every chance to deny the story—all of it or parts of it. It had not done so. No less important, it showed no sign of even thinking about issuing an injunction against me. We allowed a month to go by. If Sotheby's were going to act, it would have done so by now. It was time to move on the television front.

The first people approached were the BBC. It took Steve Hewlett, head of *Inside Story*, about a month to get back to us. He was interested and could give us a one-hour slot in September. However, because the story was so sensitive legally, he wanted our permission to show the documents to the BBC lawyers. Bernard and I refused. The last thing we wanted after all this time was to have those documents we had spent so long protecting floating around out of our control in some vast organization like the BBC. I happened to know that BBC Bristol was making an entire eight-part series on Sotheby's. The people making those programs did not have the access to sensitive material that we had, but if our documents disappeared within the "Beeb," who knew where they might turn up? So it was no go with the BBC.

All that to-ing and fro-ing took up the summer, and it was not until September 1994 that Bernard and I approached Channel 4. There the atmosphere was much more businesslike. Bernard was known as a program maker, while I was known as a journalist and author. Our evaluation of the story was accepted. David Lloyd, the

editor of *Dispatches*, Channel 4's investigative series, was decisive; he was to prove a very brave and imaginative editor. We had at least three meetings to consider how we might corroborate the documents, to explore the legal problems we were faced with, and to assess whether, in the final analysis, any program we might construct could be safely broadcast. The meetings stretched into early 1995, but at the end of January we got the go-ahead.

—⚏—

The Apulian Vases

N ow we get to the meat of the matter. After four years we were ready to tell part of the story. We chose five sets of documents for the first program. Two related to smuggled antiquities that had been specifically mentioned at Hodges's trial, two related to antiquities but had not been introduced in Knightsbridge Crown Court, and the fifth was a different matter entirely.

We needed to start with matters raised in court, because, as we kept reassuring ourselves, not only had no one on the Sotheby's side even hinted that those specific documents were forged, but the process that *we* thought was revealed in the documents had been discussed in court—again, without any effective contradictions from the Sotheby's side. If Sotheby's thought our attention was focused merely on matters stemming from the court proceedings, it would have no reason to try to obtain an injunction against us. But at the same time we needed to go beyond the trial. At some stage we would be seeking to publish all or many of the documents we had, and we needed to know if the others were as genuine as those mentioned in the trial. So we needed to include *some* documents not mentioned in court.

Again, Hodges had no part in deciding which documents to use. That was obviously an important point; in fact, to begin with, he had no idea what we were up to. With regard to matters not mentioned at his trial, we opted for two sets of documents from inside the antiquities department, because the paperwork was strong and detailed and in one case described the smuggling scheme vividly. And we chose one document outside the antiquities department. At some stage, we would have to venture beyond Hodges's own territory. Two added reasons for the choice of this fifth document were that the procedure it described would look good on screen, and that we thought the practice it described was outrageous.

Far and away the most striking form of wrongdoing, and the natural starting point for our investigation, lay in the realm of Apulian vases. Background information is necessary here, to help explain why Apulian vases are so important, and indeed why Hodges had come to me in the first place.

We need to go back again to 1985, to that Wednesday at the end of November, mentioned earlier, when I had called the antiquities department and briefly spoken to Hodges before he had put me through to Felicity Nicholson.

When Brian Cook, the curator in the Department of Greek and Roman Antiquities at the British Museum, told me flatly that Sotheby's was selling smuggled antiquities, I had asked him to explain what he meant and how he could be so sure.

The sale, he said, included a dozen Apulian vases. Most people know these vases from museums: they usually have a black background with clear-cut, finely drawn, brownish-red figures on them. Apulia is a region of southern Italy, centered around Foggia, that was once part of greater Greece, Magna Graecia. Cook explained that the important point to grasp was that the world of Apulian vases is, in effect, a closed world, in the sense that every legally excavated vase—and some six thousand are known to scholars— has been listed in a three-volume catalogue compiled by the late

Professor Dale Trendall and updated, to 1983, by Professor Christopher Cambitoglou. Between 1983 and the date of my meeting with Cook, any other legally excavated vase would have been published in one of a small number of professional journals. Cook was familiar with these journals, and none of the Sotheby's vases had been published there, or in Trendall/Cambitoglou. By definition, therefore, these vases had been illegally excavated and smuggled out of Italy.

"One or two might have been missed by Cambitoglou or Trendall," said Cook, "but not the large numbers we are now seeing in the salerooms." Some of the vases in the Sotheby's sale were very important, he added, and there was one in particular, estimated at £60,000 in the catalogue, that the British Museum would dearly have loved to have. But the museum considered the sale unethical and so would not be bidding. Instead, the trustees of the British Museum wanted such sales stopped and after due consideration had authorized Cook to speak to me.

As I left the museum, Cook accompanied me part of the way, to where the museum's own Apulian vases were displayed. There he underlined for me how important these vases are. As decoration they often show scenes of everyday life in classical times. Beyond their beauty, they are therefore valuable historical documents in themselves. Moreover, what they depict is often related to where they are buried. Thus, if vases are illegally excavated and then smuggled abroad, important details may be lost to study. So the underground trade is more than a contravention of Italian law; it is a sad and significant loss to scholarship and our understanding of the classical world.

The Observer had run the story, on the front page and an inside page, in its issue of December 1, 1985. Other newspapers, and television channels, in Italy, France, Greece, and the United States picked up the story. While no civil or criminal proceedings were commenced, Sotheby's was pressed to withdraw the vases by a special representative of the Italian government, Dr. Luigi d'Urso, who flew to

London for the purpose, and by Professor Felice Lo Porto, superin-
tendent of antiquities in the Apulian region. He, as noted earlier, let
it be known that a large fourth-century-b.c. tomb near Arpi had re-
cently been looted; he said he believed the Sotheby's vases had come
from there. Other British museums, such as the Royal Museum of
Scotland in Edinburgh, joined the British Museum in calling for
Sotheby's to withdraw the objects, and Lord Jenkins of Putney, a for-
mer minister of the arts, put a question in Parliament.

Sotheby's, however, took the view that there was "no evidence"
that the vases it was selling were either looted or smuggled. Instead,
Felicity Nicholson attacked Cook, saying he was unrepresentative
of scholarly opinion, and added that Sotheby's clients were entitled
to sell what was theirs. Despite the opposition, the sale went ahead
and the vases sold quite well. The art world is nothing if not cynical,
and maybe the publicity had even helped. Anyway, after a fruitless
few days in London, Dr. d'Urso went home and the scandal died
down. I did not forget all about it. At other sales, unprovenanced
Apulian vases continued to be sold in much the same numbers.
Brian Cook and I would sometimes discuss it.

But, as was briefly noted in Chapter 5, what I did not know, and
what Sotheby's did not know, was that James Hodges was watching
this exchange from his unique vantage point as administrator in the
antiquities department. He was shocked but also amused at the way
Nicholson treated the press. For the truth of the matter was that in
1985 I had only scratched the surface of the scandal.

What Hodges knew and I did not, at the time of my article, was that
all the Apulian vases that Brian Cook reckoned to have been illegally
excavated and smuggled out of Italy had been consigned to
Sotheby's by Christian Boursaud working out of offices in Geneva
and a shop known as the Hydra Gallery. Some of the vases were
consigned by Boursaud directly, some in the name of the Hydra
Gallery, and some by Serge Vilbert, his partner and/or employee.
Moreover, Hodges knew that Boursaud was one of Sotheby's

biggest clients, consigning hundreds of unprovenanced Italian antiquities for the sales.

Nor was this all. Felicity Nicholson had told me, "I don't think one ever knows where antiquities come from. We assume that our clients have title to whatever it is they are selling." But Hodges had seen documentation that threw the validity of this comment into serious doubt. Only four months earlier, Nicholson had received a letter from Dietrich von Bothmer, chairman of the Department of Greek and Roman Art at the Metropolitan Museum of Art in New York. Dated July 3, 1985, it read in part: "Your catalogue, 'Artemis' [the name Sotheby's gave to its sale on July 17, 1985], has just come and I feel honor-bound to inform you that lot 540 (Attic black-figured amphora) has just been illustrated in [the Italian magazine] *Epoca* (see enclosed xerox) as having been patiently excavated and put together by an Italian *tombarolo* [tomb robber] of Tarquinia [near the coast, north of Civatavecchia, not too far from Rome] and sold to a dealer for 4 million lire. This may get you or your would-be purchaser in trouble should the Italian authorities read your catalogue and make the same identification."

As a result of von Bothmer's letter, lot 540 was withdrawn from sale. Hodges found the computer printout for account number 046753, which referred to a Mr. Vilbert, whose address was c/o Boursaud, PO Box 41, 57 Avenue Bois de la Chapelle, 1213 Onex, Geneva. The printout showed that this company, Christian Boursaud, consigned for sale in the July 1985 auction some 104 unprovenanced antiquities, among them lot 540. In other words, Felicity Nicholson had good reason to be suspicious of objects arriving from Christian Boursaud, but chose to ignore the inconvenient facts that put the objects he consigned into doubt.

All this made Hodges cynical enough about antiquities. As we have seen, moreover, the fuss blew over. Sotheby's was not raided and the sale went ahead. But Hodges's attention had been drawn to Boursaud *et al.*, and from then on he made sure that he took photocopies of all documents concerning them and related companies.

Soon Hodges was able to compare these documents with the marked copy of the antiquities catalogue. (The marked catalogue is the auctioneer's copy, containing details of who has consigned what for sale and what the reserves on each lot are.) What Hodges found was that the consignment notes from Christian Boursaud closely matched many of the objects described in the catalogue. For example, one item was described in the Boursaud consignment note as "I amphore attique à figures noire avec son couvercle, VIème Siècle avant J.C." with a reserve of £120,000. This corresponds closely with lot 132 in the December 1985 catalogue, "An Attic Black-figure Amphore [*sic*], by the Bucci painter, last quarter of the 6th century B.C.," with a reserve of £110,000. The name of the painter had been added, but otherwise the descriptions were similar.

Also compare lot 310, "A group of Miscellaneous Italo-Corinthian Pottery Aryballoi," estimated at £600–800, with items 43 and 44 on Boursaud's consignment list—ten "Aribalos Italo-Corinthien Terre Cuite," with a combined reserve of £500. And so on. Overall, Hodges found that between December 1983 and December 1986, Boursaud and Vilbert consigned 248 objects to six sales with a total value of at least £640,880. Separate miscellaneous documents showed that in 1986, 1987, and 1988, Boursaud had traded other goods worth around a quarter of a million pounds.

It was big business.

These were the first set of documents that Hodges had made available to me. But they contained one other twist that was to prove important. On March 13, 1986, Boursaud wrote to Nicholson, by registered letter, to announce the temporary closure of his gallery. Blaming health reasons for this situation, Boursaud instructed Nicholson not to sell any more antiquities on his behalf. On the face of it, this was straightforward. But there was more to it than Hodges at first realized. This came home to him when he noticed that Nicholson did not reply to Boursaud for some time, but when she did, she used these words: "Dear Christian, Thank you for your letter and I am sorry to hear you are not well. With regard to the prop-

erty we have here, I understand that you have been acting *as the agent* for the owner and we will of course wait to hear from him regarding the disposition of the rest of the property we have here from him for sale." (Emphasis added.)

Hodges read the file copy of this letter with great interest. Here at last was confirmation of something he had strongly suspected—that Boursaud was not the principal in the Italian antiquities business. Reading between the lines, and listening to Felicity Nicholson in conversation with Oliver Forge, Hodges had come to believe that the true owner of the Boursaud objects, the real force behind the trade, was an Italian, Giacomo Medici. And the reason Boursaud was stepping down was not ill health but that they had fallen out after the publicity created by the *Observer* article in 1985.

After the exchange of letters in spring 1986, the pattern of Sotheby's antiquities sales changed. In the next sale, held on July 14, 1986, there were no objects consigned by Boursaud. That part of the business appeared to have gone dead.

In October, however, Hodges noticed something new about the antiquities paperwork. Consignment notes had started to arrive from a different Geneva company, and what attracted his attention was that the lists were laid out in much the same way as Boursaud's and the price was written in the same way, on what looked like an identical typewriter. For example, £2,000 was written not as 2,000 but as 2'000. It could have been a coincidence, but it was the coincidence that attracted Hodges's attention, and led him to another.

Lot 314 in the December 1986 sale was "A Roman Marble capital, decorated with double palmettes and scrolls to either side, 33 cm by 35 cm (13 in by 13.75 in)." The estimate was £2,000–3,000 and it had been consigned by a new company, Editions Services. Hodges suspected he had seen this item before. The catalogue for the December 1985 sale was on the shelves nearby, and he reached for it. Antiquities catalogues usually begin with ancient glass, then proceed via Middle Eastern, Greek, and Etruscan antiquities to Roman objects. There were many similar pieces listed, but at lot 106,

Hodges was brought up short. It was the same object. Moreover, it had been consigned for sale in the name of Christian Boursaud.

The profile of the goods Editions Services sent for sale at Sotheby's was exactly the same as Christian Boursaud's. Moreover, in the next sale, in July 1987, a Roman marble pilaster capital that had previously been offered in the December 1985 sale by Christian Boursaud was again consigned for sale, by Editions Services. There could now be no doubt: Christian Boursaud's company had resurfaced, after a short interval, as Editions Services. To Hodges, and to me, this showed that the individual behind this traffic, Giacomo Medici, was a prudent man. After the fuss created by *The Observer*, Medici had decided to dissolve Christian Boursaud, to lie low for a year, and then to regroup under a different company name, acting from a different address.

That Editions Services was now gaining in confidence again was suggested by the fact that in the December 1987 sale, which consisted of 360 lots, 101 were sent in by Editions Services. Once again, none of these antiquities had any provenance, and again the shipment included twelve Apulian vases. The May 1988 sale included 76 lots consigned by Editions Services, without provenance, and contained fifteen Apulian vases. And finally, the December 1988 sale, of 401 lots, included 46 lots by Editions Services, all without provenance, and 6 of them Apulian vases.

These documents from Hodges made an impressive packet. However, speaking logically and legally, there was one hole in them. Hodges might be convinced that Giacomo Medici was involved, Felicity Nicholson might have admitted in court that Giacomo Medici was the force behind Editions Services, and Cook's argument about Apulian vases was logically consistent. But in no single case could any of these objects be traced back beyond Switzerland. Without such a link . . .

For the first television program, therefore, we decided that we had to track an object from the soil of Italy all the way to Sotheby's, to show the entire circuitous route.

Bernard had appointed as director of the program a man named Peter Minns, a good-looking, soft-spoken veteran of the BBC who specialized in arts documentaries. They had worked with Sam Bagnall as researcher and thought highly of him, and so he was brought onto the team. Peter and Sam started by reading the draft manuscript and, as I had, came to the conclusion that we had to trace one of the objects to its origins. Both Peter and Sam knew a researcher in Rome, Cecilia Todeschini, who was friendly with the carabinieri, and, as noted, she agreed to complete the team.

It was obvious which object we had to concentrate on: lot 540, the Attic vase mentioned in the letter to Nicholson by Dietrich von Bothmer of the Metropolitan Museum. We knew that this had been sent for sale by Serge Vilbert, Boursaud's number two, and we knew it had been dug up in the soil of Italy. In fact, the *Epoca* article von Bothmer had sent Nicholson showed a photograph of a man who *said* he had dug it up. His name was Luigi Perticarari and he lived in Tarquinia.

Sam traveled to Rome on a reconnaissance, and our first break came when Cecilia and he located Perticarari. He was a small man, garrulous, who enjoyed his notoriety as a tomb robber and seemed not to have been affected by the eleven years he had spent in jail for his crimes. When we interviewed him later, on camera, in 1995, he willingly showed us how he dug for tombs with his *spillo*, or long metal spike, by means of which he could locate the roof of a buried sarcophagus. He showed us many photographs of objects he had "excavated," and he even still had in his possession one or two black Attic figures, which he was reassembling.

He remembered lot 540, he said. He had sold it to a man who used to visit him on a small motor scooter, but now drove a big car and lived in a big house and was "worth millions." To the all-important question of who this man was, he said he would not answer on camera. We switched the camera off. He then confessed that he had sold lot 540 to a man called Giacomo Medici. We had left our tape recorder running.

—ɯɯ—

The Orchard

By this time, we had been in touch with the art branch of the Italian carabinieri. When we told the carabinieri what we had discovered, they did not say much, but clearly Medici meant something to them.

He had two addresses, one in the shadow of the Vatican walls in Rome, the other at a seaside resort not too far away at Santa Marinella. In July 1995, we spent two days staked out near the Vatican, to no avail. Medici was not at Santa Marinella either, but his wife was, and we left a message that we wanted to talk to him.

We then left for the south of the country. One of our aims in the television program was to show just what tomb robbing consisted of and what its effects were; we needed to bring home to viewers the damage that lay behind the London auctions. Cecilia had reconnoitered Foggia and its surrounding area and had located a very helpful archaeologist, Dr. Marina Mazzei, who said she could show us a looted tomb and the local cache of looted objects. On our first day there it was uncomfortably hot while we filmed the local museum,

where were stored not only excellent examples of Apulian vases but also, in the attic, many vases and other antiquities that had been seized from tomb robbers and were being stored as evidence to be used in the forthcoming trials. The vast amount of loot was depressing.

Our second day of filming was to prove truly exciting. We began by driving out of Foggia to visit a tomb whose contents had been looted but whose "bones" were intact. When we turned off the paved road onto a dirt track, we found the way blocked by large stones. Marina Mazzei was immediately on edge. Through Cecilia she explained that the stones were usually placed across the road by *tombaroli*, to prevent looters from being disturbed by the carabinieri, local farmers, or archaeologists. Sure enough, no sooner had she said this than we spotted a car about a quarter of a mile away, with its trunk open. Three men were crouched nearby, over a hole in the ground. We had the camera out and focused in no time. With the right lens the distance was no object. However, they had seen us; they clambered back into their car, and sped away.

When we reached what was known as the tomb of the Medusa, which was protected by a corrugated iron shed, the full enormity of tomb robbing came home to us. The tomb was large, and a sloping path led down into the main chamber. Side chambers led off the main one, each separated by an elaborate arch. Traces of decoration could be seen, and there was a small hole in one of the side chambers where, Dr. Mazzei explained, the tomb robbers had first broken through. But what really caught our attention was the "teeth marks" of a huge mechanical digger that had been used, desecrating the tomb, presumably once it had been located with the *spillo*. Dr. Mazzei explained on camera what the tomb would have consisted of, and which vases—of what sizes and in what numbers—would have been taken. The tomb was at least the size of a tennis court. We were all quite chastened by what we saw.

Afterward, as we were packing the cameras and sound equipment into our van, Sam suddenly called out, "Look!" and pointed. Five

hundred yards away was another group of tomb robbers. There was a car, and three men, two of whom could be seen jumping in and out of a hole in the ground. In no time we had the camera out and rolling. After about ten minutes they noticed they were being watched, and they too drove off. But it certainly brought home to us the scale of the problem. We had seen two gangs in operation in one day, and filmed the terrible consequences of their work.

We got back to the hotel in Foggia at about seven, tired and dirty after spending much of the day below ground. As I was waiting for the key to my room at the reception, the hotel telephonist approached me. "There's a call for you," she said. I was mystified, as no one except the crew knew where I was. I took the call in the lobby— and heard a man say, "This is Giacomo Medici."

I motioned to Cecilia to listen in. Medici said he had called our hotel in Rome, which had given him our whereabouts in Foggia. He was calling, he said, from the Milan airport and would be back in Rome in two days' time. He told us to be very careful in what we said about him; he said that if we accused him of any wrongdoing he would take us to court "for millions." Since we had made no mention of why we wished to talk to him, this was an interesting comment. He gave us the number of his mobile phone and said he would be going to London shortly and we could meet there. But we should talk, via the number he gave us, the following Saturday, when he would be at home and could give us a firm date for a meeting. Then he hung up.

It was time for dinner. We were beginning to order when another call came in. This time it was for Cecilia. She rushed back into the dining room to say it had been the local carabinieri. When she had organized the Foggia trip from Rome the week before, the carabinieri had said that perhaps they might have "an operation against the *tombaroli*" while we were in the area. She had thought nothing of it then. Now, she said, if we left immediately and made for a small town about forty minutes' drive to the north, we might get some sensational film.

To the dismay of the hotel restaurant, which had just lost seven dinners, we dashed for the van and drove north fast. The sun was setting and the flat countryside looked glorious in the red light, which turned black as we arrived at the town. It was nearly 10:00. At the police station, we transferred to unmarked police cars. Sean Bobbitt, the cameraman, was given the best bite at this particular cherry. He was allowed to go on the raid with the main carabinieri group, which had been tapping the phones of a gang of *tombaroli* for weeks.

Sean was led through an orchard that ran alongside a flat field. What he saw on the edge of the orchard took his breath away. There, in the middle, in the light of the moon, was a huge mechanical digger, tearing into the soil, snatching enormous chunks of earth from above the roof of a tomb. Television cameras often "see" better at night than people do, and Sean's film, when we looked at it later, was dramatic. It brought home the sheer barbarity of the tomb robbing and desecration that Italy suffers at the hands of the *tombaroli*, and the disgraceful, tawdry nature of the illegal antiquities trade that terminates at posh auctions in London or New York.

That night the robbers were surrounded, and four arrests were made before any serious damage could be done. We had gone without dinner, but to good effect.

On Saturday, needless to say, Signor Medici never once answered his mobile phone when we rang. (We rang it for weeks afterward, but there was never any reply. We sent letters to both his addresses, requesting an interview. Silence.)

That did not matter either. On Sunday we arrived in Geneva. There we tracked down Christian Boursaud's old address, 57 Avenue Bois de la Chapelle, Onex. Box number 41 now showed a different name, which was disappointing but not exactly unexpected. However, as we were about to leave, I noticed a name on another letter box that we *did* recognize: Serge Vilbert.

Monsieur Vilbert was not at home right then, so we waited. After two hours he had not returned, so we adjourned for lunch. When we rang his bell in the afternoon, his wife answered; he followed soon after. Vilbert was a thin, blond man in his late thirties. At first he was reluctant to answer questions, but when I pressed him he admitted that he had worked for Christian Boursaud some years before, consigning antiquities to Sotheby's in London. Vilbert was only an employee, he said, but on the all-important point he was clear: Giacomo Medici dealt regularly with Boursaud, getting into Switzerland all manner of sculptures, statues, vases, and antiquities.

And so, at last we had a whole picture. Medici bought the objects from the tomb robbers, who dug up the antiquities from Italy. He sent the stolen objects to Switzerland, where Boursaud consigned them to Sotheby's, "laundering" them in the process. Medici was indeed the principal in this unholy trade, and Boursaud—with Vilbert—the agent.

Vilbert also cleared up another area of confusion for us. We had found him; he existed. At the same time, Felicity Nicholson had said at James Hodges's trial that she understood Medici and Vilbert to be one and the same. Hodges, however, understood Vilbert to be a partner of Medici's. This confusion appears to have arisen from the fact that the real Vilbert, though he existed all right, never went to London. At times Medici used his name, and at times another man used the same cover name. It underlined the clandestine nature of the cloak-and-dagger, shovel-and-*spillo* business they all were engaged in.

This was the picture we had come to Europe to confirm.

And there was more to it than that. The picture of antiquities smuggling that we had uncovered was exactly the same as James Hodges had described it. Our investigation had confirmed the veracity both of the documents and of Hodges's interpretation of them.

—⚭—

The Temple Singer

Giacomo Medici was not the only person we tried to track down in Italy in the summer of 1995. There was a second man whose role in antiquities smuggling was equally interesting, though rather different. Once again, we need to look back to the autumn of 1985.

At much the same time as the fuss blew up over the Apulian vases, a quite separate matter was taxing Felicity Nicholson and her staff. The first Hodges knew about it was when he was called into Nicholson's office one morning in October that year. She had a personal policy of smoking only in the afternoon, but that day she had already lit up. She told him that that morning, in a quiet side street in Chelsea, at the home of an Italian living in west London, she had been to see a fine statue. It was black, made of basalt, a volcanic rock that looks splendid when polished, and was of a temple singer from the reign of the sixth-century-B.C. pharaoh Psammetichus. Moreover, she said that the statue was academically important. Some months earlier she had been sent photographs of the object and had valued it at £60,000–80,000. Now, having seen the statue in the flesh, so to speak, she thought it might be worth twice as much. This was

not a lot of money for an old master or an impressionist painting, but antiquities were her domain, and for an antiquity it was a small fortune. It could be the main attraction in the forthcoming December sale.

However, she added that the figure was not without its problems. For one thing, she said, it had been smuggled to London from Rome. As a result, there were no papers to go with the statue—nothing to explain how it had reached London. But Nicholson was not going to let this problem stand in her way. Her plan was for the statue to be exported from England and then reimported from Switzerland. The Swiss allow the free movement of all art objects into and out of the country, so once the statue was in Geneva or Zurich, where Sotheby's had offices, it could be returned to London and made to look perfectly legal. Hodges was to have a role in all this, which was why, of course, he was being taken into Nicholson's confidence. His job was to have a box made for the statue and to organize its export to Geneva. He was also instructed to telephone a Mr. Fantechi, in Chelsea, and explain what was happening.

The export went fairly smoothly, although the problems surrounding it meant that it could not be put in the December 1985 sale but instead was intended as the chief attraction in the July 1986 auction. After reaching Geneva, the statue was sent back again. This time there was an interesting gloss. The paperwork that accompanied the statue showed—or pretended to show—that it belonged to a Ms. Domitilla Steiner, who had an address in Switzerland. Any customs or tax official inspecting the documents relating to the basalt statue would never suspect that Ms. Steiner had any connection with Sotheby's. Hodges found out otherwise on January 20, 1986, when Felicity Nicholson sent him this memorandum: "James, please make sure that we note the terms of sale of the block statue which is coming in via Geneva office. It will be in the name of ? Steiner, who is in fact one of Nicholas Rayner's stepdaughters."

Hodges knew Rayner, or at least knew him by reputation. He was a senior Sotheby's executive, an old Etonian, and then ran the com-

pany in Switzerland. He was a bobsled fanatic and had initiated
Sotheby's successful jewelry sales in St. Moritz, held in the second
week of February to coincide with the height of the skiing season. A
qualified jeweler who had worked for Chaumet in Rome, Rayner
was a member of the European glitterati. His brother was a promi-
nent banker in the City of London. Later, Rayner would be the man
who auctioned the Duchess of Windsor's jewels, for $50 million.

Soon, however, they faced a new difficulty. It was explained in a
memo, which Hodges passed to me, dated March 24, sent by
Nicholson to Joe Och, then Sotheby's legal officer: "I saw this [the
statue] originally in London, and agreed to sell it after extremely
difficult negotiations. There was *great* secrecy about the actual
owner's name and I still do not know it. The piece had to be re-
imported into this country as there were no import documents and
the agents could not provide us with evidence of import (almost cer-
tainly because it had come direct from Italy). It was then re-
exported (not by us) and re-imported from Geneva where it was
entered under Nicholas Rayner's stepdaughter's name (Nicholas
Rayner was involved because he knows a friend of the owner. The
owner lives in Rome I believe). The piece has been published
twice. . . . The owner says if we are going to mention the publica-
tions he will withdraw the piece! It is the best piece in our sale and
quite the best piece we have had for some considerable time. The
estimate is £100,000–150,000 and the reserve is £130,000. What do
you think? Can you treat this as a matter of urgency."

A second memo, a sort of aide-mémoire, followed. Dated March
27, 1986, it was unsigned and in part read: "1. Joe Och says OK to
go ahead with sale of block statue. We don't know when it came of
Italy [*sic*] etc. FN spoke to him on telephone. As far as we are con-
cerned it came out legally."

However, the one problem Sotheby's could not get around was
the awkward fact that the statue had been "published." In other
words, the figure was unusual enough and important enough to have
been written about in three scholarly journals (not two, as Nicholas

Rayner thought). One reference, with a picture, was published in the *Bulletin de l'Institut français d'Archéologie Orientale*, in 1960; the second appeared in 1970 in an Italian journal, *Oriens Antiquus*; and the third in *Documents relatifs à Sais et ses divinités*, published by the French Institute in Cairo in 1975. These were hardly large-circulation publications, but any potential buyer of an antiquity of this importance would know his or her way around the field and have ready access to them. (For example, two of them are kept at the British Museum and it took me less than an hour to locate the reference.)

The paradox was plain. In normal circumstances, such academic references would have been useful both for Sotheby's and for the seller. They were independent confirmation that the statue was important and (no small matter) genuine. But in this case, the references were extremely dangerous and embarrassing, and both parties knew it. In addition to discussing the importance of the statue and the meaning of its decoration and various hieroglyphics on the back of the figure, the articles confirmed that as recently as 1960, the object was in Italy, in the collection of Count Andrea Beaumont Bonelli, in Naples. There had been no substantial change in Italian export law since then, so there was no way that the statue could have been exported from the country legally.

The next document in this affair is even more revealing. It too is unsigned but again it has the feel of an aide-mémoire, summing up the author's thinking.*

1. If it is sold to a museum, there is *NO* way it is not going to be published. They would *not* buy it if there were any restrictions. One of the first questions will be is it published?
2. The same applies to a Private Buyer or Dealer. There is *NO* way that a buyer of a piece of such importance is not going to know or

* Sotheby's disputes this document, believing it to be inauthentic. This objection lacks plausibility. Besides being of a piece with other documents in the sequence—in terms of typewriter face, layout, etc.—it is on Sotheby's notepaper, and it describes in part exactly what happened: that the statue was imported from Switzerland. The document was mentioned in the 1995 program and it took Sotheby's well over a year to dispute it.

find out about the provenance and it could well be that they would
at some time offer it for sale at either Sotheby's or Christie's; when
the provenance and publications are bound to come out.

3. Surely as far as the present owner is concerned all he has to say is
that he sold it in the late 1970's [i.e., after the last reference was
published, in 1975] and that the piece is no longer his. As far as
Sotheby's are concerned it belongs to someone in Switzerland; it
was imported to us absolutely legally from Switzerland and that is
the end of the affair. . . .

Paragraph 3 was the crux. Someone inside Sotheby's antiquities
department was suggesting that the company be prepared to con-
done falsehoods, to make its actions appear aboveboard, and to mis-
lead others so as to secure a sale.

Two days later, there was yet another memo. It too was undated
and unsigned but was laid out in the same way as the others, and with
the same typeface. It was addressed to "Joe" and read: "Could we do
this—*NOT* mention collection of Andrea Baubeaumont [*sic*] Bonelli
or the name of the article but just say . . ." and went on to list the
three journals in which the statue had been published. This was pre-
sumably intended as some sort of compromise. The reference would
have been published in Sotheby's catalogue, and so if any problems
arose at a later date, the company could claim that it was not hiding
the provenance of the statue. At the same time, if just the titles of the
relevant journals were mentioned and not the titles of the articles,
perhaps no one would check them out and put two and two together.

However, despite the twists and turns to bring the Temple Singer
to auction, it was eventually decided that the academic references
could not be left out of the catalogue and that therefore the risk that
someone would spot that the piece had recently been in Italy was
too great. Reluctantly, in April, the figure was withdrawn from the
summer auction.

But that did not mean the matter was closed. Far from it.

· · ·

A letter, dated April 9, 1986, from Nicholas Rayner to a Madame Christine Burrus in Geneva was included in the file. Rayner became involved in this affair because, according to Nicholson, he and the owner of the statue had a close mutual friend. Madame Burrus may well have been that friend, for Rayner's letter read as follows: "Dear Christine, Our antiquities expert Felicity Nicholson has informed me that we would risk severe criticism to surpress [sic] the artical [sic] referring to the object. We would be open to the accusation of deliberately concealing its origin. . . . Knowing the view of the owner, I have therefore asked Miss Nicholson to withdrawn [sic] the object from the catalogue."

Despite errors, the wording of this letter was meticulous. For although the statue was withdrawn from the *catalogue*, this did not signify any change of moral conviction inside Sotheby's. For the company now tried to sell the piece *privately*. Two weeks later, on April 24, 1986, Felicity Nicholson wrote again to Joe Och, saying that she had been asked to sell the statue privately and asking whether, besides the three academic references, prospective purchasers should be given "any other information." Amazingly, she was still trying to cut corners.

Six months later, on October 22, a deal was finally concluded. The statue was sold to a Californian dealer, Heidi Betz, for $255,500. The deal was consummated on Sotheby's premises, Hodges was present, and so was the owner of the statue, a Mr. Giulio Jatta. He signed the Sotheby's paperwork, and gave his address as "Via L. Respighi, 16," in Rome, thus confirming—if more confirmation were needed—that the Temple Singer had been smuggled.

This matter was raised at Hodges's trial. Mr. Fantechi had been referred to only as "Mr. F" and Giulio Jatta as "Mr. J," but the travels of the statue back and forth between London and Switzerland had been discussed and not contradicted by any of the Sotheby's witnesses.

There were certain moves we could make in July 1995 to advance the situation. One was to consult Mr. Fantechi in London. He did not reply to our letters requesting an interview, so we called upon him at his home in Moore Street, Chelsea. He answered the door, but as soon as he realized who I was and that he was being filmed, he immediately turned around, refused to discuss the matter, and closed the door in my face.

In Rome a week or so later, we tried to contact Mr. Jatta. He no longer lived at Via L. Respighi, but the concierge in the apartment block said he thought Mr. Jatta had moved to the Parioli area of the city. In the telephone book we found a Giulio Jatta who lived on the Via Gaetano Scipio, in that suburb. We called on him; he was very displeased to hear from us, denied selling anything at Sotheby's, and insisted that we not bother him at home.

However, we did pick up some information about Mr. Jatta. Cecilia Todeschini went to the town hall in the Via del Plebiscito and found the registration of Mr. Jatta's birth. It showed that Mr. Jatta's mother's maiden name was Anna Beaumont. The Temple Singer had once been in the collection of Count Andrea Beaumont Bonelli, in Naples.

Nor was that all. Earlier I described visiting Felicity Nicholson in 1992, to discuss the international traffic in antiquities. This meeting had been cut short when Felicity Nicholson claimed that she had another appointment, but not before I had asked her about the Temple Singer. She had refused to discuss the matter, citing "client confidentiality," but I had managed to ask her if Sotheby's had sold the statue privately. "No," she had replied. "No, we did not."

"But wasn't the sale finalized on Sotheby's premises?"

"Yes, it was. But we had no part of the deal."

"Did you not receive a commission?"

"No, we did not. Absolutely not."

A document showed that Sotheby's shared a 2.4 percent introductory commission on this sale—or £4,200.

—ɷ—

The Lion Goddess

The July 1995 trip to Italy and Switzerland was proving to be successful. Giacomo Medici, Serge Vilbert, and Giulio Jatta were all real people. The smuggling of Apulian vases, and of the Temple Singer, was a reality, too; both had been mentioned at Hodges's trial, the documentation unchallenged. In the case of the Sekhmet, a statue of the Egyptian Lion Goddess, we were entering new territory.

The relevant documents had not been introduced at the trial, and in that sense had not been tested. However, we had sent a set to Sotheby's, with our interpretation of what they might signify, and Sotheby's had simply replied with "No comment." There was no threat of injunction, and no denial. We decided to go ahead.

The chief document in this instance was a memorandum written by Marcus Linell. Now, Linell was someone I knew and liked. He was a dark-haired, open-faced man, with a ready smile, who paid great attention to detail. I had always found him courteous and helpful. At one stage, in the early 1980s, he had been talked about as managing director. By the end of the decade, however, his star had fallen somewhat. Even so, he was still a main board member of

Sotheby's Europe and a figure who had been responsible for, or in-
volved in, many of the company's more imaginative deals. It was
Linell who had been responsible for the company's travel subsidiary,
for a big British Rail Pension Fund art investment program, for per-
suading Lloyd's of London to accept works of art as security in the
underwriting of insurance policies, and for many special sales, such
as Littlecote, an Elizabethan house in Hampshire with a remarkable
armory.

The document written by Linell was dated October 18, 1985, in
other words only a few days after Felicity Nicholson had visited Mr.
Fantechi in Chelsea to view the Temple Singer. It was addressed to
Julian Thompson, Tim Llewellyn, and Tom Tidy—an interesting
triumvirate. Thompson was an expert in Oriental art but also
deputy chairman of Sotheby's Europe, a main board member, and
on the board of Sotheby's Holdings, the parent company in Amer-
ica. Llewellyn was an expert in old masters and managing director of
Sotheby's London. Tidy was finance officer of Sotheby's Europe
and a main board member. In other words, they were all very senior
people indeed.

The memo was headed: "Sekhmet Figure, the property of Xoilan
Trading Inc. (Robin Symes)."

The mention of Xoilan, and Robin Symes, had also drawn Hodges's
attention. Symes is a London dealer who has a close relationship with
Felicity Nicholson. At one stage, he rented a studio in Nicholson's
garden, where he put up visiting dealers. Xoilan, Hodges knew, oper-
ated from the same address in Geneva as did Editions Services and
consigned a similar range of antiquities.

The text of Linell's memo read: "We have briefly discussed the
problem which has arisen with regard to a private sale which we or-
ganised. The situation is that just over a year ago Felicity Nicholson
saw a very good Egyptian stone sculpture at a dealer's shop in Italy.
The dealer is well known to us, and a regular consignor. Felicity
went with Michael Thomson-Glover and her estimate for the figure
was £80,000 to £100,000.

"In the discussions which followed, it emerged that the dealer did not wish to make arrangements for the export of the figure, and insisted on a private sale. Felicity approached Robin Symes to see if they would be interested in purchasing the figure, without any promise that it would be sold at auction by us. . . . It was agreed between them that Felicity would pass on an offer of £40,000. The owner accepted this, payment was made and we received a commission of [left blank]. . . . We subsequently arranged for the figure to be sent to Rome, and one year later we heard that the figure was in London. . . ."

The wording of Linell's memo had turned coy, but it was not hard to see what had happened, especially as the second page of the memo gave a breakdown of the costs of bringing the Sekhmet out of Italy. These were as follows:

	£
Cost price including our commission	48,800
Transportation to Rome [from Genoa]	2,850
Transportation to Geneva	10,700
Transportation to London	633
Transportation to New York	616
From New York to Sotheby's	100
	63,699

Several things leap out. The first is that although the Genoa dealer had been reluctant to send the statue abroad, Felicity Nicholson showed no such compunction. The second was that Sotheby's charged £8,800 commission on the cost price of the £40,000, which amounted to 22 percent, presumably 10 percent to the seller, the Italian dealer, and 10 percent to Symes, plus a 1 percent currency or insurance risk to each party.

The third—and perhaps most revealing—item was the transportation costs. The cost from Genoa to Rome was high, according to a later paragraph in the memo, because a box had to be made for the Sekhmet. But what was most revealing was that whereas it cost

just £633 to transport the statue the six hundred miles between Geneva and London, and £616 for the 3,500 miles between London and New York, it cost a colossal £10,700 for the four hundred miles from Rome to Geneva. The figures spoke for themselves. This was the cost of smuggling the Sekhmet across the Italian-Swiss border.

Armed with this document, we made two attempts to corroborate the information it contained. In the first place, we tried to contact Robin Symes, at his gallery in Jermyn Street in London. He refused even to acknowledge our letters, although we sent him a copy of the above memorandum by registered mail. We therefore called at his home, in Seymour Walk, southwest London. Although I was invited into his house by his maid, he made it clear over an intercom that he had no wish to speak with me. He did, however, confirm in passing that he had received my registered letter; then he asked me to get out, saying he was about to leave for the airport.

We waited outside. Shortly afterward, a red Bentley drew up and Mr. Symes stepped out of his front door. I approached him again, saying that I wished to discuss the Sekhmet affair with him. He asked me to go away, got into the Bentley without speaking further, and was driven off.

So, in Rome, in July 1995, we approached a company called Cointra, with offices near Leonardo da Vinci Airport. Cointra is one of the largest shipping agents in Rome and frequently transports art objects around the world. We asked staff members how much it would cost to send to Geneva a statue of the same dimensions and weight as the Sekhmet. They said that provided the statue had proper documentation for export—and they would not handle it otherwise—the maximum they would charge would be for an express shipment. This would be the lire equivalent of £1,500, plus £300 for insurance and £100 for the box—a total of £1,900, against the £10,700 "shipping fee" that the Sekhmet had actually incurred.

In some ways, Linell's memo was the most revealing of all. But it was backed up by five others, which implicated Sotheby's Florence office.

The first was a handwritten note scribbled on the foot of a photograph of the Lion Goddess: "FN spoke to MTG. R&C are interested but as they will be in NY for some time we go ahead & try & get it ourselves. If they cant [*sic*] they will still be interested. FN quoted £80,000 when she saw it." This takes some deciphering. FN is Felicity Nicholson, MTG is Michael Thomson-Glover, who then ran Sotheby's Florence office, and is still (in 1997) a director, in Billingshurst, Sotheby's Sussex saleroom, while R&C refers to Robin Symes and his partner, Christo Michaelides. NY is, of course, New York.

The second document is unsigned and undated and reads as though it came next. It is headed "SEKHMET IN ITALY (Michael Thomson Glover)" and reads: "MTG says client wants £60,000 but probably some room for manoevre [*sic*]. It will have to be bought first by R&C. Michael will be able to do anything they want. It can not come direct." Note here the words "It will have to be bought *first* by R&C [emphasis added]. . . . It can not come direct." What seems to be happening here is that Symes was being set up by Sotheby's as a front man—made to appear as the buyer, so as to keep Sotheby's books in order—when in fact both the auction house and the dealer were part of the plan.

The third of the five subsidiary documents is another handwritten note, this time from Felicity Nicholson to Carol Lennox, one of the secretaries in the antiquities department, and dated July 11, 1984. It reads: "Please make a note for the files that I spoke to Michael Thomson-Glover and made an offer of £40,000 on the Egyptian figure on behalf of Robin Symes. He will let us know."

The next memo, dated January 2, 1985, confirms all. Written by Felicity Nicholson, it reads: "Some time ago, I was shown an object in Italy by the Florence office. I then arranged a private sale. This was all done in Italy by the Florence office (see attached). They were paid by the buyers 110 million lire (approx. $58,000) including buyer's premium." Finally there is a fifth memo, dated October 22, 1985, confirming details: "RE: SEKHMET. The amount we re-

ceived in Florence was 110 million Lira, from which we deducted 10 million lira from the purchaser and 10 million lira from the seller. The transaction was done on ??? The reason for the high transport expense from Genoa to Rome was because we had a special case made for the piece."

So, the head of Sotheby's antiquities department in London, the head of its office in Florence, and a major international antiquities dealer were involved in spiriting an important piece of ancient art out of Italy and into America, via Britain. This was not a case of Sotheby's turning a blind eye to something that was happening anyway, and organized by others. In this case, as the documents show, senior figures inside Sotheby's conceived the idea and helped to arrange the funds and the transportation.

The Sekhmet affair did not end there. In fact, the whole business descended into farce in a way that explained why all these incriminating details were put down on paper. The giveaway lay in the second page of the Linell memo, the one that gave a breakdown of costs. For when the statue arrived in America, the situation changed dramatically. The last paragraph of Linell's memorandum makes amusing reading. "After its arrival [in Manhattan, the statue] was set up to be photographed, and while it was extremely well lit they noticed that there was something wrong with it. It emerged that it was a cast, made of a mixture of Portland cement, charcoal, calcite chips and some wood. Both Robin and Felicity say that they have never seen this type of fake before, and it was therefore a completely unprecedented surprise to both of them. . . ."

So much for Nicholson's, and Symes's, expertise. There is surely something ironic about this turn of events. After such an effort to get the Sekhmet out of Italy—and at such a cost—the damn thing is shown up as a fake. And this, of course, is why the top brass at Sotheby's were being brought into the affair. Robin Symes was out of pocket, by £63,699 (more than $90,000), and Sotheby's, in the form of Felicity Nicholson and Michael Thomson-Glover, who had

set up the whole deal, were responsible. It was this that necessitated the breakdown of the costs, set out in black and white.

Linell was in no doubt that Sotheby's was responsible for the basic cost, which should be paid back to Symes. In a later memo, again addressed to Tim Llewellyn and Tom Tidy, he wrote, "I have now had long discussions with Robin Symes, Felicity Nicholson, and also with Dede Brooks," who was then Sotheby's executive vice president in New York. It was agreed that Sotheby's would pay Symes "all the expenses which he incurred up to the time when the figure arrived in England. . . . This totals $88,176."

It now fell to Sotheby's to recoup what it could from the dealer in Genoa. That did not prove easy. Shortly before Christmas 1985, Tim Llewellyn wrote to Linell to ask if there had been any progress in getting a refund. Linell replied that the original vendor was "somewhat sympathetic" and that Michael Thomson-Glover was "in the midst of discussions with him to see what we can get back." This turned out to be optimistic, however, for in a telex dated February 11, 1986, Thomson-Glover told Felicity Nicholson, "I went ten days ago to discuss [the Lion Goddess] and client is being very difficult. I have to return again and talk to him and lawyer."

Sotheby's may well have believed that the Genoese dealer had suspected all along that the Sekhmet was a fake. That was why he *preferred* an under-the-counter deal, because Sotheby's would think it was getting a bargain, and not inspect the statue too closely. It can never be forgotten, however, that Sotheby's is a powerful force in the art world. As Linell said in his original memo, the Genoese dealer was a "regular consignor." The man could scarcely hope for continued cooperation from Sotheby's (especially if he was selling smuggled goods) unless some accommodation was reached over the Sekhmet figure.

As of May 1986, the Genoese had softened his position. On the 26th, Thomson-Glover sent a letter from Florence to Felicity Nicholson, with a copy to Tim Llewellyn. In it he said that he had

had "further long discussions with the seller in Genoa" and they had arrived at an agreement. "The seller agrees to pay half the difference between the price for which we can sell the cat in New York and the 90 million lire that he received. As we cannot go through any legal proceedings I think it would be difficult to do better than this and I have only been able to persuade him to accept these terms by putting on moral pressure."

The idea of one lawbreaker putting "moral pressure" on another—and in the same sentence in which he concedes that he cannot go through any legal proceedings—is farcical. But mention of a possible sale in New York brings us to the final chapter in this unlovely affair. Plans were now made to put the figure in a minor sale, an "arcade auction" on December 17–18, 1986. Arcade auctions are relatively informal sales of decorative items rather than major works of art. The cataloguing is less detailed, there are no specialist categories, and the time between consignment and sale is much shorter.

The Sekhmet had fallen a long way, for it now carried an estimate not of $200,000–300,000, as it once had, but of $4,000–6,000, with a reserve of $3,000. In fact, bidding stopped at $2,750 and it was left unsold. It was reentered in a sale on November 25, 1987, when it was finally sold—for $8,000. The "value" of the Lion Goddess was nothing if not a matter of ups and downs.

In one respect, the Sekhmet episode was more important than either the Temple Singer affair or that of the Apulian vases. This was because of the particular Sotheby's figures involved—not as principals, it is true, but they were brought in when things went wrong. Tim Llewellyn and Julian Thompson were the top people in London; at the time, Dede Brooks ranked fourth in New York, after John Marion, Michael Ainslie, and owner Alfred Taubman himself. Yet none of these top people took any action against the wrongdoers. There is no sign of any criticism of Felicity Nicholson or Michael Thomson-Glover, nor any questioning of their relation-

ship with Robin Symes. And it should not be forgotten that Sotheby's had initiated this deal, and was forced to repay Symes.

Was there then no disciplinary action? Did the top brass condone what went on? Several times, throughout 1994 and 1995, we asked Sotheby's whether any disciplinary action had been taken against Felicity Nicholson or Michael Thomson-Glover. The company's reply continued to be the consistent "No comment."

CHAPTER 14

—∽—

A Call from Zurich

After returning from Italy, our first priority was to secretly film that summer's antiquities sale, at Sotheby's. This was important, for the company usually denies permission to film openly—saying that the objects are too fragile to risk the presence of a camera crew. We suspected that there might be another reason. The evidence includes a memo written by D'Este Bond, of the company's press office. Its main purpose was to examine Sotheby's treatment by the press after the Apulian vases scandal, but in the course of her argument she considered whether the company should "ban TV from antiquities sales . . . in order to protect Italian clients." And she added, ". . . should we stop selling anything that might have been smuggled, for P.R. reasons? How much would there be left to sell in certain instances?"

That summer's sale contained six Apulian vases, none with any provenance whatsoever. The dubious trade went on unabated.

After filming the sale, we all took a break for the summer, and I went fishing in Scotland. Our next task would be to explore further areas of possible wrongdoing inside Sotheby's. Together, the three

cases of smuggling out of Italy showed that Sotheby's antiquities department, under Felicity Nicholson, was often shameless. But that was only part of our aim. The documents we possessed showed that malpractice inside Sotheby's extended beyond antiquities, and beyond smuggling.

As I stood up to my thighs in the River Esk, in pouring rain, I tried to think of a way forward. We had so many documents that it was difficult at times to know what to choose; some were technical, of more interest to professionals—dealers or collectors—than to the general public who, we hoped, would be watching the program. Late one rain-soaked morning I heard but could not see an RAF fighter plane zooming overhead, practicing flying by radar. I found it awesome that the pilots should take such risks. It also set me off on a train of thought.

The skies were murky but, thanks to radar, pilots could see clearly. What we were faced with, however, in the first of our programs, was in a way a reversal of that situation. The auction process is supposed to be open, clear, clean. But that was simply not true—there were all manner of opportunities for auctions to be rigged. What was apparently clean was in fact murky. That was what we would show in the rest of the program: how easy it is to rig auctions. Everyone could understand that.

Back in London, we settled on two documents—each a page long—that together showed how remarkably easy it is.

As mentioned, an auction is supposed to be an open system of buying and selling—at least on the face of it. An owner or vendor puts an object into a sale, stipulates the minimum price ("reserve") that he or she will sell for, and then waits to see what happens. On the day of the auction, people turn up and bid, according to how much they want the object and/or can afford to pay. All other things being equal, the person who bids the most—who is prepared to pay the most—gets the object, provided that the bid is above the reserve set by the vendor.

In practice, it does not always work out like that. One of the most common ways in which auctions vary from this ideal situation arises from the fact that, for one reason or another, a buyer cannot attend the auction. He or she may, for example, live abroad, have more important things to do at the time, be ill, or not want to be seen because of worries over security or taxes, or countless other reasons. In such an event, the potential buyer can send someone else—an agent—to bid on his or her behalf. Or a "commission bid" may be left with the auction house.

This latter case—the commission bid—is clearly special because it puts the auction house in a privileged position. It knows what the owner wants for the object, but it also knows what a buyer is willing to pay for that same object. Let us suppose an object is coming up for sale with an estimate of £100,000–120,000 and a reserve of £90,000. Let us also suppose that a couple of days before the auction, a client who cannot attend the sale leaves a bid on the object of £125,000. Further suppose that, as often happens, there is no one else very interested in this object. In a perfect world, the object would be knocked down for £90,000. The vendor would receive £81,000 (£90,000 less 10 percent commission), the buyer would pay £99,000 (£90,000 plus 10 percent buyer's premium), and the auction house would receive 2 × £9,000 = £18,000 in commission. The auction house would have fulfilled its responsibilities to both vendor and purchaser.

However, it takes no genius to work out that a saleroom cannot equally please the seller while it is pleasing the buyer, and vice versa. The seller wants the highest possible price, while the buyer wants the lowest possible price. Moreover, the higher the price achieved, the larger the auction house's commission. In our example, had the object sold for, say, £110,000, the vendor would have received £99,000 (£110,000 less 10 percent), the buyer would have paid £121,000 (£110,000 plus 10 percent), and the saleroom would have received 2 × £11,000 = £22,000 in commission. It follows that when an auction house is in possession of both sets of informa-

tion—what the seller wants and what a buyer is prepared to pay—
the temptation may exist to sell the object for a higher sum than,
strictly speaking, it should go for.

Salerooms say this does not happen. They say that, like banks in
London or on Wall Street, they have "Chinese walls," a system
whereby those who record commission bids are forbidden to convey
these details to the departmental specialists, who know the reserves
on the objects being sold. Sotheby's version of Chinese walls is
known as the "Comm Box," in effect a box where all commission
bids are placed in advance of sales. Theoretically, bids in the Comm
Box cannot be seen by those fixing the reserves.

But there are two weaknesses to this system. In the first place, it
relies on trust, and trust alone, for one party not to talk to the other.
If a company earns more by bringing the two parties together, can
that system be considered foolproof? The second weakness is that
however separate the commission bids are kept *ahead* of the sale, for
the sale itself the auctioneer has to know the reserve on each lot and
what the commission bids are. The auctioneer therefore often
knows, at the beginning of a sale, what the reserves are and what
certain customers are willing to pay.

Salerooms say that this system is never abused. Such an abuse oc-
curred in December 1985, in the antiquities sale of so many con-
tentious Apulian vases. The document that Hodges gave me was
dated January 27, 1986, and was written by Felicity Nicholson to
Tim Llewellyn, in his capacity as managing director of Sotheby's,
London.

"Dear Tim," it began. "Colin Mackay [head of the Chinese de-
partment] has asked me to write you a note with regard to the sale of
antiquities on Monday, 9 December 1985, lot 64 [a Middle Eastern
silver bowl, consigned by a Professor Snellgrove], which was sold for
£80,000. . . . The net reserve on this lot was £65,000. . . . During the
sale I was told by my administrator [Hodges] that there was a bid of
£80,000 on this lot and should we raise the reserve—I agreed and he
then mentioned a figure of £75,000. I agreed again. . . ."

What had happened in this case was that Hodges had looked over the shoulder of another Sotheby's employee, Peter Batkin, and seen that he was prepared to go up to £80,000 on behalf of a client of his.

Hodges, of course, was hardly less culpable than Nicholson, in that it was he who told his superior about Batkin's bid. But Hodges says that it was routine for him to tell Nicholson of commission bids ahead of any antiquities sale. He says: "I used to supply her with a sales catalogue marking the reserves and the bids." No less important, Nicholson accepted Hodges's tip and immediately acted on it. She saw nothing wrong in raising the reserve even after the auction had started and immediately did so. That is where the wrongdoing occurred, in raising the reserve after she knew about someone's bid and before she was aware of what competition there was in the sale-room.

And this, of course, is what Hodges had claimed at his trial—that he was a small fry surrounded by bigger fish, all of whom connived in wrongdoing.

Even though *I* thought this document was very damaging to Sotheby's, for credibility's sake we needed an independent expert to give an informed view on it. Peter Nahum, a London dealer and former auctioneer at Sotheby's, thought the practice was disgraceful and said on camera that it went on "all the time." And during the autumn of 1995, Sam made contact with Professor Brian Harvey in the faculty of law at Birmingham University. Professor Harvey is an acknowledged authority on auction law and, incidentally, from time to time advises Sotheby's. We shall come to what he had to say, but first some other scene-setting is required.

When I first met Hodges and spent two weeks going through the documents, at his house, there were a number of papers that, as noted, he had not put in the red ring binders. He thought they were unimportant, but I regarded them as quite the opposite. There was one in particular that I thought was explosive.

By April 1991, I was well into another book, a history of the art market, beginning in the fifteenth century but concentrating on the more recent art boom. I had researched the various auction houses and the major dealers and collectors in London, New York, Paris, Hong Kong, and Switzerland. From all this it had become clear that the success of the international auction houses—Sotheby's, Christie's, Phillips, and the Parisian rooms—has been the chief feature of the postwar art market. Various reasons have been given, from the characters involved to the fact that in today's media-oriented, more meritocratic world, the new middle class prefers the public, open nature of auctions to the hushed secretiveness of private dealers.

But this is disingenuous. In practice, and traditionally, auction houses have been subject to two particular forms of manipulation, two ways in which the professionals of the trade bend this apparently straightforward process to their own advantage. The first of these is the "ring" and the second is "chandelier bidding," also known as taking bids "off the wall." Each is a form of deception.

A ring is an agreement by a group of bidders, usually dealers, to refrain from bidding on certain items in return for advantages later. It works as follows. Say dealer A bids 100 units for object Z, a clock, and gets it at that price, with all other members of the ring abstaining. Later, in a "knock out," or "settlement"—in effect a second, invitation-only auction, usually held in a nearby pub shortly after the sale proper—the clock is put up for sale again, but this time only among members of the ring. Let us say that on this second occasion it is bought by dealer B, who bids 250 units. Dealer B now pays 100 of that 250 to dealer A, reimbursing him fully for what was paid in the auction proper. The remaining 150 units go into a "kitty" or "pool." When all the ringed items have been disposed of in the settlement, the total kitty is divided equally among all the members of the ring.

Several things are achieved by this. First, the object is usually (though not invariably) knocked down in the auction proper for

rather less than it is really worth, because a number of interested parties are, temporarily, abstaining. Second, powerful dealers, who do not want anything in a particular sale, can still make money from the pool, simply by refraining from bidding. Third, when rings operate (very often, but not always, in provincial salerooms), their mere presence intimidates other dealers who are not part of it (but who are well aware of what is going on), and they either keep away or do not bid. This too may help reduce prices.

The most sensational ring of the twentieth century was that at Ruxley Lodge, in Surrey, the traditional home of the Barons Foley of Claygate. In 1918 the Claygate library was sold and 637 lots of rare books fetched £3,714 12s 6d. However, that sale was ringed by book dealers, and in the later settlement, the books fetched a colossal £19,696 17s. The difference, £15,982 4s 6d, would equal about £500,000 at present-day values. In effect, the seller had been defrauded of that sum and the auction house robbed of its commission on the larger total.

What is called "chandelier bidding" theoretically exists to prevent rings from operating. It exists because, say the auction houses, the reserve on any object must be kept secret. Their argument runs as follows. If bidding at auction started at the reserve, as some dealers would like to see happen (and as happens in Austria), a ring could still operate. Its members could sit on their hands, make one bid—enough to secure the object—and then have their own "settlement" afterward. The method that has evolved in the major salerooms to counteract this activity works as follows. Usually, the reserve on an object is a bid or two (say 10–15 percent) below the low estimate as printed in the catalogue—but no one knows exactly, and it may be well below the estimate, or there may be no reserve at all. Chandelier bidding is necessary, the salerooms say, to create an impression that there is a market for every item and to confuse any potential ring about the size of the reserve. The auctioneer therefore looks around the room, nods and smiles, says "Thank

you" or "Are you bidding?"—though to begin with this is all a pretense. At this stage, no one except the auctioneer knows whether there are any genuine bids or not.*

Another argument against published reserves, the salerooms say, is that if bidding started at the reserve, and there was no interest in an object, there would be no bidding at all, not even fake bidding, and the auction would fall flat. By starting down the price range, the auctioneer attempts to create a "buzz" in the saleroom, an impression that there is activity.

In the old days, before the recent art boom, say, when most of the people in the salerooms were trade—i.e., dealers, museum people, or agents, who went to auctions several times a week—it is probably fair to say that these professionals knew what was going on. They may not have liked it or agreed with it, but they were aware of saleroom practice. But as the salerooms changed in character after World War II, and especially in the 1980s, chandelier bidding came under attack. Now sales were attended more and more by individuals who were relative strangers there and were not aware of these traditional practices. To them, chandelier bidding could seem like a simple but blatant form of deception.

Matters came to a head in the 1980s, in New York, when both Christie's and Sotheby's were shown to have practiced deception in the salerooms. In Christie's case, the firm's chairman, David Bathurst, misled the press by claiming that more paintings had sold at one high-profile auction than was actually true; this was an attempt to create the impression that the market was healthier than it was. In the Sotheby's case, the company falsely claimed it did not know the identity of the person selling some illuminated Bibles that

* Sotheby's lawyer maintains that chandelier bidding is legal in London; our expert, Professor Brian Harvey of the University of Birmingham, said on our film that *consecutive* bidding is illegal under the Theft Act and the Sale of Goods Act, adding that it has not been tested in law because who would admit to such a thing. Sotheby's Conditions of Business, printed in every catalogue, now says that the reserve shall be 75 percent of the low estimate, though this was not true at the time, nor was it true of the Nogari.

turned out to have been stolen in Europe during World War II. Sotheby's said it had dealt with an agent, but later it emerged that it had dealt with the principal.

Neither of these cases involved chandelier bidding, but together they served to focus attention on the routine deceptions of the auction process. Commissioner Angelo J. Aponte, in New York's Department of Consumer Affairs, set up an inquiry into auction house practices. At more or less the same time, the Department of Trade and Industry in London announced an inquiry into the operation of rings, while the Environment Committee of the City of Westminster announced that it was thinking of requiring all auction houses within its jurisdiction to be licensed, as happened in New York and Paris.

Outwardly, Sotheby's took a robust attitude toward these inquiries, adopting the line that neither in theory nor in practice was there anything wrong with the way auction houses operated. Hodges's documents, however, showed that privately Sotheby's reaction was somewhat different: the company commissioned an in-house survey of saleroom practices in New York, London, Hong Kong, Switzerland, Amsterdam, and Spain. In particular, Sotheby's considered the question of chandelier bidding. Michael Ainslie, chief executive officer in New York, sent out a questionnaire. Its most interesting aspect in our context was question 7a, which read: "But are you [i.e., Sotheby's auctioneers] pretending to make sale bids which are not made?"

The replies Ainslie received to this question make revealing reading. Graham Llewellyn had originally replied: "Some auctioneers may employ a technique of opening bidding below reserves with *successive* bids whilst others will simply open up bidding at one bid below reserve." (Emphasis added.) This is hardly startling, but it may well have been the first time anyone in a major auction house admitted in black and white that chandelier bidding does take place. Note also the emphasized word, "successive."

Graham Llewellyn and Julian Thompson had "additional thoughts" about question 7a, which put a most interesting gloss on the subject.

Thompson's memo to Ainslie, dated August 16, 1985, reads: "The question would read more clearly if phrased, 'Does an auctioneer ever make fictitious bids?' The question might be phrased in more detail, 'When the auctioneer starts a lot by announcing a bid below the reserve and no bid is made in the room, does he sometimes announce two or three more bids in *succession* to try to draw out a reluctant bidder in the room?' [Emphasis added.]

"The answer we have given has been influenced by our discovery that in a television programme entitled 'In at the Deep End,' in which an actor was trained by us to become an auctioneer it is clear that he was taught by his instructor, Peter Nahum, to adopt the practices we are considering. The film of this programme is held by the BBC and we are sure would be made available if pressure is brought. This means in effect that our position is much nearer Christie's following Burg's [*sic*] comments to the New York Times than we had hoped could be substantiated. . . ." (Christopher Burge is chairman of Christie's for America.)

The phrasing of this memo is curious and yet revealing, especially those words at the end of the paragraph: ". . . than we had hoped could be substantiated." The fact is that the BBC film confirmed that Peter Nahum, then head of Sotheby's British picture department, had taught an actor to acknowledge "bids" that had never been made. However, it seems that but for this, Thompson and Llewellyn would have preferred that Sotheby's give a different answer.

Another memo circulating at this time was written by John Marion, Sotheby's chief auctioneer in America and, subsequently, chairman. This was Marion's response to Ainslie's questionnaire. On August 23, 1985, he wrote, in part, "Bids to protect the reserve are made by the auctioneer in competition consecutively against order bids [commission bids], telephone bids and bids in the room. Bidding opens at a percentage of the low estimate (usually 40–50%). It is not uncommon for the auctioneer to make the *first few bids* on his own in order to move the sale along." (Emphasis added.)

These internal memorandums are all important background for
the document that I thought so shocking. They revealed a certain
sensitivity on Sotheby's part about chandelier bidding—but that did
not mean that the firm was about to give up auction manipulation.
On the contrary, at the time Michael Ainslie was carrying out his
in-house survey, his colleagues—subordinates—were refining the
technique in new ways. Like so many of the documents, this one
may speak for itself. Dated February 19, 1987, it was a telex sent
from J. G. ("Jurg") Wille, head of Sotheby's in Zurich, to John Goss,
in the book department in London. It read:

> Re: Sale Monday Feb. 23
> As indicated Inez Bodmer will protect following numbers
> up to value known by you:
> 124, 132, 144, 146, 155, 162, 164, 168, 170, 180, 188, 253,
> 254, 255, 262, 263, 325, 326, 327, 328, 329
> Natasha as follows:
> 129, 142, 145, 147 [and so on]
> Myself over the phone will protect:
> 206, 207, 208, 209, 210, 216, 217, 227 [and so on]
> Please keep telephone free for my calls

So there we have it. The sale on February 23 was a routine auc-
tion of maps and books. Despite the internal questionnaires, the
worries by Graham Llewellyn and others as to how much the com-
pany should admit about chandelier bidding, Sotheby's had in fact
developed and refined this ploy in a particularly modern way. In this
instance, three members of the Zurich staff were on the telephones
to London during the sale, pretending to make bids on (i.e., "pro-
tecting"), in all, seventy-one lots. The lot numbers in the telex all
referred to a single section of the sale, a collection of maps, de-
scribed as the "Property of a European Nobleman," which ran from
lots 124 to 337 inclusive.

As part of our research for the first Channel 4 program, we tele-
phoned J. G. Wille, in Zurich. He confirmed the authenticity of the
telex that Hodges had provided. He also said that there was nothing

wrong in what Sotheby's had done in this instance. We asked the company in London if it was regular practice for fake telephone bids to be employed in its auctions. It refused to comment.

Despite this, there seems little doubt that the new practice is blatantly at variance with the intention of the law and goes against Sotheby's publicly stated policy. More than ever, a false impression is being created, an impression that there is a brisk market for certain items when, in fact, the market may not exist. It is impossible to know how often this technique is being used, or has been used in the past, but the routine nature of the telex strongly suggests that this was not the first—or the last—time that fake telephone bids have puffed up Sotheby's auctions.

Now we may return to Professor Brian Harvey, of the faculty of law at Birmingham University, a world expert in auction law. He confirmed that in Britain fake bids may contravene either the Sale of Goods Act or the Theft Act. He also said that according to the law, the auctioneer may only bid on behalf of the vendor. This wording, he said, may be taken to mean that a company like Sotheby's may only bid *once* from the rostrum, or take *one* bid off the chandelier or wall. *Successive* bids, according to Professor Harvey, are probably illegal. (He used the word "probably" because although the wording of the law is clear, it has never been tested in court.) It will be recalled that in the exchange of documents referred to earlier, Julian Thompson, Graham Llewellyn, and John Marion all confessed that Sotheby's auctioneers *do* make successive bids to get auctions under way.

That completed the five sets of documents that we used as the basis for the first program, which Channel 4 entitled *Sale of the Centuries*. The whole of October 1995 was spent in the editing suite, trying to compress what we had into fifty-three minutes that, with commercial breaks, would make up an hour-long program.

—ɯ—

The 1995 Broadcast

In our original television venture, our first program was broadcast on November 8, 1995. An article based on the Sekhmet incident had appeared in the London *Observer* the previous Sunday. Sotheby's, which had been given a total of five opportunities to take part in the program, and had been told repeatedly in advance what we were going to say, had offered only "No comment."

In one instance, however, Sotheby's broke its own rule: its lawyers, Freshfields, put into writing, in a letter of complaint to Channel 4, a charge that hitherto it had insisted should be *off* the record and that it had expressed only verbally. This was its view that some of the documents Hodges had supplied had been forged, some were altered, and some were genuine.

Whenever Sotheby's had said this before, I had always responded in the same way. If the company would show us which documents had been altered or forged, so that I could see how the story changed, then I would either alter what I wrote or not publish at all, if the true story was substantially different from that revealed in the documents.

Not once, however, did Sotheby's explain just how—or which or where—documents had been forged. Sotheby's was, in effect, willing to risk having a falsehood about them published rather than set the record straight ahead of publication and perhaps prevent publication altogether.

Interestingly, Sotheby's did not say at that stage what George Carman had warned us it might say—that the documents were genuine, but did not give the whole picture, and that when the whole picture was seen the reality was very different.

I came to the conclusion, over the months, that Sotheby's stance was a posture, an elaborate form of bluff. The documents were not forged or altered, but Sotheby's wanted me to think they were, so that nothing detrimental to the company would appear on air or in print. This was an unreasonable way to behave, and I told Sotheby's so. I also regarded myself, in this instance at least, as released from the restriction of the "off the record" basis of our conversations. Sotheby's had broken the embargo itself, in the Freshfields letter to Channel 4. Still, Sotheby's was adamant and refused to cite chapter and verse about how the documents had been changed.

What it came down to, therefore, was that the only way to test Sotheby's argument was to go ahead, and to see how it responded. In particular, would it sue?

The reaction to the program in the art world was electrifying. Everyone was talking about it; no one seemed to doubt what was revealed. I heard that the employees of Bonhams, a rival but much smaller auction house, had been instructed to watch the program, or get hold of a tape if they had missed it. As I understood it, Bonhams wanted its employees to be aware of the way scams operated so that they could avoid being caught up in them.

After the initial lawyers' letters (Freshfields also wrote to *The Observer*, objecting to a headline), Sotheby's lapsed into silence. I was disinvited from a couple of social events but managed to find other things to do. In practice, the company made only two responses. One was to a Middle Eastern journalist who wrote an article, in Ara-

bic, for a Saudi Arabian magazine. To her, Diana Phillips, Sotheby's
chief press officer in New York, dismissed me as an "upstart" jour-
nalist who craved fame. This, I thought, was a bit much, since when
I had been researching my earlier history of the art market, Phillips
had arranged for me to interview her boss, Alfred Taubman, chair-
man, an American who normally did not speak to journalists or writ-
ers. Taubman, as I've suggested, seemed a decent type. Since the
beginning of the Hodges affair, I had often wondered whether Taub-
man knew what he was buying into when he acquired Sotheby's.

A more substantial reaction took place when Sotheby's talked to
Anthony Thorncroft, the *Financial Times*'s respected saleroom cor-
respondent, who had been asked to review the program for the
American magazine *Art & Auction*. The review, which occupied a
page, was headed "Watson v. Sotheby's," a personalization of the
matter that to me seemed off the point. This was not a personal
grudge of mine. Although the review contained some criticisms of
the program (mainly, that many of the objects discussed had not ac-
tually reached the saleroom), the article concluded that the art trade
in general felt that it showed "first blood to Watson."

In the course of the review, however, Sotheby's more recent boss,
Dede Brooks, who had agreed to talk to Thorncroft, said she was ir-
ritated by the article because it "lionized" a "convicted felon" who
was conducting a "vendetta" against his former employers, because
the practices it described no longer went on, and because the cur-
rent management had been besmirched by association with these
ancient habits.

There were a number of observations to be made about Ms.
Brooks's comments. The first was that Ms. Brooks seemed to be
conceding that improper procedures had been followed in the
past—an implicit agreement with our accusations concerning such
conduct by Sotheby's in the past.

The second point was that it was simply not true that the man-
agement at Sotheby's was entirely new. Yes, Dede Brooks was herself
new in the top job, not having taken over until many of the incidents

reported in this book were past; yes, Tim Llewellyn had left to be-
come director of the Henry Moore Foundation, and was replaced as
chairman in London by ex-dealer Henry Wyndham, who could not
be associated in any way with past practices. George Bailey had been
brought in from outside to run Sotheby's Europe. But that was all.
In 1995, Julian Thompson was still on the board of both Sotheby's
Holdings, Inc., and Sotheby's Europe; Marcus Linell was still a se-
nior director, as were Michael Thomson-Glover and Colin Mackay.
Felicity Nicholson was still in charge of antiquities, Oliver Forge
was still her deputy, and Brendan Lynch had actually been pro-
moted, to head the new department of Indian and Southeast Asian
art. None of these people were shown to have suffered or been dis-
ciplined in any way for their activities. Dede Brooks, of course, had
been a member of Sotheby's management since the late 1970s and at
least fourth in seniority in New York since the mid-1980s.

And third, there was the fact that although Ms. Brooks and her
press officer and in-house attorney had repeatedly told me—albeit
off the record—that the documents on which the program was to be
based were either forged or altered or tampered with, she made no
such claims to Thorncroft. This confirmed me in my view that the
company's earlier stance had been a bluff, a misuse of the off-the-
record conventions that exist between journalists and many of the
people they deal with. The company had simply abused the arrange-
ment to suit itself, and I therefore regarded myself as free to write
about what they had told me.

So far as lionizing a convicted felon was concerned, that was, I
suppose, a matter of interpretation. But, for the record, the fifty-
three-minute program contained less than two minutes of inter-
views with Hodges, two minutes about my early meetings with him,
and two minutes on the trial. That was all. Referring to the stolen
documents he had made available could in no way be regarded as li-
onizing him.

As was highlighted in the first program, in Sotheby's antiquities
sale in July 1995, which we secretly filmed, the company sold six un-

provenanced Apulian vases. The logic of the British Museum con-
tinued to apply: Sotheby's was still selling material that it had known
was, by definition, illegally excavated and smuggled out of Italy.
Many other objects in their sales had no provenance. Nothing had
changed.

The attitude of the company was truly extraordinary. It was a
blunt refusal to accept logical arguments, to acknowledge that what
it was doing was wrong and could be seen as wrong. However, for
the time being, Bernard, Sam, and I were content to let this go.

A month went by. David Lloyd, the editor of *Dispatches* at Chan-
nel 4, was well aware that the first program might be followed by an
even stronger one, but at that stage he had not committed to an-
other program and said that it was not even worth discussing until
we had given Sotheby's a chance to respond more fully.

It was not until then, therefore, that David, Bernard, and I met to
talk tentatively about a second program and its possible content.
Channel 4 had, in the opinion of many people I talked to, been very
brave in going ahead with the program, which strongly criticized a
high-profile company. David Lloyd and Channel 4's in-house law-
yer, Jan Tomalin, had shown impeccable judgment in helping to
give the first program its final form.

At our lunch, David's main concern was that for the second pro-
gram we should try to update the material in the documents. The
long delay in getting the story out meant that the paperwork was
now dated, because it related to events in the mid to late 1980s. He
accepted that Apulian vases were still sold in much the same num-
bers as always and so, on the face of it, the old practices—and mal-
practices—continued. Nonetheless, a journalistic investigation of
Sotheby's practices in the mid-1990s, where we now were, would
make a far stronger current-affairs program. Even then it was still
too soon to go firm, and we decided to adjourn for another month,
until the end of January. The auction season dies between the sec-
ond week of December and the second week of February. If

Sotheby's was going to respond further, it would have the opportunity to do so.

I realized that the one area where we did have solid information and where we might be able to update the story was in old master paintings smuggled out of Italy. We knew which office was most concerned, we knew what sort of goods were involved, we knew which people were involved, and we knew how the approach should be made.

I had a meeting with Bernard and Sam in the last week of January 1996. They agreed. There was just one problem—we needed an old master we could use in what we referred to as an "experiment." I had of course been down this route some time before.

This time Bernard came to the rescue. He thought he might be able to persuade Channel 4's David Lloyd to put up the money to buy an old master. How much did we need?

How long is a piece of string? I replied, thinking wildly of buying a Canaletto. I said £25,000 (about $40,000) would be reasonable.

Bernard frowned.

"Fifteen?" I said.

"I'll shoot for twelve," he replied.

In the event we got ten. But if £10,000 was disappointing compared with the £25,000 that we wanted in an ideal world, it was still a great deal better than nothing, and showed that David Lloyd was still proving to be a loyal and imaginative editor. If we could buy the right painting we might be able to find out if, whatever Dede Brooks and Diana Phillips said about Sotheby's being under new management, the story had changed. Sam and I made arrangements to meet Cecilia in Rome, prior to traveling to the city we'd use first in our "experiment"—Naples.

Now we are back to where this book began, to February 1996, and our successful attempt to have "our" painting bought, smuggled, and put up for auction in London.

BOOK THREE

THE ARREST

—ᴍ—

The Auction of
the Old Lady

When the painting we had purchased turned up in the auction house's London catalogue, we knew that, intellectually speaking, our project was over. We had demonstrated that Sotheby's continued active trading in smuggled Italian old masters. We now understood even better how the procedure worked and what sort of pictures were involved.

But we wanted to follow one painting through to auction. This course, however, posed its own set of problems. Strictly speaking, although Sotheby's had been the prime mover in the smuggling itself, we were passive accomplices, in that we had allowed Italian law to be broken. This seemed a minor infraction, considering the kind of thing we were exposing, but it still left us with a responsibility toward the Nogari. We needed to buy the painting back. Whatever it cost, we could not let someone else buy it. We had to have it, and then return it to Italy.

This was dangerous. What if there was someone else in the saleroom who loved the Nogari and simply had to have it? I explained to Sam and the others that this was not the threat it seemed. The

Nogari was a nice piece of art, but not one that many people were likely to fall in love with.

We cleared the plan to buy back the painting with Channel 4. It involved them in some extra expense, but not as much as might appear. And, as noted earlier, film of the actual auction would be valuable evidence. The Nogari was estimated at £7,000–10,000, which meant that it was unlikely to go for more than the higher sum. If it sold for £10,000, we would have to pay a 15 percent seller's commission of £1,500, a 15 percent buyer's commission of £1,500, plus VAT on the commission, plus 1 percent insurance, plus £450 for the illustration in the catalogue. The total charge would, therefore, be £4,075. If the picture fetched more, say £15,000, then Sotheby's charges would be £5,887.50. Channel 4, as both seller and buyer, would in either case get back the remainder, even though it would be by a roundabout route (Sotheby's would pay Heather Cotham, as the putative owner of the picture, and she would reimburse Channel 4).

This did, of course, mean that we had to have someone to buy the picture on our behalf—someone whose bank account would be temporarily flush with Channel 4 funds. This time it was Peter Minns, the director of the program, who came up with a name: Eve White, a friend of his, the wife of a pop star. When we met, I thought she was perfect. She was in her thirties, beautiful, bright, and brimming with self-confidence, and had a gleaming smile worthy of any toothpaste advertisement.

A few days before the sale, Peter took her to Sotheby's to show her the ropes. Since we were going to film the sale, using hidden cameras, we needed her to sit somewhere convenient, preferably on the aisle, halfway along. There both the cameraman and the auctioneer could see her easily. But first we had her call Sotheby's and inquire about registering for the sale. If you are going to bid at auction above a certain financial level, you need to have your credit rating checked in advance by the saleroom's credit department. But £10,000—and even £20,000—was below that limit. Provided she registered her name and address before the sale, Eve could bid on what she wanted,

and could pay by check, credit card, or bank draft. The painting would be released only after the funds had been cleared.

Having told Eve where to sit and how to pay, I then helped her with bidding. A lot of nonsense is talked about auction bidding. There is in practice almost no chance of someone waving to a friend, or blowing her nose, or scratching an eye, and then finding she has bought an expensive masterpiece. Auctioneers are not stupid, objects are not knocked down that quickly, and if there is any doubt about a bid the auctioneer will usually say, "Are you bidding?" He will often identify the bidder in some general way—"The bid is near me, in the aisle"—so that people have a good idea what is going on. Accidents almost never happen. Nowadays, also, when bidders register they are given a plastic paddle with a number on it. The salerooms prefer people whom they do not know well to begin bidding with these paddles, to show they have registered and to identify themselves later if they are successful.

Accordingly, I told Eve to start bidding by raising the paddle she would be given when she registered. She was not to be shy; she should stick it right up in the air. After she had got the auctioneer's attention, I said, he would keep coming back to her, if there were other bids in the room, and she could bid in any way she wanted— by nodding her head, raising her finger, even winking, though with her looks I did not recommend the latter course. The estimate was £7,000–10,000, so the bidding would probably start around 40–50 percent of that.

"And what if it goes over the estimate?" she asked.

"Keep going. Buy back the painting, whatever it costs."

"But what if it goes to fifty thousand, a hundred thousand, millions?"

"Keep bidding. But it won't go that high."

"How can you be so certain?"

"Because it's a nice picture, nothing more. It's well painted, but an unattractive subject. The people around you will be professionals. They are not going to bid up a painting that isn't worth it."

In fact, the only danger I could see was if someone just happened to have the pair to our Nogari, the young woman to go with our old crone, as Kollewijn had mentioned. If anyone did have the pair, then he or she might go above the estimate—but even then not by very much. I did not tell Eve this, however, since it might have confused her. As it was, she was amazingly composed, and eager to do well for us.

There was one final potential problem we had to deal with. Right at the beginning of the project, back in Naples, Concha Barrios, from whom we had bought the Nogari, had recognized me, or so she said. In all probability, she and Antimo d'Amodio would be in London for the sales. I was not worried about Concha Barrios recognizing the Nogari; she would be perfectly entitled to assume that Peter Carpenter, or someone else, had got it out of Italy, and it was none of her business. No, our problem was that my dealer friend in London had given me an introduction to d'Amodio but I had used a different name. If d'Amodio were to meet my friend and ask about "Peter Carpenter," my friend might just put two and two together. At the same time, if he noticed the Nogari in the Sotheby's catalogue, he might recognize it as the picture he had valued for me. Here then was someone who could link Peter Watson to Peter Carpenter to the Nogari.

I called my friend three times in the time leading up to the sale. I called him the day the catalogue came out, I called him a week later, and I called him the day before the sale. Each time we had a conversation about the art world and the old masters sale. I gave him every opportunity to raise the topic of the Nogari. If he had spotted it, we needed to know, in case he was gossiping. But he never raised the matter. The Nogari was buried toward the back of the catalogue and he had not noticed it.

The day of the sale, July 3, was cloudy: the recent hot weather was over. The tennis tournament at Wimbledon was doing us a favor. In

the afternoon, when our picture would come up for sale, at around 3:00, Britain's Tim Henman was playing Todd Martin of the United States in the quarterfinals of the men's singles. Henman was the first Briton to reach the quarterfinals since 1973, and with any luck half the nation would be glued to the television, leaving the saleroom half empty and reducing our competition.

Eve reached Sotheby's at about 11:30 A.M. She was wearing a champagne-colored silk suit with a white shirt underneath and looked fabulous. She watched the morning sale, then took lunch in Sotheby's own café on the ground floor. She allowed herself a single glass of red wine to settle her nerves. She was back in the saleroom at 1:45 P.M. and took her seat on the aisle, about halfway back. The sale was due to resume at 2:00. One of the cameramen sat opposite her. He had his camera hidden in a bag, which he kept trained on Eve. The other cameraman wandered about the room. His camera was hidden in his tie and his aim was to film Eve from a different angle, but also to get the auctioneer and the Nogari as it came on the block. Inside his jacket he had a small monitor, which showed the scene as viewed by the camera. But to his alarm, at 1:55 he found that the camera was not working. He nodded to his colleague; they both adjourned to the men's room. Eve looked concerned but could do nothing.

In the men's room the cameramen found that a wire had come loose from the camera and had to be soldered. As the sale was starting they ran out of the building toward Hanover Square, where Sam was sitting in a parked car, guarding the cases of equipment. Quickly, using the cigarette-lighter socket in the dashboard and a small rod of solder, they fixed the wire, adding surgical tape for good measure. Then they rushed back to the auction. Fortunately, the seat across the aisle from Eve was still empty and the cameramen resumed their positions. It was half-past two.

The sale thus far had been mixed. Earlier in the day, the main attraction, the Pieter de Hooch, *A Maid with a Broom and a Pail, in a Sunlit Courtyard*, had been disappointing, selling at the low end of its

estimate, £3 million. However, another important picture, *Death of a Picador* by Francisco Goya, had done very well, fetching £2.5 million against an estimate of £1–1.5 million. The pictures auctioned immediately before the Nogari were a varied bunch. There was the Netscher I had seen in the index, a portrait of an extremely ugly man by Herman Collenius, a Regnault, and a Grimou—all minor painters and, to me, boring subjects. But then lot 140, the Nogari, was put on the block.

A nice irony was that the auctioneer that afternoon was George Gordon. He began the bidding at £3,500, and it soon reached £5,500. Eve now raised her paddle. Gordon saw her straightaway— thank God—and called out, "Six thousand pounds."

There was another bid behind her, and she raised her hand. "Seven thousand pounds. Lady's bid," cried Gordon. Eve was on tenterhooks. There was someone behind her interested in the picture. Would he—or she—bid again? How high would the Nogari go?

Then: "Sold!" Gordon called out. "May I see your paddle, madam?"

Eve held up her green plastic paddle. She had done it. We had bought back the Nogari. Now we could take it back to Italy.

Once we had done that, we could tell our story.

Roeland Kollewijn's actions, and his many admissions to Victoria Parnall in Milan, reported in the Prologue, show that Sotheby's continued to cooperate in the smuggling of old master paintings out of Italy. What we need to do here, however, is explore, for a moment, certain documents that Hodges had at the beginning of our association. They will show why we were so certain that this particular illegal traffic operated out of the Milan office, and why we knew how to go about approaching the staff there.

As we have seen, while he worked at Sotheby's, Hodges was first employed at the Pantechnicon, the company's second-string saleroom in Belgravia, as an administrator in furniture and antiquities. Documentation came his way naturally. One of the things administrators do in auction houses is file the paperwork. But this chapter

concerns departments in which Hodges never worked. How, there-
fore, had he come across this paperwork?

The documentation on Italian old masters that Hodges gave me
comprised thirty-four memorandums—fifty-five pages—stretching
over a number of years, between Tim Llewellyn, at one time head of
old masters at Sotheby's, and Nancy Neilson, an American art his-
torian attached as a consultant to the Sotheby's office in Milan. The
bulk of the correspondence concerned Neilson's contacts with Ital-
ians living in Italy who wanted to sell their paintings "in London."
Here are just a few examples:

June 10, 1980, Nancy Neilson to Tim Llewellyn: ". . . Cortona
has been by and wants to sell his little Guardi portrait in London
with a riserve [sic] of £2500 net. . . ."

June 17, 1980, Tim Llewellyn to Nancy Neilson: ". . . we would
be happy to put the Guardi in the London December sale but we
need to have it very soon. . . ."

April 10, 1981, Nancy Neilson to Tim Llewellyn: ". . . the Stand-
ing Man seems to be a candidate for the London July sale. . . . Ask
Dennis about a P. Longhi he and I saw together. We made an esti-
mate of 20/30.000.000. The owner wants a reserve of 26.000.000,
but wants to sell in London, i.e., a reserve of c. £13,000. . . ."

December 15, 1981, Nancy Neilson to Tim Llewellyn: "Enclosed
is the photo of the Zuccarelli we were talking about some time ago.
The owners did not like the estimate of 40/60.000.000, insisted the
picture was for London etc. etc. Have you any further comments?"

March 8, 1982, Nancy Neilson to Tim Llewellyn: ". . . the other
pictures belong to a client who wants to know if London is inter-
ested in the two still lives. He doesn't want to sell the Foschi in Flo-
rence because he is afraid of a notification—wrongly to my mind."

December 20, 1982, Nancy Neilson to Tim Llewellyn: "What do
you think the enclosed Eismann could make in London? The owner
is also interested in a private sale if possible."

Normally, then, certain Italians would contact Nancy Neilson
and ask her to provide two valuations for what they wanted to sell—

one for Italy and one for the open market in London. Neilson would either reply directly or ask advice from Tim Llewellyn in London. The information would be relayed back to the client, and, some time later, the pictures would turn up in London. On occasion, in the process the Italians would have acquired a British address.

Most of these pictures (there were exceptions, for example the Guardi) were not by well-known artists—but that was the point. Well-known paintings draw attention to themselves. Reputable art historians or museum curators might well have seen them in Italian homes, and would therefore be able to testify that if they did not have export licenses—and they did not—they must have been smuggled out of Italy. This traffic was in minor works but was frequent, helping to provide part of the bread and butter of Sotheby's old master sales.

Other documents showed how the procedure worked in detail. There were, for example, several letters on headed notepaper from one Bruno Scaioli. The address on these letters, all concerning paintings, was given as 31 Corso Lamarmora, Alessandra, in northern Italy, although in property receipts his address was only ever given as "c/o Alex Apsis" at Bond Street. (Apsis now works for Sotheby's in New York, where he is a director in the impressionist and modern department.) In one of his letters, Scaioli pointed out that his property would often be consigned in the names of Graciello Castillo or Roberta Necchi, but that in either case the property was still his. At least fifty paintings were sent for sale using this device. We traced twelve pictures of his that were sold in London.

By far the most sophisticated scheme was disclosed in a number of Sotheby's internal memorandums relating to a very odd couple indeed—a Mr. Turri and a Mr. Sturm. Nancy Neilson, in a memo dated July 28, 1980, to Tim Llewellyn, referred to a painting by Marco Ricci. Ricci (1679–1730) was a Venetian who specialized in landscapes and *capricci*—imaginary and improbable architectural fantasies. The memo read: "The owner of the Marco Ricci is happy

with 3/5 milioni, but may want to sell in London. He will let us know."

This must be set alongside a second memo, dated December that year, that according to Hodges was kept in the same file. It referred to "Paintings belonging to Mr. Turri, inspected in Zurich." The fourteen paintings listed included a work by Jacopo del Sellaio, *Christ as the Man of Sorrows*; a *Judith and Holofernes* attributed to Rodolfo Ghirlandaio but with "Lattanzio Gambara" scribbled in the margin; *Tobias Cutting Open the Fish*, by Lorenzo Lippi; *The Sacrifice of Isaac*, "in the following of Carlo Dolci, perhaps near Orazio Marinari"; a pair of paintings with no title, attributed to Gobbo da Cortona; *Figures Outside an Inn*, by the circle of Mattei dei Pittocchi; a pair of anonymous eighteenth-century Italian pictures; "a fine, big Huillot, which is signed and dated 1718 and in an excellent state"; a *Virgin and Child* attributed to Biagio di Antonio; and a pair of landscapes by Marco Ricci.

Bear in mind that this memo was kept in the same file as the Neilson document referring to the owner of the Marco Ricci who was "happy with 3/5 milioni," i.e., happy with an Italian price. Could this mean, therefore, that although Mr. Turri's pictures were inspected in Zurich, those mentioned above had just come from Italy? This is confirmed in the same memo. Tim Llewellyn referred to four octagonal pictures—these include the Lippi and the follower of Dolci in the above list—but then added, "The two *still* in Florence of the Healing of Tobit should *remain* there and eventually be sold there." (Emphasis added.)

This sentence indicates that the rest of the paintings originated in Florence and that Llewellyn and the others in Sotheby's, such as Neilson, knew that they did. Further evidence comes in a note appended to this report, which reads as follows: "For John Winter [a consultant]: Mr. Turri wants a print expert and an expert in Anatolian rugs to see him in Florence."

In other words, Mr. Turri, who lived in Florence, showed his pictures to Nancy Neilson in Milan, was given a valuation, then took

the pictures to Zurich, where they were seen again by Tim Llewellyn. But that was not the end of this story. Another memo in the same file was undated but was in the same typeface as the John Winter and Turri memos and had a similar layout. However, it had been sent to Dr. Jurg Wille of Sotheby's in Zurich. Llewellyn wrote: "Re. 'Emile Sturm' [note the quotation marks] We have now considered this group of pictures and would very much like to include the best of them in our important sale in November. . . ." He then went on to discuss the same list of paintings that earlier had been described as belonging to Mr. Turri.

Why the change of name? Could it be that consigning the paintings from Switzerland was not enough of a disguise in this case? Mr. Turri may have worried that if customs or tax officials ever raided Sotheby's in London, his name would be discovered.

Seven of these paintings were sold in Sotheby's old masters sale, in London, on November 17, 1982. The attributions are substantially the same as in the early lists, as are the estimates.

Finally, in the case of Sturm, a more recent memorandum, written on January 19, 1988, from Oliver Forge in London antiquities to Guy de Lotbinière in Sotheby's Rome office, was kept in the same file. Headed "Mr. Emil Sturm," it began: "We still have a marble torso and a marble head belonging to the above client at the warehouse. Could you let us know what we are to do with them? Could we include them in our 23 May 1988 sale? Our estimate on the torso is £1,200–1,500 (suggested reserve £1,000) and on the head £600–800 (suggested reserve £400)."

De Lotbinière wrote his reply in hand on the very same fax. "Dear Oliver, I'm afraid I know nothing about this client or his property. In the two and a half years I have run the Rome office I have never had anything to do with antiquities as it would have been a criminal offense to have such objects on the premises! I suggest you continue to [obliterated] through some other office."

Forge certainly had the impression that Sturm lived in Italy.

But Mr. Turri and Emil Sturm were not the only names of inter-
est. Another was one Carlo Milano, said to be a resident of Zurich.
On May 3, 1988, for example, Sotheby's issued a property receipt
for two objects, an Egyptian stone statuette of the Ramses period
(18th–19th dynasty) and an Egyptian stone relief. The statuette,
about 30cm high, was valued at around £30,000, and the relief,
about 26–28cm square, at £20,000. Both had been consigned, ac-
cording to the documentation, by Mr. Carlo Milano, c/o Sotheby's
in Zurich. They were entered in the antiquities sale of July 11–12
that year, as lots 30 and 50.

Before the sale, on June 23, Oliver Forge wrote a memorandum
to Felicity Nicholson, calling for subterfuge: "Bruno rang about the
2 Egyptian pieces in the July sale. He would like the reserve on the
block statue (Lot 30) to be £14,000 and on the relief (Lot 50)
£12,000. If you would like to change them could you refer to the
block statue as 'the 1st baby' and the relief as the '2nd baby.' Also
refer to suggested reserve just as 10 (when referring to £10,000). He
says he feels this is necessary."

The question arises: who was "Bruno"? According to Sotheby's
Group Telephone Directory for 1989–90, there was no Bruno
among the twenty-five staff listed for Zurich and Geneva. There
was, however, a Bruno Muheim among the six staff of the Milan of-
fice. A second memo concerning lots 30 and 50 referred to a "1st
baby" and "Bruno M." Yet again, therefore, we appear to have a
rerun of the Turri/Sturm procedure, whereby objects apparently
coming from Switzerland arrived from Italy.

Now we move forward a year, to May 18, 1989, when a tele-
phoned message was sent to James Hodges from Grazia Besana, in
Sotheby's Milan office. This referred to the fact that one of the lots,
30 or 50, had failed to sell. The owner, wrote Grazia Besana, wanted
to know when the objects would be offered again. However, she re-
ferred to the owner not as Carlo Milano but as a *she*. A fax from the
Milan office identified a Mrs. Dal Bono as the person who was to

receive all the receipts, and a separate memo said an introductory commission was to be paid to a named individual in Milan. Carlo Milano, like Emil Sturm, was a fiction—a rather simplistic, crude code in fact.

Two more documents attracted our attention. The first, on blue memo paper, was dated August 1, 1984, and addressed to Jonathan Bourne, in furniture, from Richard Camber, in antiquities. It showed that what was happening with antiquities, with old masters, and with nineteenth-century paintings coming out of Italy was almost certainly happening with furniture, too. Headed "Property in Italy," it read: "Thank you for your note of July 12 regarding Mr. Rossi and the other Italian clients who have difficulty exporting their property from Italy to Monte Carlo. I foresee three difficulties with the scheme which you outlined: 1. Even if a third party buys the pieces from Mr. Rossi and exports them in their name as opposed to his they might still be recognized as having been his property. They would, accordingly, be stopped from leaving Italy. 2. If the third party buys the pieces from Mr. Rossi and money changes hands, irrespective of whether it be full or partial payment, it could be extremely difficult to retrieve this money in the event of the property being stopped. 3. Unless the company in question was quite distinct from Sotheby's, the purchase of the property, or alternatively the granting of a 100% advance, could place us in the position of principals rather than agents, which we are most anxious to avoid. In the past I have dealt with the situation in another way, which I would prefer to explain to you personally rather than commit to paper. May we discuss when I return from holiday at the end of August? In the meantime, you might want to have a word with David Ward to see whether or not Al Taubman's Financial Services scheme is designed to deal with situations of this nature."

Questions: Was it Jonathan Bourne's plan to buy furniture in Italy, and have it brought out, because Mr. Rossi was wary of such a move? If so, this idea echoes Felicity Nicholson's plans for the Sekhmet figure in Genoa. What was Richard Camber's preferred

method of doing business in this way, which he would not commit to paper but had used in the past? But coming on top of everything else, this memo certainly supports the notion that old master paintings, antiquities, and furniture were making their way north, illegally, from Italy to London or Switzerland or Monte Carlo, to be sold at Sotheby's auctions.

The last document in this particular group may describe the most audacious scheme of all. I failed to appreciate its significance at first, but when I did I was dumbfounded. The blatant nature of the law-breaking described is sobering. It was part of a series of five transactions, eight pages in all, describing yet more old masters being sent from Italy to London, among them a Scarsellino and a Bassano. There, in a memo sent by Llewellyn to Neilson on March 10, 1980, he concluded that he was going to Florence on March 24 "to finish the June sale."

Now, according to Sotheby's itself, when we asked, posing as picture researchers for the dealer Peter Carpenter, the company held three old master sales in Italy in 1980. They took place in Florence on May 6, September 27, and November 25—that is to say, there was no Sotheby's sale of old masters in Italy in June 1980. On the other hand, there *was* a sale of old masters in London on June 11. In other words, and if Sotheby's own records are to be believed, Tim Llewellyn was organizing the London sale *from Florence*.

The arrogant way in which Sotheby's was removing Italian paintings from under the noses of that country's law enforcement agencies and the copious documentation that described this appalling trade, putting much of it on paper, just cried out for the exposure that we were working on.

Sam, Peter Minns, Victoria Parnall, and I returned to Naples and Milan in October 1996, to reconstruct the events as accurately as we could, for the second television program. Cecilia Todeschini was again our local researcher. Despite torrential rain and Princess Diana's arrival in Rimini to receive an award (an event that made rival claims on Cecilia's time), everything went well. We interviewed

Colonel Conforti, the head of the carabinieri's art squad, again. By
now, of course, he had seen our first program, and he was greatly
angered by its disclosures. He revealed that an inquiry was under
way into the Temple Singer affair and that he had set in train an in-
ternational *commission rogatoire*, a diplomatic device by means of
which Italian police would eventually be able to question Sotheby's
staff in London.

We also talked with D. Lodovico La Volpe, of the Italian Ministry
of Fine Arts. He likened the traffic in illicit works of art to money
laundering and called on the British government to take a firmer
line with any of its nationals found breaking the UNESCO conven-
tion on illegally excavated works of art.

On October 9, 1996, Victoria Parnall went back to Milan to see
Roeland Kollewijn. She said she had been disappointed by the price
"her" painting had achieved at auction in London and wondered
what she should do with the rest of her collection. He said he did
not know who had bought the picture, but felt it might have been an
Italian dealer who would have brought it back to Italy. Victoria
asked if it would have made a difference to the price if the picture
had had an export license.

"No," he said. "This was something we shouldn't do." He went
on to say that the only way she could have saved money would have
been to remove the picture from Italy herself. The way it had been
done, he said, was much cheaper than going through proper chan-
nels. Then he said, "I thought you wanted to do it the way we did
because you didn't want to be known as the owner of the picture?"

Victoria agreed that she hadn't wanted to be acknowledged as the
owner. (Not least, of course, because she wasn't.)

"That's an excellent reason not to do it in a legal way," Kollewijn
added.

He said that the old lady had not sold well because she was sad
and not an attractive subject. But if Victoria's other pictures were
much better, then they might sell in London for four times what
they would fetch in Italy. He discussed the idea of sending them out

of Italy all together, as one lot. Even if she did not sell them, he said, it was still worth her while to smuggle them out. She could take them home with her to Australia. She could enjoy them and then, at a later date, if she wanted to sell, there would be no problem.

Kollewijn was incorrigible.

—⚞⚟—

The Men from Bombay

The Milan adventure, consisting almost entirely of secret filming, was a dramatic part of our second program. Certain individuals at Sotheby's continued to do what the company denied doing.

Powerful, but not enough. Practically speaking, it was too short. What we had would amount to a maximum of twenty-five minutes on air, and the program was intended to be forty-five minutes long. More, I felt it was not intellectually thorough enough. The first program had concentrated on antiquities smuggling and auction rigging. The second program, besides updating the material, should go further, as the Hodges documents did. The whole point of making this second program, I felt, was to show that wrongdoing went well beyond smuggling out of Italy.

Here, however, there was a difference of opinion with David Lloyd. Television, even serious television, is a popular medium, in the sense that programs are frequently shown to, and need to appeal to, people who have no specialist knowledge of the subject in question. Also, as a rough guide, there are about seven thousand words spoken in a one-hour television documentary, compared with, say,

the approximately 100,000 words in this book. David Lloyd thought that some of the issues raised by the documents were possibly too complicated to be told in a fair way with the relatively restricted time at our disposal.

Bernard brokered a compromise. He agreed with David that smuggling was one issue everyone would understand, and he reminded him that Hodges's documents showed that Sotheby's had, over the years, had a hand in smuggled goods from Italy, India, and France. That, he said, was a convincing message. He thought that a second segment of the new program should examine smuggling outside Europe. He suggested India: it was the country on which we had the most documentation. David Lloyd agreed. Program two had its shape, at least provisionally.

The India venture was ambitious. Brendan Lynch's activities had been briefly mentioned in court, at Hodges's trial, again without any attempt by Sotheby's to show that the supporting pages were bogus or that such practices were out of the question. The memorandums, property receipts, and ledger entries were detailed, and even more bulky than those for Italy. Some listed legitimate business activity, and business that Sotheby's hoped to get; but there was much that was far from legitimate. Hodges explained that everyone who worked in antiquities was well aware of the degree of smuggling that went on from India and elsewhere in the Far East, that Sotheby's staff regularly traveled to India undercover, pretending to be on vacation or writing a book; and that certain dealers, such as Mr. Ghiya of Jaipur, came to London for the sales—this dealer had consigned large quantities of goods that he brought in via several Swiss-based companies. Hodges said he had often stored Mr. Ghiya's surplus items in his basement at home.

The law governing the export of art and antiquities from India is no less severe than that relating to Italy—in fact, the laws are quite similar. No art object of any kind more than one hundred years old is allowed out, except temporarily for exhibitions. Moreover, it is illegal even to possess antiquities in India without a government

license. There is, therefore, the same need for a laundering operation, in, say, Switzerland. Virtually *nothing* is allowed out legally. The sheer bulk of documentation in Hodges's possession suggested that the clandestine traffic was huge. Hodges did not know Brendan Lynch as well as he knew Felicity Nicholson—Lynch's office was separated from his by two others. But, of course, as administrator, Hodges was given all the paperwork to file. . . .

Chronologically, the first document in the package was written by Patrick Bowring, on March 18, 1986. It was a report on a visit he had made between February 6 and March 6 that year, to Delhi, Jaipur, Bombay, Calcutta, and Lucknow, during the course of which, according to the list he provided, Bowring had met seventy-three individuals. There were problems about operating in India, but these, Bowring felt, were containable. In a section headed "Sotheby's experts in India," Bowring had written: "For reasons of monitoring our position in India as regards the government it is imperative that any member of Sotheby's wishing to visit India whether on holiday or business should notify Julian Thompson or myself so that a rigid report can be kept. Any visit by a Sotheby's expert will be monitored in India and justification for such a visit should be readily available. It is unconvincing to say every expert is there on holiday and even the pretext of 'writing a book' is wearing pretty thin!"

He then launched into an account of the people he had met. The raja of Jehangirabad ("Jimmy") was "a most delightful Neurotic who has a considerable amount of good property including miniatures, jewelry, textiles, silver, etc. This was my second visit to see him and I believe I have now got his trust. Besides my taking a number of photographs, he will be bringing over a quantity of items in June, and will be contacting Nicholas Rayner direct in Geneva."

This was followed by a name that Hodges had told me about. "Ghiya. Brendan Lynch has developed a very good business relationship with this dealer despite Jack Franses's last visit which resulted in a lot of unwanted property being sent over. [Franses had been head of the Indian and Islamic department.] We now have a

clear understanding of what should be sent and have ruled out the lower end of the market. Also, we proposed to get Ghiya to pay for Brendan to fly out for 4–5 day visits perhaps twice a year so as to have agreed reserves prior to shipment. Both Brendan and I believe he will agree to this in view of the substantial business already being given to us and the possible potential."

An idea of the way some objects left India was in the next paragraph. "The Maharani [of Hokar's] painting by Alma Tadema was meant to have arrived in London by March. However her son-in-law has been drafted to Nagaland (the back of beyond) and is unable to bring it out at the moment; also she lost her granddaughter who was an air hostess on the ill-fated Air India flight. It will be coming out and should realize £80–100,000 when it does. The family have extremely good other property also."

Bowring wrapped up: "Besides the above, headway was made by meeting again the Maharaja and Rajmata of Jodhpur, Bapa Dhrandadhra's cousin and aunt, and possibly they might be swayed away from Christie's. Partha Talukdar has three paintings (value £50–70,000) which he hopefully will deliver to London. The Maharaja of Samthar will be bringing out a number of items in June, having been pleasantly surprised by the prices realized on a group of smaller items."

But the Indian authorities were not fools, and had not been entirely taken in by the constant presence of Sotheby's experts in their country. One of the Hodges documents was the original of a letter from L. K. Srinivasan, director of antiquities at the Archaeological Survey of India, in Delhi. It was headed "Auction of Objects of art and antiquities of Indian origin on 7th July, 1986 at London," and the text read: "Sir, I am very much thankful to you for the trouble you have taken to mail the catalogue of the antiquities and art objects which were to be auctioned [i.e., on July 7, 1986]. On going through the said catalogue I found that there were at least 179 objects which were either antiquities or art objects of Indian origin. Of these only in respect of 23 objects information regarding the source

of acquisition, their provenance etc. has been furnished in the cata-
logue. Similar information is not forthcoming in respect of 156 ob-
jects. The Archaeological Survey of India would like to have full
information in regard to these objects. I would be most grateful, if
you can kindly furnish us the source of acquisition, provenance etc.
in regard to the 156 objects about which the information is not
available in the catalogue supplied by you." Brendan Lynch had
added a footnote to this letter: "Felicity, I have passed this on to Joe
Och to reply." Hodges did not have any paperwork by Och on this
subject.

He did have, however, two papers that related to visits to India by
Brendan Lynch, and both documents differed very much in tone
from Bowring's. Lynch was not at all coy about the purpose of his
visits. For example, a Sotheby's travel requisition from Lynch
claimed £1,823 airfare and £3,049.70 expenses relating to a visit to
Singapore, Bangkok, Calcutta, Bombay, Jaipur, Delhi, and Islam-
abad, between January 24 and February 21, 1988. Under the head-
ing "Purpose of visit" was typed, baldly: "To obtain property for the
June 13 Indian sale." In his report, made after the visit, Lynch listed
"some 65 clients" seen during his travels and calculated that around
£275,000 worth of goods had been consigned, broken down as fol-
lows: Singapore £40,000, Bangkok £80,000, India £140,000, and
Pakistan £15,000.

A year later, in April 1989, Lynch reported on another visit to
India. He drew particular attention to customers with "Indian
miniatures for sale." Addressing his report to Margaret Erskine, an
expert in Islamic manuscripts, he said in passing, "*Calcutta* . . . Mr. B,
Grand Hotel, Sent best wishes & said his wife would come & see
you in the course of the summer to collect the proceeds of pictures
sold some years ago. Has further material which he might send for
sale. . . . *Bombay*, Esajee. He regularly supplies me with material and
there seems to be no end to the things he & his brother Fakrou
[Sham] have arriving. With some encouragement (well, probably a
lot of encouragement . . .) he would probably consign some of his

paintings. Fakrou is now in London every few months and I would suggest we go & see him together when the next consignment comes.... Mrs. Sidney Gomes, International Antiques. Former partner of Gheeya [Ghiya]. Very astute and obviously getting really good things which he keeps discreetly at his house in Bandra, meanwhile dealing also successfully in chandeliers & garden sculpture at his shop near the Taj [Hotel]. He showed me an exquisite Mughal crystal opium bowl for which he was asking £50,000.... He now has a very good group of Basholi paintings, which he told me he was keeping for the present. Definitely someone to be worked on by both of us.... Mr. & Mrs. Heeramaneck I saw some stunning Mughal textiles and glass, which they have had for the last 40 years, which I hope will come to us over the next few years.... *Jaipur*.... Mr. Gheeya [Ghiya] I listed about £60,000 worth of objects which I hope will come...."

The "travelogues" in the Hodges package by no means completed the documentation. There were also computer printouts that bore the names of sellers at Sotheby's Indian and Southeast Asian art auctions for 1985, 1986, and 1987 in London. At least seven of the people Bowring or Lynch saw in India and Pakistan featured as sellers in those sales.

Some of the traffic was lively. For example, in the November 1987 sale, a Mrs. Sabawala had six objects in the auction with a combined reserve of £26,000, and Mr. Sham had twenty lots. In the November 1986 sale, the Shams between them had forty-five lots.

Familiar tactics were employed by Sotheby's staff in the paperwork for these sales. For although the Bowring and Lynch travel reports showed that both F. Sham and R. Sabawala live in Bombay, the property receipt for Mrs. Sabawala's six objects is marked c/o B. Lynch, with correspondence all addressed to the St. James Court Hotel, London SW1, and for Mr. F. Sham there were two addresses—20 Aberdeen Court, Maida Vale, London W9, and 38 Crommeock Gardens, W9. For the record, according to the local

authority in that part of London, there never has been any such address as 38 Crommeock Gardens, W9.

But the true nature of the trade from India was nowhere more in evidence than in a set of documents relating to Fakrou Sham. The main item on the property receipt issued to Mr. Sham, at his nonexistent British address, 38 Crommeock Gardens, was an object described as a large stele—that is, a stone slab decorated with carvings or inscriptions—depicting a goat-headed goddess. The stele was estimated at £10,000–15,000, with a reserve of £7,000. It was entered as lot 92 in the November 14, 1988, sale and was described in the catalogue in this way: "A large central Indian Buff sandstone stele depicting a goat-headed goddess. Post Gupta, 8th/9th century." The goddess, described as seated in *lalitasana* (cross-legged), was fifty-two inches high, and there was a full-page illustration.

Maybe this illustration was Sotheby's mistake. For among the Hodges documents were four pages of photocopies from an Indian book (written in English) entitled *Yogini: Cult and Temples.* The book, by Vidya Dehejla, now a curator at the Smithsonian Institution in Washington, D.C., describes a number of *yogini*—gods—on top of an isolated hill in the Banda district of Uttar Pradesh, northern India, near the village of Lokhari. Originally there had been twenty images of gods on this one hill, each "roughly five feet in height" and carved on slabs of coarse-grained sandstone with a rounded top. Most of these statues of gods and goddesses had been made in the first half of the tenth century, had large rounded breasts, sat in *lalitasana*, and had animal heads. There was a rabbit-faced one, a snake-faced one, a cow-faced one, and a goat-faced one. Dehejla adds: "Villagers report that in recent years a number of the images were carted away in trucks by vandals." Before that unhappy fate befell the goat-faced one, however, it was photographed, and Dehejla reproduced the photograph in the book. This reproduction showed that it was *identical* to lot 92 in Sotheby's November 1988

sale. The whole rigmarole put Mr. Sham in much the same category as Giacomo Medici, Christian Boursaud, and Serge Vilbert—someone who Sotheby's had ample reason to believe trafficked in illegally excavated and/or stolen antiquities smuggled out of their country of origin.

One name, interestingly, was not mentioned in the property receipts and ledgers—Mr. Ghiya. And yet all the "travelogues" had mentioned him, one saying that he would be sending £60,000 worth of goods, another that Lynch had developed a good relationship with him and that Sotheby's would try to persuade Ghiya to fund a couple of visits a year for Lynch, etc. (This was an echo of Tim Llewellyn's organizing the June 1980 old masters sale from inside Italy, in Florence.)

Hodges explained why Ghiya's name was not on the papers. Ghiya came to London for all the Indian sales, just as Medici came for all the antiquities sales. There were, indeed, close parallels between the Medici business and the Ghiya business, for the latter too used a number of companies based in Switzerland. Hodges knew their names and had their letterheads: the companies were called Megavena, Cape Lion Logging, and the Artistic Imports Corporation. The Sotheby's documentation, when put alongside the consignment notes—again, remarkably similar to those of Christian Boursaud—showed links among these three companies. For example, payment for objects that, in computer printouts, belonged to Cape Lion Logging would be sent to Megavena. Megavena and Cape Lion shared an address in Geneva, much as Editions Services and Xoilan Trading did. The techniques for importing smuggled Indian antiquities, via Geneva, were virtually identical to those used for bringing in Italian goods, via Geneva. Six other documents showed that between 1984 and 1986, Cape Lion Logging and/or Megavena consigned at least ninety-three lots to Sotheby's sales, with a combined value in the region of £58,000. They were a strong presence in almost every sale, and the total value of their goods ac-

cords closely with the anticipated £60,000 that Lynch looked forward to, from Ghiya, in his 1989 "travelogue." Ghiya's business was not mammoth, but it was steady.

The extent of smuggled goods in the Indian sales was also similar, on occasion, to the extent of smuggled Italian antiquities. For example, in the sale held at Sotheby's on November 24, 1986, Cape Lion Logging and E. and F. Sham accounted for a considerable number of the lots offered.

In some ways, the most impressive traffic from an artistic point of view came from Thailand. The documents showed that many Khmer objects were consigned by a general in that country. In 1988, Sotheby's was criticized by the Khmer People's National Liberation Front for selling at auction two stone heads that appeared to have been stolen from Angkor Wat, the great site of Buddhist worship in Cambodia. On that occasion, Sotheby's retorted in a defiant manner, saying that no one had challenged it *before* the auction, when the opportunity existed to prevent the sale. True, though Sotheby's own expert in Far Eastern art should surely have spotted the heads beforehand, and raised awkward questions.

In this matter, as with the Apulian vases, D'Este Bond, from Sotheby's press office, entered the fray. An internal memo examined the whole public relations issue surrounding the Khmer fuss. At the time there was a possibility that someone from Sotheby's staff would take part in a televised debate on the issue with a member of the Khmer NLF, and D'Este Bond was offering advice. She said that Sotheby's could, if it wanted, refuse to take part in a TV debate "on some pretext such as that we have been very misrepresented . . . on this subject."

"Pretext" was a favorite word in Sotheby's. Bowring had used it in his memo about staff visiting India undercover. But it was not entirely inappropriate and may have had something to do with the fact that on at least two occasions, as the Hodges documents show, Angkor Wat sculptures were sent to London disguised, in one case as "dolls" and in the other as "stone torsos."

Sotheby's never took part in the television debate with the Khmer NLF. The truth of the matter was that the Cambodians had not misrepresented Sotheby's. The company's dubious practices were more widespread than even the NLF realized.

Still, there was a limit on how much of the Indian documentation we could seek to corroborate. India is a huge country, and although the cost of living is low by Western standards, we would be a team of seven—cameraman and assistant, sound man, local researcher, Sam, Peter Minns, and I. It was decided to send Sam out on a reconnaissance. In August he went to Delhi to meet Raman Mann, a researcher who had previously worked with Minns on a documentary for the BBC.

Inspecting the map, we had decided that it was practicable to do four things. We needed first to locate Lokhari, the tiny village from which the *yogini* had been looted. This was one specific object that we knew for certain had traveled all the way from rural India to the glitzy auctions in London, and we wanted to show the object's former home. Also, asking villagers if they recognized the sculpture would confirm the theft story—an important piece of corroboratory evidence. Then, too, we wanted to interview Dr. L. K. Srinivasan, from the Archaeological Survey of India, to explore further the background of his letter to Sotheby's querying the provenance of 156 Indian objects in its sale. Next, we needed to approach Mr. Sham in Bombay, the man who had dealt in the *yogini*, to see if he was still smuggling objects out of India and selling them at Sotheby's. And finally, we wanted to approach Sotheby's itself in India, to see how it would respond to a proposal to help smuggle objects out of the country.

Raman Mann traced Dr. Srinivasan, now in retirement, to Bangalore. He was willing to see us—indeed eager to do so—but Bangalore is an hour and a quarter south of Bombay, by plane, and more than a thousand miles away from Lokhari. Our destinations were scattered all over India, and our itinerary was already a heavy load on us and our budget.

Before Sam went off, we had put out feelers among academics in the field. There were not many, but eventually we located Dr. Dilip Chakrabarti, in the Department of Oriental Studies at Cambridge University. He agreed to see us, although we did not explain exactly what we were doing. We worried anew about security leaks. Dr. Chakrabarti gave us the names of colleagues in India.

In Delhi, Sam spent an evening with Raman, briefing her on the project—we hadn't risked saying too much over the phone or by fax. We knew from the document by Vidya Dehejla that Lokhari was in the Banda district of Uttar Pradesh, and that the nearest town of any size was Allahabad. But that was all. Lokhari could not be found on any of the maps of India to be bought in London or, to Sam's consternation, in Delhi. He and Raman therefore flew to Varanasi (Benares) and drove from there to Allahabad without knowing exactly where they were going beyond that.

They arrived in Allahabad early in the evening of Tuesday, August 14, as it was getting dark. Allahabad is a university town and a legal center, and so, before finding a hotel, Raman and Sam combed the bookselling area of the city looking for a local map. There were none until they came to the university's own bookshop. This shop did have a local map—in fact, a British map, more than fifty years old—and Sam breathed a sigh of relief. Not for long. There was no Lokhari on it.

The bookseller had now entered the spirit of the chase, and although the shop was closed, he took out a copy of the latest census of Uttar Pradesh—for 1990. The good news was that Lokhari featured in the index. The bad news was that there were no fewer than four Lokharis in the Banda region, and one of them was six to seven hours' drive from Allahabad. Sam was due in Bangalore in two days' time; again, there was simply not enough time—or budget—to visit four Lokharis looking for "ours."

The bookshop owner made another suggestion: Raman should telephone the Allahabad University Department of Archaeology and speak to Professor J. N. Pandey. By now it was evening, and

there was no reply. Fortunately, the bookshop owner had the professor's home number. When he answered he was suspicious of an Englishman inquiring after antiquities, and was about to put down the phone when Sam happened to mention Dr. Chakrabarti. At this, Professor Pandey's attitude changed completely and he became a model of cooperation. All those clichés about time spent on reconnaissance not being wasted sprang into Sam's mind. Pandey listened to Sam's story, said he would telephone a colleague, and suggested Sam call back at 10:30.

Raman and Sam found a hotel and had dinner. The rest of the hotel restaurant was taken over by a large group who were combining dinner with a bingo game. Sam had been to India before but had never come across a bingo dinner.

He called Pandey a little later than arranged, at about 10:45. The professor had good news. He had located the right Lokhari. Better still, he knew a local archaeologist who was familiar with the site and had said that he would make himself available to help Raman and Sam the next day. This was a Mr. Dubey, a graduate of Allahabad University, now studying under Professor Pandey for his Ph.D. Mr. Dubey could be found, said the professor, "near the railway station at Bargarh," and he gave Raman directions.

Next morning the two researchers set off. Allahabad is a city of about a million and a half inhabitants, and Bargarh was a surprising contrast. It consisted of no more than a dozen houses. Although the railway line passed through the hamlet, there was no "station" in the accepted sense of the word—just a second line where trains could pass. In such a setting a white face was unusual, and Sam, with Raman, was immediately surrounded by locals, among them a Mr. Pandeyji, the local Communist Party organizer, who offered them tea. It emerged that everyone knew Mr. Dubey, but he lived near the train station only in the sense that his hamlet was two and a half miles away, down a dead-end road, which meant that he had to cross the railway line every time he went anywhere. Mr. Pandeyji offered

to show Raman and Sam where Mr. Dubey lived—once they had had a second cup of tea.

Dubey, a tall, serious man with shiny black hair, was expecting them. He immediately stopped what he was doing to escort them to "his" Lokhari, about fourteen miles away. And so Sam set off on the last leg of his journey to a village that was on no known map. He was shown the shrine and saw the horrendous damage it had suffered. He met the headman of the village, who was still passionately angry about the thefts, even after ten years, and said there had been a terrific "hue and cry" when the *yogini* had been taken. These were not just sculptures of gods, he said—but gods themselves.

In Bangalore the next day, Sam failed to see Dr. Srinivasan, for the archaeologist was in hospital for an operation. They did speak over the telephone, and Srinivasan confirmed that he was still upset with Sotheby's and said that when we returned he would be only too happy to give us an interview.

In Bombay the situation was trickier. We would be returning with our equipment to film in secret and needed to set up a cover story. We had decided that Sam would pose as my son, Charles Carpenter, who worked for me. He would say that I was an antiquities dealer who had just inherited some Indian artworks and was beginning to think about dealing in ancient Indian objects. He implied, but did not specify, that we would need to get these things out of the country. His job was to see "the lay of the land," and he was not allowed to authorize any transactions on his own. The point of this exercise was to establish our presence and to emphasize that we were international in our dealings, wealthy enough to come and go, and not in a hurry. So Sam met the Shams—the father Fakrou, the son Zohar, and the father's brother Essa—and then flew back to London. It was ironic that the Indian dealers we had in our sights were so perfectly surnamed.

—⅏—

The Hill and the Warehouse

Peter Minns, Sam, and I arrived in Delhi two months later, on October 15. That evening we had a production meeting with the local film crew we had hired and explained the great need for secrecy. The next morning we flew to Varanasi.

Varanasi—or Benares—is of course a world-famous religious center. The reason for its holiness, it was explained to us, is that at Varanasi the Ganges, about half a mile wide at that point and itself a holy river, turns away from the direction in which it has hitherto been flowing. Hindus believe that God looked with favor on the place and spared it from being overwhelmed by the mighty river. Here we filmed some of the hundreds of famous ghats—temples in front of which people ritually bathe before praying.

That evening we drove to Allahabad, and early the next morning we moved on to Lokhari. We arrived at midday, in intense heat, and climbed a hundred uneven steps to the shrine. On top of the hill were two large trees, which offered shade. Up here a breeze blew from the west. The hill offered wonderful views for miles around—

a man-made lake, mysterious man-made mounds, and other hills.
But what caught the eye was a black stone platform with, on the
west side, a wall against which leaned nine slabs of stone—or rather,
their remains. We knew from Vidya Dehejla's book that there had
once been twenty complete carved *yogini* on this site. Now there was
not a single one whole. Eleven had been stolen, and the nine that re-
mained had been smashed and were little more than rubble.

As we stood there, sadly taking this in, the image of a mechanical
digger came into my mind. That sight had brought home what
damage the *tombaroli* do in Italy—the shabby trade behind the glam-
our in London. As we started to set up the camera, one of the vil-
lagers, a tall man in his late twenties, arrived. He took off his shoes
before mounting the stone platform, then prostrated himself in
front of one of the piles of stones.

Shortly afterward, two sadhus or holy men appeared, dressed in
saffron-colored robes and carrying metal staves or spears. For about
half an hour they prayed and chanted and sprinkled holy Ganges
water on the sacred rubble that had been their gods. Then one of
them played a set of percussion instruments—a form of castanet
made of steel and shaped like huge fern leaves. These moments
were both pathetic and very moving.

By now, the villagers knew that a camera crew had arrived, and
about twenty of them climbed the hill. They gathered around while,
on camera, I showed Mr. Dubey the catalogue entry in the Sotheby's
sale, in which the stolen *yogini* featured. He spoke passionately
about the "rape" of the shrine, of how it had been a sacred site of
worship for more than a thousand years. Several of the villagers re-
membered the *yogini* and spoke, on camera, too, about their feel-
ings. One revealed that there had been a chase one night when the
robbers had been overheard—but they got away. Another villager
said bluntly that he (they were all men) wanted their gods back. The
others nodded vigorously.

After filming, we descended to the village. This too was an expe-
rience. Lokhari is a medieval village, and for once medieval is no

exaggeration: there is no electricity, no running water (just two wells), and no sewage disposal. The houses are made of mud, with thatched roofs. Cows, goats, and sheep share the dwellings with humans. Rats and mongooses skitter in the walkways, while frogs play in the puddles formed by the wheels of oxcarts. Where the houses end, the sugarcane and rice paddies begin. The filth and smell are overpowering.

The village, which can be reached only on foot, does have a quiet dignity, however—highlighted partly by its poverty, by its primitiveness, and above all by its silence. Most of India is an exceedingly noisy place, with traffic horns, music, and the loudspeakers of the endless political rallies—but not here. The other feature that underscored Lokhari's dignity was the carved gods and goddesses fixed into the walls of the houses. The headman said that the villagers had been offered as much as £15,000 for these objects but had always turned down the money. How can you sell a god? they asked.

The presence of these gods in the village highlighted the nature of Hinduism. They were part of village life, passed several times a day and familiar to everyone. Some of the gods had been brought inside the village, for safety. The taking of such objects was more than art theft: it was stealing the soul of the community.

We left as it was getting dark, after promising that we would try to trace the goat-faced *yogini*. We had all been affected by the experience. We would never think about Indian antiquities in the same way again.

The following day, in Bangalore, we met Dr. Lakshme Srinivasan. A distinguished-looking man, he met us wearing his striking caste mark, a vertical line in red on his forehead, with yellow and white patches, the significance of which I was never quite sure. What I was sure about was his anger, directed at Sotheby's. He told us that when he had written to the company, ten years earlier, as director of the Archaeological Survey of India, he could not see why, if Sotheby's could give the provenance for twenty-three Indian objects that it

was selling, it could not do so for the 156 other objects in the sale—
unless, of course, those objects had been smuggled. He said that he
had never received a satisfactory answer. His successor, Dr. I. K.
Sharma, had also written to Sotheby's. He too had never received a
reply of any substance.

Dr. Srinivasan grew more outspoken. Shown the document in
which it was said that the "pretext" of writing a book or being on va-
cation as used by Sotheby's staff visiting India was wearing thin, he
said that such behavior was "fishy." He said he had no idea that
Sotheby's staff had visited so many Indians or that the traffic was so
large as the documents revealed it to be. He called then for the gov-
ernment to take action and for Sotheby's to be investigated. Coming
from such an impeccable source, his anger was a compelling con-
demnation.

To Bombay. A number of collectors and dealers in the city had
regularly consigned material to Sotheby's. But that was back in
1985–89. Did the same practices, and malpractices, continue? It
seemed that they might, for in some of the memorandums Sotheby's
staff visiting India had referred to business expected "over the next
few years."

The situation we faced was in some respects more difficult than it
had been in Italy. We had the names of private collectors who, on
the face of it, had smuggled material out of the country. But it was
unlikely that we could approach them—not without a suitable in-
troduction, anyway. And to gain their confidence would take far
more time than we had. We had to concentrate on the dealers.
Those most strongly implicated in the documents were Ghiya, of
Jaipur, and the Sham family, of Bombay. We chose to concentrate
on the Shams. It was the Shams who had handled the Lokhari *yogini*
and a number of other objects—including two silver howdahs—that
the documents showed to have been sent out of India. And it was the
Shams who operated with a fake address in Crommeock Gardens.

Our cover story was imperfect. During his reconnaissance in Au-
gust, Sam, visiting the Shams and other dealers, had claimed to be

the son of Peter Carpenter, who had recently inherited some Indian antiquities. A few days before we left London, I had sent a fax to the Shams, as Peter Carpenter, saying I was looking forward to meeting them. However, the uncomfortable truth was that Peter Carpenter had no collection of antiquities, inherited or otherwise.

In order to make our cover credible, we had to show the Shams a few objects that had been left to me. We attempted to solve this by taking photographs in Lokhari of the gods that had been brought inside for protection, photographing them in such a way that their surroundings were not visible. It was highly unlikely that the Shams had been the actual vandals at the shrine; they had almost certainly bought the *yogini* either from the thieves or from middlemen. There was a small risk of discovery, but we had no choice.

Sam and I approached the Shams' main gallery—Z.N. Exporters, a few blocks from the Taj Mahal Hotel, right on the bay—at about 4:30 on the afternoon of Friday, October 18. Sam—my supposed son Charles—was carrying the camera, hidden in a bag. I carried a radio microphone in the top pocket of my jacket—although it was stifling hot I wore a double-breasted jacket in an effort to look wealthy and art-world dapper. As we entered the gallery, four people were huddled at a desk; they looked up, separated, and smiled.

The senior Sham—Fakrou—was not there, we were told. He was in London for the sale of Indian, Islamic, and Himalayan art that had been held the day before. At the time we did not know whether that was good or bad news. It was Fakrou's son, Zohar, who greeted us. We were expected. Cold drinks were brought, and the street door was closed—a boon for the microphone in my pocket. I started the ball rolling by asking Zohar if his father had been buying or selling at the Sotheby's auction.

"Both," he replied.

A promising start. There were 168 lots in the October 17 sale, and only nine were twentieth-century objects; everything else came under the Antiquities Act. If Zohar Sham were to explain exactly what his father was selling in London . . .

To establish more fully what I was doing in India, I explained that I was British, but lived in New York, where I dealt in Greek and Roman antiquities (a subject about which I knew a little, and I hoped the Shams did not). That world, I said, was changing. More and more museums, and serious collectors, were insisting on proper provenance for objects, so it was getting harder all the time to sell unprovenanced antiquities. Of course, in the context of our discussion, "unprovenanced" was a euphemism for "illegally excavated and smuggled." I then added that, coincidentally, an aunt had died earlier in the year. Though of British descent, she had spent all her life in India, and had married an Indian of Portuguese descent, a man named Pinto. At her death, I had inherited a number of things—the photographs were being developed and would be ready in a day or two. I said this partly because it was true—we had not yet had a chance to develop the photographs—and partly because I wanted an excuse for a further meeting. I did not expect the Shams to reveal the inner workings of their business at a first meeting, so if we could engineer a second meeting, in a couple of days' time, we would not seem in a hurry; we could present ourselves as substantial people who were taking our time, looking around, doing our job thoroughly, gathering knowledge and building trust.

I said that we were going to be in Bangalore on Saturday (which was true; we were to see Dr. Srinivasan). Zohar said that the shop would be closed on Sunday but open on Monday. I proposed lunch, and he countered with dinner. That was agreed. I then changed the subject and handed across the catalogue for the Sotheby's London sale of the previous day, the one his father had attended. Zohar leafed through it and stopped at a page that showed a photograph of four fifteenth- or sixteenth-century granite columns from southern India. He tapped the photo with the back of his fingers and said, "These could be ours—we have some very like that." This was tantalizing.

He added that his father would be remaining in London for a few days and that maybe we should meet him on our return. He would be speaking to him over the weekend.

I thought that we had got as much as we could out of a first meeting and in any case was growing nervous about the microphone in my pocket, because it had a light that glowed red when it was switched on. I was sitting down, so every time Sham stood up there was a risk he would see the glow.

When I took back the catalogue, I leafed through it and stopped at a photograph showing some nineteenth-century wooden doors. I said that I had been left similar doors (in an effort to expand the range of objects that I had "inherited"). Zohar said he had some doors too—here in Bombay, at his warehouse. Sam casually asked if the warehouse was nearby. Zohar said it was, and asked if we would like to see it. Despite my misgivings about the microphone, I obviously had to agree, so we walked two blocks and climbed to a second-story door. When it was opened a huge space was revealed, with lots of glass vessels laid out in lines on the floor. Against the walls were doors and an ornate carved screen. The camera and tape recorder were still running, so we questioned Zohar about the screen. He explained that it was nineteenth-century, and therefore, in theory, could have been just less than a hundred years old. In any case, he said, what they did with screens like this was clean them up and export them as new.

This was a fresh admission, and we spent some time discussing the price of such a screen and what it would cost to get it to London.

The meeting had now gone on for some time. We had to make our exit before ninety minutes were up—the camera always produced a loud "click" when it switched itself off. So we repeated our intention of coming back on Monday and left.

The next day, Saturday, Bangalore. On Sunday we filmed establishing views of Bombay: the docks, the high-rises, and of course the beggars and the appalling slums.

On Monday our first session was to be with Dr. Usha Ramam-
rutham, Sotheby's representative in Bombay. She had just returned
from London and the October 17 sale, and she had agreed to meet
us in the lobby of the Centaur Hotel, in the Juhu beach suburb.

Aged somewhere between thirty-five and forty-five, she had, she
said, worked for Sotheby's for five years. Before that she had had a
distinguished career as an archaeologist, training at New York Uni-
versity and then working as a curator at the Brooklyn Museum. We
swapped a few names in the art world, waiting for coffee to arrive,
and then I told her the same story I had told Zohar Sham on Friday.
I also showed her the photographs of the Lokhari objects, which I
said I had inherited. It is fair to say, I think, that she became wary at
this stage. One of the statues had a red line on its brow, and that
meant, she said, that it was still being worshiped. The statue must
therefore either still be in a temple or have been taken from one re-
cently. I replied airily that I assumed the local villagers worshiped
the figure in my aunt's garden, where these things were stored. I
then added hurriedly that the material my aunt had inside her house
was in much better condition but was all jumbled up and it would
take a month or so to sort it out and photograph it. I added that all
I could be certain of was that the other objects included some "Kola
bronzes." (Sam had discovered on his reconnaissance that Chola
bronzes—properly pronounced with a *ch*, not a hard *k*—from the
south of India are very valuable and much sought after in the sale-
rooms.) And I said that Charles and I were coming back in a few
weeks to try to decide what to do with these better objects. I had cir-
cled one or two objects in the catalogue for that week's sale in Lon-
don, objects mainly from north or central India where my aunt
supposedly lived. I pretended that I had similar objects.

Throughout the meeting Dr. Ramamrutham maintained that the
Indian laws against the export of antiquities were rigorous, that it
was both expensive and risky to smuggle objects out of the country,
and that neither she nor Sotheby's would have anything to do with
it. Impressive. She repeated this several times, but, given our expe-

rience in Italy, I did not know whether this reflected the truth or might merely be Dr. Ramamrutham's stance on first meeting.

As time went on—and the meeting lasted for an hour and a quarter—four possible chinks did show in her otherwise robust upright attitude. She denied knowing Fakrou Sham when I asked her. I found this hard to believe. Sham had been a big consignor to Sotheby's over the years. He, like her, was based in Bombay and, like her, had been in London at the same time, attending the same sale. Both had a professional interest in a relatively small field.

A second chink came as we discussed Sotheby's activities in India. Only one sale had been held in the country, in 1992. That was apparently successful, but there were no plans to hold any more, at least not until the rupee was fully convertible, which might, she said, emphasizing the "might," be toward the end of 1997. I therefore asked what, in these circumstances, her job consisted of. Valuations, she said, for which she did not charge. And at that point she allowed that when she gave valuations she gave both an Indian price and a London or New York price. An echo of Milan? She said that for many objects the market was better in India than it was in London (again as Kollewijn had indicated about Italy), and that very often the price differential—three to five times as high in London and New York as in India—was wiped out by the costs of "shipping." Shipping costs sufficiently costly to wipe out selling prices triple or five times higher? That could be the third chink: she knew details of the illicit trade. When I asked her how she knew so much, she smiled and said that she had been in the business a long time.

The fourth chink exposed itself when I asked what would happen if, despite her warning, I took the risk and shipped some forbidden Indian objects to London or New York. Would she sell them? Despite her earlier unequivocal attitude, she now hesitated, then said: "We'll cross that bridge when we come to it. At the moment, it's hypothetical."

A different wrinkle appeared. She made it clear that the main problem in exporting objects was not the Indian customs authority

but unscrupulous Indian exporters who quite often "lost" objects. These "sharks" were people to beware of, she said.

Yes.

After an hour and a quarter, Sam—my son Charles—gave a pre-arranged signal to indicate that we were getting near the end of the tape and should make our exit. So we wound the meeting up, promising to be in touch again in a few weeks, with photographs of our Chola bronzes.

This time I pronounced it correctly.

In the afternoon we called on Zohar Sham again. The first thing he said was that he could not have dinner with us after all. An important foreign client was in town and he had to have dinner with him. This was disappointing, so we accepted the offer of a Pepsi. This had barely arrived, and the substantive conversation had not started, when the telephone rang. Zohar took the receiver and spoke a few words in Hindi. Suddenly, he shouted and stood up; more words in Hindi, then everyone else in the shop shouted and stood up.

Zohar turned back to us. "I am sorry," he said, "I must go. The client I was to have dinner with has expired."

"Expired?" I repeated. "You mean he's died?"

Zohar nodded. Sam nearly choked on his cigarette. Then Zohar ushered us from the gallery. "I am sorry, I must go and see, have the news confirmed. Please, come back in an hour." With that, he and his assistant ran off down the street.

Sam and I looked at each other. Was it true—a bizarre, macabre coincidence? Or was it part of some elaborate scheme—was our cover story blown and were we in danger of exposure or something worse? Had Dr. Ramamrutham seen through us and warned the Shams to be careful?

We left to return to the lobby of the nearby Taj Hotel, and Peter Minns, who was waiting for news. (Had we gone to a restaurant with Zohar, we had devised an elaborate plan for Peter to film us from an adjacent table.)

When Sam and I reached the Taj, however, the first person we saw was Zohar. He was deep in conversation with a group of people, some Indian, some who turned out to be Americans. We did not want Zohar to see us talking to Peter, but it was already too late to backtrack, so I went up to him and asked loudly if the news was confirmed. He said that it was, and repeated that we should meet again. Fortunately, Peter Minns cleverly read the situation and did not approach Sam or me. We sat in the lobby for a while, then Sam went to the men's room. A few minutes later, Peter followed and Sam briefed him.

By the time we approached Z.N. Exporters for the second time that day it was 6:30 P.M. and growing dark. We were both nervous. It looked as though the sudden death of the American dealer was a terrible coincidence and not something more sinister, but . . .

As it happened, Zohar was standing outside his gallery, in the street, talking to another man as we arrived. He was introduced as Zohar's uncle, Essa, Fakrou's brother. This was Essajee, who had been mentioned in the documents. It is worth recalling Brendan Lynch's comments: "*Bombay*, Essajee. He regularly supplies me with material and there seems to be no end of things that he & his brother Fakrou have arriving. With some encouragement (well, probably a lot of encouragement . . .) he would probably consign some of his paintings."

We shook hands and went inside. As we did so, however, Essa Sham said, looking at me: "I know your face. I've seen it before."

Unnerving. In fact, it was more—it was eerie. It was exactly what Concha Barrios had said in Naples. Sweating copiously, I smiled weakly.

For this meeting, I was seated on a beautiful carved wooden chair. Essa sat opposite me and Zohar between us—a perfect arrangement for filming. Zohar said that his father would not be able to see us, as he had already left London for Dubai, where he was mounting an exhibition. This was disappointing in one sense, but on the other hand, James Hodges had once remarked to me, months earlier, that

he thought some silver howdahs the Shams had sold at Sotheby's had been brought via Dubai. Yet another piece of Hodges's information seemed solid.

But at that meeting it was Essa who took control. Older than Zohar, he was also a much more forceful character, muscular, handsome, though with rough skin. We began with some small talk about the sudden death of the New York dealer, who specialized in glass. Then I switched topics. Essa listened carefully, looked at the photographs, pronounced one of the objects in them to be fake, and dismissed the others as being in poor condition (which was undoubtedly true). This was not a good start. But whether he thought that Charles and I were gullible fools, with more money than sense, or that we were shady types who had ripped off a temple, or Western sharpies out to cut a fast deal, he seemed to relax. He said that there was plenty of material available in the countryside. Like Dr. Ramamrutham—he confirmed that he knew her—he said that it was risky and expensive to export materials, and that for many objects the best market was India.

He added quite categorically that it was so difficult to get things out of the country that no one like me could actually select things in India and then pay to have them smuggled. I did not quite know what to say to this. I had presented myself as a seller of objects I had *inherited*, but he seemed intent on regarding me as a buyer. That was fine by me, so long as it was a credible stance. I decided to let him run on.

For someone like me, he said, the business worked the other way around. I must have looked puzzled. He had an agent in London, he said, who could show me things that had already been brought out of the country. If I wanted Indian antiquities, I could choose from a selection that was already safe. This, I now realized, made a lot of sense: they would not want rivals muscling in on their territory. And it was, of course, the reason why Essa was being so forward. He saw me not as a seller of things, in India, but as a buyer in Europe or North America.

I was not about to dissuade him, so I produced the catalogue of the previous week's sale. Handing it to Essa, I said, "I understand Fakrou had some things in last week's sale. Is there anything there of yours? It would be good to see what you deal in."

He took the catalogue and flipped through it. And then we had a stroke of luck. His hand came to lot 119, a second- or third-century mottled pink sandstone miniature column, from Kushan in northern India. "This is mine," he said, tapping the page with his finger. This is where luck came in. Because the catalogue said north-central India, I had circled this lot with my pen and shown it earlier in the day to Dr. Ramamrutham, when pretending that I had inherited something similar. Hoping to make the most of the coincidence, I turned to Sam and said, "Look, Charles, the one we circled, because it is so beautiful." To Essa I said, "This is exactly my taste."

"I've got four," he said. "You can see the others in London."

The situation had reversed itself. Having arrived as a seller, I had now been forced into the role of buyer. All the others present seemed happier with the arrangement this way around.

I took back the catalogue and reread the entry for lot 119. It was estimated at £5,500–6,500 and below the main entry, in smaller type, was an extra line: "A similar column was sold in these rooms, 25th April, 1996, lot 232."

"Was that yours, too?" I asked.

"Yes," he replied. And then he added, "It took me four years to arrange the shipment, a whole container."

"How did you manage that?" I said.

He made a dismissive motion with his hand. "The diplomatic bag."

So that is how the trade worked. The Shams took their time amassing a great many objects—a whole container load—and then sent them out, perhaps when a diplomat was moving house. Diplomats cooperated. The Shams kept the stock in London, selling them gradually, at auction and, no doubt, privately as well.

Not only did the trade continue; it went on in bulk.

I wanted to leave as quickly as possible now but forced myself to ask who Essa's agent was in London and when I could meet him. He refused to answer, saying he would be in London himself in two or three weeks and would be in touch.

We swapped business cards and promised to fax each other about meeting in London. Then we made our farewells and stepped out into the night. Sam and I walked back to the Taj Hotel without speaking. Once inside the hotel, still without speaking, we both headed instinctively to the same place: the bar.

—∞—

The Man from Rome and
the Man in London

The Bombay experience was wearing. Working undercover is tense, and you continually have to plan for contingencies that may never arise. But from our point of view, India, like Italy, had worked. Whatever Sotheby's said publicly, the smuggling described in Hodges's documents still occurred. Either the new management had no idea what went on in its name, or it was no better than the "old" management, some of whom were still in place.

Back in London we took two days off, and then met with Bernard Clark. He had always taken Hodges's side more than I had, and I now had to concede that maybe his instincts were better. Hodges might have served five months in jail, but the information he had given us had checked out in place after place. Indeed, we had corroborated the details in the documents far more significantly than we had dared to hope.

But despite that, we were not through yet. The investigation still had several twists and turns to make. Once we had recovered from the Indian trip, we began to put together the various background el-

ements for the television programs. The first excursion was to Cam-
bridge. On Friday, November 1, 1996, we went with a camera crew
to interview Dr. Dilip Chakrabarti, whose contacts had been so
much help to Sam. Dr. Chakrabarti had some harsh words to say
about the illicit trade in Indian antiquities, and he, too, called for an
Indian inquiry into Sotheby's.

While the camera crew was setting up the lights for the interview,
I handed Dr. Chakrabarti a copy of Sotheby's catalogue for the sale
of Indian, Islamic, and Himalayan art that had taken place a couple
of weeks earlier—the sale that Fakrou Sham and Dr. Usha Ramam-
rutham had attended, and to which Essa Sham had consigned smug-
gled goods.

As Dr. Chakrabarti leafed through the catalogue, he suddenly
flinched and shook his head. "Mr. Watson, look at this," he said,
pointing to a page of Indian sculpture. Three objects were depicted,
Sunga sandstone votive plaques of female figures between five and
ten inches high. The estimates ranged from £1,000 to £3,000. The
catalogue entries stated that they were "Probably Chandraketugarh,
West Bengal, 2nd/1st century, B.C."

Dr. Chakrabarti said, "There is a site near Calcutta which flour-
ished roughly between the third century B.C. and the tenth to
twelfth century A.D. Its ancient name is not known, but the modern
name is Chandraketugarh. I doubt very much if the news of major
finds from this site reaches professional archaeologists anymore. I
have been recently told that the villagers living on the top of this site
are offered money these days to renovate their ponds in exchange
for everything found in the freshly turned-up earth. This site wasn't
discovered until the mid-1950s, and not excavated until even later.
Since the antiquities law was already in place by then, by definition,
anything that comes from Chandraketugarh has been illegally exca-
vated and smuggled out of India."

Alongside these three votive plaques was pictured a Sunga ivory
handle, also from West Bengal, also second to first century B.C.
"These were not known until about six years ago," said Dr. Chakra-

barti. "Which means that this one must have been illegally excavated and smuggled out of India very recently."

The wording in the Sotheby's catalogue was perhaps revealing. "Probably Chandraketugarh" suggests that the company is fully aware that anything from that site must be illicit, but may think that adding "probably" lets it off the hook, keeping the objects' exact status somewhat vague and uncertain. Sotheby's appears to think that because it cannot be 100 percent certain that the material is from an illicit site, it is allowed to sell such wares. But of course this doesn't let Sotheby's off the hook at all, not if it claims to have experts on its staff—or just a phone call away—who can make the same deduction as does Dilip Chakrabarti. This is not the sort of corner-cutting one expects from a famous company that makes high claims for its probity.

What struck me about the Chandraketugarh objects was how much their situation paralleled that of the Apulian vases. In both cases, the objects were by definition illegally excavated and smuggled. Sotheby's did no extensive research on its own part, and, moreover, refused to face up to a clear logical argument. And the Apulian vases were, of course, where the whole project had started. The investigation had come full circle.

At the beginning of 1997, even as the television programs were being readied for broadcast, I flew to New York to see James Hodges, to bring him up to date on the results of our investigations. I had not seen him for about a year, and until then he had had no details of the Milan project and no idea of what we had found out in India. We met for breakfast at the Mayfair Regent Hotel on Park Avenue.

He listened to what I had to say in silence, and when I had finished he said little. I was at first surprised by this. But he soon explained that he had always known he had been telling the truth, so that even though he thought we had done a great job in corroborating the documents he had never for a moment doubted them. So, in

a sense, what was there to get excited about? Because he had been convicted and sent to jail, because he had failed a lie detector test, he had had to get used to being treated as untrustworthy, he said. Yet he knew what he knew and our confirmations were of what he had been certain of all along.

He was pleased that everything was going to come out at last, but although it might change attitudes toward Sotheby's, and might help clean up the antiquities trade, he wondered whether—after a long delay—it would change attitudes toward him.

I could see what he meant, and to an extent I sympathized. Maybe we could have worked more quickly on the corroborations, but not much. We had only got as far as we had by not pushing things, by slow and painstaking research and reporting, until we had ultimately tested what the documents had asserted.

It was curious. What I had assumed would be a celebration was anything but. At the end of breakfast we stood on the pavement on Park Avenue and shook hands. There were no fine words or dramatic farewells. He got into the first taxi that came along and drove off to the station to catch his train back to Washington. I had the rest of the day to kill before my flight to London. We made no plans to see each other again.

Only on the plane back did my own feelings begin to coalesce. In previous chapters, I have tried to write a factual account of the story, as it happened, introducing only such feelings—nervousness, bewilderment, amusement—as were appropriate to the investigation at various points along the way. Now, however, something else is called for. Five years have elapsed since Hodges's trial, but this is the time and place for a host of other relevant facts to be placed in context. Documents of the kind that James Hodges made available are unlikely to surface again in the art world, and so this is an opportunity that almost certainly will not come again.

As mentioned earlier, on the day after Hodges's trial ended, I was invited into Sotheby's, as other journalists no doubt were, for a brief-

ing by Tim Llewellyn, and it is worth reminding ourselves of the salient points of what he had to say. "Sotheby's was not on trial here," he told me. "Hodges was a solitary rotten apple in the barrel. He made a number of wide-ranging allegations in court for which there is no evidence and which we refute entirely." Among other things, Llewellyn had conceded there was a "lot of funny stuff" knocking around in antiquities, but had insisted that Sotheby's was here "to make money." His company could not police the market, he said, his clients had a right to anonymity, and Sotheby's avoided breaking the laws of the countries in which it traded.

Readers of this book, and people who saw the television programs, may now, as in other instances, judge for themselves. But it is not enough simply to describe the wrongdoing. The picture revealed in the papers that I was shown that night in the White Horse, the way Hodges acquired them, and Sotheby's response raise wider issues. For the revelations are not yet entirely exhausted.

First, however, let us get a side issue out of the way. There is little doubt that the laws governing the export of cultural objects from countries such as Italy and India are draconian. Their very fierceness, some may feel, contributes to the problem: if such laws were not so unreasonable they would not be broken so often or so flagrantly. There is some truth to this view when seen from the perspective of the collector, or dealer, or auction house, who all benefit from the circulation of cultural goods. There are several counterarguments as well.

Both Italy and India jealously guard their heritage, as they are surely entitled to do. Both are democracies. In the case of Italy, Apulian vases come from a relatively poor part of the country. Who knows if the *tombaroli* have not already destroyed spectacular archaeological remains that, had they been excavated (and therefore studied and displayed) properly, would not only have brought to light unique aspects of an ancient civilization, for the benefit of scholars, but also created beautiful archaeological sites, which would have attracted many tourists, for the benefit of all? In the case

of India, twice in the past ten years Sotheby's has tried to get the law governing the export of cultural objects changed. This the company was perfectly entitled to do. Both times, however, it failed in its quest and then continued to sell goods that had been smuggled, and that some of its staff must have known had been smuggled. Further, the attitude of the company is not helped by its behavior in regard to art objects exported illegally from France, such as the broken vase mentioned earlier. French law is not draconian. On the contrary, it is perfectly reasonable, a sensible compromise between the rights of individuals and the rights of the state.

Returning to the main issue, at least four basic questions need exploration at this point. These are, first, is the picture revealed in these documents a onetime snapshot, reflecting one man's desire to embarrass his former employers, or is it a reliable view of certain inner workings of the company? In other words, did he manage to collect most of the examples of wrongdoing, or did he simply acquire a few examples that would be reproduced elsewhere in the company, at other times and in other places? Second, is it true that in writing this book and making the programs about Sotheby's I have lionized a convicted felon, as I have been charged with doing? Third, was there a miscarriage of justice in the conviction of James Hodges? And fourth, was Hodges the only rotten apple in the Sotheby's barrel, as the company has always maintained?

Clearly, the view given by the documentation is unique. However, there is some independent evidence to suggest that the pictures are not merely isolated snapshots.

Take the Quedlinburg treasure. Somebody did. This is a set of medieval objects—bejeweled gospels with illuminated text, liturgical combs, silver reliquaries—that were looted from the church of Quedlinburg in Germany at the end of World War II (it was in this church that the kings of Saxony were traditionally crowned). These objects appeared on the market secretly in the 1980s, offered by lawyers on behalf of the heirs of an American soldier who had been

stationed in Quedlinburg in May and June 1945. The treasures were eventually returned to their rightful home, but not before they had been seen by several major book dealers and auction houses around the world. None of these organizations saw fit to call in the law enforcement agencies. Sotheby's response was especially interesting in the context of this book. Dr. Christopher de Hamel, director of Sotheby's department of Western manuscripts in London, wrote to the academic who was offering the treasure on behalf of the heirs of the soldier who stole it, saying it was worth about £10 million on the open market, but that it had been stolen during the war. He said, "In a public sale, with no legal impediment hanging over it, this . . . could be a £10,000,000 manuscript." But then he added: "With the risk of a lawsuit over it, we could perhaps sell it privately for a million pounds. . . ." This document was revealed during the court case that resulted from the soldier's heirs' attempts to sell looted objects.

Another episode concerns the New York art dealer Richard Feigen and a two-thousand-year-old marble sculpture of Artemis, the chaste Greek goddess of the moon. In 1990, he had paid $130,000 for the three-and-a-half-foot, four-hundred-pound torso, and in 1995 he decided to sell it at auction. He entered it for sale at Sotheby's in New York, where it was catalogued with an estimate of $60,000–90,000. Not a single bid was registered. However, when the catalogue was published, Italian government officials recognized the torso as one that had been stolen from a convent near Naples in 1988. In the court case that followed, in which the Italian government (successfully) requested the statue's return, evidence emerged that Mr. Feigen had bought the Artemis from Robin Symes, and that both had acted in good faith. What was not revealed at the trial was that Symes had originally bought the Artemis from Sotheby's.

Other evidence, then, does tend to support the patterns revealed in the Hodges documents. The same practices, the same names, recur.

. . .

Is this book a whitewash of a convicted felon, one who has been conducting a vendetta against his former employers? Regarding "lionization": from a very early stage I told Hodges that this would have to be a "warts and all" book. I emphasized that we needed to know everything about him that was relevant to the subject under discussion, and said that if, after the book was published and the programs were broadcast, anything emerged that he had not told me and that would have affected anything I wrote, I would sue him. I was especially tough on him while he was in Ford Open Prison. I reasoned that once he was out of jail, he might want to put the whole thing behind him. It may sound harsh, but I also thought that jail was the low point for him, the time when he would be most vulnerable and therefore likely to tell me anything else that was unfavorable to him and his arguments. And so, on his day visits to the local town of Arundel, we sat in a tea shop or walked by the river, and I grilled him. As a result of those questions, several "warts" were revealed that have already been reported in this book.

Let me now dismiss the idea that Hodges has a vendetta against his former employers. Certainly, before the trial he wanted to do anything that would cause the proceedings to be stopped. That is entirely natural. After he came out of prison, he went to America and began a new life—successfully, so far as I am aware. Since then, over the last four years, we have talked intermittently—once every two months perhaps, mostly, but not always, at my initiative. He had no knowledge of our investigations until well after they were over. The truth is that this investigation has been out of Hodges's hands since before his trial, and since he left prison he has taken no part in it, other than the occasional piece of advice, the two days when he took the lie detector test, and one day's filming for the first TV program. There has been no vendetta.

But there are two other points about the trial and the nature of the evidence against Hodges that must be made before we get to the last and greatest irony within this story.

Our Milan operation showed that when smuggled objects arrive in London, the couriers need to be paid in cash. In our case the sum was £200 for one painting. Sensibly, from Sotheby's point of view, Sotheby's wanted the client to pay the courier directly (which we did). This meant that Sotheby's staff had one less job to do, there was no possibility of misunderstanding, and the transaction was kept off the company's books.

But our Victoria Parnall was a brand-new client at Sotheby's. Roeland Kollewijn agreed to arrange to smuggle the painting for her after only a couple of visits. For regular clients who consigned much larger quantities of merchandise several times a year, Sotheby's may have done more, as Hodges said, and arranged payment to the couriers, in cash. If that happened, then to prevent those sums from appearing in its books, the company may well have needed just the kind of bank accounts Hodges says he set up, with "introductory commissions" paid into them, to provide funds. Having set them up for this purpose, Hodges may well have used them, from time to time, for his personal use. He may have regarded this as a "perk," a compensation for the risk he was taking. In fairness to him, *everything* else that he told us about the documents was corroborated.

In fairness to Sotheby's, on the other hand, the consignment notes from Christian Boursaud and Editions Services, among the biggest traders in smuggled goods, were from Switzerland. Strictly speaking, Sotheby's had no need to hide any payments to couriers from that country. The whole point in bringing the antiquities through Geneva was that they were laundered in the process. Their import into Britain was, on paper, perfectly legal.

Sotheby's motivation in bringing Hodges to trial was perhaps further called into question by the instructions the firm appears to have given its London lawyers, Freshfields. Under British law, prosecutions in criminal matters are brought by the Crown. All the documents unearthed by the Crown Prosecution Service are by definition court documents and in British law are held to be neutral—the property of the prosecution and the defense equally.

In this case, however, a number of documents gathered by Fresh-
fields, acting for Sotheby's, did not come to Hodges's attention until
the start of the trial. These documents were mainly company
ledgers showing that Hodges had scribbled various payments on
them by hand. The interpretation of these documents was clearly
all-important: did they show, as Sotheby's was to maintain, that he
had embezzled money on his own account, or that he had indeed
been paying off couriers, as was the heart of his case? It will be re-
membered that the late presentation of these documents was one of
the matters put to the judge on the Monday before the trial started.

The judge agreed that Hodges should have access to those papers,
and the defendant spent several hours a day after that in Fresh-
fields's offices, making his last-minute researches even as the trial
was getting under way. Michael Grieve, Hodges's barrister, had
never known a case like this one—where a defendant was not told
about potentially damaging documents until so late in the day—but
he decided not to make more of a fuss because it might have back-
fired. He didn't want to risk alienating the judge in regard to the use
of documents, since he himself planned to introduce a large number
of papers that, after all, Hodges had stolen from Sotheby's.

In not playing entirely fair by Hodges with regard to the evidence
against him, Sotheby's may have felt that he had not played fair by
it, in stealing property that was Sotheby's by right. Sotheby's had a
point; but then it was not Sotheby's that was on trial.

Taking all the evidence presented above, can one say categorically
that Sotheby's set out to scapegoat Hodges, as he firmly believed?
On balance, the answer must be that it did not. One can say this
with some confidence because of an extra piece of information that
came my way rather late.

It seems that around the time Hodges left Sotheby's, a major loss
of objects was discovered. The missing artworks were worth, in
total, about £500,000. They included the helmet and bowl we have
heard so much about, and also an African figurine that was far and
away the most valuable of the missing items. Hodges returned two

of the less valuable items, in such a bizarre fashion that Detective Sergeant Quinn, and/or Sotheby's, was perhaps encouraged to believe he had also taken the more precious figurine. As it happened, the African figurine was recovered later and its disappearance was found to have nothing to do with Hodges.

By that time, however, the New York meetings had taken place, Hodges had been regarded by the top brass in America to be attempting a "blackmail" operation, the Yarrow and Banks accounts had been unearthed, and Michael Ainslie and the New York management of Sotheby's may have worried that the byzantine practices and false accounting shown up by Hodges were perhaps echoed in the actions of other members of the London staff. So they may have sought to make an example of him.

But of course the prosecution was brought in London, and was primarily in the hands of those very people who were incriminated by the documents in Hodges's possession. That may explain why they kept the evidence so close to their chests until the zero hour. If he was right about the false bank accounts, the trial could really have blown up in their faces—more explosively than it did—and could have shown how many rotten apples there were in the Sotheby's barrel. As it was, the prosecution of Hodges appears to have gone ahead without Sotheby's top brass in New York knowing how much information he had or realizing that the wider range of charges would enable him to present himself as a small cog in a much larger machine. That was their miscalculation. At that stage, they may simply not have known the full extent of the dubious practices inside the London office. They know now.

Once the trial took place, the company had an interest in keeping it as low-key as possible. From Sotheby's point of view, this was the trial of a solitary miscreant whose allegations about wider misconduct were a desperate attempt to throw mud in all directions. As soon as the jury had gone out, but before the verdict was reached, Sotheby's press office, which until then had remained silent on the case, which was, of

course, sub judice, telephoned a number of journalists, this author in-
cluded, and requested a meeting after the verdict so that managing di-
rector Tim Llewellyn could put across Sotheby's official view.

Before that, in the trial proper, the company had done everything
to keep its secrets. Many clients had been referred to by their initials
only, and many documents presented in court had the names and
addresses of additional clients blacked out. Sotheby's justification
was that its commercial secrets should not be displayed in open
court when they were not strictly relevant to the matter at hand.
This was fair enough, but, when added to other aspects of the trial,
it also made many of the proceedings very confusing to anyone—
like the press—watching from the public gallery.

Was James Hodges the only bad apple in the Sotheby's barrel? Now
we come to two final insults at the heart of this story. For observers
of the art trade, and the airs and graces in which auctioneers love to
clothe themselves, it is a delicious irony, wonderfully revealing of
the vanities of the art world. But these insults reveal more: they
show the real nature of the corruption as it existed within Sotheby's.

Recall the condescending tone taken by senior Sotheby's person-
nel at the time the company was nearly taken over by two New York
self-made millionaires, Marshall Cogan and Stephen Swid. Julian
Thompson told them that they were "the wrong kind of Ameri-
cans," and Graham Llewellyn threatened to blow his brains out if
they succeeded in their takeover, claiming that they were "the
wrong kind of people." Now it emerges that these individuals, the
snobs-in-chief, the most vocal and vicious condescenders during
that takeover battle, stand revealed as among the figures compro-
mised by the documents Hodges had. Julian Thompson was well
aware of the Sekhmet scandal, and was one of those who, with Peter
Bowring, kept tabs on Sotheby's experts when they were in India.

And then there is Graham Llewellyn, the man who thought
Cogan and Swid were "sharpies," "wholly unacceptable." Now we

find that Llewellyn was the man who, with Julian Thompson no less, was prepared for Sotheby's to show a striking lack of candor concerning chandelier bidding, had not a television program, inadvertently, it seems, let the cat out of the bag. Even more remarkable is the fact that at the time Llewellyn senior was sounding off about Cogan and Swid, Llewellyn junior was organizing the smuggling out of Italy of old masters. Not only was he undoing the work his father-in-law had risked his life for in World War II, when he had been part of a team of scholars charged with salvaging artworks in Italy, but this, together with his involvement in the Sekhmet scandal, the raising of the reserve on the silver bowl, and the falsification of paperwork, scarcely provided a moral basis for the attitude taken against Cogan and Swid—or anyone, for that matter.

In the circumstances, the posturing of the Sotheby's board at the time of the takeover battle reeked of humbug.

The second point concerns the human dimension of Hodges's trial. One of the lawyers involved in the case put it well, I think, when he said: "It is entirely possible, in this case, that Hodges did everything that Sotheby's accused him of, and that Sotheby's did everything he accused them of." But even if that was true, surely the more important point is that Hodges's crimes were discrete, petty, inconsequential, whereas the activities of his colleagues were on an international scale and involved objects that were in some cases of considerable historical and cultural importance. The wrongdoing by the people who gave evidence against Hodges thus raises profound questions with complex moral implications.

There is one final document in the matter of Felicity Nicholson, the director of antiquities in London, that is revealing of Sotheby's in a more general way. This was another personnel review, written in November 1986 by her superior, Colin Mackay. A long, thoughtful memo, and in general very positive about Nicholson's performance, it included this sentence: "The sales have gone according to

plan, but yours is a complex field and you suffered a hard time over the Apulian vases since when you have been careful to avoid adverse publicity on excavated material."

There is no condemnation whatsoever, but it is the reference to "excavated material" that draws the eye. Mackay cannot be referring to objects that had been excavated many years earlier, for they were brought out of their countries of origin before modern laws were in operation, so that there could be no question of "adverse publicity." He must, therefore, be referring to recently excavated antiquities— and the only possible reason for adverse publicity, which was to be avoided, would be that such excavation itself was illegal, and sending the objects abroad made the transactions doubly illicit. The phrasing of Mackay's memorandum implies that he was well aware of the trade in illegally excavated and smuggled antiquities. Remember that it is Felicity Nicholson's—and James Hodges's—superior who is the author of this memorandum.

This is crucial for the following reason. It has never been a defense, in law, for an accused to say: Yes, I did wrong, but those around me were guilty of far greater wrongdoing. However, in this case that is exactly what the judge did say to the jury. Let us remind ourselves of his exact words: "Of course, if they did know and he was operating these accounts with their approval . . . you have then to ask yourself if the accused was operating these, even if he was making money on the side, as he says, that he would have been doing it with the permission of his superiors and therefore obviously not acting dishonestly; he could not possibly be."

The overwhelming evidence shows that Tim Llewellyn was wrong in his assessment of the situation. James Hodges shared Sotheby's big barrel with some distinctly rotten fruit.

In the week that the first program was aired, in November 1995, I received a letter from Michael Cumiskey, a retired headmaster living in Uxbridge, west London.

Dear Mr. Watson,

I was Foreman of the jury that was asked to consider the charges referred to [in your program], brought against Mr. Hodges at the Crown Court. . . . The complexity of the documentary evidence presented and the assorted range of witnesses called, left me convinced that Sotheby's were guilty of institutionalized collusion in the illegal import of antiquities. . . . a convincing case was made that at least one Director of the Company was well aware that artifacts, in this instance brought from India, did not satisfy export regulations from that country. Indeed there were admissions made by some senior members of Sotheby's staff that could leave little doubt in that regard. . . . Given the nature of the detail exposed in the case, I cannot have been the only person left to wonder why the Serious Fraud Office or the DPP [Director of Public Prosecutions] did not pursue the matter further.

For reasons best known to themselves, neither the DPP nor the SFO then took up the challenge. The British government is known to be worried that London will lose its preeminent position in the international art market, which shows signs of switching to New York and/or Switzerland, so perhaps that was part of the reason. An official inquiry into Sotheby's would not have helped.

In any case, it left the field free for us. And now let's return to the final events of the investigation, which occurred in early 1997, just as the programs and the book were being made ready.

After we had returned from India, at the end of October 1996, I had kept in touch intermittently with Essa Sham. In Bombay he had hinted that he had an outlet in London—an agent with a warehouse, or showroom, or storeroom—where the goods he had sent out of India could be seen. We were interested to visit this British outlet.

Mr. Sham failed to respond to my first faxes, ostensibly sent from Peter Carpenter in New York. Eventually, a couple of weeks before Christmas, I spoke to him on the telephone. He had mentioned he might be coming to London but now said that was impossible and he

wouldn't arrive until February. He did, however, ask me if I knew Sebastiano Birva Gallo, an Italian who specialized in Asian art and lived in London. I said I didn't, though the phone connection to India was not good and I could not be sure I had heard the name right. Sham ended the call without saying more, and it would have appeared suspicious for me to have pushed things harder.

I could not find the name Sebastiano Birva Gallo in any of my directories of art and antiquities dealers. There was an S. Gallo in the phone book, but whenever we called there was no reply.

We broke for Christmas. Sam Bagnall went to Australia, I went to the Bahamas. While in Nassau I was invited for a drink at a flat belonging to some friends of friends, persons I had not known beforehand. When I arrived at this flat I was amazed that it was crammed with Indian objects of art—sculptures in stone and bronze, wooden screens, ivories, silver, and much else. This naturally formed the chief topic of conversation, for our hosts were very proud of their collection. However, it also emerged that they bought all their art from an Italian living in London—named Sebastiano Barbagallo.

The coincidence was extraordinary. I wasted no time. It was easy to find Mr. Barbagallo's address and phone and fax numbers. On my way back from Nassau I faxed Mr. Barbagallo from New York, introducing myself (as Peter Carpenter) and saying that I had made contact with the Shams while in Bombay with my son the previous autumn.

Because I had appeared in the first television program, we decided it would be unsafe for me to pay Mr. Barbagallo a visit. So Sam went instead, soon after he returned from Australia.

One Thursday morning in late January, equipped with a secret camera and tape recorder, Sam went to Barbagallo's gallery in Pembridge Road. During this encounter, Barbagallo confirmed that he had a business relationship with Essa and Fakrou Sham. They had shared a warehouse off London's Old Kent Road. Barbagallo was indeed the agent responsible for consigning antiquities sent from India by the Shams to Sotheby's.

We also discovered that Mr. Barbagallo still had his warehouse in St. James Road. Sam showed him the catalogue of Sotheby's sale of Indian works of art in London in October 1996, pointing to lot 119 and saying that his "father" was very interested in the Kushan sandstone pillar. Barbagallo said that there had once been four of these, but two had sold and there were only two left. This tallied exactly with what we had been told by Essa Sham in Bombay, that there had originally been four. Barbagallo also revealed that, as well as the Kushan sandstone pillar, nine further lots in the Sotheby's October 1996 sale came from the Shams—lot 121, a medieval sandstone panel; lots 130–135, stone and wood figures; lot 138, four southern Indian granite pillars; and lot 141, a nineteenth-century door.

Sam met Barbagallo again five days later, on January 28, 1997, this time at his warehouse near the Old Kent Road. It consisted of four rooms, crammed with Indian artifacts and handicrafts. One room in particular was given over to stone sculpture of museum quality. There Sam was shown the two Kushan pink sandstone pillars Essa Sham had told us about, and four tall stone columns similar to those Zohar had told us belonged to him. Barbagallo said they were not the same, but that they came from "the same temple."

This information fitted perfectly. At the last minute, therefore, we had identified both ends of a network of individuals trading in illegally excavated antiquities smuggled out of India and sold at Sotheby's. New characters but a familiar story.

It will be remembered that I had approached Sotheby's five times before the first program was broadcast, showing staff some documents together with my interpretation of those documents. At all times the company refused to comment. After the first program was broadcast in November 1995, we received one letter from Sotheby's via its lawyers, Freshfields, but nothing else until we contacted Sotheby's about three weeks before the second program was to be aired in early February 1997. Once again, Sotheby's was reluctant to make any detailed response on the record; instead, it issued a statement to Channel 4.

The statement was fairly bland, emphasizing what a widespread company Sotheby's was, with hundreds of experts who saw a million objects every year. The company also said that it cooperated closely with governments, cultural ministries, and law enforcement agencies worldwide and had helped in the recovery of a number of stolen or looted objects. It said its specialist staff worked to clearly defined standards of behavior, supported by strictly defined rules and regulations. "If errors are made they are neither excused or ignored." The company said it cared deeply about its reputation. The statement said that Sotheby's welcomed investigative journalism, provided it was fair.

On Tuesday, January 21, 1997, the day that the British edition of this book went to press, we received an urgent message from the art squad of the Italian carabinieri, through Cecilia Todeschini in Rome. Following an investigation, Giacomo Medici had been arrested and was being held in Latina Prison, two hours south of the capital.

On top of that, we were told that the contents of not one but *four* warehouses had been seized at the Geneva Freeport. General Conforti (he had been promoted from colonel) told us that these warehouses contained ten thousand "finely made" antiquities from sites all over Italy—they were of Etruscan, Roman, Apulian, and Campanian origin—and valued at 50 billion lira, or £25 million. This was an enormous sum, far greater than we had expected. It was possibly the largest and most valuable seizure of antiquities ever made.

The following day the carabinieri held a press conference in Rome. Part of their statement read:

> The . . . investigation, intended to limit the serious problem of illegal excavation damaging the vast archaeological areas which exist on national territory, started in Rome in 1995, but was soon extended to Switzerland and England. In fact, the operations in London, which were carried out with the help of the English police [Richard Ellis at

Scotland Yard], recovered a Corinthian capital, a sarcophagus and a bas-relief of the Roman period—items which turned out to have been stolen some years earlier from a residence in San Felice Circeo.

In the course of the inquiries it was established that the seized goods belonged to a company based in Geneva, "Editions Services s.a.," which, although managed by a Swiss citizen, could actually be traced back to a large-scale international trafficker of archaeological objects: Giacomo MEDICI, 59 years old, Roman, resident of Viale Vaticano 44.

Shifting the investigation to Switzerland, with the active assistance of the local police there, it was possible to identify Medici's secret warehouse at the Geneva Freeport, which consisted of four large premises which were not in his name. . . . The importance of the find caused the local magistrature to act immediately and to seal the items while awaiting the *commission rogatoire* [the request, via diplomatic channels, from the Italian government].

Medici, who for many years has been the real "mastermind" of much of the illegal traffic in archaeological objects on an international scale, had set up a vast network of accomplices who, starting from individual groups of tomb robbers [*tombaroli*], going on through intermediaries, also included employees of important international auction houses, which were used for the selling of the smuggled goods. . . . Investigations are currently under way to establish the extent of the criminal activities of Medici's accomplices.

The Public Prosecutor's Office of Latina has already sent some international *commission rogatoires* to the relevant Swiss magistrature with the aim of finally repatriating the precious objects. In view of their large number and their historic importance, once they are back in Italy, these objects, which have already been catalogued by the representative of the Archaeological Superintendent for Southern Etruria, could give rise to the establishment of a new archaeological museum.

A new museum. Ten thousand objects, worth £25 million. That certainly helps to put the little matter of clandestine traffic in antiquities into perspective. There can now be no doubt about the colossal size of this trade or the damage that it does to countries like Italy or India. Ironically, a new museum containing the most beautiful

looted objects, located in a relatively poor region of the country, might prove a tourist attraction and help repair some of the damage that has been done.

Moreover, mention of the links to "international auction houses" shows that the posh sales, in London, New York, and elsewhere, far from being fringe areas of this world, are in fact vital to it. But the net is now closing.

The arrest of Medici and the seizure of ten thousand objects highlight two arguments that surround this topic. First, it has been said that as a result of the investigation reported in this book and that carried out by the Italian carabinieri, Sotheby's—and maybe other auction houses—may stop selling antiquities, and that the business will go underground. One may reply that a great deal of the traffic is already underground. The more important point is that Sotheby's is the biggest single player in this market anywhere in the world. If the company was to stop dealing in unprovenanced antiquities, the market would contract and fewer sites would be plundered illegally. On top of that, Sotheby's announcement that it was no longer going to sell unprovenanced antiquities would be a powerful signal of a changed attitude to this traffic, which, in the medium to long term, would help kill or at least dampen the appetite to trade in such objects. For the past decade the British Museum has refused to acquire unprovenanced antiquities. In the past twelve months both the Getty Museum in Los Angeles and the Metropolitan Museum of Art in New York have announced a similar policy. So attitudes are changing in this field, just as they have changed recently in the realm of ivory trading and ivory poaching. Sotheby's could provide leadership here.

Second, since the publication of this book in the United Kingdom, many dealers, collectors, and museum people have commented that Sotheby's is not the only institution nor its people the only individuals involved in this traffic; the other auction houses, dealers, and corrupt government officials in the countries con-

cerned must also share some of the blame. That may well be true—
but where is the hard evidence? This book and the television pro-
grams have been devoted to uncovering or corroborating evidence.
That, I suggest, is why the story has had the impact it has. It also ex-
plains why this book is about Sotheby's and Sotheby's alone.

The documents I was shown relate only to one company, and
formed part of the circumstances that led to the trial and imprison-
ment of one man.

But there is another point. When Giacomo Medici's warehouses
were seized in the Geneva Freeport, some objects were found to
have Sotheby's labels on them. Medici may have bought these ob-
jects at Sotheby's, or he may have, as the Italian police believe,
bought *back* his own objects, laundering them in the process, to
show they had been through a reputable auction house. Either way,
one may note that none of the objects in the Geneva warehouse had
any other type of label on them.

Medici was released from Latina Prison on the morning of Fri-
day, January 24, 1997, but held under house arrest at his home in
Rome in the shadow of the Vatican's walls. It is important to point
out that, as this is being written, he has not been convicted of any-
thing.

EPILOGUE

—_ww_—

A Dubious Trade

A week before this book was due to appear in Britain, in tandem
with the television programs, there were premonitions of disaster.
The first program, with the revelations about Giacomo Medici, was
aired on Thursday, January 30. Unknown to us, on the following
Monday a major trial was due to start in London involving antiqui-
ties smuggling. The defense lawyers in the case informed us on the
morning after the first program that they intended to argue before
the judge that our programs were in contempt of court and prejudi-
cial to the defendant, and that therefore the second one should not
be broadcast for the duration of the trial.

As the trial was then expected to last for six weeks, this was very
unwelcome news indeed. The lawyers in the case did not, of course,
know about the book, but any arguments that applied to the pro-
grams naturally applied to the book as well. We had negotiated a se-
rialization agreement with the London *Times*, which would be
featuring the book on the morning when the second—and more
sensational—program was due to be aired. All was now threatened.

The threat was real. The first program was due to be rebroadcast over the weekend, but Jan Tomalin, Channel 4's lawyer, removed it from the schedule so as not to compound any possible contempt. The rest of us had to sit tight for forty-eight hours until the judge gave his ruling.

On the morning of Monday, February 3, Peter Minns, Sam Bagnall, and I were in the editing suite trying to put the finishing touches to the second program. But until we heard from Jan Tomalin at the court, it was difficult to concentrate. Printing of the book had begun. We had held back as long as possible, for reasons of security, but if publication was to go ahead that week we could delay no longer.

The court hearing was set for 10:30. Jan had said it would last for between forty-five minutes and an hour and a half. By noon we had heard nothing, and our hearts began to sink. Shortly before 12:30 the phone rang. It was Jan. "We won!" she shouted down the phone.

It was a relief, but there was one other unanticipated consequence of the court case. In order to reassure the judge that program two was not in contempt, the barrister acting for us had been required to disclose—in open court—what it consisted of, and he had been obliged to go into some detail.

As it turned out, this was for the best. The London *Times* had been planning to lead with the main allegations contained in the book and program. But late on the afternoon of Wednesday, February 5, we learned that Sotheby's had suspended Roeland Kollewijn and George Gordon.

This, of course, made our story even stronger; something had happened as a result of the investigation. And so, on the following day, *The Times'* headline was SENIOR STAFF SUSPENDED BY SOTHEBY'S.

Inside, the paper ran a two-page spread, mainly the material on Kollewijn, under the heading SOTHEBY'S AND THE ART OF SMUGGLING. It also ran an editorial, GOING, GOING, with the subheading "Sotheby's must act fast before its reputation has wholly gone."

The *Evening Standard* was quick to follow, and its front-page "splash" later that morning was SMUGGLING ROW HITS SOTHEBY'S. All the nontabloid British papers followed the story, and the next day *The Wall Street Journal* ran with ART SMUGGLING SCANDAL BUFFETS SOTHEBY'S.

The New York Times followed on February 8, with an account headed ART SMUGGLING AT SOTHEBY'S: EXECUTIVES SUSPENDED. It quoted George Bailey, managing director of Sotheby's Europe, who said: "The law has been broken in this isolated case."

Meanwhile, *The Times* of London reported: "Sotheby's chief starts inquiry." It said that chief executive Diana Brooks had flown to London from New York to "take charge of the company's damage limitation exercise," and also that "the circumstances behind the export of a second painting, a study of St. John the Evangelist, by Fra Filippo Lippi, were being investigated by General Roberto Conforti, head of the carabinieri art theft division in Rome." That painting had been "withdrawn from a Christie's sale last December after its origins were questioned." I had broken the news about this painting, owned by Barbara Piasecka Johnson of New York, in *The Observer*.

Also on February 8, *The Times* ran a story headed SOTHEBY'S HONESTY DEFENDED BY ITS AMERICAN CHIEF. Ms. Brooks was quoted as saying, in part: "I want to stress how serious we are about these issues. . . . From time to time there are situations that arise that put everything we are about at risk." She accused me of entrapment, and said she was "calm because I'm a professional but I'm outraged." The "internal inquiry" would "continue to be conducted by George Bailey," who had been "appointed in 1993 to tighten up procedures."

In 1993.

An unnamed spokesman agreed that "there would be no independent presence in the investigation." But he denied the affair was

being "swept under the carpet." He added: "This is a purely internal inquiry. Answering questions about the nature of the investigation would make it much more of a public one. It is better not to do that."

John Marion, a former chairman of Sotheby's in America, said the TV report seemed "quite a bit of trickery and it doesn't put the press in the best possible light." He said: "It's a national sport in Italy to take things in and out of the border. It's regrettable," he added, "not shocking. . . . I have never been involved in Europe."

On February 18, *Newsweek* wrote: "Sotheby's Reputation on the Block," and quoted the *Evening Standard*, in which CEO Brooks "dismissed the accusations as . . . 'innuendo and speculation.' " February 27 brought the London *Times* account that the "Italian police seek to question Sotheby's staff," meaning Felicity Nicholson, Oliver Forge, and James Hodges.

The American magazine *Archaeology*, reviewing the British edition, said that "much of the discussion has been couched not just in terms of legality or illegality but also in terms of morality and of Sotheby's integrity and reputation" and cited "a forceful editorial in the Art Newspaper," outlining what it called the "moral ground": ". . . by the time the Indian sculptures—broken and stolen from a place of worship—appeared in the sale room, physical damage had been inflicted on a work of art, theft had been committed, with the exploitation of the poor (and sacrilege, if you are not completely impious). If Sotheby's role in abetting such crimes was indeed as conscious as Peter Watson's programme suggests, then the sale room must reorganize its priorities or forfeit all claim to respect."

By an ironic coincidence, on February 11 *The New York Times* reported: "At the wire, auction fans, it's . . . it's Christie's!"

This story put forth the news that Sotheby's "sibling rival" was ahead in sales for the first time in forty-three years.

· · ·

This did not complete the media reaction, not by any means. A version of the Channel 4 programs was broadcast on *60 Minutes* in the United States. I had more than fifty press, radio, and television interviews within three days of the book's publication in Britain. Countless cartoons appeared lampooning high-handed auctioneers who smuggled works of art. Eventually, the Channel 4 broadcast itself was aired on public television in the United States.

The sheer magnitude and spread of the media reaction was itself one measure of shock at the disclosures in the book and programs. People everywhere were astonished by the revelations. While many found Roeland Kollewijn's admissions regarding old masters appalling, still others were upset by the extent of antiquities smuggling and its effects on the countries of origin. The television scenes in the Indian village of Lokhari were regarded as especially moving.

In Italy, Dr. Ferri, an investigating magistrate, took formal possession of the Nogari, and a copy of the book, as evidence in any forthcoming trial, and we forwarded the bundle of documents relating to wrongdoing in Italy to Rome. Later he traveled to London to interview me in the Italian consulate. The Indian director of revenue intelligence made a special journey to London to inspect those papers that referred to his country and took them away with him. By then, Zohar and Essa Sham had been remanded in jail for three weeks. In London the Inland Revenue paid a visit to Sebastiano Barbagallo, and Richard Ellis of Scotland Yard's art and antiques squad also took possession of some of the documents.

Now that the dust is settling, for the moment, it is time to place our investigation, and its revelations, into a broader context. The investigator is not necessarily the best-situated person to judge the moral complexities of a field where he has spent so much time immersed in the detail, but he can at least raise the issues, for if change is to come, certain moral choices need to be made in the art market. Sotheby's is central here, but the issues concern not only auction houses.

. . .

In a BBC interview broadcast on the day the second program was aired, George Bailey claimed that Kollewijn had been "entrapped" by us into smuggling an object and that this device was disgraceful. The words he used in his interview were perhaps revealing of the attitudes inside Sotheby's. For Bailey also said that all Kollewijn had done was to "slip up," and he added, "Mr. Watson has penetrated our barriers only once." The BBC interviewer took Bailey to task for these statements, asking whether he regarded the breaking of Italian export laws as a mere "slip-up" and what Bailey and his colleagues had to hide behind these "barriers." Bailey insisted that he would carry out his own inquiry to find out the true extent of wrongdoing inside the company.

Dede Brooks's point about the "entrapment" of Kollewijn was supported by a Conservative backbench member of Parliament who said that he disapproved of obtaining evidence by such a method.

Note that by now there was still no suggestion from Sotheby's that the documents we had used as the basis for our investigation were forged or altered. That part of Sotheby's argument apparently had been dispensed with. Instead, Sotheby's main point had become that Kollewijn had been entrapped. Now, the chief objection to entrapment (leaving aside for the moment whether the term is at all appropriate) is that the process vitiates the wrong it seeks to demonstrate because the method itself involves wrongdoing. But the law is similar in Great Britain and in the United States. Entrapment occurs when the law enforcement agency, or the journalist, persuades someone to do something wrong that he or she would not otherwise do. It is not entrapment if the police, or journalists, merely tap into an illicit practice that is already ongoing, in order to demonstrate the specific nature of the wrong and that it is still occurring.

And this, of course, is the light in which our efforts in Milan can be seen. We had fifty-five pages of documents as evidence that the traffic in old masters out of Italy went on via Sotheby's Milan office

and had been doing so since at least the early 1980s; those documents prescribed an appropriate approach. It appeared to us as if with Kollewijn a floodgate had opened: he was in the end only too keen to do business—as before—and to smuggle the Nogari and the rest of the "collection."

And can one really believe that this story could have been told in any other way? The art world is sophisticated, and a great deal of money swirls around in it. In my earlier book *The Caravaggio Conspiracy*, I was able to show how the trade in stolen paintings occurred only by becoming part of that world, by going undercover. Between that book and this one I wrote four other works of nonfiction, none of which required such behavior on my part. A sophisticated world requires sophisticated investigative techniques to get at the truth.

Sotheby's announced inquiry into its practices was to be "independent" only to the extent that it would be carried out by Sotheby's nonexecutive directors assisted by an outside law firm. This was disappointing, but a few days later, the company did announce that Roeland Kollewijn had resigned. He, incidentally, was described by unnamed members of Sotheby's as a "loose cannon"—not their normal sort of employee, but someone who in his spare time wrote romantic novels. Now he was the only bad apple in the barrel, supposedly.

Sotheby's also made much of the fact that the company was under "new management," that Dede Brooks had been chief executive officer since 1994 and that she had appointed new people, from outside Sotheby's, to run things in London. Because the company set such store by this argument, it is worth pointing out two things. One, Sotheby's seemed to be conceding—implicitly at least—that the former management was not all it might have been in terms of probity or managerial skills. If this is the case, who were the crucial members of the old management who are now out of the picture? Because the fact remains that though Ms. Brooks has taken over as CEO, some senior Sotheby's experts implicated in the documents on which this book is based continue to be employed by the company. Felicity

Nicholson did not leave until the end of 1996, and both Oliver Forge and Brendan Lynch have been promoted. It would thus seem that the new management is unacquainted or out of touch with the activities in several parts of the company that are described in this book. Ms. Brooks, in any case, has been at Sotheby's in New York in one management capacity or another since the late 1970s.

As this epilogue is being written, the independent inquiry into Sotheby's has yet to report. Its conclusions, of course, cannot be predicted. But does Sotheby's really expect us to believe that Roeland Kollewijn was acting alone? Does it really expect us to ignore the comments by Kollewijn, reported on film in the second Channel 4 program, that he sees smuggling all the time? Does it really expect us to treat as a joke his statement that "if I were a judge I'd arrest the whole lot here"? Are we to turn a blind eye to his statement "Why are we here?" On the second day that this story broke in Britain, the London *Times* rang every one of Sotheby's twenty-four directors for a comment. All but two were either unavailable or refused to comment. Now it was the turn of *The Times*, in its editorial that day, to condemn such behavior as "outrageous" and urge the company to bring in truly independent investigators to see "whether the crime committed in Milan was as isolated a case as Sotheby's claimed."

A month or so after the story broke, Sotheby's announced that an internal inquiry had cleared George Gordon of any complicity in smuggling the Nogari, though it also said that the independent inquiry would look again at his role. This did not look exactly like the action of a company determined to clean itself up. What was George Gordon's role in the smuggling of the Nogari? It certainly appeared to us that he was well aware of what was going on, condoned it, and had gone through similar procedures before.

And one may also ask: what is the point of holding an independent inquiry if one of those centrally implicated is cleared even before the independent inquiry has met? In this regard a document not previously referred to is relevant. In the middle 1980s, when the

auction houses (in the plural) came under fire in both New York and London, for various irregularities, Sotheby's instituted an independent inquiry into, among other things, the practice of chandelier bidding. On that occasion the outside expert called in was Sam Stamler, QC. Mr. Stamler's report was a bombshell for Sotheby's. It concluded that chandelier bidding was illegal under the Theft Act and under the Sale of Goods Act. But Mr. Stamler's report never saw the light of day; Sotheby's buried it.

The same behavior must not be allowed to occur this time. If Sotheby's hides behind the entrapment smear and persists in regarding Roeland Kollewijn as a solitary loose cannon, if the company refuses to acknowledge its intimate association with smugglers who are doing such harm in countries like Italy and India, then surely it is only storing up trouble for an even bigger explosion later. Sotheby's must act now, and be seen to act, not least for the sake of the great majority of its sixteen hundred employees who are honest.

Some observers of the art market said that Sotheby's was less of an evil than were the draconian laws in force in countries such as Italy and India, that this is a morally complex field where even the Mafia exists in the background. To an extent, this issue was addressed in an earlier chapter, where it was argued that both India and Italy are democracies whose laws must therefore be respected, if not liked. Furthermore, what is plain from the documents and the secret filming is that the people involved in these clandestine activities are perfectly aware what they are doing is wrong, and that does not dissuade them. This is not simply a case of turning a blind eye to the wrongdoing of others. It is the active encouragement or participation by auction house personnel in the flouting of laws. They are saying, in effect, "These laws enacted in other countries are unreasonable, and therefore we are entitled to break them."

Against this may be ranged the attitude of certain prominent museums that are instituting policies whereby they will no longer acquire antiquities that have no detailed provenance and therefore,

almost certainly, have not been excavated in the proper manner. This is a new attitude, which also reflects a commensurate change in many underdeveloped countries, rich in artistic heritage, which realize that properly excavated sites can not only add to our knowledge of who we are but attract scholars, students, and tourists as well, with all that this implies commercially and culturally.

A quite different argument made by Sotheby's after the book and programs appeared was that the Nogari was not very valuable and "probably" would have received an export license had one been applied for. Far from mitigating Kollewijn's behavior, this only made it worse. If he was willing to smuggle the Nogari, how much more likely would he have been to smuggle a more valuable work?

Another argument raised in the wake of British publication was that if the auction houses do not deal in these illicit goods, the trade will go underground. This is a world-weary argument, but a moment's reflection will show that it doesn't hold water. By the best calculations of archaeologists at the University of Cambridge, 30–40 percent of the world's available antiquities pass through the salerooms. Of that, around 90 percent is unprovenanced and very probably illicit. This is a measure of how the salerooms act as a magnet for this traffic, *creating* a market. Without this magnet, the trade would be smaller, and maybe much smaller.

Think what a change would follow on a decision by the world's major auction houses to refuse to sell unprovenanced antiquities. Coming on top of the actions of the major museums, it would send a signal across the world that looted antiquities are now beyond the pale. Such a change of attitude has been achieved in regard to ivory poaching and the pelts of rare animals, so it is by no means wishful thinking to hold that such a change in attitude could take place in regard to antiquities. Moreover, a study published in *Archaeology*, the journal of the American Archaeological Association, showed how sensitive the market in illicit antiquities can be. The object of the study was Cycladic figures—sculptures made in the Cyclades islands of Greece. At one stage, these objects were fetching very high

prices at auction, and forgeries started to flood the market. In time this so put off the collectors that the market collapsed—and the looting also declined in response.

Of course, there will always be private buyers, but the attitude of private collectors is often determined by what goes through the saleroom; if the rooms are full of unprovenanced material, the private buyer is invited to believe that such objects are aboveboard.

Another aspect of this morally complex field stems from the fact that many of the objects are minor works, a long way from being "national treasures." Even if this is true, the salerooms do themselves no favors by making no distinction between the more valuable and important unprovenanced antiquities and the everyday material: they sell it all. They would have more of a case if there were evidence that they refused to traffic in the better, more important items. Sotheby's says that it is not its responsibility to police the market; Sotheby's is right, but that is far from accepting that it has no moral responsibility at all in this matter, no need to take "due diligence" to see that what is sold in its name is not illegitimate, given its expertise in antiquities, old masters, etc. Sotheby's should be aware of how much material is illicit in some areas and ought to take action at least to reduce that amount significantly.

Yet another argument made in the wake of publication holds that Sotheby's culpability is somehow less because it is not the only one involved. Dealers from Italy and India, corrupt customs officials who permit themselves to be bribed to turn a blind eye to smuggling, diplomats who allow the diplomatic bag to be abused to get illicit objects out of the country, and others may all be singled out for censure.

This is manifestly true, but has it anywhere ever been a defense that one kind of wrongdoing renders other kinds permissible? Of course not—and a somewhat similar argument was certainly not accepted at Hodges's trial. Once again, this ignores the crucial and magnetic role of auction houses in the art market. Although it is unlikely that smuggling will ever be stamped out, there is a world of

difference between the occasional, isolated illicit transaction and having an auction house serving, unwittingly or not, as a clearinghouse for such works.

Here again the central problem is one of attitude. Sotheby's appears unwilling to acknowledge that it is a magnet, for both legitimate and illegitimate goods, and that therefore it has a special responsibility in this field, one that is not shared by, for example, dealers, who, being a far more fragmented part of the market, can never occupy this role.

Which brings us to one final commentary on the book—namely that we unfairly focused on Sotheby's, that the rest of the art world is just as corrupt. On the face of it, this is a fair point. The rivalry between Christie's and Sotheby's is so keen precisely because the two houses are so very similar. On reflection, however, and after taking legal advice, we decided that an investigation of Christie's, or any other group in the art world, was much easier said than done.

The first—the most obvious and most fundamental—objection was that the all-important documents that were leaked to us involved Sotheby's, and Sotheby's alone. It was hard enough to corroborate the picture painted in the documents; to have looked outside Sotheby's would have been much more difficult. Moreover, *that* would have risked committing entrapment. Had we tried to investigate Christie's, say, because our documents implicated Sotheby's, that would have been a dubious course, both morally and legally. Journalism has force only when there are prima facie grounds for beginning an investigation. Some people may feel that the general accusation that "they are all at it" may amount to grounds for investigation, and perhaps they are right. But neither David Lloyd at Channel 4, nor Bernard Clark, nor Sam, nor I agreed with that view. This did not make us "blinkered," as one critic said; it made us careful.

Nonetheless, the other auction houses, and dealers, are not let off the hook completely. They must know, for instance, whether they have or have had dealings with some of the dubious characters ex-

posed in this book, and they therefore have exactly the same obliga-
tions as does Sotheby's to clean up their acts in the future. In this
regard an article in a forthcoming issue of *Archaeology* is especially
relevant. This article, by Christopher Chippendale and Dr. David
Gill, of the University of Wales, Swansea, examined thousands of
antiquities coming up for auction in London and New York at three
salerooms in December 1994 and again in June 1997. They found
that in London just under 90 percent had no provenance whatso-
ever and had first "surfaced" in the 1990s. Each of the auction
houses—Bonhams, Christie's, and Sotheby's—showed similar trends,
while in New York just under 80 percent were unprovenanced. In
other words, the picture in New York was slightly better, but not
by much.

These are chastening figures. Virtually nine out of ten antiquities
sold on the London market are of dubious origin and eight out of
ten in New York. At least three of the big four auction houses sell
them.

The second reason for concentrating on Sotheby's concerns
James Hodges, the person who handed over the documents. There
was a personal element in this story that led to the investigation in
the first place. The full background of Sotheby's (and the Crown's)
prosecution of one man is part of the story and needed to be told.
That background involved Sotheby's and no other institution in the
art market. Some newspapers ran headlines saying, in so many
words, that I was the "Scourge of Sotheby's." Nothing could have
been further from the truth. Like any journalist I dealt with the ev-
idence that came to me, nothing more and nothing less.

In summing up, it is important to say this. The art market, indeed
the art world as a whole, has long been awash with rumors that
Switzerland is the laundering center for smuggled art, and that a
good proportion of old masters, antiquities, and other objects that
come up for auction are illicit in some form or other, even that the
Mafia has a hand in these affairs. We have now moved beyond rumor

to the realm of corroborated documentation. We now have names, objects, prices, places, dates, lot numbers, details of the procedures employed.*

We have demonstrated, we believe, two important matters. First, the traffic across national frontiers in illicit goods that end up at auction is unacceptably widespread and takes place in bulk. And second, the auction process is by no means as open and clean as it is frequently presented to be, but is susceptible to all manner of manipulation and massage, and it is in the public interest to know the details.

The damage done in the archaeological field is almost certainly considerable. An article in *Archaeology*, published in 1993, pointed out that the Oxford Research Laboratory for Art and Archaeology, which authenticates ceramic objects by thermoluminescence, has reported that 40 percent of ceramic works submitted to it are not ancient. The authors of the *Archaeology* article add that with Cycladic antiquities, there are two major forms, male figures and the so-called harpists, that have never been discovered in any legitimate excavation. Since it is very hard even for experts to distinguish genuine Cycladic objects from fakes, it is entirely possible that whole categories of so-called Cycladic art are in fact recent inventions. All this is thanks to the illegal excavators and smugglers.

A review of this book in the British archaeological journal *Antiquity* called for the Oxford laboratory mentioned above to refuse to offer its help in the authentication of antiquities (as happened, for example, with the votive plaques from Chandraketugarh). The reviewer pointed out that the laboratory had earlier promised not to do this after it had been argued that its authentications of objects sent out of Mali illicitly were giving credibility to such traffic.

The reviewer went on to add that in 1992, the Fitzwilliam Museum in Cambridge, England, had exhibited a collection of Ghandaran antiquities from various sites in Afghanistan and Pakistan. At

* And, incidentally, we found no evidence of Mafia involvement. This doesn't mean there wasn't any, of course, but the subject was never raised, not by the carabinieri, the *tombaroli*, or the archaeologists.

the time it was well known in the antiquities field that as a result of
the Afghan war, many sites in the region were being plundered, and
representations were made to the museum to cancel the show. De-
spite this, the museum pressed ahead.

The exhibition, according to the reviewer (who then worked at
the Fitzwilliam), was owned by "A.I.C." "Cambridge and London
gossip was that the initials related to an antiquities investment com-
pany based in Switzerland. Lo and behold, Watson reveals that a
company that used to launder looted Indian antiquities was the
Swiss based Artistic Imports Corporation. If these two A.I.C.s are
indeed the same trust, then the Fitzwilliam appears to have been in-
volved in the wilful display of smuggled antiquities, and providing
the owner with a respected platform to present his (or her) loot. It
may become clear, when the Fitzwilliam properly explains itself,
whether this fine museum was naive or knowing."

The *Antiquity* reviewer also said: "I recall one ancient art consul-
tant telling me that it was well known that certain smugglers of an-
tiquities also traded in drugs and arms; do we want to endorse these
actions as well?" And he concluded: "Watson's investigations have
provided significant evidence which should be used to call for the
cessation of the antiquities market before more irreversible damage
is done. Those unconvinced that the antiquities trade is surrounded
by sleaze should read this book; those already convinced have been
provided with powerful ammunition."

And more pressures are building. Shortly after this book and the
TV programs appeared, *The New York Times* reported that the In-
ternational Council of Museums had traced six stolen Cambodian
antiquities looted from Angkor Wat. Of these six, five passed
through Sotheby's. Some were actually sold at auction; others were
withdrawn when it was discovered that their provenances were un-
certain.

Further, in the same month, a BBC program, *Watchdog*, reported
an operation it had conducted with another London auction house,
Bonhams. In this case, a reporter took into the auction house a

drumstick that he (falsely) claimed had belonged to Ringo Starr, the Beatles' drummer. This stick subsequently appeared in the catalogue with its famous provenance—Bonhams had done nothing to check that Ringo Starr had indeed owned the stick, as it admitted later.

This was a minor object (to most people), but that is not the point. The point is that, coming on top of our investigation, the *Watchdog* program underlined the fact that in all manner of ways, auction houses are unregulated bodies, offering dubious objects under conditions of sale that would not be tolerated in other walks of life—in supermarkets, for example, where detailed guarantees about foodstuffs are routinely given and often required by law. One of the British antiques dealers associations has recently been at pains to point out that dealers give undertakings about the authenticity— and legality—of the objects they sell, and are obliged to make refunds if it can be shown they have fallen short of these standards.

The auction is both an ancient and a contemporary way to trade; it often lends itself to drama, and it is for the most part honorable. Very probably it is here to stay.

The real reason Sotheby's has reacted with such ferocity to the revelations in this book is not so much that it was entrapped but that the secret filming, etc., caught it red-handed. This was a scandal just waiting to be revealed—because the arrogance of certain senior figures within the company made them grow lax and commit so many incriminating details to paper. In the end the documents are even more damning than the filming.

The dubious trade in illicit cultural objects is a complex field, both ethically and legally, and I would be the first to admit that there is no easy solution. But it cannot be right for any auction house, large or small, to engage in the dubious trade revealed in this book. Those practices must change.

On July 23, 1997, *The New York Times* said: "After allegations that it had been selling artifacts smuggled into Britain, Sotheby's an-

nounced that it would no longer have its general sales of Greek and Roman antiquities or Indian and Himalayan works of art in London.

". . . exceptions would be made," the newspaper reported, "if a special collection came up for sale with an impeccable provenance and the seller agreed."

All property in these fields, Sotheby's officials said, would be sent to New York instead.

At the same time, "two of Sotheby's top experts in these fields . . . —Oliver Forge, who headed Sotheby's antiquities department . . . and Brendan Lynch, head of its London Islamic and Indian department—have left the company on the heels of the announcement."

Sotheby's said it was not closing the antiquities department.

Index

PETER WATSON, journalist and author, has written for *The Sunday Times* (London) as part of its famed Insight Team, and for *The Observer, The New York Times,* and *The Spectator* magazine. He is the author of *The Caravaggio Conspiracy,* for which he received the Gold Dagger Award from the Crime Writers Association in 1983. He is also the author of *From Manet to Manhattan* and other books. Since September 1997 he has been a research associate at the McDonald Institute for Research in Archaeology at the University of Cambridge. Watson lives in London and France, and is often in the United States.

ABOUT THE TYPE

The text of this book was set in Janson, a misnamed type-
face designed in about 1690 by Nicholas Kis, a Hungar-
ian in Amsterdam. In 1919 the matrices became the
property of the Stempel Foundry in Frankfurt. It is an
old-style book face of excellent clarity and sharpness. Jan-
son serifs are concave and splayed; the contrast between
thick and thin strokes is marked.